TREASURES

THE ROYAL COLLECTION

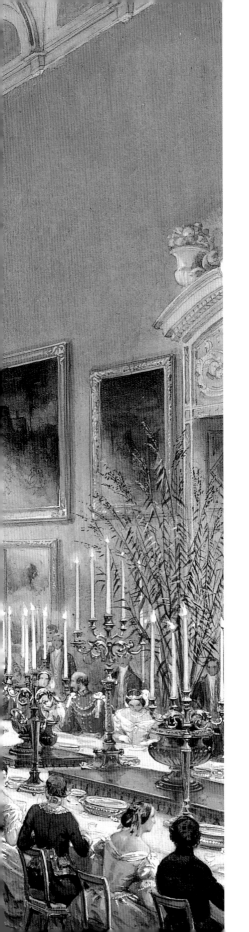

TREASURES
THE ROYAL COLLECTION

Edited by
JANE ROBERTS

ROYAL COLLECTION PUBLICATIONS
and
SCALA PUBLISHERS LIMITED

Published in 2008 by
Royal Collection Enterprises Ltd
St James's Palace
London SW1A 1JR, UK

in association with

Scala Publishers Ltd
Northburgh House, 10 Northburgh Street
London EC1V 0AT, UK

The text in this book is abridged from
Royal Treasures: A Golden Jubilee Celebration edited by Jane Roberts,
published by Royal Collection Enterprises Limited in 2002

Hardback (English language excluding USA and Canada) ISBN-13: 978 1 905686 05 6 / SKU: 012129
Hardback (USA and Canada) ISBN-13: 978 1 85759 568 0
Paperback ISBN-13: 978 1 905686 06 3 / SKU: 012128

British Library Cataloguing-in-Publication data:
A catalogue record for this book is available from the British Library

Text edited by Rosalind Neely and Jane Roberts
Designed by Yvonne Dedman
Project Manager, Scala: Esme West

Printed in Italy by Studio Fasoli, Verona

10 9 8 7 6 5 4 3 2 1

Page 1:
Detail of crest from Queen Victoria's jewel-cabinet, 1851 (see p. 94)

Frontispiece:
LOUIS HAGHE (1806–1885)
The Picture Gallery at Buckingham Palace, 28 June 1853
Watercolour and bodycolour over pencil; 33.0 × 47.4 cm
Signed and dated *L. Haghe. / 1853*
RL 19917

❧ CONTENTS ❧

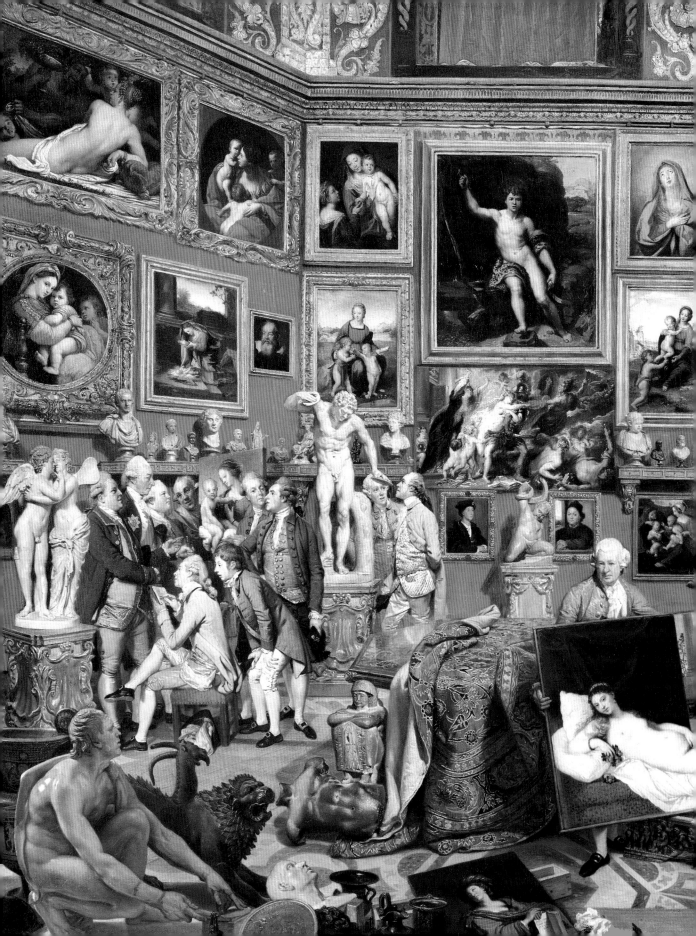

THE ROYAL COLLECTION

❧ HUGH ROBERTS ❧

What is the Royal Collection? For many people, the answer to this deceptively simple but hydra-headed question might come in a phrase such as 'one of the world's great picture collections'. Images of paintings from the Royal Collection, made familiar through countless reproductions and loans to exhibitions, spring easily to mind, and a seasoned visitor to Windsor Castle, Buckingham Palace, Hampton Court Palace or Kensington Palace – or to exhibitions at The Queen's Gallery over the last 40 years – would probably have no difficulty in putting together a list from remembered masterpieces, perhaps including the jewel-like Duccio *Crucifixion* (p. 27), Van Dyck's haunting images of Charles I (p. 38), the matchless Rembrandt double portrait of the *Shipbuilder and his wife*, Vermeer's perfectly balanced *Lady at the virginal with a gentleman* (p. 45) and Canaletto's miraculous views of Venice. The list might well go on to include some of the stupendous drawings at Windsor – masterpieces by Leonardo da Vinci, Michelangelo, Raphael or Hans Holbein the Younger. But only for a very small percentage of visitors would the infinitely more numerous splendours of the decorative arts in the Royal Collection – Sèvres porcelain, French furniture, Fabergé, gold plate, jewellery or armour, for example – figure in any way. And books and manuscripts – intrinsic to most long-established collections – would probably not even rate a mention.

Views such as this reflect not only the traditional supremacy of painting over the other arts but a widely shared difficulty in grasping the complexity, let alone the context, of such a historic and extensive accumulation of works of art – in fact the last great European dynastic collection still to survive in royal ownership. It is not just that the Royal Collection is very large, very widely spread and exceptionally varied (all of which simple statements are true). More than anything it has the character of a 'collection of collections' typical of an ancient and (in origin) essentially private assemblage of works of art. These sub-groups or 'collections within' vary considerably: some are of a single category of object assiduously brought together by one or more individuals; others are entirely disparate in character and linked purely by date of acquisition; and each one bears to some degree the imprint of the personality of the collector or collectors responsible. Distinct collections of this type that still carry the name of, or an association with, a former owner are to be found in most of the principal categories or sub-divisions of the Royal Collection, including drawings, paintings and books, gems, tapestries, silver, porcelain and furniture. Many of these sub-groups have been assembled piecemeal or in small consignments, but some have arrived ready-made, *en bloc*. In this extended accumulative process, purchase, gift, exchange, sale, debt, confiscation and destruction have all played their part. Over time, these collections have all been assimilated, layer upon layer, by succeeding generations of the royal family, to coalesce in an almost organic way with the generality of royal possessions ('all the old trash belonging to the crown') in the various royal residences, masterpieces mingling with the 'rubbishy pictures of kings and queens' that W. Hazlitt so deplored at Windsor.

In this respect at least, the Royal Collection is wholly unlike a museum collection. With few exceptions, the British national collections have been formed deliberately and selectively to provide as nearly as possible a comprehensive representation of the arts and sciences, with the specific purpose of satisfying in an educational manner the requirements of the public. Additional pressures, such as the need to bolster national pride and (occasionally) to burnish the reputation of an incumbent director, may also have played a part in this process. The Royal Collection by contrast remains above all else a testament to the personal collecting quirks and acquisitive instincts (or lack of them) of the royal family of this country from the late Middle Ages to the present day. It also reflects the fact that the existence of an hereditary monarchy, repository over a long period of time of an enormous quantity of accumulated possessions, has (on the whole) helped to ensure the safe passage of such possessions from one generation to the next.

Detail: Johan Zoffany, The Tribuna of the Uffizi, *c.1772–78 (see p. 53)*

The House of Stuart

Of course it has not always been a safe or easy passage; and gains and accumulation have been more than matched by loss and dispersal. Changes of rule or of dynasty have been the usual cause of loss, as a brief survey of the principal collectors will make clear. Chief among such losses was the dispersal of the incomparable collection of Charles I during the Interregnum (1649–60), a blow from which it seemed for a long time the Royal Collection would never recover. Charles I is acknowledged as the most perceptive collector ever to have sat on the throne of this country. His numerous acquisitions of paintings and sculpture prove the point beyond any argument. If these acquisitions are added to the distinguished collection that Charles I inherited from his elder brother Henry, Prince of Wales, and to the possessions passed down from their Tudor forebears, chiefly Netherlandish paintings, tapestries and jewellery, it is clear that the Royal Collection as it existed in the 1630s was for the first time in its history on an equal footing with any of the great royal collections of continental Europe.

But what is more difficult to discover – and this is true of all royal collectors from Charles I to the present day – is the degree of personal taste and interest that lies behind the process of making such acquisitions. For a royal collector there are, as Francis Haskell put it, 'certain obligations – to the expectations of their courtiers and subjects, to the traditions of their ancestors, to the Church, even to the cause of ostentation itself – which may stand in the way of expressing a more personal discrimination'. And if this is true of individual acquisitions, how much more so when it comes to the purchase of a collection *en bloc*, especially a foreign collection such as that of the Gonzaga of Mantua, which Charles I acquired from 1627 to 1628 and which included one of the most important series of Italian pictures ever acquired by a European monarch, the *Triumphs of Caesar* by Andrea Mantegna, and a celebrated collection of antique and Renaissance sculpture.

There is a further aspect of royal acquisitions: the influential role played by advisers, agents and diplomats, which is often equally difficult to pinpoint, but which is of great importance in determining the character of this collection. Very few post-Renaissance English monarchs before Queen Victoria were able to travel abroad – even before they acceded to the throne – so inevitably much of the scouting for works of art was done by others on their behalf. In this respect Charles I, when Prince of Wales, was exceptionally fortunate in being able to visit Spain in the company of the Duke of Buckingham, also a serious and adventurous collector of pictures. This visit

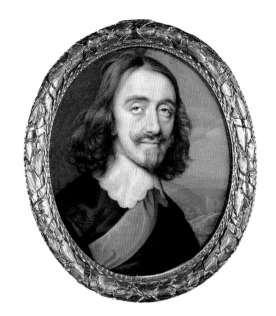

John Hoskins (*c.*1590–1665)
Charles I, c.1640–45
Watercolour and bodycolour on vellum laid on card;
oval miniature, 7.5 × 6.2 cm
Signed at left *IH fe*
RCIN 420060

in 1623 to negotiate a marriage with Philip IV's sister, the Infanta Maria, was to give the Prince a first-hand view of the splendours of the Spanish royal collection and a lasting love of the paintings of Titian, whose works were magnificently represented there. Although the marriage negotiations were unsuccessful, two masterpieces by Titian were acquired, the *Venus del Pardo* (now in the Louvre) and the *Emperor Charles V with a hound* (now in the Prado). These paintings, which came as gifts from the Spanish King, set the standard for Charles I's later acquisition of works by Titian; and, by the same token, they occupy a significant place in the long history of art and diplomacy, by which the composition of the Royal Collection (and most ancient collections) has been radically altered from time to time. It was also while he was in Spain that Charles I – perhaps on the advice of Rubens – concluded negotiations for the purchase of the Raphael tapestry cartoons from Genoa. Other major figures in Charles I's circle who worked directly or indirectly as agents and advisers included Nicholas Lanier (who assisted with the Gonzaga negotiations), Sir Balthasar Gerbier, Sir Dudley Carleton and Lord Arundel (who among other things was responsible for the acquisition of two important Dürer portraits). Such a pattern of assistance, involving artists, courtiers and diplomats, was often to be repeated with later monarchs.

The example of Charles I's collecting highlights the question of personal royal taste, although in his case the evidence from contemporaries is unusually clear and the objects tend to speak for themselves. He was not only a knowledgeable connoisseur of Old Masters in his own right, but also a discerning patron of contemporary artists, above all of Rubens and Van Dyck. The spectacular Rubens ceiling in the Banqueting House and the series of glamorous portraits of the King, his family and court by Van Dyck, bear eloquent testimony to his distinction as a patron. He was also prepared to back his judgement in the way that only a true collector will in exchanging one work of art for another that he considered more desirable. In this way, the exquisite Raphael *St George and the Dragon* (now in the National Gallery of Art, Washington, DC) entered the collection between 1627 and 1628 by exchange with Lord Pembroke, who received in return the valuable volume of Holbein portrait drawings of Henry VIII's family and court (see pp. 222–25). Although the Raphael left royal possession permanently in the Interregnum, the Holbein drawings re-entered the collection in the reign of Charles II.

The calamitous sale of Charles I's collection scattered to the winds not only pictures, miniatures, drawings and sculpture of supreme quality, but also examples of the majority of decorative arts as well – including the King's insignia and personal jewellery, silver, armour, furniture and many of the tapestries. Some of these treasures were recovered at the time of the Restoration, given back by loyal monarchists, or forcibly repossessed. They rejoined those parts of the old Royal Collection that had been reserved from sale by Cromwell for the decoration of the palaces which he had continued to occupy. Well before 1660, however, many of the greatest masterpieces from Charles I's collection had become prized – and permanent – possessions of the French and Spanish courts.

Some of the gaps were filled by the arrival of 72 paintings bought by Charles II in the Netherlands, and by the handsome gift of pictures and sculpture from the States-General of Holland in 1660, which included a powerful portrait by Lorenzo Lotto (p. 30) and a possible Giorgione. The King also managed to retrieve the important group of pictures – amongst which was Holbein's '*Noli me tangere*' (p. 32) – that his mother, Queen Henrietta Maria, had apparently taken to France in her widowhood. In doing so, he had to fight off the claims of his redoubtable sister, the Duchess of Orléans – not the last occasion on which family disputes threatened to damage the integrity of the collection. To all these were added in due course a considerable number of newly acquired contemporary works by Lely, Kneller and others, and the

volume containing around 600 drawings by Leonardo da Vinci.

The decorative arts in the Royal Collection, most notably silver and jewellery, had suffered catastrophic losses during the Civil War and Interregnum. With the exception of the 12th-century Anointing Spoon, all the ancient coronation regalia had been melted down in the year following Charles I's execution. Earlier on, much royal plate had also been melted to support the King's straitened finances, as had masterpieces 'tainted' by religious practices deemed unacceptable by Puritan extremists. The magnificent Garter altar plate by Christian van Vianen, seized in 1642 from St George's Chapel, Windsor, was probably the worst casualty of this type. Immediately following the Restoration, orders were placed for new regalia and for substantial quantities of new plate, both ecclesiastical and secular (see pp. 157–59). This was supplemented by gifts from those individuals or bodies (such as the cities of Exeter and Plymouth) wishing to re-establish or underline their loyalty to the Crown. Large orders were placed with the royal banker and goldsmith, Sir Robert Vyner, and this great influx of Baroque silver, much of it made by immigrants attracted to London by the prospect of lucrative commissions from the new court, remains at the heart of the present collection.

Despite all these attempts to repair the damage inflicted during the Interregnum, the overwhelming impression was of irretrievable loss; and while the King's building projects – which included new palaces at Winchester and Greenwich, the remodelling of Windsor Castle and the rebuilding of the Palace of Holyroodhouse in Edinburgh – achieved the aim of re-establishing the prestige of the monarchy, it was not for another hundred years that the contents of the royal residences could begin to compare with the splendours of Charles I's day.

By contrast, the second revolution of the century, the deposition of the Catholic James II by the Protestant William III in 1688, brought about comparatively few changes to the collection. The exiled Stuarts took little with them except Mary of Modena's extremely valuable personal jewellery, most of which was subsequently sold in France. The incoming King moved his focus of interest from Whitehall to the newly acquired Kensington Palace and to Hampton Court Palace, shortly to be transformed by Christopher Wren from a Tudor rabbit warren into one of the finest Baroque palaces of Europe. But architectural gains of this kind, accompanied by substantial orders for grand new furniture and furnishings, were balanced by grievous losses. In 1698 the ancient and historic Palace of Whitehall – principal seat of the English monarchy

since 1530, when Henry VIII appropriated it from Cardinal Wolsey – was destroyed by fire; the only substantial part of the palace to survive was the Banqueting House. In the flames perished one of the very few surviving pieces of Charles I's magnificent collection of contemporary sculpture, the celebrated bust of the King by Gianlorenzo Bernini. This was arguably the single greatest total loss of any work of art from the collection. Further inroads occurred when William III transferred an important group of paintings to his palace in Holland, Het Loo. They were subsequently claimed back by his sister-in-law and successor Queen Anne, but in vain – a pertinent example (of which there were to be many more after the arrival of the Hanoverian dynasty) of the potential danger to the collection of having a British monarch with sovereign territories overseas.

William III's consort and co-sovereign, Queen Mary II, was the first member of the royal family to show a serious interest in ceramics. Her apartments at Het Loo and Honselaarsdijk in Holland and later at Kensington Palace were filled with great quantities of highly fashionable oriental porcelain (both Japanese and Chinese); and in the Water Gallery overlooking the Thames at Hampton Court she kept her collection of Delft, some of which remains at Hampton Court Palace to this day. However, a large part of the oriental collection was lost when it was given after Queen Mary's death to William III's favourite, the Earl of Albemarle. This was by no means the only occasion on which a generous (or infatuated) sovereign made inroads into the collection. Such losses were often compounded by the system of perquisites, by which leading courtiers were entitled to lay claim by virtue of their office to certain valuable royal possessions, for instance at the death or coronation of a monarch.

The House of Hanover

For the Royal Collection, this fluctuating pattern of gains and losses established at the end of the 17th century continued into the 18th century, although for the first 50 years the pace was slower, with the balance overall in favour of gains. The arrival of the Hanoverians in 1714 in the person of George I signalled the start of almost half a century of inactivity, during which the spotlight fell first on Caroline of Ansbach, consort of George II, and then on her elder son Frederick, Prince of Wales. Queen Caroline's intellectual interests, demonstrated by the construction of a library for her personal use at St James's, included a deep interest in English history, particularly of the Tudor period. She rediscovered at Kensington the

long-forgotten Holbein drawings, probably instigated the purchase of the superb Holbein oil portrait of Sir Henry Guildford and commissioned from Rysbrack the remarkable series of terracotta busts of kings and queens of England, all but three of which were accidentally destroyed at Windsor in the early part of the 20th century. She also brought together a distinguished collection of cameos and intaglios, some part of which may have survived from the 16th-century royal collection and which, with later purchases, forms the nucleus of the present collection of gems and jewels (see p. 131).

George II and Queen Caroline's eldest son, Frederick, Prince of Wales, was the first of the Hanoverian dynasty to show any real artistic sensibility and the first from whose collecting activities a clear indication of personal taste emerges. Although Prince Frederick was estranged from his parents and living away from their court, his choices – particularly of

PETER SCHEEMAKERS (1691–1781)
Frederick, Prince of Wales, 1741
Marble bust; 59.7 cm high
RCIN 31169

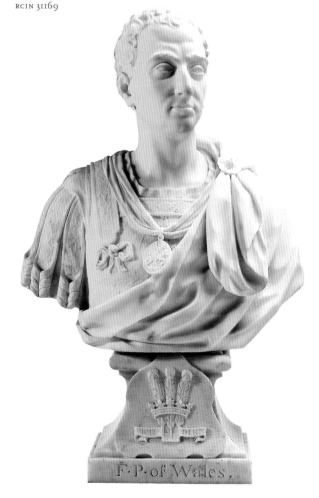

paintings by Rubens and Van Dyck – could be seen as a tribute to the royal collector whom he most closely resembled, and whom he most admired, Charles I. With advice from a circle of friends who included General John Guise and Sir Luke Schaub, and with the assistance of the painters Philippe Mercier and Joseph Goupy, Prince Frederick formed a significant collection of French, Flemish and Italian paintings including major works of the 17th century by Claude, Gaspar Poussin, Le Sueur, Jan Brueghel the Elder, Rubens, Van Dyck and Guido Reni. In the contemporary field he patronised artists such as Mercier, Amigoni and Van Loo, whose light interpretation of the rococo style – very much at variance with the prevailing taste at his father's court – the Prince clearly admired.

In other areas, too, Prince Frederick made important additions, including an album of drawings by Poussin from the collections of Cardinal Massimi and Dr Richard Mead, and a superb group of miniatures by Isaac Oliver (see pp. 63, 64) also from Dr Mead. The Prince's taste for the rococo – not a style that was widely taken up in England – found further expression in his adventurous patronage of goldsmiths such as Paul Crespin and Nicholas Sprimont, and of the frame-maker Paul Petit. His commissions for furniture indicate a more conventional taste, for the restrained Palladianism of cabinet-makers and carvers in the Burlington–Kent circle, such as Benjamin Goodison and John Boson.

Following Prince Frederick's death in 1751 and that of his widow Augusta in 1772, the Prince's collections, which had at different times been scattered between Leicester House and Carlton House in London, the White House at Kew and Cliveden in Buckinghamshire, were merged with those of their son, by then reigning as George III. With George III's accession in 1760, a long period of stagnation in the Royal Collection came to an end. A rather serious-minded young man, nurtured by his widowed mother Augusta and by the cultivated but dry magnifico, the Earl of Bute, George III emerges early in the reign as the monarch who made the most significant additions to the collection since Charles I.

In 1762, two months after purchasing one of the finest houses in London, Buckingham House, for his young bride Charlotte of Mecklenburg, George III acquired the celebrated collection of paintings and drawings, books, manuscripts, medals and gems formed by the British consul in Venice, Joseph Smith (c.1674–1770). As had happened in Charles I's time, agents and diplomats necessarily played the most significant part in the negotiation of this major foreign purchase. Richard Dalton, the King's unscrupulous Librarian and protégé of Lord Bute, and Bute's brother, the British Minister

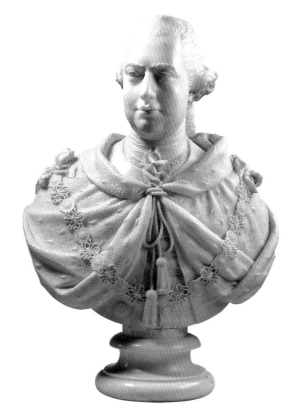

John Bacon (1740–1799)
George III, 1775
Marble bust; 64.1 cm high
RCIN 31610

at Turin, were closely involved in the purchase and their enthusiasm persuaded a cautious monarch to part with the enormous sum of £20,000 without having seen any of the collection. This coup brought to the Royal Collection a superb series of modern Venetian paintings and drawings by Canaletto (pp. 48, 248), Sebastiano (p. 244) and Marco Ricci, Zuccarelli, Carriera (p. 244) and Piazzetta (p. 242); earlier Italian works by Bellini, Strozzi and Guercino; drawings by Raphael, Castiglione (p. 235) and others; and an important group of Northern pictures including the incomparable *Lady at the Virginal* by Vermeer (then attributed to Frans van Mieris; p. 45). Many of these splendid new arrivals were put to immediate practical use – indeed practicality seems to a large extent to have driven the acquisition – to furnish the empty walls of Buckingham House. The newly hung pictures were shown to the public in December of the same year.

Smith's library, in which the bibliophile King was especially interested, contained an important group of early printed books and manuscripts, as well as fine gems, coins and medals.

These were to be absorbed into George III's steadily growing collection which eventually filled five large library rooms, added to Buckingham House for this specific purpose. By the early 19th century, the King's library was regarded as one of the finest in Europe. In his pursuit of books – verging almost on mania – George III managed to fill the void left after the public-spirited, if historically regrettable, disposal of the old Royal Library (its contents dating back to the reign of Edward IV) by George II. This great collection had been given to the newly founded British Museum in 1757.

Consul Smith's gems (see p. 135) – a mixed bag of ancient and 17th- and 18th-century Italian cameos and intaglios – added significantly to the existing collection, as did Smith's coins and medals. The latter were included with the majority of Smith's books and manuscripts (but not the gems) in the second (and in some ways more unexpected) royal gift to the British Museum, that of George III's enormous and important library, presented by George IV in 1823.

George III's patronage of contemporary artists such as Ramsay, West, Zoffany (p. 53), Gainsborough, Hoppner, Copley (p. 54) and Beechey – but not Reynolds, whom the King and Queen disliked – was predominantly geared to portraiture, although in the case of the most highly favoured of these, the American-born Benjamin West, the King also commissioned a series of exemplary compositions, designed to illustrate virtues that he particularly admired such as honour, fortitude and chivalry. While West's reputation has declined, George III's other commissions have usually been seen as more successful: Zoffany's intimate portraits of the Queen and her children at Buckingham House, for example, and the felicitous full lengths of the King and Queen by Gainsborough – who also painted the enchanting set of portraits of the royal children – vividly establish in the mind's eye the character and personalities of George III's court.

George III's taste – thoughtful, sober and in many ways the epitome of the Augustan age – commended itself to many; but not every visitor to Buckingham House would have echoed the American John Adams's praise of the elegance and simplicity of the restrained neo-classical interiors devised by the King's architect and architectural tutor, Sir William Chambers. Nor would all have accepted Adams's favourable comparison of the principal residence of the King of England with that of the King of France at Versailles. The supporting cast of decorative arts at Buckingham House positively radiates quality and meticulous attention to detail, and (in addition) demonstrates the King's concern to support British manufacturers and entrepreneurs. Here was to be seen superb mahogany furniture by Vile & Cobb, Bradburn, and France & Beckwith (but

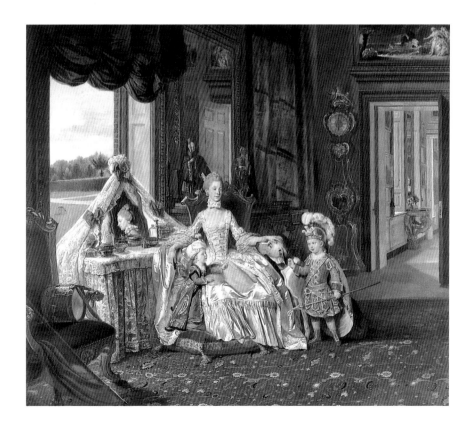

JOHAN ZOFFANY (1733–1810)
Queen Charlotte with her two eldest sons, c.1765
Oil on canvas
112.2 × 128.3 cm
RCIN 400146

not by Thomas Chippendale, who was never awarded a Royal Warrant); silver by Heming; porcelain from Chelsea, Derby, Wedgwood and Worcester; ornamental metalwork from Matthew Boulton (pp. 90–92); and clocks, barometers and scientific instruments by Vulliamy, Eardley Norton, Pinchbeck, Adams and Cumming (p. 85).

In Queen Charlotte's apartments at Buckingham House, Windsor Castle and, especially, at Frogmore House – the retreat in the Home Park at Windsor purchased for her by the King in 1792 – a different and lighter taste emerges. A liking for the Orient – lacquer, ivory (especially furniture), porcelain and embroidered silk – and a dash of continental *brio* (Meissen and Sèvres porcelain, jewelled *objets de vertu* and painted furniture) characterised her taste in the decorative arts. For the Queen, the arts and sciences (particularly the study and practice of botany) provided a solace and a constant source of pleasure through the difficult years of the King's illness, and the diversity of her interests are vividly evoked in Christie's catalogue of her collection, the sale of which took place the year after her death, in May and June 1819.

This dispersal – the first time that a collection with such direct royal associations had been sold at public auction since the time of Charles I – was designed, with laudable intent, to benefit the Queen's four youngest surviving daughters, Mary, Augusta, Elizabeth and Sophia, for whom none but the most meagre provision would otherwise have been made. By prior agreement, a number of items were reserved from the sale, and the Prince Regent bought back some important pieces, including the suite of Indian ivory furniture acquired by George III for Queen Charlotte (see pp. 88–89). Nonetheless, a very great quantity of fine objects, including all the Queen's personal jewellery (mainly diamonds) and her considerable library, was dispersed.

By chance, the disposal of this jewellery in 1819 set in train a sequence of events which was to reverberate through the later history of the Royal Collection. George IV had high-handedly disregarded that part of his mother's will by which she left to Hanover certain important state jewels, deemed by her to be Hanoverian in origin. Until the separation of Hanover from the British Crown in 1837, this impropriety remained unchallenged, but thereafter her fifth son, Ernest, Duke of Cumberland – by then King of Hanover – initiated a claim against his niece Queen Victoria which eventually resulted in the forced return to Hanover of some of the most prized of the royal jewels.

These losses were to be recouped from a source which, from the late 18th century, was to play an increasingly important part in the shaping of the collection – the newly emerging empire overseas, in particular India. From time immemorial vassal states had paid tribute in jewels and precious metals to the seat of empire. Ironically, the 1819 sale of Queen Charlotte's property had included the celebrated Arcot diamonds, given to the Queen by the Nabob of Arcot and considered to be among the earliest 'treasures of empire'. The flow of jewels and precious objects to the Crown increased dramatically after the annexation of the Punjab in 1849 and the establishment of British rule, and continued well into the 20th century (see p. 143).

George IV's love of jewellery, vividly and lavishly proclaimed at the time of his coronation in 1821, was not the only one of Queen Charlotte's tastes that he had inherited. Her continental outlook, expressed in the acquisition of French and German porcelain and perhaps the occasional piece of French furniture, in the commissioning of Zoffany's masterpiece *The Tribuna of the Uffizi* (p. 53) and in her fondness for decorating, blossomed in the case of her eldest son into an all-consuming passion for collecting and an obsessive concern with architecture and interior decoration.

Not since the time of Charles I had there been a monarch with such an approach to the arts: the contrast with the sober and cautious habits of his father, George III, could not have been more extreme or more widely noted by contemporary observers. From the moment of his coming of age in 1783 and taking possession of his London residence, Carlton House, George IV set out on a spending spree without parallel and within ten years he had run up debts to the colossal tune of £400,000. George IV's additions to the collection at all levels and in all branches – pictures, furniture, porcelain, silver and armour especially – were fundamentally and completely transforming; and never before or since has the collection – or its various settings – been in such a state of continuous change or under the eye of such a deeply art-loving monarch.

Some idea of this relentless activity emerges in the meticulously kept receipt and despatch records of the King's inventory clerk, Benjamin Jutsham, who was charged with the unenviable responsibility of keeping track of George IV's collection. Disposal as well as acquisition played a significant part in the shaping of the character and content of the collection. Like many of his predecessors, notably Charles I, George IV loved to give works of art to especially favoured friends (Lord Yarmouth, later 3rd Marquess of Hertford, and the Marchioness Conyngham were particular beneficiaries), and he was not afraid to cull in the interests of refining and improving. Thus, when he acquired Sir Thomas Baring's collection of superlative Dutch pictures *en bloc* in 1814, a number of lesser items (mainly still lifes) from this haul were sent for

sale; and when negotiating in the same year for the Rubens *Landscape with St George*, the balance of the price was made up with four lesser pictures, including two from the Baring purchase. Other more disinterested – if regrettable – disposals included the gift to Greenwich Hospital of Turner's *Battle of Trafalgar*, the only oil painting by this greatest of English artists in the collection, painted for George IV in 1823; and the prodigious gift (already mentioned) of George III's large and celebrated library to the British Museum, also in 1823.

Like many of his predecessors, George IV relied heavily on a circle of agents, dealers and friends to keep him abreast of the art market and to search out possible acquisitions. In the early years at Carlton House, he depended on the Anglo-French *coterie* revolving round Dominique Daguerre, the fashionable Parisian *marchand-mercier* whom he had summoned with the express purpose of superintending the decoration and furnishing of Carlton House after its architectural transformation (the first of many) by Henry Holland. Daguerre's influence can be seen in the influx of substantial quantities of smart Parisian furniture and *objets d'art* in the 1780s and 90s (see p. 150), providing the foundation of French decorative art which so decisively marked the character of the Royal Collection thereafter.

The upheavals on the Continent in the wake of the French Revolution provided George IV – in common with all the leading collectors of the period – with remarkable opportunities to acquire works of art of the finest quality, and these he seized with enthusiasm. His taste for Dutch and Flemish pictures in particular was fed by the appearance on the market of some of the greatest continental collections, notably those of Braamcamp and Gildemeester, and by the activities of dealers such as Michael Bryan, William Buchanan and Alexis Delahante. At the same moment, superb furniture from the French royal collections flooded onto the market and in the first three decades of the 19th century George IV was able to amass an astonishing range of French 18th-century decorative art, extraordinarily rich in Boulle furniture, pietra dura, gilt bronze and, above all, Sèvres porcelain. To achieve this, he used a network of agents loosely connected to his personal servants Jean-Baptiste Watier (officially Clerk-Comptroller of the Kitchen) and François Benois (officially Confectioner), while also relying on friends such as Lord Yarmouth, Sir Harry Featherstonhaugh, Sir Wathen Waller, Sir Thomas Liddell (later Lord Ravensworth) and Sir Charles Long (later Lord Farnborough) to seek out objects which they knew would delight or intrigue him.

As with Charles I, there is enough direct and indirect evidence of George IV's personal tastes to be able to form a view of the way his likes and dislikes shaped the collection. Religious art and still lifes played only a small part, although the former category included such masterpieces as the Rembrandt *Christ and the Magdalen at the tomb* and the Rubens sketch of the *Assumption of the Virgin*. One of the great masterpieces of Northern painting, Van Eyck's *Arnolfini Marriage*, was sent on approval to Carlton House and turned down; it was perhaps considered too severe. Even more surprisingly, negotiations to buy Rubens's ravishing *Châpeau de Paille* broke down because the King was advised that it was too expensive – one of the very few occasions in his collecting career when such a consideration seems to have carried any weight. Italian pictures, which had figured strongly at Carlton House in the 1790s, had virtually disappeared from display by the 1820s, whereas Dutch and Flemish pictures of superb quality had been added in considerable numbers. Works with a strong family connection were keenly sought; in the same way that George III had bought back the Van Dyck *Five Children of Charles I* (while turning down the same painter's marvellous *Roi à la Chasse*, now in the Louvre), George IV added the famous Van Dyck *Charles I in three positions* after protracted negotiations with its reluctant seller.

George IV's patronage of contemporary artists is well documented. The traditional royal appetite for sporting art was met by the most distinguished equestrian artist of the 18th century, George Stubbs, in a series of superb canvases (p. 51) and, to a lesser degree, by Ben Marshall, Sawrey Gilpin and George Garrard. In portraiture, always among the strongest and most numerous parts of the collection, George IV had an unparalleled choice of artists. Unlike his father, George IV had an easy manner that promoted good relations with painters and sculptors and he was served well by Reynolds, Gainsborough, Beechey and, pre-eminently, by Thomas Lawrence. As Van Dyck was to Charles I and his court, so Lawrence became to George IV, expressing in a great series of bravura portraits the character and style of this beguiling monarch and that of his family, friends and contemporaries. In no setting is George IV's patronage of Lawrence seen to better advantage than in the Waterloo Chamber at Windsor Castle, where portraits of the allied sovereigns and military and political leaders involved in the overthrow of Napoleon are gathered in one great Valhalla (p. 56). On a smaller and more intimate scale, genre painters such as David Wilkie, Edward Bird and William Mulready were favoured, their style and anecdotal subject matter blending with the many Dutch and Flemish cabinet pictures the King had assembled in quantity.

Carlton House, regarded by many as one of the most perfect houses in Europe, was demolished in 1826, the King

hours visiting the site and looking at plans and drawings provided by his architect and decorator.

In anticipation of the splendid new spaces that would be available to him, the King continued to acquire paintings and works of art of all kinds at an undiminished pace and almost entirely regardless of expense. His single greatest purchase of French decorative art and sculpture – the acquisition of 31 lots from the sale of the collector George Watson Taylor (including those on pp. 102–03) – took place in 1825, and important works (paintings, furniture and silver especially) continued to be added to the collection to within a month or two of the King's death in June 1830. In 1828, with work on the Private Apartments close to completion, George IV spent two happy days with his favourite artists, David Wilkie and Francis Chantrey, arranging some of his best pictures and sculpture in the newly completed Grand Corridor. Although the sculpture did not include any of the King's three superb pieces by Canova (which were reserved for Buckingham Palace; see pp. 74–75), a telling display of likenesses of friends and contemporaries, mainly by Nollekens and Chantrey, was arranged along both sides of the Corridor, mingling happily with portraits by Gainsborough, Reynolds and Lawrence, sporting pictures by Stubbs and Wootton and Italian views by Canaletto and by Sebastiano and Marco Ricci (see p. 76). By the time of his New Year party at the end of 1828, at which the Lievens were present, the King had tactfully arranged that the large malachite urn recently sent by Tsar Nicholas I should be in a prime position, even though this meant displacing another diplomatic gift, the marble and gilt bronze centrepiece presented in 1816 by Pope Pius VII in gratitude for help in the return to Rome of works of art looted by Napoleon.

This glorious period of expansion came to a dramatic halt with the death of George IV and the accession of his brother William IV in 1830. The new King had none of his brother's interest in the arts – indeed his only pronouncements on such matters tend to support the popular view of him as an ignorant philistine. Although he established the Royal Library in its present form, he evidently cared little for paintings and still less for their settings. He hated Buckingham Palace and did everything in his power to avoid having to live there, preferring to continue to reside in the more domestic setting of Clarence House. His lack of affinity with his stupendous inheritance makes it all the more surprising that this unpromising monarch was responsible for acquiring some of the most impressive porcelain in the Royal Collection, including two of the finest services ever made by the Worcester and Rockingham factories (see pp. 109, 110). He also added to the already enormous assemblage of silver-gilt banqueting plate,

having decided that Buckingham House had greater potential as the main royal residence in London. The magnificent contents – including such features as chimneypieces, pier-glasses, doors and architectural carvings – were divided between Windsor Castle, then undergoing transformation at the hands of Jeffry Wyatville, and Buckingham House, eventually to emerge almost unrecognisably as Buckingham Palace.

The work of modernising the Private Apartments at Windsor, begun in 1824, gave George IV his last and in many ways greatest opportunity to stamp his personality on the Royal Collection. He had ensured the appointment first of Wyatville as architect and then of the French cabinet-maker Nicholas Morel, who had formerly been employed at Carlton House, to oversee the decoration and furnishing of the east and south ranges of the Upper Ward of the castle. Between them they managed to transform an uncomfortable and cold house into a royal residence that even the notoriously critical Princess Lieven, the wife of the Russian Ambassador, found 'magnificent in the extreme'.

George IV spent much of his last years at Windsor, first at Royal Lodge, his house in the Great Park, then moving to the castle at the end of 1828. He took a very close interest in the work of renovation there (and little in public affairs), spending

although the cost of this was offset by the sale (to Rundells, the royal goldsmiths) of the majority of George IV's collection of bibelots. These disposals included more than 300 gold boxes and the same number of watches, seals and rings; over 100 miniatures and a quantity of medals and coins.

The House of Saxe-Coburg and Gotha

The focus of the collection shifted again – and decisively – with the accession of Queen Victoria in 1837. In the course of her reign of 63 years, and in particular in the 21 years of her marriage to Prince Albert, the Queen added substantially and comprehensively to all parts of the Royal Collection at all levels; and of these activities there is, for the first time in the history of the collection, a very substantial and detailed record in the form of bills, accounts, correspondence and journals. The paintings collection (certainly in square footage of canvas) grew more than at any other time before or since. In terms of quality, however, the results were mixed. As far as contemporary painters were concerned, the Queen at first responded enthusiastically to the romantic bravura of Wilkie, Grant and the early Landseer. After marriage, her more adventurous instincts seem to have become submerged in Prince Albert's drier and more serious approach to art. They shared an appreciation of good likenesses (whether of people or animals) and a fondness for the anecdotal or narrative elements in a picture; and as patrons, the royal couple appeared interested and well informed, enjoying cordial relations with most of the painters they employed. Hayter, Leslie, Landseer, Frith and Winterhalter, skilful in the accurate representation of royal personages and events, found frequent employment. Of these, Landseer held a special place in the Queen's affection as the painter who had so memorably captured images of people, places and (especially) animals from the early, happy part of her life in both England and Scotland, before Prince Albert's death in 1861. It was the cosy domesticity of much of the Queen's and the Prince's taste in contemporary art that gave it its special character – but which also aroused the fierce criticism of commentators such as Thackeray. Winterhalter on the other hand perfectly responded to the Queen's and the Prince's traditional royal taste for fashionable and elegant portraiture, and from the early 1840s over a period of almost 20 immensely productive years, he created the iconic images of the Queen, her handsome consort, their growing brood of children and their immense network of relations.

While the favoured painters were heavily (perhaps too heavily) patronised, whole movements in the 19th-century art world passed the Queen and Prince by: the Pre-Raphaelites, for example, are virtually unrepresented; there are few French 19th-century paintings of distinction; and (less surprisingly) there were no Impressionists. While their patronage of contemporary artists may have been restricted, Queen Victoria and Prince Albert more than made up for this by the attention they paid to the historic collection which they had inherited. Prince Albert's rational and ordered mind rose to the challenge of sorting out the chaotic state of the picture collection, particularly the paintings at Hampton Court Palace, and the work he began definitively laid the pattern for the care of the collection down to the present day. Inventories were compiled, photographic records were made for the first time, programmes of cleaning and repair were organised and picture displays in all the royal residences were overhauled and rearranged. At the same time order was instilled in the newly created Print Room at Windsor, where Prince Albert and the Queen spent much time sorting through drawings and prints, arranging their growing collection of watercolours in souvenir albums and organising the collection of portrait miniatures.

Prince Albert also instigated a number of important additions to the historic collection, for which Queen Victoria usually paid. The largest acquisition came with the Öttingen Wallerstein collection of early Italian, German and Flemish pictures, accepted by the Prince as repayment of an outstanding loan. Other purchases, mostly achieved with the help of the Prince's artistic adviser Ludwig Gruner, included significant works by Fra Angelico, Daddi (p. 28), Gozzoli and – outstandingly – a triptych by Duccio (p. 27). These early Italian works were mostly kept at Osborne House. After the Prince's death, 22 of the best pictures from the Öttingen Wallerstein collection were given by the Queen to the National Gallery.

Prince Albert's influence on the collection was lasting and profound. Apart from the activities charted above, he was the first member of the royal family to encourage scholarship and publications about the collection (especially the paintings and drawings) and he supported vigorously the view that exhibitions were of value in raising awareness of art and design in this country. For the Great Exhibition of 1851, in the planning of which Prince Albert played the decisive role, he arranged for several important works, commissioned by him or the Queen, to be displayed. He also championed the extraordinarily comprehensive Art Treasures Exhibition at Manchester in 1857, to which the Queen lent extensively, and which attracted 1.3 million visitors in the five and a half months of its opening.

In the decorative arts, both the Queen and Prince bought extensively, but on the whole conventionally. Their purchases, many again overseen by Gruner, ranged from the utilitarian

Porcelain plaques of Queen Victoria with Albert Edward, Prince of Wales, and Prince Albert,
after Robert Thorburn, from Queen Victoria's jewel-cabinet, 1851 (see p. 94)

and domestic to the elaborate and specially designed. The former category included large quantities of new furniture and furnishings for Osborne House and Balmoral Castle, their holiday homes in the Isle of Wight and Scotland. For Osborne plain mahogany furniture was chosen; for Balmoral pale maple, all supplied by the Mayfair firm of Holland & Sons. In the older palaces and residences, especially after Prince Albert's death, there was a conservative programme of replacement and renewal, but only as required and apparently without any attempt to reflect – let alone influence – prevailing fashion. Occasionally, the Queen branched out, buying modern French furniture from Kreisser and Grohé and gilt bronzes from Barbedienne; and as sovereign of the most powerful country in the world and ruler of a vast empire, she was in receipt of a never-ending stream of diplomatic gifts from foreign rulers which ranged from jewels, tapestries, furniture, metalwork and porcelain to quaint curiosities and mementoes of every description and nationality.

Some of the decorative arts lent themselves more directly to the Queen's and Prince's personal involvement than others. Next to painting, sculpture was the area in which the royal couple most concerned themselves; and, rather in the same way that their commissions to painters reflected their desire for good likenesses, uplifting allegory or attractive genre subjects, so their sculptors were patronised according to their skill in rendering these subject categories in an acceptable manner. The artists employed by Queen Victoria – from Francis Chantrey and William Behnes at the beginning of the reign to Onslow Ford at the end, via R.J. Wyatt, John Gibson, William Theed and Joseph Boehm (among others) – constitute a pantheon of 19th-century British sculpture, to which was added, under Prince Albert's and Gruner's guidance, a sprinkling of favoured continental (mostly German) sculptors.

Queen Victoria's interest in the historical aspects of the collection, sharpened no doubt by Prince Albert and perhaps by the example of her predecessors, led her to acquire a number of objects which she felt were of special relevance to the collection. Chief among these was the celebrated Darnley Jewel (p. 133) which she purchased, together with the so-called Anne Boleyn clock, at the sale of Horace Walpole's famous collection from Strawberry Hill in 1842. Later in the reign, she acquired a handful of notable historic pictures and miniatures (see p. 60) and, with the encouragement of her Librarian, a small number of Old Master drawings and an outstanding group of Sandby watercolours of Windsor. Such acquisitions were, however, rare.

In the closing decade of Queen Victoria's long reign nothing was allowed to disturb the settled stillness of the collection, the arrangement of which had been sanctified by the omnipresent taste and judgement of the long-dead Prince. Such programmes of restoration and rehanging of the pictures and reordering of other parts of the collection as Prince Albert had initiated had come almost to a standstill and by the time that Edward VII succeeded to the throne in 1901, much needed to be done. As the new King knew little about art, many of the sweeping changes he initiated were too briefly considered and came to be regretted later, not least by his daughter-in-law Queen Mary. Among such changes were the obliteration of Gruner's spectacular polychrome decorations at Buckingham Palace, the culling of the displays in the Guard Chamber at Windsor, and the disposal of Osborne House.

King Edward's additions to the collection strongly reflect his personal interests, among them the family, the sea, race-horses, shooting and attractive women. These subjects are well represented in painted and sculpted form at Sandringham House, the aesthetically deficient but characteristically comfortable new house he had built in north Norfolk. Marriage in 1863 to Princess Alexandra of Denmark prompted the arrival of interesting Danish paintings, porcelain and sculpture and, through the Princess's interest, led in time to the formation of what was to become one of the finest collections of Fabergé in the world (see p. 181). Royal tours – King Edward was an active and enthusiastic traveller – produced the inevitable shower of gifts from foreign potentates. Of these travels, the most remarkable – and for the Royal Collection the most productive – was the tour of India from 1875 to 1876 on behalf of the Queen-Empress, which resulted in the acquisition of a large and magnificent collection of Indian works of art, mainly arms and armour. This lavish gift was divided under the King's supervision between Sandringham, where it adorned the Ballroom, and special display cases in Marlborough House, his London residence when Prince of Wales; the latter display, with the most valuable part of the collection, was transferred to Buckingham Palace in 1901.

In this context of jovial philistinism, the King's commission to the most original and advanced sculptor of the age, Alfred Gilbert, to create the tomb of his elder son, the Duke of Clarence, following his early death in 1892, is surprising. The Clarence Tomb, in the Albert Memorial Chapel at Windsor, is one of the masterpieces of Art Nouveau style and in its bold originality, enormous scale and heady symbolism ranks as one of the finest royal tombs ever made. The contrast with the sober conventionality of Queen Victoria and Prince Albert's tomb in the Mausoleum at Frogmore could hardly be greater.

Diplomacy continued into the 20th century to play a part, as it had over previous centuries, in the shaping of the collection. Of the 'diplomatic' losses to the collection that occurred in Edward VII's short reign, the most significant was that of 12 French 15th-century illuminated miniatures, given to the French government in 1906 with the manuscript from which they had been cut. This was the King's contribution to the *Entente Cordiale*, the treaty of friendship with France for which he saw himself as chiefly responsible. However, as had happened in the reign of Queen Victoria, losses were often matched – even exceeded – by gains in the form of tribute of empire, particularly jewels. By far the most significant of such offerings was the Cullinan diamond, the largest diamond ever found, which was presented to King Edward VII in 1907 by the Government of the Transvaal on his sixty-sixth birthday. This gift was welcomed as a generous gesture towards re-establishing good relations after the bitterness of the Boer War.

The House of Windsor

The pattern for the early part of the 20th century, so far as the Royal Collection was concerned, was set more firmly in the reign of King George V, who succeeded to the throne in 1910. Like some of his early Hanoverian predecessors, King George combined a considerable lack of interest in art and a general disapproval of scholarship (which was shared by many royal and aristocratic owners at this period) with a strongly proprietorial view of the collection. These characteristics no doubt eased the departure of five superb late 17th-century French bronzes from the collection to the City of Paris during a State Visit to France in April 1914 – almost the last occasion on which works of art from the Royal Collection were alienated in the interests of diplomacy. Even so, further changes to the balance of the collection took place when, on the advice of the Librarian Sir John Fortescue, arrangements were made for the disposal of a portion of the celebrated Paper Museum of Cassiano dal Pozzo, acquired by George III (see p. 232), together with George IV's collection of political and personal caricatures and Queen Victoria's complete set of Whistler etchings. More storage space was required for the newly mounted Old Master drawings. Income generated by these disposals was paid into the newly established Royal Trust Fund.

The approach of the King's consort, Queen Mary, was rather different. Though no scholar herself, she took the liveliest possible interest in the decoration and contents of the royal houses, rearranging furniture and pictures and assembling objects by type into 'collections within'. While much of this

(enlarged)

classifying and sorting was of value, it resulted in some unfortunate losses. Like many of her contemporaries, Queen Mary had a strong prejudice against what she thought of as 'heavy' or 'Victorian' objects (anything post-Regency). She disposed of much of the Gothic furniture and furnishings designed for Windsor Castle by the younger Pugin, and significant pieces of historicist plate made for George IV.

If it is true that Queen Mary 'never bought a really good or important picture', she certainly added substantially to other areas of the collection, concentrating above all on objects of family interest. These included such major items as the carved mahogany bookcase and the inlaid jewel-cabinet by William Vile, made for Queen Charlotte in the 1760s, which had descended in the family of Queen Mary's mother, Princess Mary Adelaide of Cambridge. Her interest in 'family' is typified by the delight she felt at being able to give her great-grandson Prince Charles (HRH The Prince of Wales) for his christening in 1948 a silver-gilt cup which had been given by her great-grandfather George III to a godson in 1780.

Queen Mary's own collections came eventually to cover a very wide range. They included Fabergé, piqué, jade, lacquer, silver, enamels, rings, seals, Stuart memorabilia, fans, gems and jewels and gold boxes; and, while the pursuit of quality was sometimes sacrificed to family sentiment, the additions are for the most part interesting and often impressive. Perhaps

the most piquant – certainly the most elaborate – addition was the magnificent Dolls' House, designed by Sir Edwin Lutyens and presented to Queen Mary in 1924. In its decoration and range of content – pictures, works of art, books and household paraphernalia including wine, linen and motor cars – it has come to be seen as the epitome in miniature of a way of living entirely familiar to Queen Mary's generation, but now almost entirely vanished.

Provenance and history were all-important to Queen Mary and in consequence a great many of her possessions acquired little hand-written notes describing their origin and date of acquisition. The almost obsessive importance the Queen attached to list-making and ownership, which may have been an effect of her peripatetic and impoverished childhood, was no doubt heightened by awareness of the fate of other European royal collections at the end of the First World War. It resulted in the production of a series of leather-bound volumes in which her collections were described, illustrated and personally annotated. These volumes were drawn up at the Victoria and Albert Museum under the direction of Sir Cecil Harcourt Smith, one of a number of museum and gallery directors and writers on the decorative arts with whom Queen Mary remained on friendly terms. She was equally familiar to the fraternity of West End dealers and auction houses and liked to be kept abreast of art world news by figures such as Sir Alec Martin of Christie's and Sir Owen Morshead, the Librarian at Windsor Castle. On Queen Mary's death in 1953, the vast majority of her acquisitions was absorbed into the main body of the Royal Collection. The surplus from Marlborough House, consisting for the most part of pieces that the Queen had acquired, was sold by Christie's in 1957.

The rather dutiful tradition of acquiring or reacquiring objects with a family connection, so marked through the history of the Royal Collection, reached a high point with Queen Mary. In the case of Queen Mary's daughter-in-law Queen Elizabeth The Queen Mother, such interests were tempered by a lighter touch. With the support of King George VI and advice from a wide range of friends interested in the arts – including Sir Kenneth Clark, Sir Jasper Ridley and Sir Arthur Penn – Queen Elizabeth assembled her own collection of paintings and works of art reflecting her interests in a highly personal way. Her good natural eye, coupled with 'an infectious pleasure in pictures and objects', brought together a collection strong in 20th-century British art (William Nicholson, Augustus John, Matthew Smith, Walter Sickert, Duncan Grant, Paul Nash, John Piper and Graham Sutherland), but which also embraced important works by Monet and Millais, as well as more traditional royal interests – superb examples

of Fabergé, English (notably Chelsea) porcelain, silver (especially relating to the Bowes Lyon family), miniatures and bibelots (see pp. 60, 61, 159, 185, 192). In King George VI's reign, heavily overshadowed by the Second World War, a few significant paintings were added (with Queen Elizabeth's encouragement) to the main Royal Collection, including works by Sebastiano Ricci, Kneller, Knyff and Bower, some historically important sculpture and fine pieces of furniture.

The steps taken to ensure the survival of the collection – or at least the most important parts of it – during the Second World War may have been of more significance than any acquisitions made at this period. In 1942, as the fate of Europe hung in the balance, the finest paintings from Buckingham Palace and Windsor Castle – together with the Leonardo and Holbein drawings, the best of the miniatures and some books – were sent to join the National Gallery's pictures in the Manod slate quarry at Blaenau Ffestiniog in north Wales, where they remained until the end of the war. This operation was supervised by Kenneth Clark, who at the time held the positions of Director of the National Gallery and Surveyor of the King's Pictures, and Owen Morshead, the Royal Librarian. At the same time, the principal stones from the coronation regalia were removed from their settings and stored in great secrecy away from London.

With the benefit of a long perspective, the accession of Her Majesty Queen Elizabeth II in February 1952 can now be seen to have marked the beginning of a period of change – usually quiet and unhurried, sometimes sudden and dramatic – which has been without parallel in the long and complicated history of this remarkable collection. During these years, the emphasis has gradually but certainly moved from the notion of the Royal Collection as essentially a private one, to which the public were occasionally allowed access, to a generous commitment to make as much of the collection available as possible and to bring its extraordinary history to life through interpretation, exhibitions – at The Queen's Gallery and elsewhere – and, very significantly, through publications. Beginning with The Queen's decision to open to the public Queen Victoria's private rooms at Osborne House in 1954, this process has gone on to encompass virtually every occupied and unoccupied royal residence, most recently (in 1998) the private drawing rooms at Windsor Castle restored after extensive fire damage in 1992, and the ground-floor rooms at Clarence House, following their reoccupation by The Prince of Wales in 2003.

This change of perception has moved hand in hand with the development of a new and much more rigorous approach to the conservation and care of objects in the collection – a far

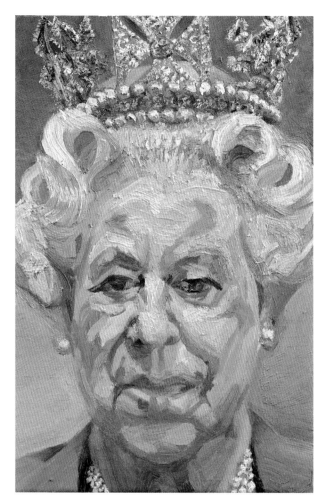

LUCIAN FREUD (b. 1922)
HM The Queen, 2000–01
Oil on canvas; 23.5 × 15.2 cm
RCIN 407895

cry from the scrubbing and daubing of previous centuries – and a much keener awareness of the value of sound historical research and imagination in the decoration and presentation of rooms open to the public. In their different ways, Frogmore House, the Palace of Holyroodhouse and Windsor Castle have all shown these new skills to great advantage. Much the same pattern of imaginative and well-researched restoration and representation has been seen at Hampton Court Palace, Kensington Palace and the Tower of London. These palaces, containing important parts of the Royal Collection, are maintained and managed by the Historic Royal Palaces Trust – first set up in 1991 and re-established in 1998 as a trustee body.

Over the last twenty years, all aspects of the care and display of the collection have been greatly assisted by the creation of a

new computerised inventory, a massive labour begun in 1987 and completed at considerable cost ten years later. This new resource, which is regularly updated, contains basic custodial information on every object in the collection (running to more than 500,000 entries), and replaces the previous manual systems of inventory books and card indexes and for the first time allows an overview of the collection.

While the twin themes of access and conservation have run strongly through the recent history of the collection, new acquisitions have continued to play their time-honoured part. Neither so numerous nor so wide ranging as those of some previous sovereigns, the additions to the collection in the present reign have been sometimes adventurous, frequently distinguished and always interesting. In the suggestion of possible purchases (but not necessarily in the final decision), The Queen has often depended on advice from her Surveyors. The thrust of such advice has generally been in the direction of works which complement existing objects or groups of objects, or which have a powerful association with past sovereigns or members of the royal family. Thus, in the picture collection, historic portraiture has almost inevitably come to dominate. Important additions to date have included images by Blanchet of the Young Pretender and his brother; the children of the King and Queen of Bohemia by Honthorst; and miniatures by Hoskins of Henrietta Maria (p. 67), and by Cooper of the architect Hugh May. Among the hundreds of drawings and watercolours acquired have been outstanding views of Windsor by Paul Sandby (see p. 247), Joris Hoefnagel and J.M.W. Turner, as well as a large group of designs for Windsor dating from the late 1820s. Gifts arising from official or state occasions continue to swell the numbers, especially of drawings – for example the selection given by the Royal Academicians to mark the Coronation and the Silver Jubilee.

Acquisitions of contemporary paintings – mostly by British or Commonwealth artists – have not greatly changed the overwhelmingly historical face of the collection, although the additions in this area, much encouraged by Prince Philip's interest in the subject, have included a fine group of paintings by Sydney Nolan, Barbara Hepworth, Ivon Hitchens, Russell Drysdale and Graham Sutherland. The ongoing sequence of portrait drawings of members of the Order of Merit (see p. 251) has provided The Queen with an opportunity to commission work by a wide cross-section of artists; and the arrival in 2001 of Lucian Freud's portrait of The Queen (opposite) is a very notable addition to royal iconography.

The equally strong tradition of recording royal residences has continued with the commission to Alexander Creswell to draw Windsor Castle after the fire of 1992 and then after the restoration in 1997.

Much the same processes have guided the addition of works of art to other parts of the collection. Great historical interest, rarity and high aesthetic quality determined the acquisition of the caddinet that had belonged to William III (p. 160); the same considerations applied to Queen Mary's patch box (p. 176) and, more recently, to the Sèvres vase from a garniture made for Marie-Antoinette (p. 120). Equally, state or official gifts still play a part in enriching the collection and belong to a tradition which flowered prodigiously in the reign of The Queen's great-great-grandmother, Queen Victoria.

With the enormously inflated value of major works of art today, the opportunities for purchase that were available to previous sovereigns have now greatly diminished; and while traditional representational work is likely to continue to be commissioned – as can be seen in the burgeoning collection of The Prince of Wales – cutting-edge contemporary art does not look as though it will easily find a place in the Royal Collection. While a few may regret this, the focus has in any case moved decisively in the present reign towards the care, conservation and display of the treasures that already exist in the collection. Such work is now funded by the Royal Collection Trust, a body set up by Her Majesty The Queen in 1993 under the chairmanship of The Prince of Wales, to safeguard the independence and viability of the Royal Collection. This decisive and far-reaching change followed the establishment in 1987 of the Royal Collection Department as one of the five departments of the Royal Household, which brought together the various strands of curatorial and commercial activity under a single head. In pursuit of the Royal Collection Trust's objectives, income from the public opening of Windsor Castle, Buckingham Palace and the Palace of Holyroodhouse and from associated retail activities, which together provide the funding for the Royal Collection, has been allocated to various major projects. They have included the restoration of Windsor Castle after the fire in 1992, the rebuilding of The Queen's Gallery at Buckingham Palace, and the construction of a new gallery at the Palace of Holyroodhouse. The two gallery projects, both completed in 2002, marked the Golden Jubilee of Her Majesty The Queen, and demonstrated the continuing commitment of the Royal Family to share with the public the extraordinary riches of this unsurpassed collection.

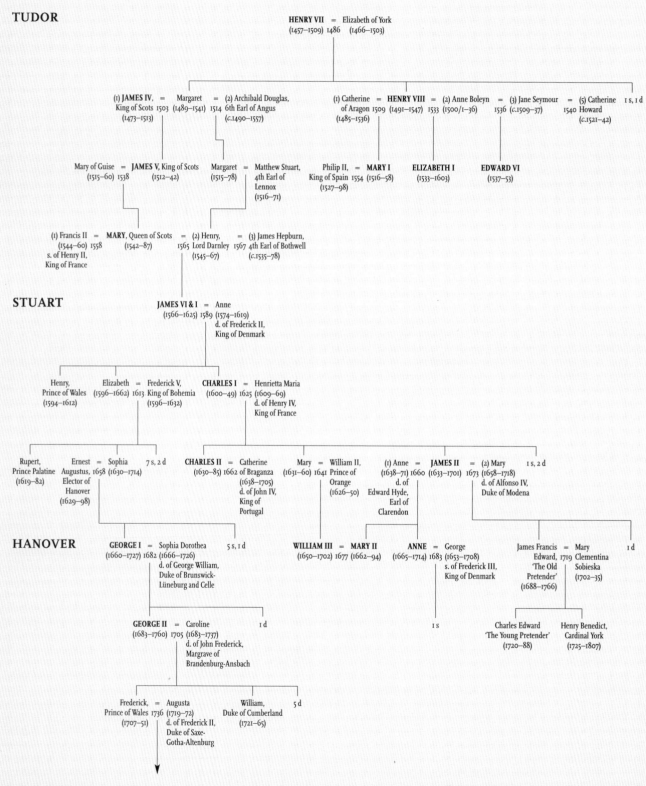

TUDOR

HENRY VII = Elizabeth of York
(1457–1509) 1486 (1466–1503)

(1) **JAMES IV,** = Margaret = (2) Archibald Douglas,
King of Scots 1503 (1489–1541) 1514 6th Earl of Angus
(1473–1513) (c.1490–1557)

(1) Catherine = **HENRY VIII** = (2) Anne Boleyn = (3) Jane Seymour = (5) Catherine 1 s, 1 d
of Aragon 1509 (1491–1547) 1533 (1500/1–36) 1536 (c.1509–37) 1540 Howard
(1485–1536) (c.1521–42)

Mary of Guise = **JAMES V,** King of Scots
(1515–60) 1538 (1512–42)

Margaret = Matthew Stuart,
(1515–78) 4th Earl of
Lennox
(1516–71)

Philip II, = **MARY I**
King of Spain 1554 (1516–58)
(1527–98)

ELIZABETH I
(1533–1603)

EDWARD VI
(1537–53)

(1) Francis II = **MARY,** Queen of Scots = (2) Henry, = (3) James Hepburn,
(1544–60) 1558 (1542–87) 1565 Lord Darnley 1567 4th Earl of Bothwell
s. of Henry II, (1545–67) (c.1535–78)
King of France

STUART

JAMES VI & I = Anne
(1566–1625) 1589 (1574–1619)
d. of Frederick II,
King of Denmark

Henry,
Prince of Wales
(1594–1612)

Elizabeth = Frederick V,
(1596–1662) 1613 King of Bohemia
(1596–1632)

CHARLES I = Henrietta Maria
(1600–49) 1625 (1609–69)
d. of Henry IV,
King of France

Rupert,
Prince Palatine
(1619–82)

Ernest = Sophia 7 s, 2 d
Augustus, 1658 (1630–1714)
Elector of
Hanover
(1629–98)

CHARLES II = Catherine
(1630–85) 1662 of Braganza
(1638–1705)
d. of John IV,
King of
Portugal

Mary = William II,
(1631–60) 1641 Prince of
Orange
(1626–50)

(1) Anne = **JAMES II** = (2) Mary 1 s, 2 d
(1638–71) 1660 (1633–1701) 1673 (1658–1718)
d. of d. of Alfonso IV,
Edward Hyde, Duke of Modena
Earl of
Clarendon

HANOVER

GEORGE I = Sophia Dorothea 5 s, 1 d
(1660–1727) 1682 (1666–1726)
d. of George William,
Duke of Brunswick-
Lüneburg and Celle

WILLIAM III = **MARY II**
(1650–1702) 1677 (1662–94)

ANNE = George
(1665–1714) 1683 (1653–1708)
s. of Frederick III,
King of Denmark

James Francis = Mary 1 d
Edward, 1719 Clementina
'The Old Sobieska
Pretender' (1702–35)
(1688–1766)

GEORGE II = Caroline 1 d
(1683–1760) 1705 (1683–1737)
d. of John Frederick,
Margrave of
Brandenburg-Ansbach

1 s

Charles Edward
'The Young Pretender'
(1720–88)

Henry Benedict,
Cardinal York
(1725–1807)

Frederick, = Augusta
Prince of Wales 1736 (1719–72)
(1707–51) d. of Frederick II,
Duke of Saxe-
Gotha-Altenburg

William, 5 d
Duke of Cumberland
(1721–65)

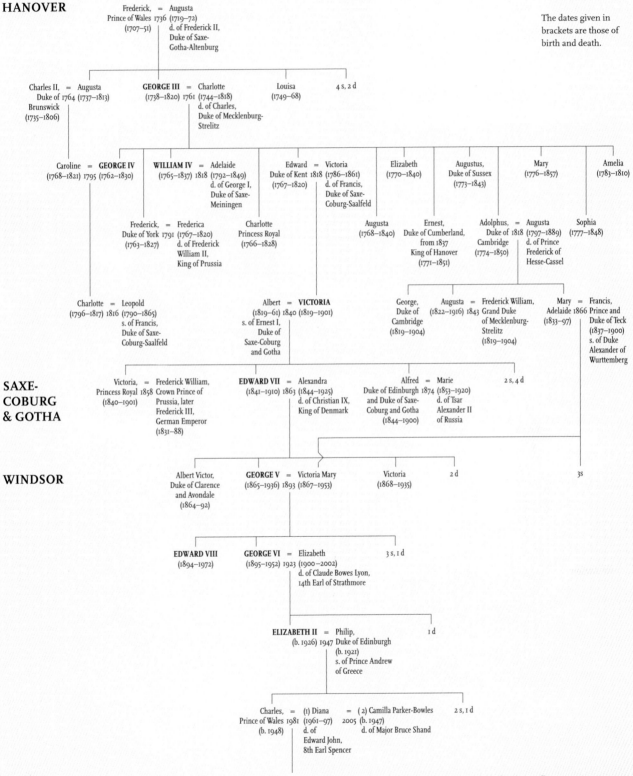

Only individuals
mentioned in the text,
and other offspring
who survived beyond
their fifth birthday,
are included.

The dates given in
brackets are those of
birth and death.

Frederick, = Augusta
Prince of Wales 1736 (1719–72)
(1707–51) d. of Frederick II,
Duke of Saxe-
Gotha-Altenburg

Charles II, = Augusta
Duke of 1764 (1737–1813)
Brunswick
(1735–1806)

GEORGE III = Charlotte
(1738–1820) 1761 (1744–1818)
d. of Charles,
Duke of Mecklenburg-
Strelitz

Louisa
(1749–68)

4 s, 2 d

Caroline = **GEORGE IV**
(1768–1821) 1795 (1762–1830)

WILLIAM IV = Adelaide
(1765–1837) 1818 (1792–1849)
d. of George I,
Duke of Saxe-
Meiningen

Edward = Victoria
Duke of Kent 1818 (1786–1861)
(1767–1820) d. of Francis,
Duke of Saxe-
Coburg-Saalfeld

Elizabeth
(1770–1840)

Augustus,
Duke of Sussex
(1773–1843)

Mary
(1776–1857)

Amelia
(1783–1810)

Frederick, = Frederica
Duke of York 1791 (1767–1820)
(1763–1827) d. of Frederick
William II,
King of Prussia

Charlotte
Princess Royal
(1766–1828)

Augusta
(1768–1840)

Ernest,
Duke of Cumberland,
from 1837
King of Hanover
(1771–1851)

Adolphus, = Augusta
Duke of 1818 (1797–1889)
Cambridge d. of Prince
(1774–1850) Frederick of
Hesse-Cassel

Sophia
(1777–1848)

Charlotte = Leopold
(1796–1817) 1816 (1790–1865)
s. of Francis,
Duke of Saxe-
Coburg-Saalfeld

Albert = **VICTORIA**
(1819–61) 1840 (1819–1901)
s. of Ernest I,
Duke of
Saxe-Coburg
and Gotha

George,
Duke of
Cambridge
(1819–1904)

Augusta = Frederick William,
(1822–1916) 1843 Grand Duke
of Mecklenburg-
Strelitz
(1819–1904)

Mary = Francis,
Adelaide 1866 Prince and
(1833–97) Duke of Teck
(1837–1900)
s. of Duke
Alexander of
Wurttemberg

Victoria, = Frederick William,
Princess Royal 1858 Crown Prince of
(1840–1901) Prussia, later
Frederick III,
German Emperor
(1831–88)

EDWARD VII = Alexandra
(1841–1910) 1863 (1844–1925)
d. of Christian IX,
King of Denmark

Alfred = Marie
Duke of Edinburgh 1874 (1853–1920)
and Duke of Saxe- d. of Tsar
Coburg and Gotha Alexander II
(1844–1900) of Russia

2 s, 4 d

Albert Victor,
Duke of Clarence
and Avondale
(1864–92)

GEORGE V = Victoria Mary
(1865–1936) 1893 (1867–1953)

Victoria
(1868–1935)

2 d

3 s

EDWARD VIII
(1894–1972)

GEORGE VI = Elizabeth
(1895–1952) 1923 (1900–2002)
d. of Claude Bowes Lyon,
14th Earl of Strathmore

3 s, 1 d

ELIZABETH II = Philip,
(b. 1926) 1947 Duke of Edinburgh
(b. 1921)
s. of Prince Andrew
of Greece

1 d

Charles, = (1) Diana = (2) Camilla Parker-Bowles
Prince of Wales 1981 (1961–97) 2005 (b. 1947)
(b. 1948) d. of d. of Major Bruce Shand
Edward John,
8th Earl Spencer

2 s, 1 d

2 s

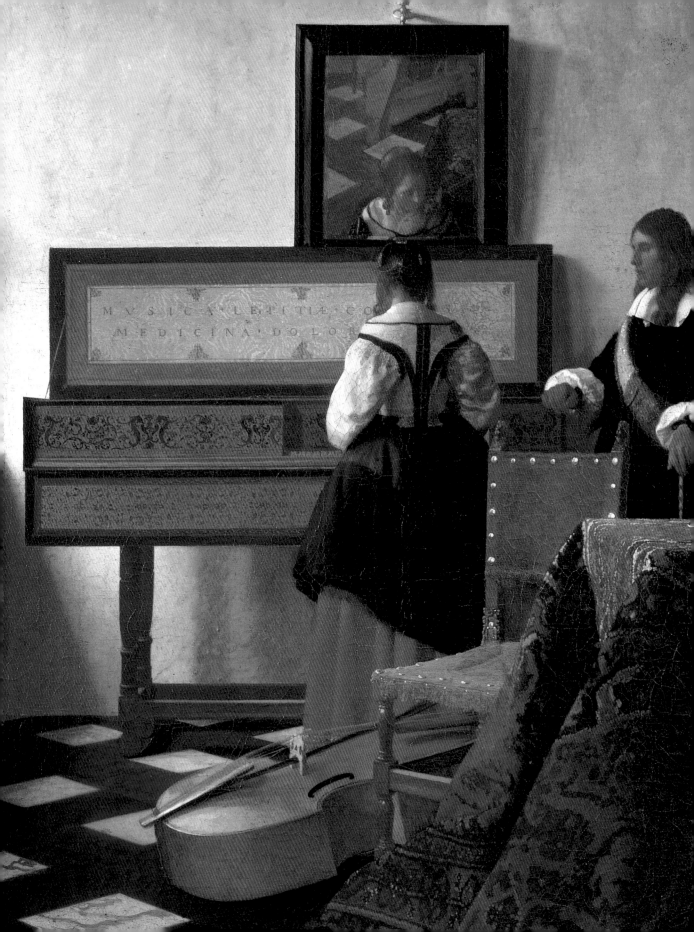

~ CHAPTER 1 ~
PAINTINGS AND MINIATURES

The 7,000 paintings and 3,000 miniatures in the Royal Collection form one of the most important holdings of Western art in the world. In contrast to a museum collection, which aims to provide a comprehensive survey, the Royal Collection reflects the personal interests of different monarchs over the last five centuries, from the Tudors to today. Its reputation – especially for British portraiture, European Old Masters and Victorian painting – has resulted largely from the enthusiasms of just a few royal collectors.

Of all the schools of painting the best represented is the British. The paucity of indigenous talent at the outset led to the employment by the Tudor and Stuart courts of high-calibre artists such as Hans Holbein the Younger and Rubens (p. 34). Their example helped to nurture a British school of painting which had by the 18th century achieved a true identity of its own in the work of Thomas Gainsborough (p. 52) and Johan Zoffany (p. 53). The collection provides an exceptional overview of portrait painting in Britain, ranging from the grand image of Charles I by Van Dyck (p. 38) in the Stuart court to the unsentimental portrait of Queen Elizabeth II by Lucian Freud (p. 20) in our own time. Apart from portraiture, the British school of painting has a strong tradition of conversation pieces (p. 53), landscape and narrative scenes (p. 58).

Charles I, who particularly admired Italian painting, did much to establish the reputation of the collection, especially after his purchase of the Gonzaga collection in Mantua in 1628. The acquisition of works by Raphael, Leonardo da Vinci, Titian, Tintoretto and Correggio – as well as of contemporary painters such as Annibale Carracci (p. 33) – was a high point in the history of the collection. After Charles I's death, many of these pictures were sold in the Commonwealth Sale.

In later reigns both Charles II and George III endeavoured to restock the palaces with pictures – the former acquiring fine examples of work from the Italian Renaissance (pp. 30, 31),

the latter purchasing the collection of Joseph Smith, the British Consul in Venice, with great examples of the work of 18th-century Venetian masters such as Canaletto, as well as fine paintings and drawings by Dutch and Flemish artists, including Vermeer (p. 45).

The greatest collector of Dutch and Flemish pictures was George IV, who bought outstanding examples by Rubens (p. 34) and Teniers during the Napoleonic wars. The acquisition in 1814 of the Dutch pictures belonging to Sir Francis Baring brought the total of George IV's Dutch and Flemish paintings to some 200, including examples of consummate quality by Aelbert Cuyp (p. 43), Gerrit Dou and Adriaen van Ostade. Although George IV's enthusiasm for French art is not so apparent in his acquisitions of paintings, some important purchases were made in the early 19th century. More recently, the French school has also been successfully enriched, by both 18th-century works and an Impressionist masterpiece (p. 59).

Prince Albert and Queen Victoria made the last important addition to the Old Master holdings with their acquisition of primitive art of the early Italian, German and Netherlandish schools (pp. 27–29).

The 3,000 miniatures in the Royal Collection show the development of the miniature as an art form in England from its inception during the reign of Henry VIII to its decline after the invention of photography during the reign of Queen Victoria. Some of its greatest practitioners – Hans Holbein the Younger (p. 61), François Clouet (p. 62), Nicholas Hilliard (p. 62) and Isaac Oliver (pp. 63, 64) – are featured. The fortunes of miniaturists, who were able to secure royal patronage, were closely linked to their relationship with the sovereign. Monarchs who took a keen interest in miniatures included Charles I, who owned 76, George III and Queen Victoria and Prince Albert, whose passion grew out of a love of family and dynasty. Important acquisitions have continued to be made in modern times.

Details: Johannes Vermeer, A lady at the virginal with a gentleman, c.1662–65 (see p. 45)

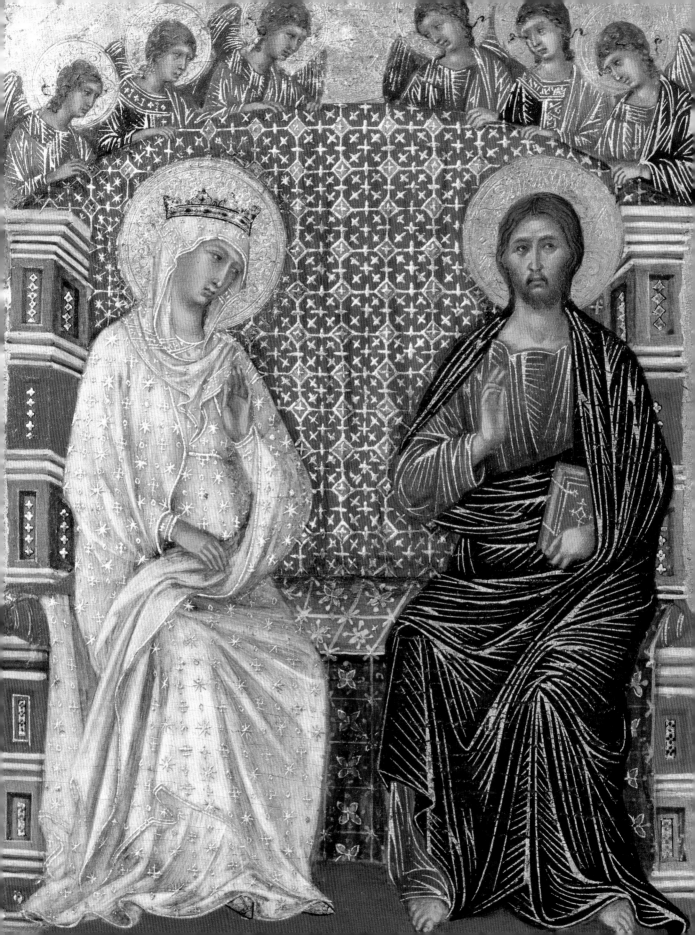

PAINTINGS

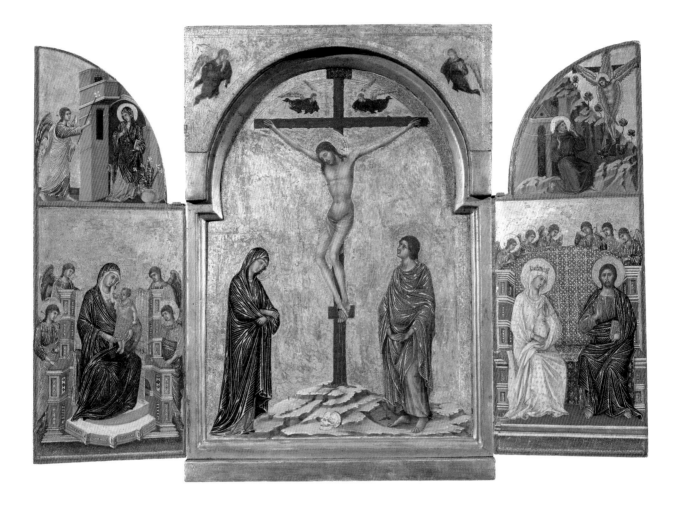

DUCCIO (fl.1278–before 1319) and assistants
*Triptych: the Crucifixion and other scenes, c.*1308–11

The Sienese artist Duccio was one of the most innovative
painters of the 14th century. His most important work is the
Maestà, the large double-sided altarpiece completed for the high
altar of Siena Cathedral in 1311. There are many parallels
between the narrative panels of the life of Christ on the back of
the *Maestà* and those in this small triptych (three linked panels),
which would have served as a portable devotional image. The
scenes are intended to be read in sequence, commencing with
the *Annunciation* and *Virgin and Child Enthroned* to the left of the
central *Crucifixion*, and continuing with *Christ and the Virgin
Enthroned* and the *Stigmatisation of St Francis* on the right. The
two enthronements are carefully balanced, neatly linking Christ,
the Virgin Mary, who appears four times, and St Francis, who
was regarded as the second Christ. It is likely that the triptych
was commissioned for a Franciscan patron.

Reconstituted before its acquisition by Prince Albert, this work
was reframed by him in one plane and was only reconstructed
as an integral triptych (with a base block) during conservation in
1988. At that time it was noticed that the internal perspective
had been adjusted by the artist to correct the apparent distortion
that resulted from the angle of the wings. Such a sophisticated
approach, combined with the high quality of many of the figures,
suggests that Duccio planned the painting himself, although he
may have shared the execution with his assistants. The triptych,
a work of great richness and complexity, was heralded in the 19th
century as one of the finest works by the master.

Tempera on panel; central panel 44.9 × 31.4 cm, round headed (painted area
41.5 × 30.4 cm); spandrel above 13.9 × 34.9 cm; wings 44.8 × 16.9 cm
RCIN 400095
Purchased by Prince Albert

BERNARDO DADDI (*fl.c.*1320–1348)
*The Marriage of the Virgin, c.*1330–42

This panel by the Florentine artist Bernardo Daddi formed part of the predella (the lowest row of panels) of the high altarpiece of the church of San Pancrazio in Florence, the most complete surviving full-scale work substantially painted by the artist. The multi-tiered altarpiece had been dismembered before the end of the 18th century, but nearly all the surviving panels are today on display in the Uffizi, Florence. *The Virgin and Child Enthroned* in the centre is flanked by standing saints to left and right. Above are half-length apostles with angels and prophets. The predella of eight panels illustrated the early life of the Virgin. *The Marriage of the Virgin* was the sixth in the sequence. It was evidently cut down after it was separated from the altarpiece and the small areas of its upper corners were repainted. (Each of the predella panels still in the Uffizi measures 50.0 × 38.0 cm, including an arched top.) This work is, however, the best preserved of the surviving predella panels.

The source for the scene can be traced to the apocryphal gospel *The Protoevangelium of James* (AD 8–9) and *The Golden Legend* by Jacobus Voragine (*c.*1229–1298), in which the Virgin's suitors were instructed to bring rods to the Temple altar. The rod belonging to Joseph flowered. When the Holy Spirit (in the form of a dove) perched on the tip of Joseph's rod, it was clear that Joseph had been chosen to be the Virgin's spouse. Here the bare-headed High Priest joins the hands of Joseph and Mary while disappointed suitors break their rods. The dignified weight of the figures shows the influence of Giotto, with whom Daddi probably trained, but the severity of Giotto's style has been reduced by other influences. The intense bright colours, delicate modelling and decorative details derive from the work of Sienese artists such as Ambrogio and Pietro Lorenzetti. Daddi belonged to the group of artists who introduced 'the miniaturist tendency' into Florentine art, a lyrical style which continued to the end of the 14th century.

Tempera on panel; 25.5 × 30.7 cm
RCIN 406768
Purchased by Queen Victoria as a gift for Prince Albert

LUCAS CRANACH THE ELDER (1472–1553)
*Apollo and Diana, c.*1530

Together with Hans Holbein and Albrecht Dürer, Lucas Cranach was the principal artist of the German Renaissance. As court artist to the electors of Saxony at Wittenberg, he was closely involved with the Protestant Reformation and was a friend of Martin Luther. The incisive clarity and linear energy of Cranach's brushwork reflect his calligraphic skills as a draughtsman.

This painting is one of three versions of the subject showing the sun god Apollo with his sister Diana, moon goddess and virgin huntress. The date 1530 on the version in the Gemäldegalerie Berlin gives an approximate date for this painting and the one in the Musée des Beaux-Arts, Brussels. Each is subtly different, illustrating the way in which Cranach's successful workshop varied ideas without exact repetition. All three versions show the influence of engravings of the same subject by Dürer (*c.*1502) and by Jacopo de' Barbari (*c.*1500–06). Diana's pose also echoes that of the antique bronze known as the *Spinario*

('thorn-remover'). Her domain of night is suggested by the depth of the forest and the dark blue of the upper limits of the sky; that of Apollo, day, by the clarity of the light describing the multiplicity of detail and the minutely rendered landscape. Cranach links the figures seen in relief with their setting so that Diana's

precisely rendered hair curls around the stag's antlers, which in turn are deliberately confused with the branches of the trees behind. In this taut style the delicate figures combine formal courtly elegance with a naïve sensuousness, giving the scene a particular intensity.

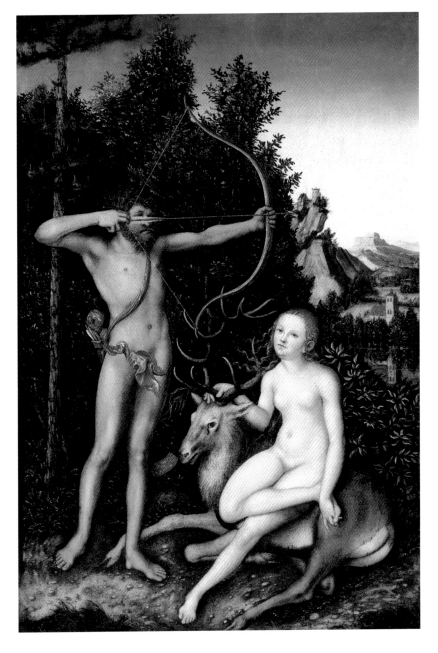

Oil on panel; 83.8 × 56.5 cm
Signed with black winged serpent, lower left
RCIN 407294
Purchased by Prince Albert

Lorenzo Lotto (*c*.1480–*c*.1556)
Andrea Odoni, 1527

This portrait of Andrea Odoni (1488–1545), a successful Venetian merchant who formed a renowned collection of paintings, sculpture, antique vases, coins, gems and natural-history objects, is one of the most innovative and dynamic portraits of the Italian Renaissance. One piece shown here, the head lower right, can be identified with a cast of Hadrian. Most of the other objects appear to be versions, probably casts, of well-known originals included by the artist to give a particular meaning, rather than to record specific items in Odoni's collection. In his outstretched right hand Odoni holds a statuette of Diana of the Ephesians, as a symbol of nature or earth. The contrast between this complete object and the antique fragments

may refer to the enduring power of nature compared with the transitoriness of art and human endeavour. However, the crucifix between the sitter's left hand and his breast suggests that for Odoni the true religion of Christianity will always take precedence over nature and the pagan worship of antiquity.

Odoni's gaze is made more arresting by his powerful gesture. Often unconventional and surprising in his portraiture, Lotto successfully challenges his great rival Titian in this painting.

Oil on canvas; 104.6 × 116.6 cm
Inscribed *Laurentius lotus / 1527*
RCIN 405776
Presented to Charles II by the States-General of Holland

Giulio Romano (c.1499–1546)
Margherita Paleologo, c.1531

This portrait depicts a noblewoman in a magnificent black overdress, decorated with an extraordinary pattern made up of what were called 'knot fantasies' (*fantasie dei vinci*). On her head she wears an elaborate headdress (*zazara*) and holds a rare lapis lazuli rosary in her right hand. In the room behind her, a maidservant greets two fashionable ladies and a nun.

Giulio Romano entered the service of Federico Gonzaga, 5th Marquess and 1st Duke of Mantua, in 1524. The portrait could depict Federico's mother, Isabella d'Este. The 'knot fantasies' pattern was specifically invented for Isabella and her sister Beatrice, wife of the Duke of Milan, although the fashion became widespread. But it appears more likely that it shows Isabella's daughter-in-law, Margherita Paleologo (1510–1556), who was sent a lapis lazuli rosary by her husband Federico, just prior to their marriage in 1531. New rooms were prepared for the couple in 1530, leaving a space for 'the large painting that Messer Giulio is to make'. The visitor in the background may be Isabella, who enjoyed Margherita's company. The portrait captures the daily life of the ruling family in this cultivated and fashionable North Italian court.

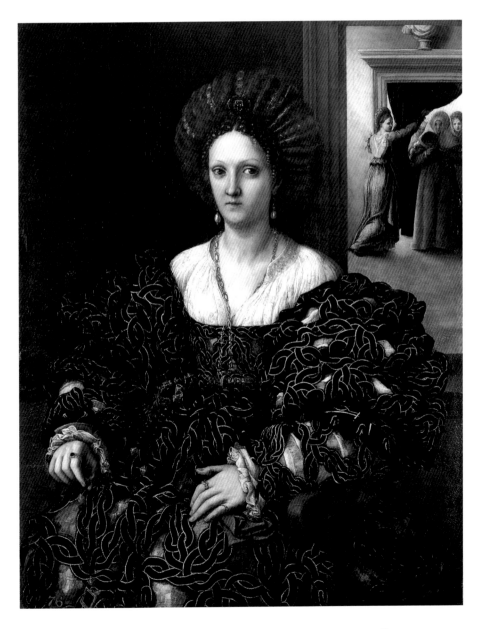

Oil on panel; 115.5 × 90.0 cm
RCIN 405777
Presented to Charles II by
the States-General of Holland

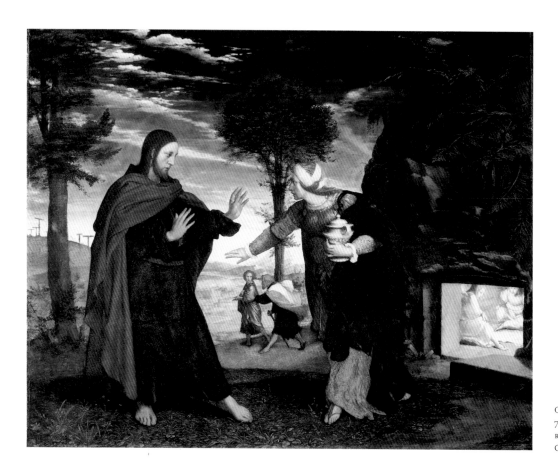

Oil on panel;
76.7 × 95.8 cm
RCIN 400001
Charles II by 1680

HANS HOLBEIN THE YOUNGER (1497/98–1543)
*'Noli me tangere', c.*1524

When the diarist John Evelyn saw this painting in Charles II's Private Lodgings at Whitehall in 1680 he recorded that he 'never saw so much reverence & kind of Heavenly astonishment, expressed in Picture'. It is possible that it entered the King's collection in 1669 on the death of Queen Henrietta Maria, who had a painting of this subject over the mantel in her bedchamber at Colombes in France, to which she returned after the execution of Charles I.

The majority of Holbein's religious paintings were intended as large altarpieces. This is a smaller, more intimate narrative scene, depicting the moment described in the Gospel of St John (20: 14–18) when Christ forbids Mary Magdalene's touch. Behind the principal figures, Saints Peter and John – who are shown returning to Jerusalem in order to announce their discovery of the empty tomb – echo their gestures. Light radiates from the tomb where two angels in white guard the grave clothes, and in the distance a number of crosses can be seen on the hill at Calvary. By this means more than one episode of the Passion is contained within the image.

This painting is associated with Holbein's visit to France of 1524 and it has been suggested that it includes evidence of his encounter with Italian art at the court of Francis I. The ointment jar held by Mary Magdalene is decorated with winged satyrs and inscribed *MARIA* around the rim of the lid. Although comparisons can be made with contemporary French earthenware (from Saint Porchaire, for example), it appears closer to the wares produced in Antwerp at that time and there is no reason to doubt that it is an object of Holbein's own design. Holbein's interest in costume is well documented and the Magdalene's clothing may be compared to the costume of the women in the foreground of the *Solomon and the Queen of Sheba* miniature in the Royal Collection.

This is the only religious painting by Holbein in the Royal Collection. In addition to the five miniatures and 80 drawings (see pp. 61, 222–25), there are seven painted portraits, all of them dating from Holbein's two periods of residence in England.

Annibale Carracci (1560–1609)
Allegory of Truth and Time, c.1584–85

This painting is an early work by Annibale Carracci, the most famous of the Carracci family of artists who were the determining influences on the development of Baroque art in the 17th century. It is generally dated to the period when Annibale, his elder brother Agostino (1557–1602) and their cousin Ludovico (1555–1619) had formed their own academy in Bologna, aiming to reform the current style of Mannerist painting by studying nature and the work of North Italian artists such as Correggio, Titian and Veronese. They collaborated on projects and from 1583 to 1584 were working on the frescoed frieze consisting of scenes illustrating the story of Jason in the Palazzo Fava, Bologna. The facial types, the elegant, boneless hands and the slightly acidic colours in both the *Allegory* and Annibale's Jason scenes show the influence of Federico Barocci as well as of Correggio.

The precise meaning and origin of this painting, and its early history, are not known. Winged Time (holding an hourglass) is shown having drawn up his daughter Truth (haloed and holding a mirror) from the depths of a well to reveal her in the light of day. She triumphs by trampling underfoot a figure personifying Deceit (also called Fraud, Hypocrisy or Calumny). On the right is Bonus Eventus (happy issue of enterprises), holding his attributes of corn and poppies and pouring a libation of flowers; the figure on the left is either Felicity, with cornucopia and winged staff or, because she has wings, Fortune. Some of the changes made by Annibale to the composition are visible today.

The weighty naturalism of the figures, particularly the two standing, counteracts its allegorical complexity. Annibale's directness combined with the inventiveness of his composition and bold colours transform the North Italian influences and herald his future achievements in the Palazzo Farnese in Rome.

Oil on canvas; 130.0 × 169.6 cm
RCIN 404770
Royal Collection by 1710

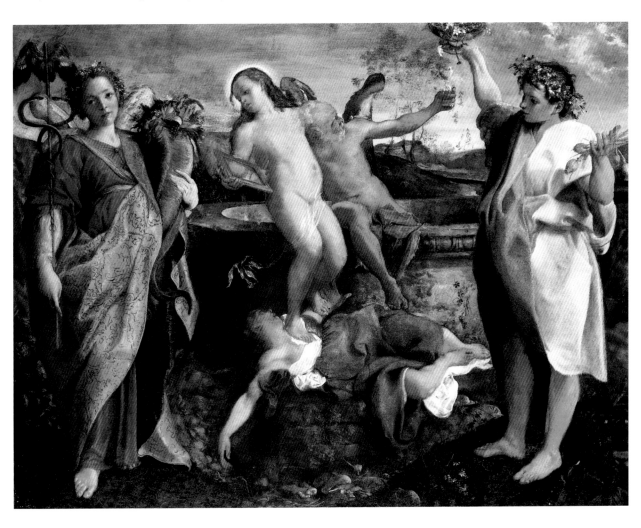

Sir Peter Paul Rubens (1577–1640)
Milkmaids with cattle in a landscape: 'The farm at Laeken', c.1617–18

The bucolic abundance and diversity of plant and animal life in this painting admirably demonstrate Rubens's life-long love of his native countryside. This is one of a small group of early landscapes painted in Antwerp between 1614 and 1618 after the artist's return from Italy. Later he was to acquire various country estates, particularly Het Steen outside Antwerp, which he recorded in other, larger canvases. The classical pose of the standing milkmaid could be interpreted as Rubens's expression of the nobility of rural life.

The composition is loosely based on a painting of a similar subject by Titian, known to Rubens through a woodcut. The painting demonstrates Rubens's patriotic sentiment, which had been strengthened by the recent restoration of peace under the Habsburg Regents Albert and Isabella. The church at Laeken north of Brussels (demolished 1894/95) seen in the upper right corner is a specific topographical feature. It was one of the principal Marian shrines and pilgrimage sites of the Catholic Southern Netherlands and its deliberate inclusion would

have had religious and patriotic associations for Rubens's contemporaries. It contained a revered statue of the Virgin and was the site of various miracles. Damaged by Calvinist iconoclasts in 1581, the church was restored and rededicated during the reign of Albert and Isabella, who made an elaborate pilgrimage there in 1623.

This picture remained in the possession of an Antwerp family related to Rubens until the 19th century. It was delivered to Carlton House in 1821 and was considered one of the finest works in George IV's collection. The Royal Collection contains a significant group of paintings by Rubens, whose strong relationship with the Stuart court led to his visit to England from 1629 to 1630. The ceiling of the Banqueting House at Whitehall (installed in 1636) was his most important royal commission in this country.

Oil on panel; 86.4 × 128.2 cm
RCIN 405333
Purchased by George IV

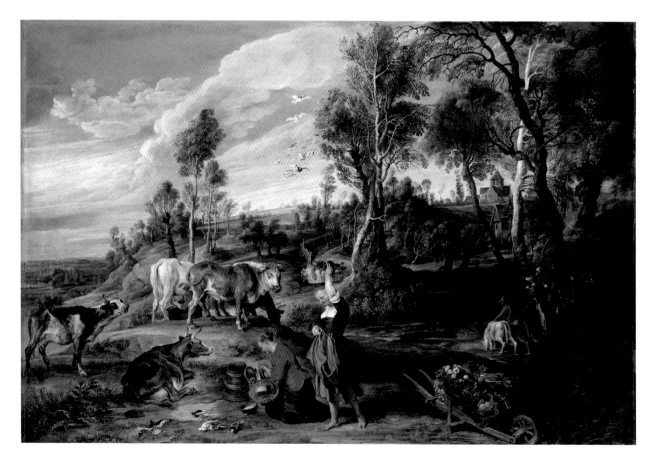

Georges de La Tour (1593–1652)
St Jerome, c.1621–23

This atmospheric painting is one of very few works in the United Kingdom by the renowned 17th-century French artist Georges de La Tour. At the time of acquisition it was described as 'St Jerome with spectacles of the manner of Albert Durer', but the identification of the figure was then forgotten. Similarly, the painting was not ascribed to La Tour until 1939. There are only a limited number of signed or dated pictures by La Tour, whose stylistic development is unclear. In spite of some surface wear in the figure of St Jerome, the less damaged areas – such as the shadowy folds of paper and wrinkled forehead – contain passages of such quality that his authorship cannot be doubted.

La Tour's work is distinctive in both style and subject. He is most celebrated for his mysterious candle-lit compositions. His art reveals knowledge of Caravaggio, particularly in the use of chiaroscuro, or of that artist's Northern followers. Here the source of light is outside the composition and is used to intensify the luminous red clothing and to render the paper almost transparent. This painting demonstrates La Tour's characteristic sensitivity to the texture of human hair and skin and his ability to endow the humblest figure with religious authority. His love of genre detail is demonstrated in the

spectacles, which give the aged saint, who wrote the Latin vulgate translation of the Bible, an air of added concentration.

This is not a typical representation of St Jerome, the first cardinal. The other more usual attributes, such as a skull or cardinal's hat, are omitted. Until recently, the present canvas support was adhered to a branded oak panel. This technique, *marouflage*, was used in Antwerp workshops in the 17th century; it is likely that the painting was sold to Charles II in that state.

Oil on canvas; 63.8 × 47.2 cm
RCIN 405462
Purchased by Charles II

Frans Hals (1580–1666)
Portrait of a man, 1630

Hals is celebrated for his distinctive animated portraits in which the character of his sitters appears momentarily captured through his use of vivid brushwork and lively expression. His works appear to have been painted with a rapid technique, but he was not an especially prolific painter. Yet he made a very great contribution to the genre of portraiture and Hals is placed second only to Rembrandt in the development of Dutch painting.

The sitter's relaxed pose and elegant dress capture the confidence and vitality of the successful burghers who made the newly created Dutch Republic the richest and most powerful nation in Europe during the first half of the 17th century.

This work demonstrates the emergence of Hals's mature style, as his portraits gradually acquired a greater sense of unity and simplicity of structure. For instance, the manipulation of the plain background through the aura of light behind the head is used to create a sharp silhouette and to give the body a genuine solidity. The figure seems to emerge from the lower edge of the picture plane, while the jutting elbow and taut clothing only serve to increase the viewer's sense of animation.

The sombre fashion for black garments was popular during the 1630s and Hals's monochromatic palette is relieved only by the restrained splash of colour of the ochre gloves. The treatment of this passage is particularly virtuoso, employing broken, angular and seemingly disconnected strokes. Among the artist's contemporaries, only Rembrandt or Velázquez could match such a dazzling display of visual pyrotechnics. This aspect of his work particularly appealed to 19th-century French painters such as Manet, whose interest encouraged Hals's art to be reassessed.

Oil on canvas; 115.5 × 88.5 cm
Inscribed upper right *AETAT SVAE 36 / AN. 1630*
RCIN 405349
Royal Collection by 1795

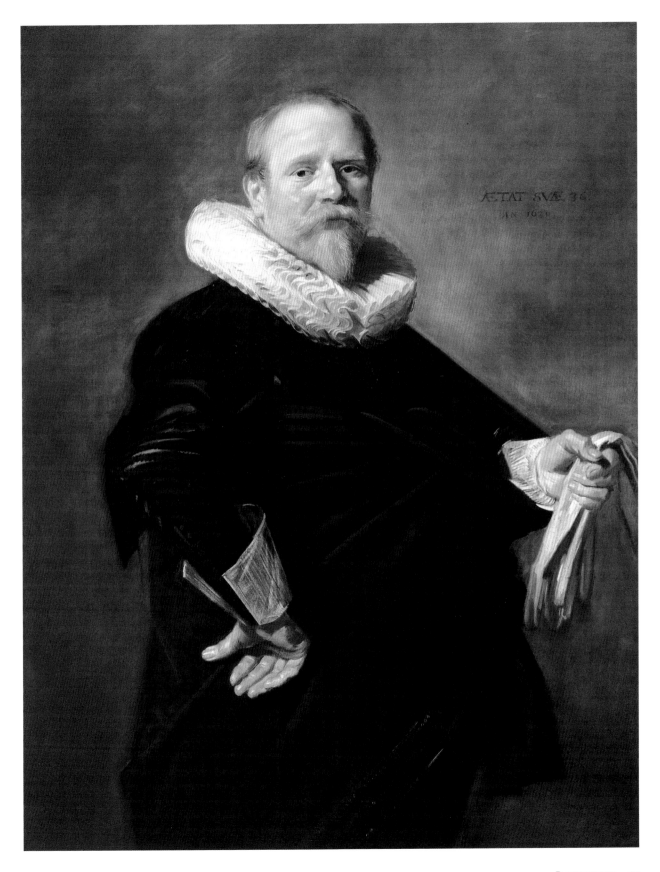

ÆTAT SVÆ 36
AN 1628

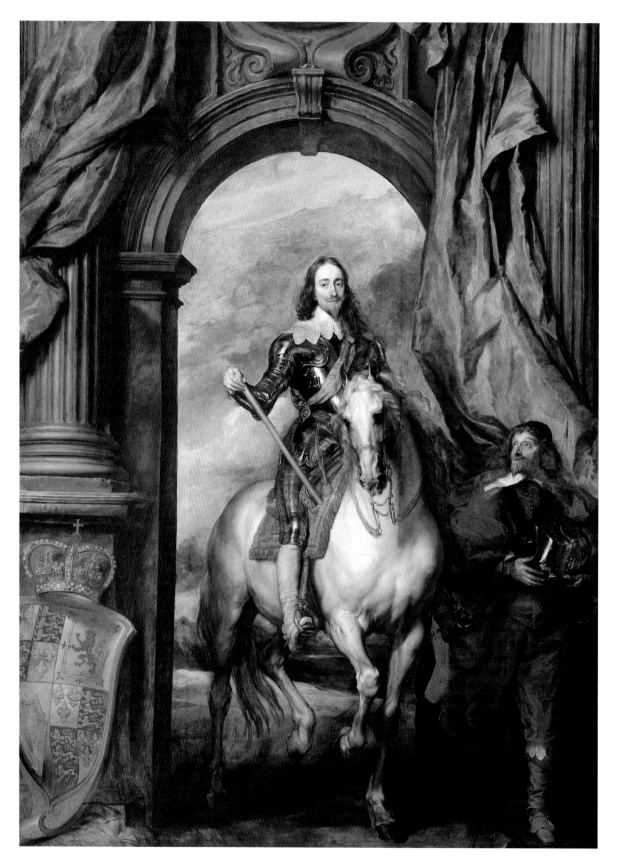

Sir Anthony Van Dyck (1599–1641)
Charles I with M. de St Antoine, 1633

In 1632, the Flemish artist Van Dyck – Rubens's most gifted follower – was appointed Principal Painter to Charles I (1600–1649; r. 1625–49). This is one of the chief paintings to result from his appointment, which revolutionised British painting and provided us with the enduring image of the Stuart court. With great fluency Van Dyck portrays Charles I on horseback on an unprecedented scale, as ruler, warrior and knight, in the long tradition of antique and Renaissance equestrian monuments. The prominent display of the crowned royal arms and the triumphal arch framing the armed King reinforce his image as ruler of Great Britain, while the King's refined features, loose hair and the sash of the Order of the Garter worn over his armour convey the impression of a chivalrous knight. Van Dyck may have designed the painting for its first position at the end of the Gallery at St James's Palace, where its theatrical effect impressed visitors. Both artist and patron admired and collected works by Titian, but a more direct influence was Rubens's 1603 portrait of the *Duke of Lerma* (Madrid, Prado), which Charles I would have seen on his visit to Spain as Prince of Wales in 1623.

Skilled horsemanship was regarded as the epitome of *virtu* and here Pierre Antoine Bourdin, Seigneur de St Antoine, a master in the art of horsemanship, carries the King's helmet. Sent by Henry IV of France to James I with a present of six horses for Henry, Prince of Wales, in 1603, he remained in the service of the Prince and later of Charles I, as riding master and equerry. He looks up at the King, whose poise stabilises a scene filled with baroque movement.

Van Dyck went on to paint two other major portraits of the King with a horse: *Charles I on horseback*, c.1636–38 (London, National Gallery) and *Le Roi à la Chasse*, c.1635 (Paris, Louvre). The present painting hung at Windsor Castle for much of the 19th century; it is recorded in both the Queen's Presence Chamber (see below) and the Queen's Ballroom (also known as the Van Dyck Room).

Oil on canvas; 368.4 × 269.9 cm
Dated *1633*
RCIN 405322
Commissioned by Charles I

CHARLES WILD
(1781–1835)

The Queen's Presence Chamber at Windsor Castle, 1817, showing the Van Dyck portrait of Charles I on the left wall

Watercolour with touches of bodycolour and gum arabic over pencil; 20.4 × 25.1 cm
RL 22099

Rembrandt van Rijn (1606–1669)
Agatha Bas, 1641

This is one of the most beautiful portraits in the Royal Collection. Its companion, in the Musée Royal des Beaux-Arts, Brussels, depicts Nicolaes van Bembeeck (1596–1661), a wool merchant who had married Agatha Bas (1611–1658) in 1638. It is also signed and dated 1641. The couple lived in the Sint Anthoniesbreestraat, Amsterdam, where Rembrandt himself lived from 1631; they were almost certainly known to the artist.

Rembrandt introduced a new compositional device in this painting: the figure is posed within a painted ebony frame which blurs the boundaries between the imaginary space within the composition and the real world outside. The sense of direct contact with the sitter is achieved partly through the striking gesture of the hand resting against the frame and partly by showing the fan protruding over the edge towards the viewer's space. The different levels of finish in the painting are particularly striking. For instance, Rembrandt portrays the fine hairs at the edge of the hairline through curling lines incised into the paint with the end of the brush, and, in contrast to such direct handling, the depiction of Agatha Bas's skin and eyes is remarkably subtle and delicate.

There are five paintings by Rembrandt in the Royal Collection, the earliest of which, *The Artist's Mother* (RCIN 405000), was presented to Charles I before 1633, and was thus one of the first works by Rembrandt to reach England. Of the three Rembrandts collected by George IV, *The Shipbuilder and his wife* (RCIN 405533), purchased for 5,000 guineas in 1811, was perhaps his most famous single acquisition.

Oil on canvas; 105.2 × 83.9 cm
Signed and dated *Rembrandt f. / 1641*
and inscribed *AE 29*
RCIN 405352
Purchased by George IV when Prince Regent

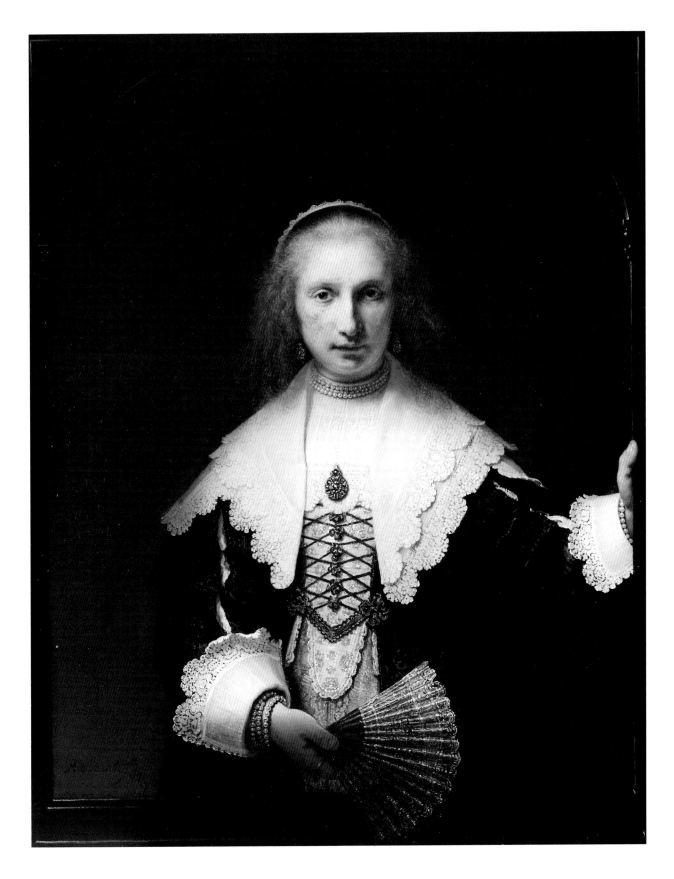

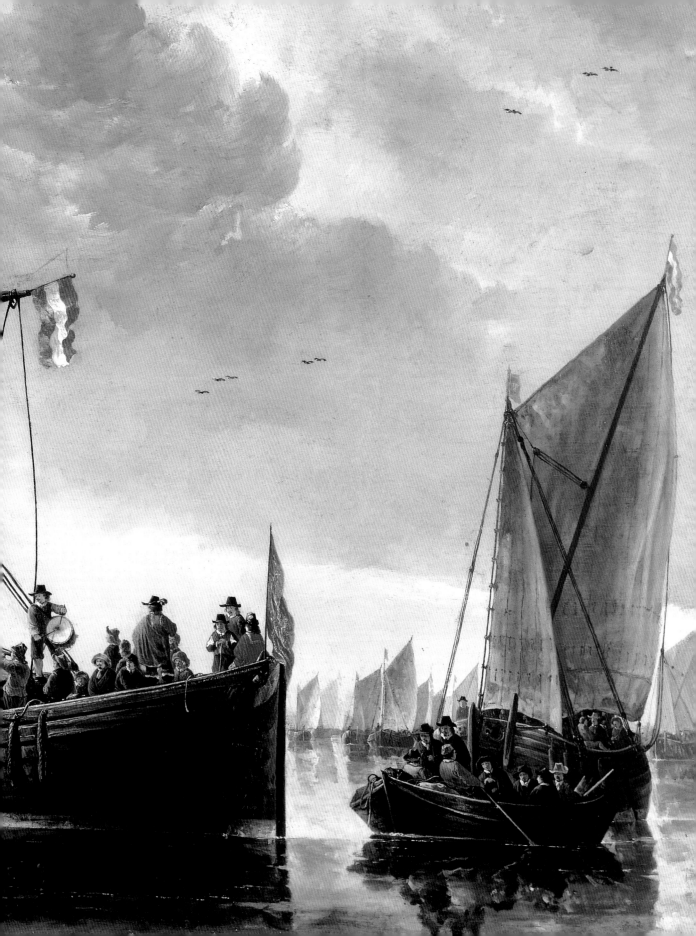

Aelbert Cuyp (1620–1691)
The Passage Boat, c.1650

Cuyp's work, which had been little known outside his native Dordrecht until the end of the 18th century, became so popular in England during the Napoleonic period that by about 1825 'a near monopoly' of his pictures had been established here. George IV owned six important pictures by Cuyp in addition to this example, which was shown hanging in the Blue Velvet Room at Carlton House in 1816, two years after its purchase.

Cuyp lived almost all of his life in Dordrecht and painted a number of magnificent shipping scenes of the river traffic on the rivers Merwede and Maas. This painting shows the arrival of the daily passage boat that plied between Rotterdam and Dordrecht. A drummer plays and the Dutch flag flutters in the wind. The vessels in the background may be an allusion to the visit of the Dutch fleet to Dordrecht in the summer of 1647. Although similar shipping scenes by Cuyp represent the embarkation or landing of some dignitary, the figure clothed in red at the prow of the passage boat does not seem to represent a particular individual.

This painting is notable above all for the rendering of the relationship between water, sky and shipping against a low horizon. The atmosphere is almost palpable as the golden evening light casts long shadows and a gentle breeze fills the sails of the boats in the background. The vigorous rendition of the clouds and the superb handling of the reflections in the foreground contrast with the sharp lines of the rigging and the strong silhouettes of the figures on the pier. Cuyp's alterations to the angle of the rigging and the lower of the two Dutch flags are clearly visible. Paintings like this made a powerful impression on J.M.W. Turner in the 19th century.

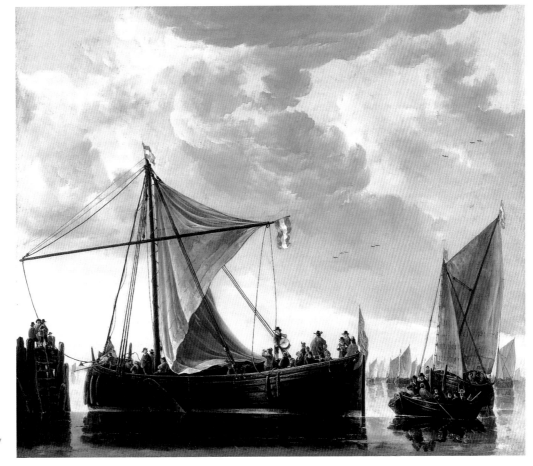

Oil on canvas;
124.4 × 144.2 cm
Signed on the rudder
A. cüyp
RCIN 405344
Purchased by George IV
when Prince Regent

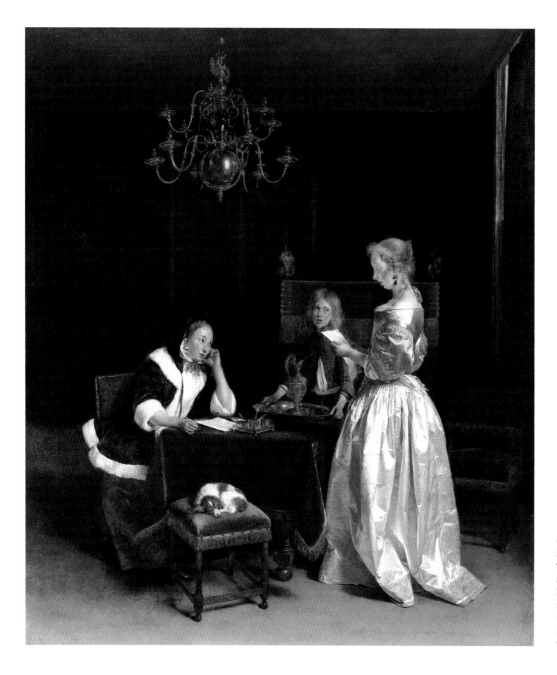

Oil on canvas;
81.9 × 68.2 cm
Traces of a signature
are visible on the
letter under high
magnification
RCIN 405532
Purchased by George IV
when Prince Regent

GERARD TER BORCH (1617–1681)
The Letter, c.1660–02

The Dutch painter Gerard ter Borch is best known for his
tranquil genre scenes, mostly painted in the Dutch town of
Deventer. He was one of three children, all of whom were
trained by their artist father and pursued artistic careers.

The simplicity of this domestic scene encourages the viewer
to delight in the beauty and detail of the objects that it contains.
The interaction between the three participants is left open to
interpretation and the significance of the letter is not explained.

Ter Borch delights in metallic surfaces, for instance the
reflections in the candelabrum and the inkwell and stand.
The use of deep-blue ultramarine edging around the woman's
neckline and the rendering of the embroidery around the edge
of her mesmerising silk skirt are masterly touches.

This is one of two paintings by Ter Borch in the Royal
Collection, both of which were purchased by George IV, an
enthusiastic collector of the work of 17th-century Dutch masters.

Johannes Vermeer (1632–1675)
A lady at the virginal with a gentleman, c.1662–65

Only 34 paintings by Vermeer are known today and few biographical details are recorded concerning the artist, who was mainly based in Delft. The meanings behind his paintings are similarly enigmatic. The inscription on the lid of the virginal – *MVSICA . LETITIAE CO[ME]S / MEDICINA . DOLOR[VM]* – can be translated as 'Music, pleasure's companion and remedy for sorrow'. On the back wall hangs the painting *Roman Charity* by the Dutch artist Dirck van Baburen (*c.*1595–1624) in which Cymon, condemned to starve to death, is being suckled by his daughter Pero, one of several allusions to love in the painting.

The painting attests to Vermeer's extraordinary technical skills in his search for verisimilitude. The perspective construction and experimentation with paint reveal his knowledge of the optical system and the visual effects obtained by the camera obscura. Vermeer also manipulates the light effects to reinforce the composition's structure. Similarly the mirror's reflection looks optically correct, yet does not match reality. Only in her reflection does the woman turn to the man, but their intimacy is undermined by a glimpse of the artist's easel, reminding us that the whole scene is Vermeer's sophisticated creation.

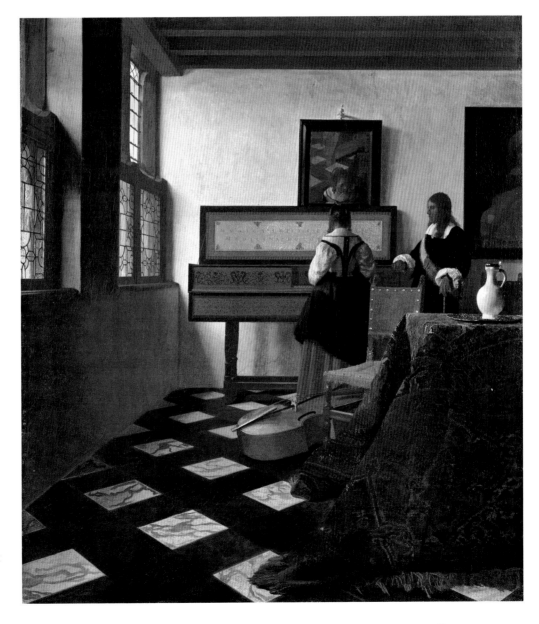

Oil on canvas;
74.0 × 64.6 cm
Signed *IV Meer*
(*IVM* in monogram)
RCIN 405346
Purchased by George III
from Joseph Smith

See details on pp. 24–25

CLAUDE GELLÉE, called LE LORRAIN (1604/05–1682)
Coast scene with the Rape of Europa, 1667

The rape of Europa is recounted in Ovid's *Metamorphoses*. Jupiter, who had fallen for Europa, the daughter of Agenor, King of Tyre or Sidon in Phoenicia, changed himself into a white bull and mingled with a herd of cattle, while Europa and her attendants were playing near the seashore. Charmed by the bull's good nature and fine appearance, Europa hung garlands of flowers over its horns and climbed onto its back. She was carried out to sea, to the island of Crete, where Jupiter resumed his normal shape and ravished her.

Claude came from Lorraine, but worked throughout his career in Rome, where he was inspired by the ruined architecture of classical antiquity, the intense southern light and the beauty of the Roman countryside. He worked in Rome alongside his compatriot, Nicolas Poussin; together they forged a new, more intellectual type of landscape, which was a fitting setting for stories taken from classical mythology.

Five versions of this subject by Claude are known. Of these, the one in the Royal Collection is the last and the most sophisticated. The calm mood of the scene is established by the carefully placed trees, the fortification and ships on the horizon, and the pale golden light. The central group seem light-hearted and part of this Arcadian world. Yet the artist has depicted the natural world with great care: the breeze whipping up the water, the waves dashing against the ships, which bob up and down on the sea, the rocky shore, the flowers on the horns of Jupiter, the grazing cattle and the magnificent trees framing the composition. Claude creates a real as well as a poetic world.

Oil on canvas; 102.0 × 134.9 cm
Signed and dated *CLAUDE GILLE IVRI / ROMAE 1667*
RCIN 405357
Purchased by George IV

Giovanni Antonio Canal, called Canaletto (1697–1768)
Venice: The Bacino di San Marco on Ascension Day, c.1733–34

The scene depicted was the principal state festival of the Venetian Republic. Every Ascension Day the Venetians celebrated the 'Wedding of the Sea' (*Sposalizio del Mar*), a ceremony which symbolised Venice's seafaring supremacy in the Adriatic. The Doge and his government would proceed in the ceremonial vessel, the Bucintoro, to the mouth of the Lido, where the Doge throws a ring, blessed by the Patriarch of Venice, into the water as a symbolic marriage between Venice and the sea. By the 18th century the ceremony was held with the idea of entertaining important visitors. Some spectators are in boats, a few wearing the white mask and black cape associated with carnival; others crowd the top of the Campanile; some seated on the parapets with their legs silhouetted against the sky. One spectator surveys the scene through a telescope from above the Campanile. In the Piazzetta below are the temporary stalls of the Ascension Day market. The ceremony has finished and the Bucintoro, navigated by the admiral standing before the flagpole, is about to dock. The gold parasol signals the presence of the Doge, who is about to disembark, while bewigged officials in red are seated in the cabin.

The Bucintoro portrayed here was designed by Stefano Conti in 1728–29 and decorated with gilded allegorical sculptures by Antonio Corradini. It was the last to be built for, after the fall of Venice to Napoleon's army in 1797, the upper part was burnt to recover the gold and it was finally broken up in the Arsenale in 1824.

Trained as a painter of theatrical scenery, Canaletto went on to specialise in views of his native Venice for the British market. His greatest patron was Joseph Smith, who sold his outstanding collection of prints, drawings and paintings by Canaletto to George III in 1762. This painting and its companion, *A Regatta on the Grand Canal*, were the final pair, larger in size, of a group of fourteen views of the Grand Canal painted for Smith, who published them in the *Prospectus Magni Canalis Venetiarum* with engravings by Antonio Visentini in 1735. Canaletto painted several versions of the composition, but in this painting he conveys with brilliant touches of colour and subtle light the pageantry of the scene, each figure a perfect vignette of Venetian life.

Oil on canvas; 76.8 × 125.4 cm
RCIN 404417
Purchased by George III from Joseph Smith

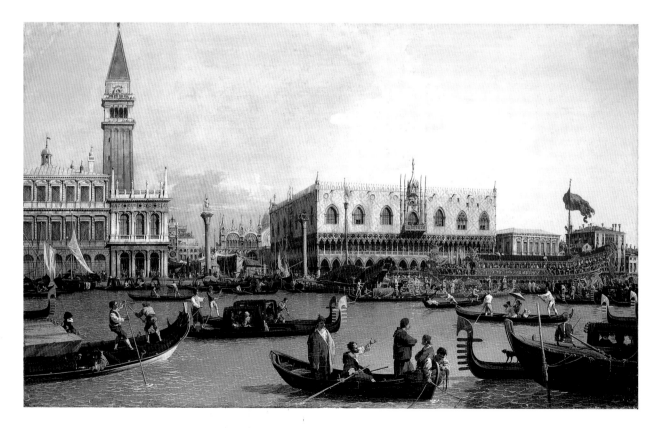

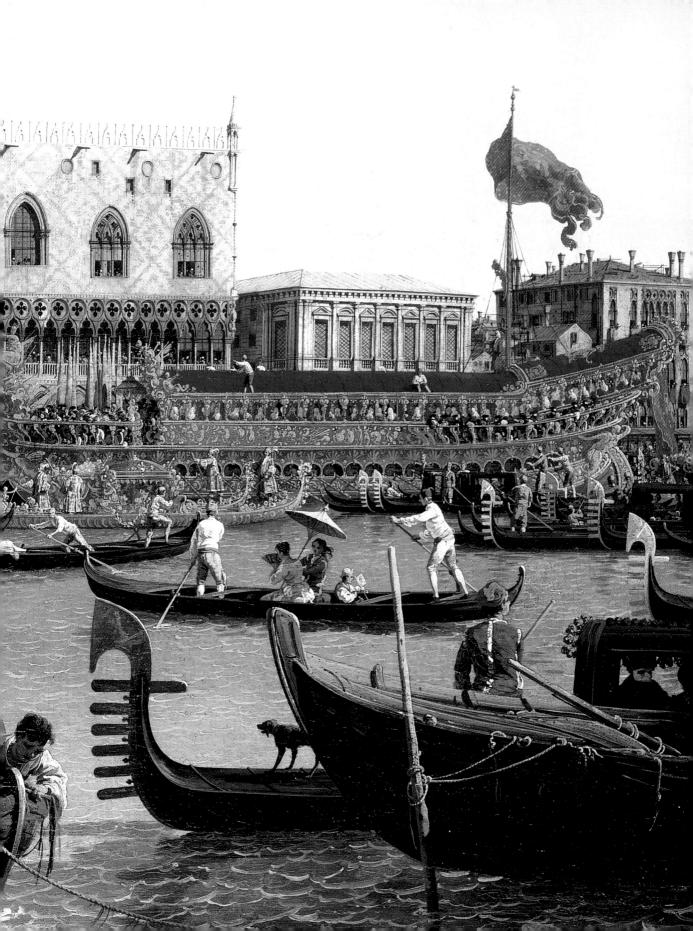

William Hogarth (1697–1764)
David Garrick and his wife, Eva-Maria Veigel, 1757

The celebrated actor-manager David Garrick (1717–1779) was one of the most frequently painted subjects in 18th-century Britain. Despite their close friendship, formed after Hogarth painted Garrick as the King in William Shakespeare's *Richard III* in 1745 (Liverpool, Walker Art Gallery), tradition has it that artist and sitter quarrelled over this portrait. Garrick was displeased with his likeness and there are signs that Hogarth scored through the eyes. X-rays reveal that the sitters were originally placed in a domestic interior which was replaced by a column with a hanging cord. Although Garrick paid £15 for the painting in 1763, it was still in Hogarth's studio at the time of the artist's death the following year.

The precedents for the composition lay both in an earlier iconographical tradition, that of Genius inspired by a muse, and also in contemporary French painting, which was similarly rococo in spirit. Hogarth has depicted Garrick's wife, the Viennese dancer Eva-Maria Veigel (1725–1822), known as Violetti, in a coquettish pose which could be seen as either inspiring or distracting the great actor from his work.

Hogarth was appointed Serjeant-Painter to George II in 1757, but his relationship with the royal family was always unsatisfactory. His preliminary oil-sketch for a conversation piece of the King's family was never realised on a larger scale.

Oil on canvas; 132.6 × 104.2 cm
Signed and dated *W Hogarth / [p]inx^t 1757*
and inscribed (on the book above the desk)
SHAKE/SPEARE and (on the paper on
which Garrick writes) *The Prologue to / Taste*
RCIN 405682
Purchased by George IV

GEORGE STUBBS (1724–1806)
The Prince of Wales's phaeton, 1793

The Phaeton was the sports car of the day: a light, open, owner-driven, two-horse carriage, with the latest in suspension technology. The name comes from Phaeton, the son of Apollo, who borrowed and crashed his father's sun chariot. This fine example of British industrial design is drawn by two sleek and beautifully turned-out horses. The scene is designed to appeal to a nobleman, who in that era would have had a good eye for horses and would have been concerned that his stable should be efficiently run and his servants well presented, as such things reflected on the owner and master.

Contemporaries would have recognised in this painting a reflection upon (even a portrait of) the owner of this equipage, the Prince of Wales, who did not stand on ceremony, even driving his own carriage and stating his rank merely with a set of modest silver arms on the horses' blinkers.

This work is painted with scrupulous attention to detail. Stubbs had studied the anatomy of the horse with as much scholarly endeavour as any veterinary surgeon of the day. He records their physique, portrays their harnesses and provides a three-quarter view of the carriage. This painting does not draw attention to itself at all; it is the opposite of 'picturesque'. It is only after we have appreciated the work of the groom that we notice the clean outlines, careful spacing and frieze-like arrangement of the artist.

Oil on canvas; 102.2 × 128.3 cm
Signed and dated *Geo: Stubbs pinxit / 1793*
RCIN 400994
Commissioned by George IV when Prince of Wales

Thomas Gainsborough (1727–1788)
Johann Christian Fischer, c.1774

Johann Christian Fischer (1733–1800), the German composer and virtuoso oboe player, made his first public appearance in London in June 1768, his superb performing technique described by Fanny Burney as 'the sweet-flowing, melting, celestial notes of Fischer's hautboy'. He wrote for the oboe and flute and was also skilled at the violin. It is likely that the piano (inscribed *Merlin Londini Fecit*) on which he leans in this painting is a pianoforte-harpsichord, as patented by John Joseph Merlin (originally from the Netherlands) in 1774; Fischer settled permanently in London in the same year. He played frequently at court and became a member of the Queen's Band; however, he failed to secure the post of Master of the King's Band in 1786.

Gainsborough, himself an accomplished musician, had met Fischer by 1773. This portrait, painted out of friendship rather than as a commission, was recorded in Gainsborough's Bath studio the following year. X-rays reveal that the canvas was reused: Fischer's portrait was painted over an abandoned imaginary portrait of Shakespeare between Tragedy and Comedy, commissioned by David Garrick in the summer of 1768. Fischer's elegant pose, developed from that of Shakespeare beneath, relates to Peter Scheemakers's famous sculpture of Shakespeare (1740) in Westminster Abbey; with his upward glance and pen in hand he seems to be seeking poetical inspiration. In 1780 Gainsborough gave unwilling consent to Fischer's marriage to his elder daughter Mary (1748–1826), correctly predicting that the union would not be a success.

Oil on canvas; 229.0 × 150.8 cm
RCIN 407298
Presented by Prince Ernest, Duke of Cumberland to George IV when Prince of Wales

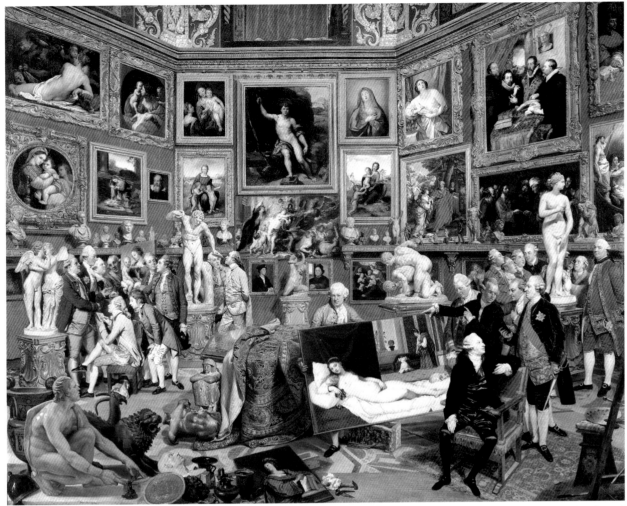

See detail on p. 6

JOHAN ZOFFANY (1733–1810)
The Tribuna of the Uffizi, c.1772–78

Zoffany arrived in London from his native Germany in 1760. He was patronised by George III and Queen Charlotte from *c*.1765 and over the next ten years produced several portraits of the King and Queen and their family. In 1772 Zoffany arrived in Florence with a commission from the Queen to paint 'the Florence Gallery'. He was still working on *The Tribuna* late in 1777.

The Tribuna is an octagonal room in the Uffizi designed by Bernardo Buontalenti for Francesco de' Medici in the late 1580s to house the most important antiquities and High Renaissance and Bolognese paintings in the grand-ducal collection. In 1737 the collection was ceded to the Tuscan government by the Grand Duchess Anna Maria Luisa. The Uffizi, and in particular the Tribuna, became the focal point for visitors to Florence. By the 1770s it was arguably the most famous room in the world.

Zoffany has portrayed the north-east section but has varied the arrangement and introduced other grand-ducal works to create his own Tribuna.

Admiring the works of art are connoisseurs, diplomats and visitors to Florence, all identifiable, so that the predominantly Flemish 17th-century tradition of gallery views is combined with the British 18th-century conversation piece or informal group portrait. The King and Queen were critical of the inclusion of so many recognisable portraits. Even so, *The Tribuna* is an outstanding example of Zoffany's technique and the consummate portrayal of the Grand Tour and 18th-century taste.

Oil on canvas; 123.5 × 155.0 cm
RCIN 406983
Commissioned by Queen Charlotte

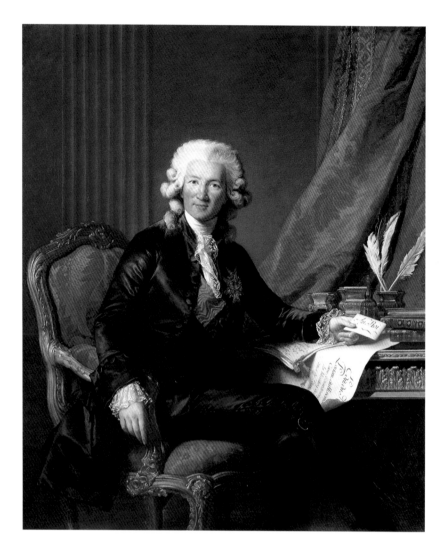

The three youngest daughters of
George III, 1785

Copley, the foremost artist in colonial
America, was virtually self-taught as
a portraitist. Having established a
successful practice in Boston, he was
encouraged to visit Europe in 1774. After
a year's travel he settled in London and
began to specialise in religious and
historical subjects, becoming a member
of the Royal Academy in 1779. A fellow
American artist, Benjamin West, who
had become Historical Painter to the
King in 1772, helped Copley to obtain
the commission from George III to paint
the three youngest royal princesses.
Copley's sense of the significance of the
opportunity is reflected in the sheer scale
of the painting, for which he made many
studies. As the royal children and pets
grew tired of the numerous sittings they
had to endure, West had to reassure the
King that Copley 'must be allowed to
proceed in his own way'.

On the left is nine-year-old Princess
Mary striking a tambourine to amuse
her two-year-old sister, Princess Amelia,
who is seated in a carriage adorned with
her mongram PA. Behind the carriage
is the eight-year-old Princess Sophia.
In the distance the Round Tower of
Windsor Castle is visible.

The painting is full of carefully
observed detail of surfaces and textures
and expresses the affectionate relation-
ship between the sisters and their natural
high spirits. However, it was judged
harshly by contemporary critics, most of
whom found its ebullience unsuited to
royalty and considered the composition
cluttered. To the modern eye, Copley has
managed to capture the energetic spirit
of childhood in a painting that is
undeniably rococo in spirit.

Oil on canvas; 265.5 × 186.0 cm
Signed and dated *J. S. Copley 1785*
RCIN 401405
Commissioned by George III and Queen Charlotte

ELISABETH VIGÉE LE BRUN (1755–1842)
Charles-Alexandre de Calonne, 1784

In 1783 Charles-Alexandre de Calonne
(1734–1802) had become Controller
General of Finance to Louis XVI. His
unsuccessful efforts to reform France's
finance and administration precipitated
the governmental crisis that led to the
French Revolution of 1789. He was
dismissed in 1787 and retired to England.
George, Prince of Wales, who owned this
painting, shared his conviction that the
French Revolution represented a threat
to every established government.

Vigée Le Brun earned an international
reputation for her stylish portrayals of
royalty and aristocratic society in Europe.
In her *Memoirs*, written towards the

end of her life, the artist strongly denied
rumours of an affair with Calonne.

This is one of the more complex of
her male portraits in terms of setting and
iconography. Details such as the dress of
the Noblesse de Robe and the ribbon and
star of the Order of the Saint-Esprit, as
well as the letter addressed to Louis XVI,
demonstrate his powerful position and
close relationship with the monarch.
Dated August 1784, the charter that led
to his downfall rests upon the table.

Oil on canvas; 155.5 × 130.3 cm
Signed and dated *Le Brun. f. 1784.*
RCIN 406988
Acquired by George IV when Prince of Wales

SIR THOMAS LAWRENCE (1769–1830)
Pope Pius VII, 1819

Thomas Lawrence dominated the art of portrait painting in England for 40 years, undertaking commissions for the future George IV from 1814. After 1818 Lawrence was largely occupied in the major royal commission for a series of portraits of the European leaders who had combined to defeat Napoleon. The series was initially proposed for Carlton House, but George IV's plans for Windsor Castle latterly came to include a new room specially created (from an open courtyard) for the display of Lawrence's portraits, the Waterloo Chamber. This portrait is arguably the most magnificent of that series.

Luigi Barnaba Chiaramonti (1742–1823), elected Pope in 1800, was imprisoned by Napoleon in 1809 for opposing his plans for the annexation of the Papal States. After his triumphant return to Rome in 1814, Pius VII became a focus for the political and spiritual regeneration of Europe. Lawrence arrived in Rome in May 1819 and was accommodated in the Quirinal Palace. He was given nine sittings by the Pope.

Lawrence must have recalled his great predecessors in the tradition of papal portraiture: Raphael's *Julius II* (London, National Gallery), Titian's *Paul III* (Naples, Capodimonte) and Velázquez's *Innocent X* (Rome, Galleria Doria-Pamphili), as well as contemporary portraits. Here, in contrast to those examples, the Pope is shown full length. His pale face, set off by jet-black hair, is made more vulnerable by the play of vivid red and white and the magnificent portable papal throne (the *sedia gestatoria*). With dazzling surface effects Lawrence portrays the Pope, a symbol in his time for the victory of peace over war, as a spiritual ruler with temporal power and all the trappings of authority.

In the left background notable pieces of classical sculpture in the papal collections are shown in the *Braccio Nuovo*, created in the Vatican for their

display under the supervision of the sculptor Canova, who had secured the return of the collection from Paris. The paper held by the Pope is inscribed *Per Ant⁰. Canova* (for Antonio Canova). The portrait has long been regarded as Lawrence's crowning achievement.

Oil on canvas; 269.4 × 178.3 cm
RCIN 404946
Commissioned by George IV when Prince Regent

Sir Edwin Landseer (1803–1873)
Eos, 1841

Eos, a greyhound bitch, was Prince Albert's favourite dog. She accompanied her master when he travelled from Germany to marry Queen Victoria in 1840. The portrait was commissioned by the Queen as a Christmas present in 1841. Her Journal records the Prince's delight and complete surprise on receiving the gift, sentiments which contrasted markedly with the great sadness caused by the death of Eos on 31 July 1844. The bronze memorial statue to Eos on her tomb in the Home Park at Windsor, partly worked on by the Prince, was modelled on this portrait.

Both artist and patron had a deep sympathy for animals, particularly dogs. Precociously gifted, Landseer learnt his accuracy of drawing from the study of anatomy and animal dissections in emulation of artists such as George Stubbs, some of whose anatomical drawings he owned. On a grand scale, the nobility and taut energy of the greyhound are intensified by the rigorous profile pose and the austere but striking play of black against red throughout the composition. Landseer, unlike Stubbs, invested animals with anthropomorphic qualities and here hints at a story. Eos appears to express steadfast loyalty for her absent owner, who may just be out of view. The deerskin footstool alludes to prowess on the hunting field, but the expensive silver collar, hat, gloves and cane refer to the noble Prince of the modern world. Until the ascendancy of Franz Xaver Winterhalter, Landseer was in effect an unofficial court painter. Queen Victoria expressed her admiration for his work in the late 1830s and her first commissions date from 1838; she remained a loyal and steadfast patron, acquiring around 100 paintings and drawings from him in the following two decades.

Oil on canvas; 111.8 × 142.9 cm
Inscribed on the back with the names of artist and sitter
and the date *December 1841*
RCIN 403219
Commissioned by Queen Victoria as a gift for Prince Albert

WILLIAM POWELL FRITH (1819–1909)
Ramsgate Sands: 'Life at the Seaside', 1852–54

On holiday at Ramsgate in 1851, Frith recorded in his autobiography that, weary of costume painting, 'I had determined to try my hand on modern life.' After three years' work, *Ramsgate Sands* was exhibited at the Royal Academy in 1854 and was so well received that Frith went on to paint his other major narrative compositions of contemporary life, *The Derby Day* (1858; Tate Britain) and *The Railway Station* (1862; Egham, Royal Holloway and Bedford New College).

The development of the railways in the 1840s transformed quiet dignified towns into crowded resorts as Londoners started to enjoy day trips to the sea. Frith, inspired by the 'variety of character on

Ramsgate Sands', shows the way in which predominantly middle-class families were forced into close proximity with other classes, entertainers and tradesmen selling wares, and the resulting humorous encounters. He took painstaking care in recording both the setting and the characters, returning to Ramsgate several times. His studies of real-life characters and models and numerous pencil sketches of groups of figures were progressed to an oil-sketch of the whole composition (Dunedin Public Art Gallery).

Frith's skill at composing the scene is most obvious when compared with contemporary photographs of beach

scenes. From our dramatic viewpoint out at sea, watched by the girl paddling and the girl with a telescope on the left, we are invited to explore a series of carefully interlocking and endlessly varied episodes. Dickens's account of the seaside in 'The Tuggses at Ramsgate' in *Sketches by Boz* (1836) could be a verbal description of Frith's painting. Contemporary reviews show that the public 'read' Frith's paintings like a novel.

Despite contracting typhoid there in 1835, Queen Victoria had happy memories of her childhood visits to Ramsgate which broke the lonely routine of the London schoolroom. There are four other oils by Frith in the Royal Collection,

CLAUDE MONET (1840–1926)
Study of rocks, the Creuse: 'Le Bloc', 1889

The French Impressionist painter Claude Monet's famous series of paintings of the 1890s (of subjects such as haystacks, poplars and Rouen Cathedral) were anticipated by the group of 24 canvases he produced between March and May 1889 while staying in the village of Fresselines in central France. Although the main subject of the series is the nearby confluence of two sources of the river Creuse, this view shows the rocky outcrop that rises above the convergence of the rivers. The uncompromising composition is dominated by the massive rock, whose colours and textures are explored in brilliant sunlight.

Many of Monet's letters survive from his stay at Fresselines. He described the wintry landscape of the area as lugubrious and his promising start to the series was soon interrupted by severe weather. As the season changed, his fears that the appearance of spring greenery would change the colours of his 'sombre and sinister' subjects were well founded. He paid a local landowner to have new leaves removed from an oak tree that was the focus of a group of paintings in order to keep its wintry appearance.

This work, along with 13 others of the same series, was shown at a joint exhibition with Auguste Rodin at Georges Petit's gallery in Paris in June 1889. By 1899 Monet had given it to his friend the statesman Georges Clemenceau, who provided the nickname 'Le Bloc' (The Rock), the title of his later political journal. It is one of a small but important group of modern paintings acquired by The Queen Mother, including work by Henri Fantin-Latour, Walter Sickert and Paul Nash.

Oil on canvas; 72.4 × 91.4 cm
Signed and dated *Claude Monet 89*
RCIN 409201
Purchased by Queen Elizabeth The Queen Mother

including *The Marriage of the Prince of Wales, Windsor, 10 March 1863* (RCIN 404545), commissioned by Queen Victoria in 1863.

Oil on canvas; 77.0 × 155.1 cm
Inscribed on the back with the title (*Life at the Seaside*) and the name of the artist
RCIN 405068
Purchased by Queen Victoria

Miniatures

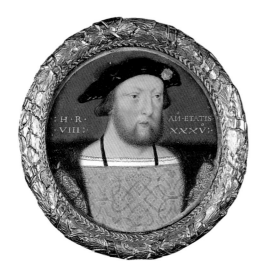

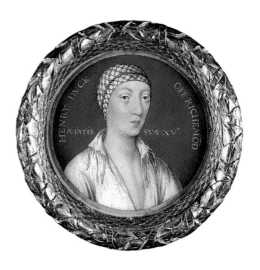

Lucas Horenbout (1490/95?–1544)
Henry VIII, c.1526–27

This is one of the first independent portrait miniatures ever produced. Significantly, the artist came from a successful family of painters and illuminators active in Ghent, but he appears to have reached London by 1524. In the following year he is first mentioned in the accounts of Henry VIII (1491–1547; r. 1509–47). Lucas Horenbout was appointed King's Painter in 1534. The earliest examples of his work coincide with the arrival in London in 1526 of two miniature portraits, probably by Jean Clouet, sent to Henry VIII by Madame d'Alençon, the sister of the French King, Francis I. It is not clear, therefore, whether Clouet or Horenbout should take credit for originating the miniature as an art form.

A number of comparable portraits of Henry VIII by Horenbout have survived, including examples in Cambridge (Fitzwilliam Museum), Paris (Louvre), another in the Royal Collection (RCIN 420010), and one in the collection of the Duke of Buccleuch. Three of them give the King's age as 35. It is not easy to establish an exact sequence for these miniatures, which portray Henry VIII both with and without a beard, as it is known that the King frequently grew a beard and then shaved it off again. Not all of these portraits would have been made from life, but Henry VIII spoke of having personal knowledge of Horenbout and it is likely that the King granted him sittings. Indeed, the high regard in which Horenbout was held is indicated by the fact that he received a larger annual salary than Hans Holbein the Younger.

Watercolour and bodycolour on vellum laid on card; diameter 4.7 cm
Inscribed : *H · R · / · VIII :·* and *· Aᴎ̊ · ETATIS · / · XXXV̊ :·*
RCIN 420640
Presented to Charles I

Lucas Horenbout (1490/95?–1544)
Henry Fitzroy, Duke of Richmond and Somerset, c.1534

The miniature is a typical work by Horenbout, whose style is detectable in the modelling of the features, the prominent shadows under the eyes and mouth, and the form of the inscription seen against a blue background. The sitter is vividly characterised in what is in essence an informal portrait, one of the first in British art. The casual clothes, probably a nightcap and chemise, may be associated with his physical frailty.

Henry Fitzroy, Duke of Richmond and Somerset (1519–1536), was the illegitimate son of Henry VIII by Elizabeth Blount, a lady-in-waiting to Catherine of Aragon. The child was officially acknowledged by the King after the early deaths of the three sons born to the Queen. After his divorce from Catherine of Aragon and his subsequent marriage to Anne Boleyn, Henry VIII's attachment to Henry Fitzroy assumed a greater significance, particularly when his second wife also failed to produce a male heir. Appointed Knight of the Garter and Duke of Richmond and Somerset in 1525, Henry Fitzroy was given several important positions, including that of Lord Lieutenant of Ireland. He was educated by the distinguished classical scholar Richard Croke and spent time at the court of Francis I in France in 1532. It appears that Henry VIII contemplated making Henry Fitzroy his heir, but Fitzroy died prematurely of tuberculosis at the age of 17. It is possible that this portrait was painted at the time of Fitzroy's marriage in 1534 to Mary Howard, daughter of the 3rd Duke of Norfolk, Treasurer of the Household and Earl Marshal.

Watercolour and bodycolour on vellum laid on card; diameter 4.4 cm
Inscribed *HENRY DVCK·OFF RICHEMŌD* and *ÆTATIS SVÆ.XV°*
RCIN 420019
Purchased by Queen Victoria

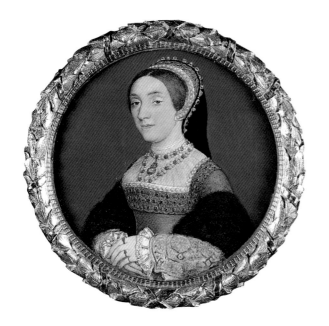

HANS HOLBEIN THE YOUNGER (1497/98–1543)
Portrait of a lady, perhaps Catherine Howard, c.1540

Catherine Howard (c.1521–1542) was the niece of Thomas Howard, 3rd Duke of Norfolk. She was a maid-of-honour to Anne of Cleves, Henry VIII's fourth wife. After Anne's divorce, Catherine married the King on 28 July 1540. Accused of adultery, she was beheaded at the Tower of London on 12 February 1542. The identification of the sitter in this portrait remains tentative, although the autograph version in the collection of the Duke of Buccleuch has been described as a portrait of Catherine Howard since the early 18th century. In the absence of an authentic likeness of Catherine Howard, other evidence has been gathered to support this identification. The necklace and gold jewel with pendant ruby, emerald and pearl also appear in Holbein's portrait of Henry VIII's third wife Jane Seymour (Vienna, Kunsthistorisches Museum) and this, with the richly jewelled bands in the head-dress and around the bodice, may be identified among the King's gifts to Catherine on their marriage.

No more than 20 miniatures by Holbein are known today, of which five are in the Royal Collection. Holbein's activity as a portrait miniaturist commenced during his second visit to England, c.1535. He appears to have been taught by Lucas Horenbout, another foreign artist based at Henry VIII's court, but soon surpassed the skills of his master. In particular, the way in which Holbein modelled interior form with a series of short strokes of colour, as in his portrait drawings (see pp. 223–25), is repeated, with extraordinary precision, on a miniature scale.

Watercolour and bodycolour on vellum laid on playing card;
diameter 6.3 cm
RCIN 422293
Possibly belonged to Charles II

HANS HOLBEIN THE YOUNGER (1497/98–1543)
Henry Brandon, 2nd Duke of Suffolk, 1541

Henry Brandon (1535–1551), here shown at the age of 5, was the elder brother of Charles Brandon whose portrait (aged 3) was also painted in miniature by Holbein (RCIN 422295). It is likely that both miniatures were executed at the same date, although compositionally they seem not to have been conceived as a pair. The details of age and date of birth given in the inscription on the present miniature are not strictly speaking correct, as Henry Brandon was apparently born on either 16 or 18 September 1535. This type of inscription often occurs in Renaissance portraiture, supplying additional information about the sitter. The nonchalant pose is also a Renaissance device, enabling the artist to suggest a sense of spatial recession, as in Titian's *Portrait of a man ('Ariosto')* in the National Gallery, London, or in Holbein's *Portrait of Derich Born* in the Royal Collection (RCIN 405681).

Henry Brandon was the elder son of Charles Brandon, 1st Duke of Suffolk, by his fourth wife, Katherine, daughter of Lord Willoughby d'Eresby. He succeeded his father as Duke of Suffolk in March 1545. Henry and his younger brother were educated with the Prince of Wales (later Edward VI) before being sent at an early age to St John's College, Cambridge. Henry Brandon carried the orb at Edward VI's coronation in 1547, after which both he and his brother were admitted to the Order of the Bath. Both died young (Henry aged 16 and Charles aged 14 or 15), of sweating sickness within half an hour of one another in 1551.

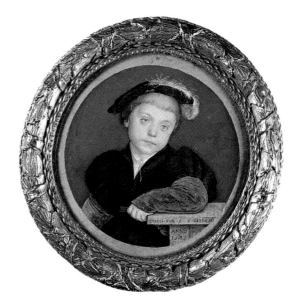

Watercolour and bodycolour on
vellum laid on playing card; diameter 5.6 cm
Inscribed *ETATIS.SVÆ.5.6.SEPDEM. / ANNO. / 1535*
RCIN 422294
Presented to Charles I

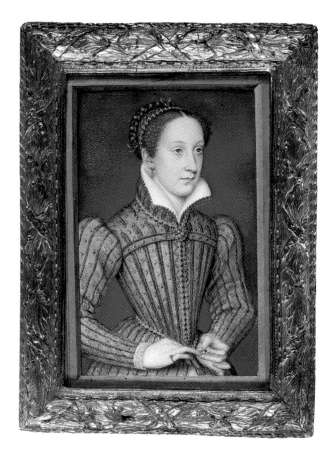

Above:
FRANÇOIS CLOUET (*c.*1520–1572)
Mary, Queen of Scots, 1558

Mary, Queen of Scots (1542–1587; r. 1542–68), the daughter of James V of Scotland and Mary of Guise, is depicted placing a ring on the fourth finger of her right hand. In all probability this portrait refers to her marriage in 1558 to the Dauphin of France, who became Francis II in 1559. After his death in 1560 his widow returned to Scotland. Mary's claim to the English throne led to her confrontation with Elizabeth I, resulting in a long imprisonment and her execution in 1587.

The miniature may be the one shown in private by the English Queen to Mary's ambassador, Sir James Melville, in 1564. It was kept in a small cabinet in the Queen's bedchamber and was wrapped in paper. Subsequently, the portrait belonged to Charles I, who had it mounted in a frame of eight miniatures of his forebears. There is no finer example of the qualities of the miniature as an art form, through its draughtsmanship, the private nature of the object and its historical associations.

Court painter to a succession of French kings, François Clouet provided a wonderful visual record of the leading personalities of the French court, comparable with the achievement of Hans Holbein the Younger at the court of Henry VIII.

Below:
NICHOLAS HILLIARD (1547–1619)
*Elizabeth I, c.*1595–1600

The full range of Hilliard's capabilities as an artist is evident in his portraits of Elizabeth I (1533–1603; r. 1558–1603). Although in favour at court from the 1570s, Hilliard only began to receive an annuity in 1599. There are a large number of images of Elizabeth I painted or designed by Hilliard in a variety of media. Indeed, Hilliard was given responsibility for the personal iconography of the Queen, of which he came to hold a virtual monopoly. The earliest miniature dates from 1572 (London, National Portrait Gallery) when the artist was still allowed to portray Elizabeth I as she appeared in life. In his *Treatise concerning the Arte of Limning* (*c.*1600) Hilliard describes such sittings; his text reveals much about the technique of miniature painting and his good relationship with the Queen.

Hilliard was also asked to devise a standard likeness of the Queen as she grew older. To counteract the growing realism with which younger painters had begun to depict Elizabeth I's ageing features, Hilliard created from 1595 the 'Mask of Youth' image, in which he adhered rigidly to one set of the Queen's features, with no hint of her increasing age. Sixteen or so miniatures of this type, including this one, are known. These idealised portraits were often set into medallions or jewels intended to be given away by the Queen. The counterpart to this kind of portraiture was the literary creation of the 'Virgin Queen', in which reference is made to arcane symbolism. The result made the Queen into an icon.

Above left:
Watercolour and bodycolour
on vellum rebacked with card;
8.3 × 5.7 cm
RCIN 401229
Possibly belonged to Elizabeth I

Above:
Watercolour and bodycolour
on vellum laid on card;
oval, 5.4 × 4.5 cm
RCIN 421029
Purchased by King George V

Isaac Oliver (*c.*1565–1617)
*Portrait of a young man, c.*1590–95

One of the finest miniatures in Oliver's oeuvre and one of the most famous images in British art, his *Portrait of a young man* reveals the artist elaborating on the full-length format first developed by Hilliard in the 1580s. The increased dimensions and the inclusion of the full-length figure extended the possibilities of the portrait miniature by allowing for the depiction of a detailed background and the introduction of a narrative element. Oliver always demonstrated particular skill in placing the figure in its setting and this miniature is in many respects comparable with Hilliard's *Young man among roses* of *c.*1585–95 (London, Victoria and Albert Museum). Both miniatures have been variously interpreted, but in each case the identification of the sitter has remained elusive. The suggestion made by Horace Walpole in the 18th century that the youth in this miniature may be identified with Sir Philip Sidney (1554–1586), soldier, statesman and poet, at Wilton House in Wiltshire while composing his poem *Arcadia*, cannot be sustained. It is now known that the background is based on an engraving in the architectural pattern book, *Artis Perspectivae ... multigenis Fontibus Liber Primus*, by Hans Vredeman de Vries (1568). Oliver has added to the narrative content by introducing two figures walking in the garden. The pattern book by Vredeman de Vries may not have been widely known to artists in late 16th-century Britain, but a copy apparently belonged to Marcus Gheeraedts the Elder – whose daughter, Sara, Oliver was to marry in 1602.

Apart from the identification of the figures and setting, *Portrait of a young man* has also been discussed in the context of the 'Elizabethan Malady', as analysed in Robert Burton's *Anatomy of Melancholy* (1621). Characterised as a state of mind associated with creativity that veered towards low spirits (or in today's parlance, depression) and the

yearning for isolation, melancholy was much affected by the aristocracy. However, apart from the distant forlorn expression and the discarded glove, other attributes of melancholy such as dishevelment are not portrayed here, and for the moment the *Portrait of a young man* retains its mystery.

Oliver learnt his art as a pupil of Hilliard in the 1570s and although he pre-deceased his master, he was keenly patronised at the newly established Stuart court. He was appointed Limner to Queen Anne of Denmark in 1605 and Painter to Henry, Prince of Wales

(see p. 64), whose funeral he attended in 1612.

Isaac Oliver was an important catalyst in Britain's adoption of the advances made on the Continent during the Renaissance, both as regards his technique and his knowledge of European – mainly Mannerist – art.

Watercolour and bodycolour on vellum laid on card; 12.4 × 8.9 cm
Signed on right *IO* (in monogram)
RCIN 420639
Purchased by Frederick, Prince of Wales

Watercolour and bodycolour on vellum
laid on card; 13.2 × 10.0 cm
RCIN 420058
Acquired by George IV when Prince of Wales

ISAAC OLIVER (c.1565–1617)
Henry, Prince of Wales, c.1610–12

Henry, Prince of Wales (1594–1612), was the eldest child of James VI of Scotland and Anne of Denmark. On the death of Queen Elizabeth I in 1603 he travelled south to London with his father, who succeeded to the English throne as James I, the first monarch of the Stuart dynasty. In July of the same year he was invested with the Order of the Garter; he is shown wearing the blue ribbon and badge of the Order in the majority of his portraits, including this miniature.

Hilliard made a number of miniatures of Henry, Prince of Wales; there are three others in the Royal Collection. This miniature was described by Van der Doort in the collection of the sitter's younger brother, Charles I, as 'the biggest lim'd picture that was made', and is indeed the principal – and largest – portrait of the Prince in this medium. It is one of Oliver's

outstanding works. The conjunction of sitter and artist symbolises an important moment in British art. Prince Henry, as a keen young patron, collected Netherlandish and Italian paintings and sculpture, as well as coins, medals and books. After his death, aged only 18, his funeral was in itself a cultural spectacle.

The sitter wears a suit of gilt armour (c.1570) with embossed ornament notable for its classicising motifs. Set against a curtain behind the figure on the right is a military encampment with soldiers and an artillery piece. The significance of this miniature becomes apparent when it is appreciated that Prince Henry himself took part in tournaments and masques. One such example was the *Barriers* devised by Ben Jonson and designed by Inigo Jones. This was performed on Twelfth Night 1610, in the Banqueting House at Whitehall.

JOHN HOSKINS (c.1590–1665)
Queen Henrietta Maria, c.1632

John Hoskins holds a pivotal position in the history of the miniature. His early output refers back to Nicholas Hilliard and Isaac Oliver, while his pupil and nephew Samuel Cooper gained a European reputation for his own work. Hoskins was trained as a portrait painter in oils, but he seems to have specialised in miniatures from early in his career. He rose to prominence at the court of Charles I, who appointed him King's Limner in 1640. Van der Doort listed nine limnings by Hoskins in Charles I's collection. There are 11 miniatures by Hoskins in the Royal Collection today, two of which were in Charles I's collection.

The miniatures of Queen Henrietta Maria (1609–1669) and of Charles I (RCIN 420060) by Hoskins add considerably to their personal iconography. This example, one of four recorded in Charles I's collection by Van der Doort, was made from life and is independent of the Queen's portraiture as devised by Van Dyck. The Queen's costume may be the 'blue dress with spangled stars' that she wore for the masque *Tempe Restor'd*, performed at Whitehall Palace on Twelfth Night in 1632.

Henrietta Maria was the daughter of Henry IV of France and Marie de' Medici; she married Charles I in 1625. At the time of the Civil War, Henrietta Maria fled to France, but at the Restoration she returned to London and lived in Somerset House for a short time. She died in France at Colombes.

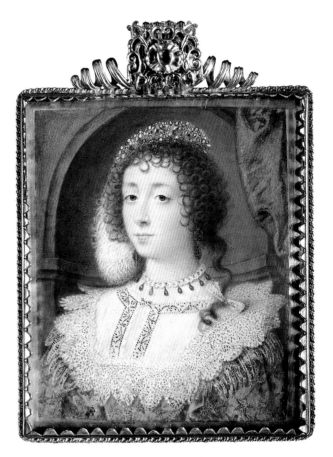

Watercolour and bodycolour on vellum; 8.9 × 7.6 cm
RCIN 420891
Purchased by HM The Queen

Watercolour and bodycolour on vellum laid on card; oval, 8.0 × 6.5 cm
Signed at left (in monogram) and dated *1661*
RCIN 420088
Royal Collection by *c.*1837

SAMUEL COOPER (1608?–1672)
Barbara Villiers, Duchess of Cleveland, 1661

Cooper was a miniaturist of supreme quality, notable for his breadth of handling and his remarkable characterisation. There are 18 autograph portraits by Cooper in the Royal Collection, and two drawings. After being trained by his uncle John Hoskins, Cooper established his own studio as the Civil War was starting. After the Restoration he was appointed King's Limner by Charles II.

In this miniature the tonal qualities of the pale flesh and the white silk dress, offset by the dark hair and the blue ground, show Cooper at his best. The direct gaze of the sitter, the oval face with the hint of a somewhat pendulous jaw, the sensuous mouth and the décolletage, leave the viewer in no doubt about the charms of the Duchess of Cleveland (1641–1709), the most celebrated and politically influential of the beauties at Charles II's court. She had become the King's mistress in 1660 and had six of his children before being created Duchess of Cleveland in 1670.

SCULPTURE

Of the 1,400 pieces of sculpture in the Royal Collection, the earliest is the terracotta head of a laughing boy of *c.*1498 by Guido Mazzoni (p. 68). Like the paintings, the sculptures can be divided into pieces that were commissioned – the largest group, including portraits, funerary monuments, architectural sculpture and coinage patterns – or purchased as Old Masters.

Royal commissions have often provided the impetus for technical developments in British sculpture (in bronze casting, for example, through the employment of Torrigiano and Hubert Le Sueur), and have helped foreign artists to gain a footing in this country.

Both Henry VIII and Charles I imported antique statues and casts into England, but none of these seems to have survived. As in so many other fields, the collection of sculpture was greatly enriched by the acquisitions made by George IV. His purchases included 70 French bronze statuettes and groups of the 18th century. George IV's taste for martial portraiture led to the acquisition in 1825 of the group of three magnificent bronze busts by Leone Leoni (see p. 69) and what is thought to be the only bronze portrait bust by Massimiliano Soldani-Benzi (RCIN 1146). A set of reliefs of the *Four Seasons* (RCIN 21932), also by Soldani, was joined in George IV's collection by one of the supreme masterpieces of this genre, Adriaen de Vries's *Rudolph II leading the Arts into Bohemia* (see p. 71), which came from the imperial collection at Prague. George IV probably also acquired the two-figure group by De Vries, *Theseus and Antiope* (p. 70).

The Royal Collection contains very few bronze statuettes of the Italian Renaissance. Charles I possessed 18 small bronzes cast by Pietro Tacca from models by Giambologna and in 1627 and 1628 he acquired with the Gonzaga collection a number of bronzes made for the Duke of Mantua by Antico. These and others were sold in the Commonwealth sales of 1649–51, and

nothing comparable has since entered the collection.

British monarchs have often looked to Rome, not only as the source of antique sculpture but for work by the best contemporary artists. Thus in 1636 Charles I commissioned from Gianlorenzo Bernini the portrait for which Van Dyck supplied the famous triple likeness of the King. George IV, who eventually bought the Van Dyck portrait for the Royal Collection in 1822, also turned to the greatest Roman sculptor of his time, Antonio Canova, for large-scale marble statues. Although he was thwarted in his attempts to secure an example of the *Three Graces*, he acquired three other works (see pp. 74, 75).

Sculpture had a special appeal for Queen Victoria and her husband, Prince Albert. Together they took a close interest in the career of John Gibson (1790–1866) and the British sculptors working in his circle in Rome. Prince Albert also showed a keen interest in the work of German and Austro-Hungarian sculptors. Of the sculptors patronised by Queen Victoria and Prince Albert, those best represented in the Royal Collection today are Sir Joseph Edgar Boehm (1834–1890; 87 works) and Mary Thornycroft (1814–1895; 50 works), whose father John Francis (1780–1861) instructed Prince Albert in modelling.

When the future King Edward VII visited Rome at the age of 18 in 1859, he was led round the sculptors' studios by the elderly John Gibson. The Prince purchased works from the American sculptress Harriet Hosmer (1830–1908) and from Lawrence Macdonald, and continued to add to his collection for the next 50 years. In view of King Edward VII's sporting interests it is perhaps not surprising that a large group of 19th- and early 20th-century equestrian bronzes, by artists such as Adrian Jones and J. Willis Goode, entered the collection during his reign. These have been joined by further horse bronzes in subsequent reigns, which have also seen the addition of portrait sculpture by Arthur Walker, Gilbert Ledward, Oscar Nemon and Franta Belsky.

Details: Antonio Canova, Dirce, 1820–24 (see p. 75)

GUIDO MAZZONI (d. 1518)
Laughing child, possibly Henry VIII, c.1498

This fragile bust seems to have remained
in the Royal Collection since it was made.
In 1925 Lionel Cust, Surveyor of the
King's Pictures and Works of Art,
attributed the bust to the Modenese
sculptor Guido Mazzoni, also known as
Paganino. Mazzoni's surviving work
consists of life-size painted terracottas of
the same strikingly realistic character and
a high degree of technical proficiency,
fully evident here. The bust was formed
of clay pressed into a mould to a
maximum thickness of 5 mm, and the
boy's open mouth, ears and nostrils
served to allow steam to escape during
firing. Paint analysis carried out in 1964
and from 1985 to 1988, when the bust
was cleaned, revealed the original
scheme in the tunic – a green glaze over
an incised layer of tin foil, perhaps
intended to imitate cloth of gold. It is not
clear whether Mazzoni came to London,
and no commission for the bust has been
found. Its identification as Prince Henry
is conjectural, supported by its royal
provenance and by the child's age.

Painted and gilded terracotta; 31.8 cm high
RCIN 73197
Possibly commissioned by, or presented to,
Henry VII

LEONE LEONI (1509–1590)
Philip II, King of Spain, c.1554–56

While the Emperor Charles V often
travelled across Europe with his imperial
court, almost continuously engaged in
war, his only son and successor, Philip II
(1527–1598; r. 1556–97), remained firmly
in Spain, at the palace of the Escorial,
where Leone Leoni's son Pompeo was
occupied with large-scale commissions,
including altar and tomb sculptures.

This bronze, which can be dated fairly
precisely on the evidence of its inscrip-
tion, was one of three ordered from Leone
Leoni by the Duke of Alba. It must have
been made between 1554, when Philip
married the English Queen Mary (Tudor)
at Winchester, and 1556, when he
succeeded his father on the Spanish
throne. Despite the title *Rex Angliae*
(King of England), he is shown wearing
the Habsburg Order of the Golden Fleece
rather than that of the Garter, of which
both he and his father were members.

This bronze differs from Leoni's
other productions in the technique of the
arabesque decoration to the armour.
Here and on the bust of the Duke of Alba
(RCIN 35337) one side of the breastplate
is etched with simple linear scrolling
foliage, while on the other side the back-
ground has been much more extensively
etched. This difference is not seen on the
bust of Charles V (RCIN 35325), which is
also the only one of the three in which
the sitter is looking directly forward.
This suggests an attempt on the sculptor's
part to emphasise the orientation of the
other two heads by creating a sense of
directional light falling on the armour.
A more elaborate explanation might lie
in the intended placing of the three busts
in the Duke of Alba's gallery; precedence
would certainly dictate that the Emperor
be given pride of place at one end, while
his son and the Duke looked across at
him from a side wall.

Bronze; 88.9 cm high
Inscribed *PHI. REX. ANGL. ETC.*
RCIN 35323
Purchased by George IV

Adriaen de Vries (1556–1626)
Theseus and Antiope, c.1600–01

The Dutch-born sculptor Adriaen de Vries was trained in the workshop of the great Florentine master Giovanni Bologna (Giambologna; 1529–1608) and travelled between several of the major courts of Europe. His best-known works were the colossal outdoor groups and fountains in Augsburg, Prague and Frederiksborg in Denmark. Many of his compositions share the elongated proportions and sense of upward movement that are strongly evident in this work.

From Giambologna onwards, subjects involving male figures carrying off females were regarded as particularly suitable for contrasting types of figures which could be viewed in the round. The identity of these two is by no means certain, but they are generally thought to represent Theseus, legendary King of Athens, abducting Antiope, Queen of the Amazons. This subject epitomises the battle of the sexes, although in this case the conflict ended unusually harmoniously in marriage. De Vries used an almost identical composition in his more widely known and repeated group of *Hercules, Nessus and Deianira* of 1603–08 (Paris, Louvre), where the space between the male figure's legs is occupied by the defeated centaur, Nessus, instead of the stunted plant included here. This element, contrasting with high finish of the figures, clearly played a part in the casting of the group, upside down and in one 'pour' from the original wax model; the plant would have served as a vent to allow air to escape as the molten bronze entered the mould.

The attribution of the *Theseus and Antiope* group to De Vries was strengthened by detailed scientific examination of the bronze (including X-ray photography) in preparation for the major exhibition of the sculptor's work held from 1998 to 2000. Nevertheless, it remains unclear precisely when the group was made and for whom.

Bronze; 95.0 cm high
Signed (cast in the bronze in the base)
AF in monogram
RCIN 57961
Probably acquired by George IV

Adriaen de Vries (1556–1626)

Emperor Rudolf II leading the Arts into Bohemia, 1609

Rudolf II (1552–1612; r. 1575–1612) rides in triumph into his kingdom of Bohemia, leading a procession of figures representing the arts. With his muscular torso turned to his right, he looks down at three nude female figures with arms entwined, representing the arts of Painting (who carries a palette and brushes), Architecture (with a T-square) and Sculpture (with a hammer and a statuette), the first of whom reaches out with her right hand to touch his. On the left side of the composition are further female figures representing Music, Astronomy and Philosophy. Under the horse's rearing forelegs is a contorted, nude female figure with ass's ears representing Ignorance.

In this superb mature work, De Vries shows his mastery of relief composition. Although it was once thought that the work might have decorated the plinth of a statue, it seems always to have been intended as an independent work of art, a metallic picture. Unlike a painter, who can command the light to shine where he will, a relief sculptor must ensure that the most important part of the composition – in this case the Emperor – is placed so as to catch the most of what light is available from outside. Every available technique, from engraving to modelling in the round, was put at the service of convincing perspective and the suggestion of spatial depth.

The relief commemorates Rudolf's edict of 1595 affording Painting the status of a free or liberal art. Thus the Emperor, like Paris awarding the apple, reaches down to take the hand of Painting. Yet there is a twist: De Vries has created a pictorial masterpiece in bronze, tacitly undermining the very proposition that he was ordered to portray.

Bronze; 60.0 × 85.8 cm
RCIN 35858
Purchased by George IV

François Girardon (1628–1715)
The Abduction of Proserpina by Pluto, c.1700–10

François Girardon was the pre-eminent sculptor of the reign of Louis XIV. His best-known works are the colossal bronze equestrian statue of the King, cast in 1692 for the Place Louis-le-Grand (Place Vendôme) in Paris, and those which formed part of the *Grande Commande* of 1674 for 24 statues to ornament the gardens of Versailles. His marble statue of *The Abduction of Proserpina* was one of four groups of similar subjects intended to represent the four elements at the four corners of the Parterre d'Eau and designed to be seen from the front. The choice of subjects was an invitation to the French sculptors to surpass the famous two- and three-figure groups of Giambologna and Bernini. Girardon's group, which was completed in 1699, was the most direct challenge to Bernini, whose 1622 version of the same subject (Rome, Villa Borghese) he no doubt knew at first hand.

Girardon's marble was reproduced as a small bronze from the late 17th century onwards. Many examples, measuring about 53 cm high, were made during the 18th century as *bronzes d'ameublement* for fashionable apartments; the Royal Collection also includes one such small bronze (RCIN 2172). The present bronze is one of only six known casts of a larger size, which probably derive from his small model for the marble group. Some of these larger bronzes were cast in 1693.

The subject is taken from Book V of Ovid's *Metamorphoses*. Pluto, having risen from his underground realm to inspect the damage caused by an earthquake in Sicily, is struck by Cupid's dart and compelled to carry the nymph Proserpina (Persephone) back to the underworld. The third figure is probably Cyane, another nymph who attempted to resist Pluto; she was transformed into a river, dissolved by her own tears. George IV acquired a few bronze statuettes of this subject. This is probably the one which arrived at Carlton House in May 1811.

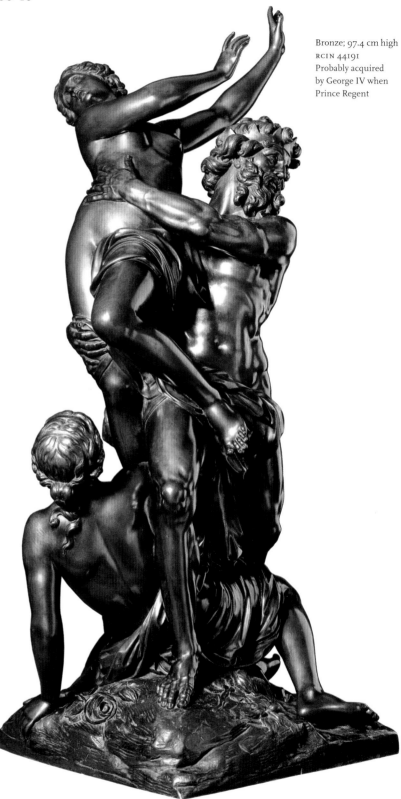

Bronze; 97.4 cm high
RCIN 44191
Probably acquired
by George IV when
Prince Regent

Marble and gilt bronze;
45.0 × 55.5 × 22.5 cm
Signed on an inset gilt
bronze plaque
*IOACH. ET PETR.
BELLI. ROM. F.F. /
PETR. SANCTES
AMMENDOLA ROM. /
I. ET. F. I. A.D.
MDCCCXV.*
RCIN 43918
Purchased by George IV
when Prince Regent

IMP . CAES. FL CONSTANTINO MAXIMO
P . F . AVGVSTO S . P . Q . R
QVOD INSTINCTV DIVINITATIS MENTIS
MAGNITVDINE CVM EXERCITV SVO
TAM DE TYRANNO QVAM DE OMNI EIVS
FACTIONE VNO TEMPORE IVSTIS
REMPVBLICAM VLTVS EST ARMIS
ARCVM TRIVMPHIS INSIGNEM DICAVIT

GIOVACCHINO BELLI (1756–1822) and PIETRO BELLI (1780–1828)
Model of the Arch of Constantine, 1808–15

George IV never experienced what had become a standard
component of the education of English gentlemen of his
generation, the Grand Tour to Italy, which usually culminated in
Rome. Here, in the Forum, visitors were shown the three partly
ruined triumphal arches set up in honour of the Emperors
Constantine, Titus and Septimius Severus. Models of the arches
in their semi-ruined condition (often effectively imitated in cork)
were some of the souvenirs with which the tourists returned to
England. However, this model – one of three acquired by
George IV – is an accurate reconstruction, complete with figura-
tive sculpture, of the original form of the Arch of Constantine,
built in AD 312.

The three models were made under the auspices of the
Roman Academy of St Luke by the silversmiths Giovacchino

Belli and his son Pietro. Pietro Santi Ammendola, who also
signed all three arches, was a Roman merchant who probably
financed the Bellis during their seven-year task.

George IV bought the three models from Ammendola for
500 guineas in November 1816. The arches were placed on
Boulle pedestals in the window reveals of the library at Carlton
House. Certain repairs to the metalwork were undertaken
by Charles Brandt in January 1818, and later the same year
B.L. Vulliamy replaced some of the ornaments, apparently in
silver gilt, and made glass covers for the three arches. After the
demolition of Carlton House in 1826 the models were taken
to Buckingham Palace. Following their transfer to Windsor
Castle, they were recorded by Joseph Nash in the Grand Corridor
(see p. 76).

Antonio Canova (1757–1822)
Fountain Nymph (Ninfa delle fontane), 1815–17

For much of the last seven years of his life, Canova was busy fulfilling the orders which resulted from his visit to London in 1815. There he had been fêted not only as the greatest sculptor of the age, but also for his official role in supervising the return from Paris to Rome of antiquities carried off by Napoleon (see p. 56). During the visit Canova was received at Windsor Castle by Queen Charlotte and the royal princesses, and at Carlton House by the future George IV, who commissioned the colossal group of *Mars and Venus* (RCIN 2038) and presented the sculptor with a gold snuff box containing £500.

The *Fountain Nymph* originated in a request made to Canova by John Campbell, 1st Baron Cawdor, as early as 1802. Campbell, who had travelled extensively in Italy, was Canova's first yet least successful British patron; two of his commissions – including the *Cupid and Psyche* (Paris, Louvre) – were pre-empted by Napoleon's brother-in-law, Joachim Murat. In 1815, after the completion of a full-size model for the *Fountain Nymph* (Gipsoteca Canoviana at Possagno),

Canova agreed to the request of Sir Charles Long (later Lord Farnborough), the Prince Regent's artistic adviser, to carve the first marble for the Prince. A drawing was sent to London in June 1816, and in August Long conveyed the Prince's approval. By that time, work was already under way; when Lady Murray visited Canova's studio on 25 July she found him at work on the nymph. The group was completed in 1817 and shipped to Portsmouth on the vessel that carried the Duke of Bedford's version of Canova's *Three Graces*.

Arriving at Carlton House on 12 June 1819, it was installed in the unlikely setting of the Gothic Conservatory by the English sculptor Richard Westmacott, who subsequently received written instructions from Canova on how it should be positioned and lit. The plinth was to be 2 feet [60 cm] high, and capable of rotating so that the sculpture could be seen from all sides. It should be lit from above. The 'large brass guard ornamented with spikes' that was erected to surround it may have proved necessary in the light of the *fêtes* regularly held at

Carlton House, when it must have been the focus of much attention.

The subject, a naiad lying on a lion's pelt beside a spring, awakened by the sound of a lyre plucked by Cupid, is described in the *Dionysiaca* by the Greek poet Nonnus, but the composition is more likely to have occurred to Canova from the adaptation of antique models such as the Capitoline *Hermaphrodite*. A second version of the group (New York, Metropolitan Museum of Art), lacking the Cupid, was commissioned by Lord Darnley for Cobham Hall in Kent. The marble for that version was found to be faulty; it was completed by studio assistants in 1824, two years after Canova's death. There are several parallels with Canova's notorious *Venere vincitrice* of 1805–08 (Rome, Villa Borghese), in which Pauline Borghese is portrayed as Venus. The musical Cupid assumed a career of its own in the 19th century through copies by Canova's assistant Leandro Biglioschi and by Bertel Thorwaldsen.

Marble; 81.0 × 182.0 × 81.0 cm
RCIN 2039
Commissioned by George IV
when Prince Regent

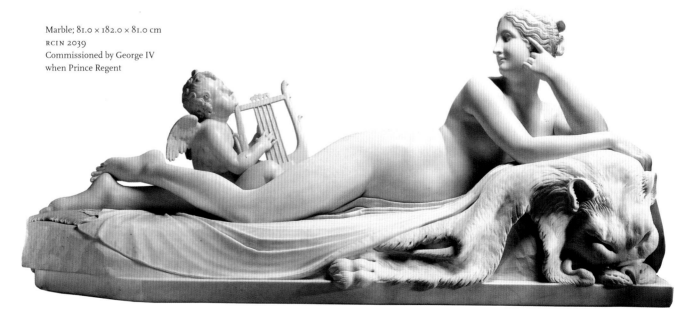

Antonio Canova (1757–1822)
Dirce, 1820–24

The presence of a second nymph by Canova in the Royal Collection testifies to the sculptor's talent for promoting sales of his work to established clients. Having commissioned the colossal group of *Mars and Venus* and pre-empted Lord Cawdor in the purchase of the *Ninfa delle fontane* (see p. 74), George IV remained anxious to secure a version of the *Three Graces* for the centre of the Circular Room at Carlton House. In February 1820 Canova wrote to offer the present nymph – *Dirce, nutrice di Bacco* – which he had just completed in plaster at full size, as a companion for the *Ninfa*, which had been installed at Carlton House the previous June. The subject, Dirce, was one of the nymphs of Mount Nysa who nurtured the infant Bacchus. Sir Charles Long replied with enthusiasm on the King's behalf and the marble seems to have been roughed out by 16 December.

Although the statue was engraved (with a dedication to Sir Thomas Lawrence) in 1822, only the head seems to have been finished at the time of Canova's death the same year; the rest was completed by the studio assistant Cincinnato Baruzzi.

In a letter to the sculptor, Lawrence described the plaster model (which he had seen in Rome) as 'the most perfect of your productions'. However, the turn of the head creates such an awkwardness in the pose of the figure as she leans weightlessly against a draped beehive that it suffers by comparison with the true touchstone among Canova's reclining nudes, the Borghese *Venere vincitrice*. The completed sculpture was sent to England in 1824 with the *Mars and Venus*, and installed at Carlton House by Westmacott. In August 1825 William Richard Hamilton, the former British Minister at Naples who had played a leading part in the post-war negotiations over the return of looted ancient sculpture to Rome, wrote to Sir Charles Long on behalf of the Abbate Canova, the sculptor's brother and executor, accepting (without complete satisfaction) the offer of 5,000 guineas in payment for the two groups delivered in the previous year. Hamilton wrote that the Abbate was none the less 'highly flattered that these his brother's latest finished works, should be deposited in the palace of the King of Great Britain, to whom he considers himself, as his brother did during his lifetime, so mainly indebted for the halo of glory which shed fresh lustre over Canova's last days'.

See details on pp. 66–67

Marble; 96.0 × 175.0 × 78.0 cm
RCIN 2042
Commissioned by George IV

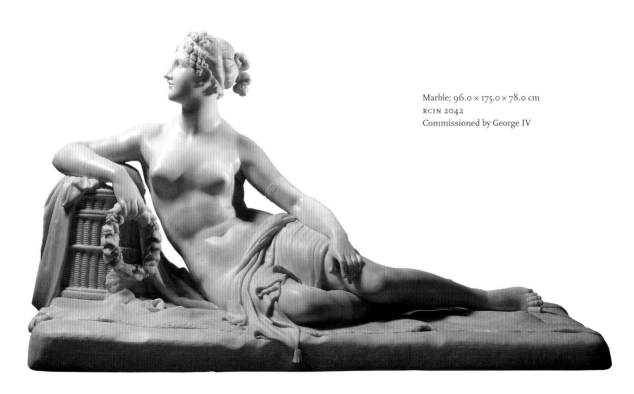

Sir Francis Chantrey (1781–1841)
George IV, 1826

This famous image originated in 1821, the year of the coronation of George IV (1762–1830; r. 1820–30). With Sir Thomas Lawrence's full-length portraits in oils it established the King's 'official' likeness in his ten-year reign. It epitomises Chantrey's ability to idealise without losing a resemblance. The King appears lofty and amiable, cloaked as an ancient field-marshal, but wearing one of his own curled brown wigs. In Chantrey's opinion the King 'had a very fine throat without the great dewlaps which he gives himself by tying up his neckcloth so tightly'.

Fifteen other marble versions of the bust are known, of which two are also in the Royal Collection (RCIN 31617, dated 1828; and RCIN 2010, dated 1837). Miniature replicas were made in bronze and silver-gilt by Rundell, Bridge & Rundell. The medallist Alfred Stothard copied it for his standard profile relief of the King. Engravings of the bust were published by S.W. Reynolds in 1823, and Chantrey was portrayed in the act of carving it in Andrew Robertson's miniature dated 1831 (RCIN 420823). Chantrey's ledger records an order for two marble busts from the King, both received at Carlton House in April 1822. One of these was presented to Lady Conyngham and remains in the possession of her descendants. The other, exhibited at the Royal Academy, is no longer in the Royal Collection. The present bust was commissioned by the King in 1825 as a gift to his brother Frederick, Duke of York, but it was not ready until after the Duke's death in 1827. It was given instead to his one-time secretary, Lieutenant-General Sir Herbert Taylor, and appears to have been presented to Queen Victoria by his widow.

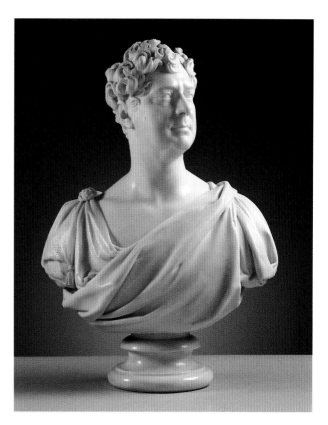

Marble; 69.0 cm high
Inscribed *CHANTREY . SC . 1826 / THIS BUST INTENDED TO HAVE BEEN PRESENTED BY KING GEORGE / THE FOURTH TO HIS LATE BELOVED BROTHER THE DUKE OF / YORK WAS MOST GRACIOUSLY GIVEN BY HIS MAJESTY TO / SIR HERBERT TAYLOR ON THE 23D. OF APRIL 1827*
RCIN 2136
Commissioned by George IV

Joseph Nash (1808–1878)

The east section of the Grand Corridor at Windsor Castle, 1846

Watercolour and bodycolour with touches of gum arabic over pencil
32.5 × 41.4 cm
Signed and dated *Joseph Nash 1846*
RL 19783

SIR FRANCIS CHANTREY (1781–1841)
Queen Victoria, 1839

It was Chantrey's distinction to portray four successive
sovereigns during their lifetimes. Queen Victoria (1819–1901;
r. 1837–1901) declared her intention of sitting to him on
14 October 1838, when she was still only 19. Despite his great
experience, the sculptor was daunted by the Queen's tender age
and the need to give the portrait a proper sense of majesty. There
were seven sittings in all, concluding on 1 February 1840 when
Chantrey made the finishing touches to the marble. Two of his
initial pencil studies of the Queen are in the National Portrait
Gallery, London, and the plaster model is in the Ashmolean
Museum, Oxford. The resulting bust, probably the last that
Chantrey touched with his own chisel, became widely known
through reproduction on coins and medals, and in a miniature
bronze version published by the Art Union in 1848. It was
shown in the Grand Corridor in 1846 (see opposite). Further
versions were ordered by Queen Victoria for her father-in-law
(now in the Fürstenbau in the Veste Coburg) and for Sir Robert
Peel (now London, National Portrait Gallery).

Marble; 58.4 cm high
Inscribed *SIR F. CHANTREY, SCULPTOR, 1839*
RCIN 31618
Commissioned by Queen Victoria

CARLO, BARON MAROCHETTI (1805–1867)
Prince Albert, 1849

This was the first of fifteen works acquired or commissioned
from the Piedmontese sculptor Carlo Marochetti by Queen
Victoria and Prince Albert (1819–1861). Marochetti had studied
in Paris and Rome before settling in England in 1848, at the same
time as his former patron, the recently deposed French King
Louis-Philippe. It was largely due to the close links between the
French and English royal families that Marochetti soon became
the favourite sculptor of the Queen and Prince Albert. After the
Prince Consort's sudden death in 1861 it was Marochetti who
was asked to carve his marble effigy – and that of the Queen
(installed 40 years later) – for the Royal Mausoleum at Frogmore.
The Baron's privileged position created resentment among
British-born sculptors.

In July 1848 the Queen recorded in her Journal that the
likeness was 'extremely successful'. Completed in marble the
following year, it was later reproduced in miniature, both in
bronze and in Minton's Parian ware.

Marble; 74.5 cm high
Inscribed *C. Marochetti 1849*
RCIN 31628
Commissioned by Prince Albert
as a gift for Queen Victoria

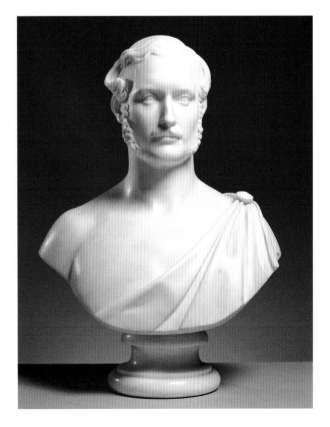

FURNITURE

The furniture in the Royal Collection falls into two groups: English and Continental. The English furniture, much the larger of the two, runs to many thousands of pieces spread among more than a dozen residences. Nearly all of it was commissioned or acquired for a specific purpose or function and for a particular context, as and when, in an unceasing cycle, royal residences were either acquired, extended, destroyed or rebuilt. As a direct consequence of these changes, the Master of the Great Wardrobe (the Lord Chamberlain from 1782) regularly had to supply new furniture, ranging from the grandest parade furniture for state rooms to the most ordinary domestic equipment such as bell-pulls. Thanks to the continuity of royal ownership, furnishings from the different residences have remained in the collection, even in periods of great social and political change.

The roll-call of cabinet-makers, clock-makers, tapestry-makers, upholsterers and other suppliers, both to the Great Wardrobe and to individual members of the royal family, includes many distinguished names. Some, such as the Huguenot Pelletier family (p. 82), the mysterious John Carrack with his immigrant connections (p. 86) and the Frenchman Nicholas Morel (p. 93), were responsible for introducing the latest continental fashions to their royal patrons. Others, such as the cabinet-makers James Moore (p. 85), Benjamin Goodison, William Vile, John Cobb and John Bradburn, provided outstandingly well-made objects in the more conservative tastes of the period.

Occasionally a specific royal interest in a particular area, such as that shown by William III and George III in barometers and clocks (pp. 82, 85, 92), brought innovation in design, materials or technology to the collection. Equally, important family events sometimes generated the need for something out of the ordinary: Queen Charlotte's spectacular ivory-inlaid jewel-cabinet (RCIN 35487) made in 1762, soon after the King

and Queen's marriage, was a significant exception to the general rule of brown furniture. On the whole, however, the vast majority of English furniture made for the court was relatively functional.

In contrast to his father George III, who preferred elegance, practicality and simplicity to ostentation, George IV, whose principal interest lay in French furniture, liked high fashion, rich style and constant change. He brought a fresh approach to furnishing royal palaces, mixing old and new furniture – English neo-classical with contemporary French and new pieces from firms such as Morel & Seddon (p. 93). Like Charles II, George IV surrounded himself with French craftsmen and designers, creating a series of interiors that were widely regarded as some of the most handsome in Europe.

He had wide-ranging tastes, encompassing 18th- and 19th-century Boulle marquetry (pp. 96, 99), furniture of either date mounted with porcelain or pietra dura plaques (p. 100), and, ahead of his contemporaries, elaborate rococo furniture. Blessed with a good eye, he also depended on his advisers to take advantage of the riches flooding onto the art market after the revolutionary and Napoleonic upheavals on the Continent, including masterpieces originally made for the French royal family (pp. 102, 103). In terms of both quantity and quality of acquisitions, no subsequent monarch could hope to match the riches that George IV added to the collection.

By contrast, Queen Victoria and Prince Albert generally preferred an unadorned style for new furniture in their private residences, Osborne House on the Isle of Wight and Balmoral Castle in Scotland. Occasionally, an important event was commemorated by an exceptional commission (p. 94).

The first member of the Royal Family to take a specific interest in English furniture, Queen Mary (consort of King George V) made some notable additions to the collection. She also spent much time recording provenances, thus laying the foundations for modern research on the furniture collection.

Details: Jean-Henri Riesener, jewel-cabinet, c.1787 (see p. 103)

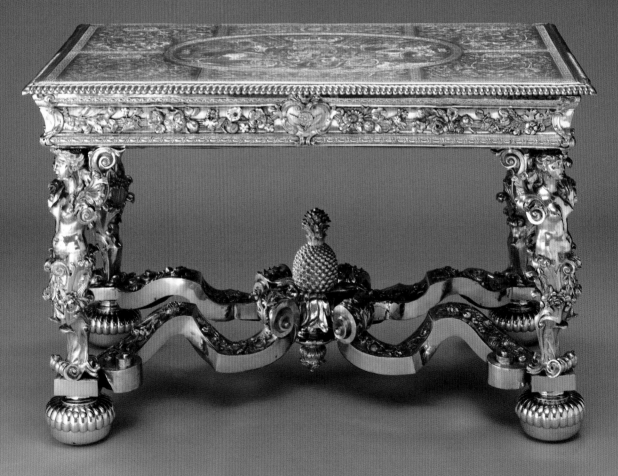

ENGLISH FURNITURE

Silver; table 85.0 × 122.0 × 75.5 cm;
mirror 227.3 × 120.6 cm
Struck with maker's mark
attributed to Andrew Moore; the
engraved top signed *R. H. Scup.*
RCIN 35301 (table), 35302 (mirror)
Commissioned by William III

ANDREW MOORE (1640–1706)
Silver table and mirror, 1699

This magnificent table and mirror are exceptionally rare examples of High Baroque silver furniture. Such pieces were among the ultimate symbols of power and wealth in the late 17th century, notably in France. However, almost all French pieces were subsequently melted. In England the only comparable pieces are another table and mirror (with stands) bearing the cypher of Charles II (RCIN 35298–300) and a set at Knole, supplied by Gerrit Jensen (d. 1715) to the 6th Earl of Dorset.

Until recently it was thought that this silver table and mirror had been presented to William III by the Corporation of London. In fact, the Jewel House records reveal that the pieces were part of an important commission for new silver furnishings (refashioned from an earlier set) for Kensington Palace, ordered by William III in 1698 and delivered the following year.

This huge commission, one of the most important of the 17th century, came to a total cost of nearly £3,660. The finished pieces were much heavier than those they replaced. The table and mirror appear to be the only survivors of this impressive suite, which also included a pair of stands, a pair of large andirons (firedogs) and a chandelier. By 1721 they had been moved from Kensington Palace to Windsor Castle, where they were listed in the Jewel House Inventory, with two other silver tables, mirrors and stands. One of these two sets survives in the Royal Collection (RCIN 35298–300); of the third set only the mirror remains.

The table top is splendidly engraved with the arms and motto of William III, surrounded by the emblems of the four kingdoms.

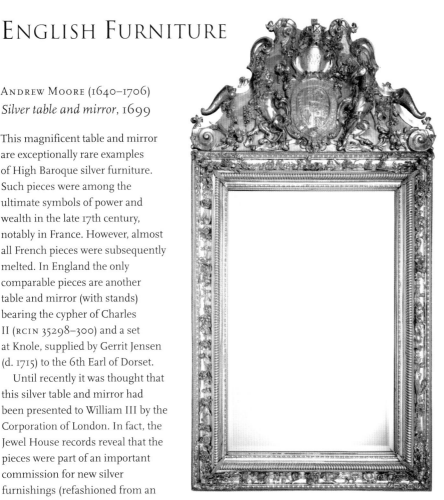

It is signed by the engraver R.H. (possibly for Romeyn de Hoogh). The table itself bears the maker's mark attributed to Andrew Moore (free 1664, i.e. granted his membership – known as freedom – of the Goldsmiths' Company after serving an apprenticeship), as used after 1697, when the new Britannia standard of silver was introduced. Moore worked as a silver chaser in the Bridewell district of London and several other pieces of silver furniture and andirons have been attributed to him. The mirror is identically marked by Moore.

In February 1805 'the novel and grand appearance' of the silver furnishings at Windsor Castle, 'repaired and beautified', was noted. This magnificent arrangement, which included four tables and mirrors, stands, chandeliers and andirons, is recorded in a view of the Queen's Ballroom at Windsor in 1817. In 1902 the mirror was 'discovered' in a lumber room at Windsor Castle, where it had been languishing for much of the 19th century. It was later restored and redisplayed, with the table, in the Queen's Ballroom.

CHARLES WILD (1781–1835)
The Queen's Ballroom at Windsor Castle, 1817,
showing the three sets of silver tables and mirrors

Watercolour with touches of bodycolour and gum arabic over pencil;
19.8 × 25.2 cm
RL 22101

Thomas Tompion (1639–1713)
Siphon wheel barometer, c.1700

The siphon wheel barometer, registering changes in atmospheric pressure on a clearly marked clock-like dial, was the invention of the eminent English scientist Robert Hooke (1635–1703). The first examples were made in about 1665 and over the next 13 years Hooke devised improvements in discussion with two distinguished fellow members of the newly founded Royal Society, his former teacher the physicist Robert Boyle (1627–1691), and the celebrated architect and mathematician Sir Christopher Wren (1632–1723). The craftsman chosen to turn these experiments into physical reality was the foremost clock-maker of the age, Thomas Tompion, whom Hooke visited twice in 1676 and again, with Boyle, in 1678. Further refinements had no doubt been made by the time that the order for this barometer was placed. This is likely to have coincided with the completion of William III's new apartments at Hampton Court Palace from 1699 to 1700. This piece was probably the barometer seen by a visitor to the Palace in 1710 and is likely always to have remained at Hampton Court. Since the restoration of the King's Apartments after the fire of 1986 it has been on view in William III's Closet.

There are two other barometers by Tompion in the Royal Collection, also made for William III around 1700. Both cases are of walnut. One (RCIN 1377) had a wheel mechanism (now changed) and an exceptionally large circular dial; the other (RCIN 1078) has a straight siphon mechanism in a Doric pillar case. All three barometers have a similar architectural look and incorporate some of the same gilt bronze mounts (the flaming urn, cypher of the King, and scrolling brackets). The most individual feature of the siphon wheel barometer is the opulent and distinctive veneer. Often wrongly described as mulberry, it is almost certainly stained burr maple.

Oak, pine, burr maple, kingwood, gilt bronze, brass; 110.0 × 29.5 × 11.4 cm
Engraved on dial *Tho: Tompion fe Londini*
RCIN 1233
Made for William III

Attributed to Thomas Pelletier
(fl.1690–1712)
Pier table, c.1704

Thomas Pelletier, son of Jean and younger brother of René (d. 1726), was appointed Cabinet Maker in Ordinary to Queen Anne in 1704. In spite of this royal appointment, and Jean Pelletier's royal commissions, very little furniture by any member of the Pelletier family has until now been satisfactorily identified. Recently a number of pieces linked by style and documentary evidence, mostly still in the Royal Collection, have been grouped together, and a picture has begun to emerge of the Pelletiers' work for the Crown in the first decade of the 18th century.

Thomas Pelletier's apparent anonymity may be due in part to his having worked as a sub-contractor (with his brother René) for the older royal cabinet-maker, Gerrit Jensen. For example, a pair of highly sophisticated gilt stands for Japanese cabinets, which seem certain to have been carved by the Pelletiers, were probably supplied by Jensen to Queen Anne for Kensington Palace in c.1704 (RCIN 35485). Several other pieces bearing Queen Anne's monogram are likely to have been sourced in the same manner, including this example. The specimen marble top, inlaid with Queen Anne's monogram at the four corners, was probably supplied by the sculptor John Nost.

The table was removed by George IV from Kensington Palace to help furnish the newly created Private Apartments at Windsor Castle in the late 1820s. After refurbishment, it joined a group of early 18th-century giltwood taken from Kensington and Hampton Court Palaces as part of the highly eclectic furnishing of the Grand Corridor (see p. 76).

Gilded pine and beech (?); 82.5 × 154.0 × 80.0 cm
RCIN 600
Made for Queen Anne

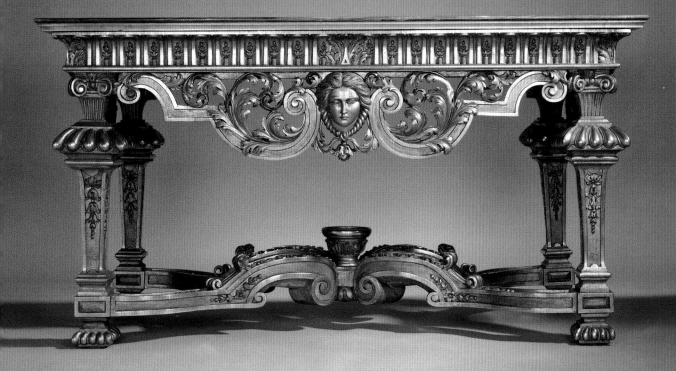

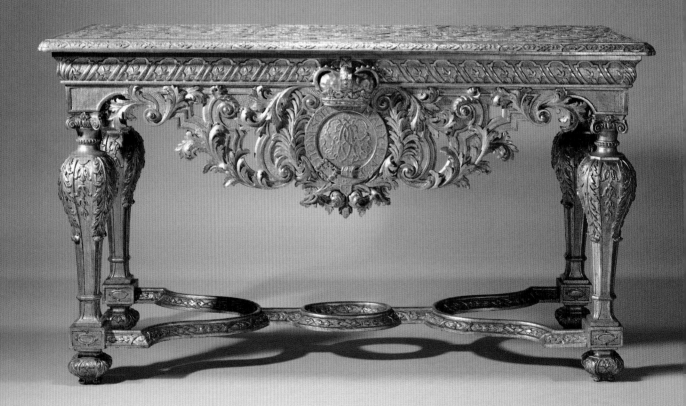

James Moore (c.1670–1726)
Pier table and candle-stand, c.1715

James Moore supplied furniture to the Royal Household during the reigns of Queen Anne and George I. His finest work involved the use of large areas of gesso (a plaster compound), usually applied to flat surfaces such as table tops, then cut into very fine patterns, and gilded. With the advent of the Hanoverian dynasty, Moore frequently used royal and national emblems for royal commissions – here the crowned monogram of George I encircled by the Garter motto. Unusually for an English maker, Moore often signed his work, as he has done on the stands (but not the table).

His table tops in particular, which usually incorporate a geometric framework of interlaced C-scrolls, highly burnished and set off against a punched ground, can be compared to silver chasing of the period and, in their precision and jewel-like surface treatment, they reflect the technical innovations introduced by the Pelletiers.

The pier table (one of a pair) and pair of candle-stands were ordered in 1715 for Hampton Court by George I.

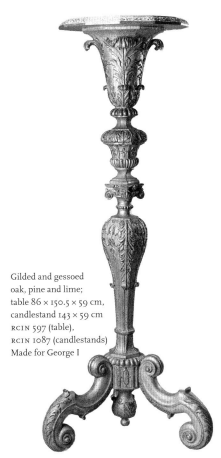

Gilded and gessoed
oak, pine and lime;
table 86 × 150.5 × 59 cm,
candlestand 143 × 59 cm
RCIN 597 (table),
RCIN 1087 (candlestands)
Made for George I

Alexander Cumming (c.1732–1814)
Barograph, 1763–65

The Edinburgh-born clock-maker Alexander Cumming, a founder member of the Scottish Royal Society, had been appointed one of the expert examiners of John Harrison's longitude watch, known as H4, in 1763. In the same year Cumming was also at work on this piece for George III, completed in 1765 for the substantial sum of £1,178. The King rewarded Cumming with a generous retainer – in effect a pension – of £150 per annum to maintain the barograph.

The elaborate mechanism of this piece, which reflects the King's interest in horology, consists of a month-going regulator clock with Cumming's own escapement and an Ellicott compensating pendulum. Surrounding the clock dial are two concentric removable parchment disc charts of six and twelve months' duration recording changes in barometric pressure. A siphon wheel barometer is supported by a pair of Corinthian columns and an entablature of carved ivory.

The outstanding quality of the case, and especially of the mounts, points to the involvement of a leading London cabinet-maker, possibly William Vile and John Cobb.

Rosewood, padouk, oak, ivory, gilt bronze;
243.2 × 57.8 × 45.7 cm
Inscribed on the upper dial *Alex Cumming London*
and *GR*; and on the lower dial *ALEXANDER*
CUMMING LONDON
RCIN 2752
Made for George III

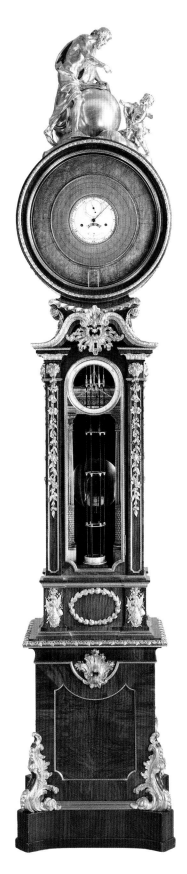

JOHN CARRACK'S CABINET-MAKER (*fl.*1760–80)
*Chest-of-drawers, c.*1770

This highly distinctive piece of furniture, together with a matching pair of corner cupboards (RCIN 21219), is likely to have been acquired by Queen Charlotte. The unusual decorative scheme of flowers framed by a simulated trellis may reflect the Queen's known love of botanical decoration, and the probable identification of this piece with the chest seen in the view of her State Bedchamber at Windsor in 1818 (opposite below) seems to support the suggested provenance. The lack of documentation may indicate that it was a private purchase by Queen Charlotte, very few of whose accounts have survived.

Recent analysis of a closely related piece (a two-door cabinet with painted neo-classical decoration in the Lady Lever Art Gallery, Liverpool) has shed some light on the possible origin of the royal suite. The Lever cabinet, with a pair of corner cabinets (now lost), was sold in 1776 by one John Carrack, through the agency of the former royal cabinet-maker John Cobb, to Sir John Hussey Delaval of Seaton Delaval. Carrack evidently traded in similar goods with the Empress Catherine the Great and may be presumed to have been involved with the Windsor suite also.

Carrack's precise role and his relationship with Cobb are not known. The picture is complicated by the appearance on some of Cobb's documented work of certain features found on the royal chest-of-drawers and corner cupboards. Carrack, who otherwise appears to have traded as a hosier and haberdasher, was evidently acting as agent for the maker of this extremely luxurious group of furniture. The identity of the maker himself remains to be discovered, but should almost certainly be sought among the immigrant cabinet-makers working in London at this period. Both English and continental features are found in the construction of the royal and Lever pieces. The shape and style of decoration, of the royal pieces especially – including the marbling of the tops – is clearly modelled on French examples of the Louis XV period. The vividness of the colour scheme, until recently obscured by layers of discoloured varnish, results from the use of transparent coloured glazes over a ground of silver leaf and (in the trellis) particles of metal foil in imitation of mica.

Walnut, pine, mahogany, painted decoration, gilt bronze mounts;
87.0 × 153.7 × 73.0 cm
RCIN 21220
Acquired by Queen Charlotte

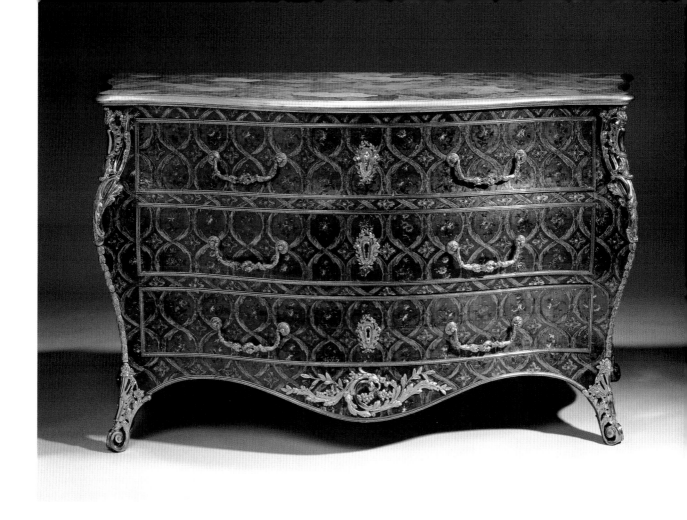

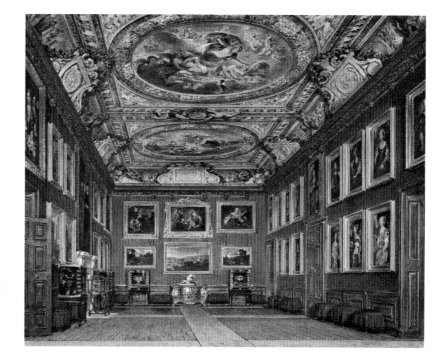

James Stephanoff (1789–1874)

The Queen's State Bedchamber at Windsor Castle, 1818, showing the chest-of-drawers in the centre of the far wall

Watercolour with touches of bodycolour and gum arabic over pencil; 20.2 × 25.4 cm
RL 22103

Chair, settee and two corner chairs, c.1770

These pieces are from a set of 14 chairs, two settees and two corner chairs which was purchased by George III for his wife Queen Charlotte. Her taste for oriental art – which embraced porcelain, jade, lacquer and carved ivory ornaments – can be deduced from the Christie's catalogues for the sale of her collections in 1819, the year after her death. The Queen possessed several examples of solid ivory furniture, presented to her by the wife of Warren Hastings and by the Marquess Wellesley; both Hastings and Wellesley had been Governors-General of India. However, the pieces shown here are made of sandalwood veneered with thin sheets of ivory decorated with dragon heads and floral ornaments. Their design must have been based on a Chippendale-style prototype, no doubt exported by the English colonial

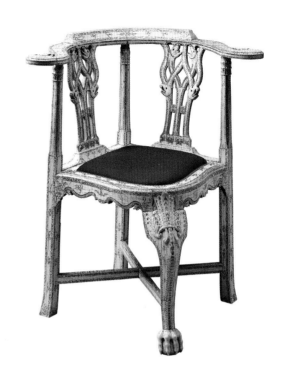

administrators. The ornament was incised into the ivory and the engraved lines were then filled with black and red lac (resin) which had first been softened by heating. The seats were originally caned, but have subsequently been fitted with independent caned sub-frames and later with the present stuffed drop-in cushions.

This set was acquired in India by Alexander Wynch (d. 1781), while he was Governor of Fort St George, Madras,

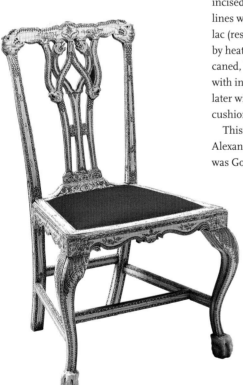

between 1773 and 1775. It was made at Vizagapatam, further up the east coast, which was an important centre for veneered furniture of this kind. Furniture of the same design with minor variations survives in other collections (for example, a chair in the Peabody Essex Museum, Salem, Massachusetts; and six chairs formerly in the Wrightsman collection). Part of the present set was included in the posthumous sale of the contents of Wynch's villa, Westhorpe House, at Little Marlow in Buckinghamshire which, according to one account, George III took the opportunity of viewing while he happened to be passing. He purchased the chairs for 14½ guineas each, and one settee for 48 guineas. At Queen Charlotte's posthumous sales in 1819, the set was bought by her son George IV. The furniture can be seen in Augustus Pugin's view of the Gallery at Brighton Pavilion published in 1824 (opposite); and it is listed at Brighton in 1826. At that date, all the pieces had tufted red morocco squab cushions.

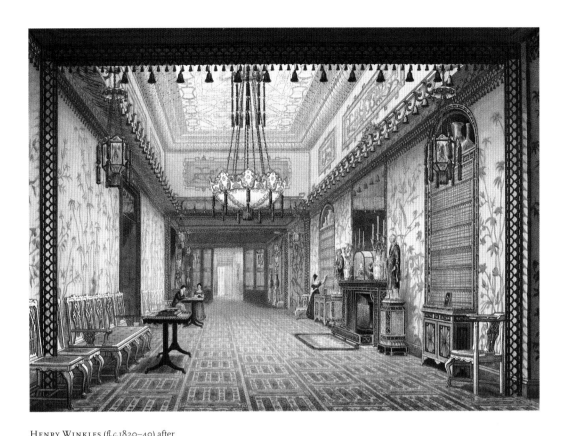

Henry Winkles (*fl.c.*1820–40) after
Augustus Charles Pugin (1769–1832)

*The Gallery at Brighton Pavilion, 1824,
showing the Indian chairs and settee*

Etching with aquatint, hand coloured;
21.6 × 29.8 cm
RCIN 1150260.an

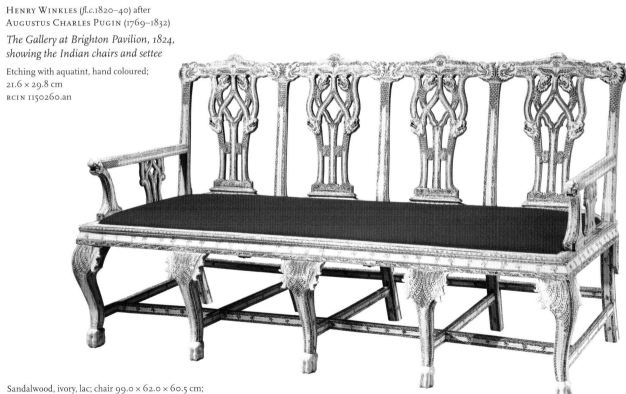

Sandalwood, ivory, lac; chair 99.0 × 62.0 × 60.5 cm;
settee 101.0 × 184.0 × 82.5 cm; corner chairs 83.0 × 78.5 × 71.5 cm
RCIN 487 (chair), 489 (settee), 488 (corner chair)
Purchased by George III as a gift for Queen Charlotte

Matthew Boulton (1728–1809) and Sir William Chambers (1723–1795)

A candle and perfume vase (one of the 'King's Vases'), 1770–71

Matthew Boulton's career as the partner of James Watt (1736–1819) and pioneering manufacturer of steam-engines is well known. But in 1765, before he became immersed in heavy engineering, he had built a factory at Soho on the outskirts of Birmingham for the manufacture of toys, buttons, buckles, silver plate and other metal goods. In the late 1760s, Boulton added ormolu-mounted ornamental vases to his repertoire. Almost from the start he seems to have decided to make the bodies of the finest vases from Derbyshire fluorspar (blue john). This distinctive crystalline stone, though brittle and easily damaged, could be turned and polished to bring out an astonishing range and depth of colour. It also provided an excellent foil for the richly chased and gilded bronze mounts in which the factory specialised.

This pair of vases formed part of the order given to Boulton after his audience with George III and Queen Charlotte at Buckingham House in February 1770. The King's interest in Boulton as an inventor, man of science and entrepreneur appears to have been at least equalled by the Queen's desire to acquire a selection of fashionable new wares for her own apartment. According to Boulton's account of the historic encounter, the Queen was particularly anxious to know how many vases would be needed to replace the china – then the fashionable norm – on the chimneypiece in her bedroom. The resulting order, which established a striking new formula for chimneypiece garnitures, included a pair of sphinx vases (RCIN 21668), a 'King's Clock' (p. 92) and two pairs of 'King's Vases'. Only one pair of the 'King's Vases' was for the Queen's chimneypiece; the second pair is probably that shown on pedestals in the Blue Velvet Room at Buckingham House in 1817 (see below).

At a meeting following the royal audience, William Chambers, the King's influential architect and chief adviser on design matters, gave Boulton some 'valuable usefull and acceptable Modells' and indicated that he would provide a better design for the foot of a candle-vase, using a sketch made by the King himself. Shortly afterwards, Chambers exhibited at the Royal Academy designs for 'Various vases, &c, to be executed in or moulu, by Mr. Bolton, for their Majesties'. One of these, drawn by Chambers's assistant, John Yenn, shows a variant design for a 'King's Vase'. The inference is that the design of the new garniture was – at the very least – strongly influenced by, and in certain respects entirely the responsibility of, William Chambers. Surprisingly, neither the 'King's Vase' nor the 'King's Clock' designs were deemed by Boulton to be exclusive to the royal family; both were repeated by him, the former becoming something of a standard line.

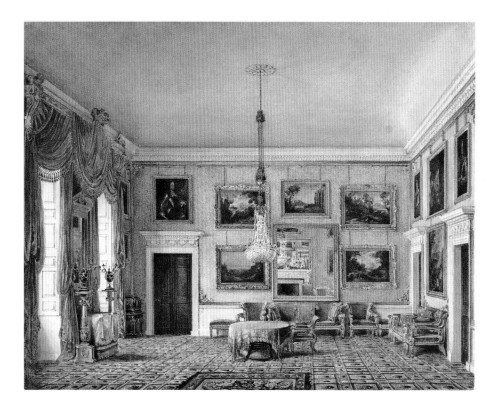

Opposite:
Blue john, gilt bronze, ebony;
57.1 × 55.2 × 17.8 cm
RCIN 21669.1–2
Made for George III
and Queen Charlotte

Charles Wild (1781–1835)
The Blue Velvet Room at Buckingham House, 1817, showing the pair of 'King's Vases' between the windows

Watercolour and bodycolour
over pencil; 19.6 × 24.9 cm
RL 22144

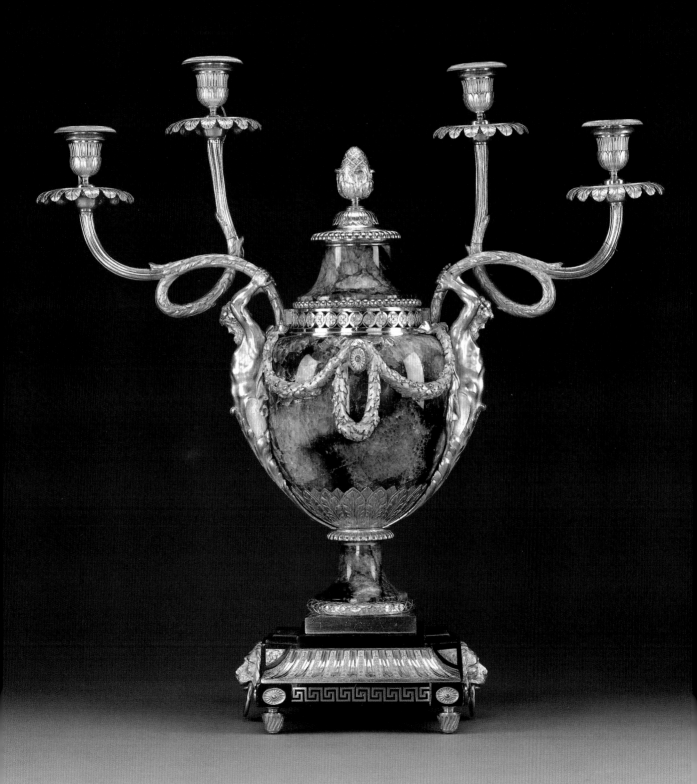

MATTHEW BOULTON (1728–1809), SIR WILLIAM CHAMBERS (1723–1795) and THOMAS WRIGHT (d. 1792)
Mantel clock ('King's Clock'), 1770–71

The commission for this uncompromisingly neo-classical clock resulted from Matthew Boulton's audience in February 1770 with George III and Queen Charlotte at Buckingham House (see p. 90). This meeting was followed by discussions with William Chambers, who was responsible for the design of the clock case. A preliminary version of this design, perhaps worked up from a sketch by the King himself, survives in the Royal Collection (RL 18366). The commission did not proceed smoothly. According to Boulton, whose firm was based in Birmingham, the London clock-maker Thomas Wright behaved 'd–––d shabily' over the fitting of the movement to the case, a process which involved sending the incomplete case twice from Birmingham to London and making significant alterations before it could be presented to the King in April 1771.

As with the 'King's Vases' (see p. 90), Boulton seems to have felt no compunction in making further versions of the 'King's Clock' for general sale – apparently more than six over the next decade. Yet, like many of his ormolu products, they were too expensive and most failed to find buyers.

The clock is recorded in the Crimson Drawing Room at Buckingham House in 1817 and was still there in 1822. By November 1826 George IV had removed it to the Throne Room at St James's Palace. In 1829 the royal clock-maker Benjamin Lewis Vulliamy moved it to the Private Apartments at Windsor.

Above:
Blue john, gilt bronze, enamel;
48.7 × 28.3 × 21.4 cm
Inscribed on the dial and engraved on the backplate *Wright*
RCIN 30028
Made for George III

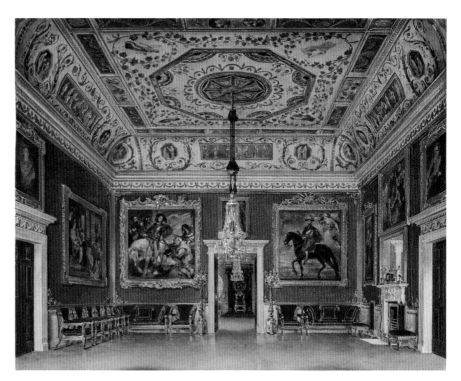

JAMES STEPHANOFF (1789–1874)

The Crimson Drawing Room at Buckingham House, 1817, with the 'King's Clock' on the mantelpiece

Watercolour and bodycolour over pencil;
20.3 × 25.3 cm
RL 22142

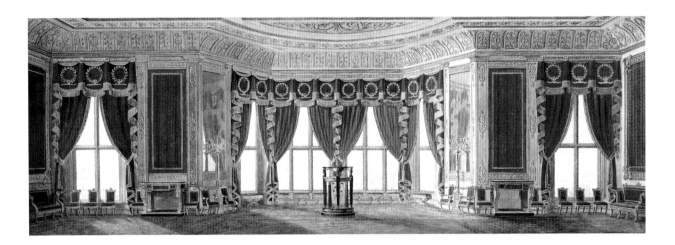

MOREL & SEDDON
Armchair, 1828

This armchair forms part of a very extensive suite of seat furniture made for George IV's new Private Apartments at Windsor Castle. Originally consisting of 56 pieces (12 sofas, 16 armchairs and 28 side chairs), the suite was divided between the Crimson Drawing Room and the Small or White Drawing Room and cost the enormous sum of £13,886 (not including the material for upholstery). By 1830, a number of pieces from both rooms had been removed to the State Apartments or to store, owing to lack of space. Some of the excess pieces were used for the refurnishing of Buckingham Palace in the 1830s and 1840s.

The French inspiration for the design of the suite, seen at an early stage in the room elevations prepared for George IV, points clearly to the influence of F.H.G. Jacob-Desmalter. One of the leading furniture-makers of the First Empire, Jacob-Desmalter was invited over from Paris, probably in 1826, to assist Morel in designing furniture for the Windsor project.

The pieces for the Crimson Drawing Room were originally upholstered *en suite* with the walls and curtains in an expensive poppy-coloured striped velvet, supplied by the mercer W.E. King. The velvet was replaced in 1869 with a crimson silk brocatelle of the same pattern, which, in turn, was changed by Queen Mary in the early 20th century to a bold Italianate design in pink silk. Following the Windsor fire of 1992, the upholstery (including curtains and wall-hangings) was changed back to crimson silk in the original striped pattern.

The Crimson Drawing Room, designed by Wyatville in a rich late classical style, was intended as the principal reception room of the new Private Apartments. It consciously evokes the room of the same name at Carlton House and incorporates furniture and fittings from that room. The Crimson Drawing Room was almost totally destroyed during the fire of 1992, but has since been meticulously reconstructed and houses the original furniture, in store at the time of the fire. This and the adjoining rooms were first opened to the public in 1998.

MOREL & SEDDON

Windsor Castle: The Crimson Drawing Room (east elevation), c.1827, showing the first designs for the suite of seat furniture

Watercolour and bodycolour over pencil, 31.3 × 90.3 cm
RL 31280

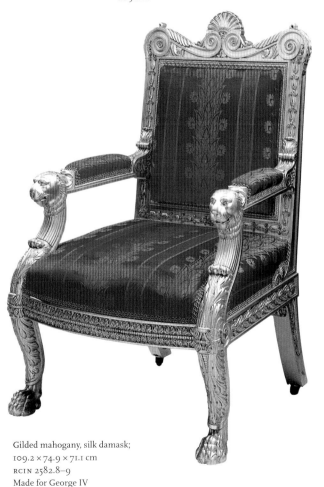

Gilded mahogany, silk damask; 109.2 × 74.9 × 71.1 cm
RCIN 2582.8–9
Made for George IV

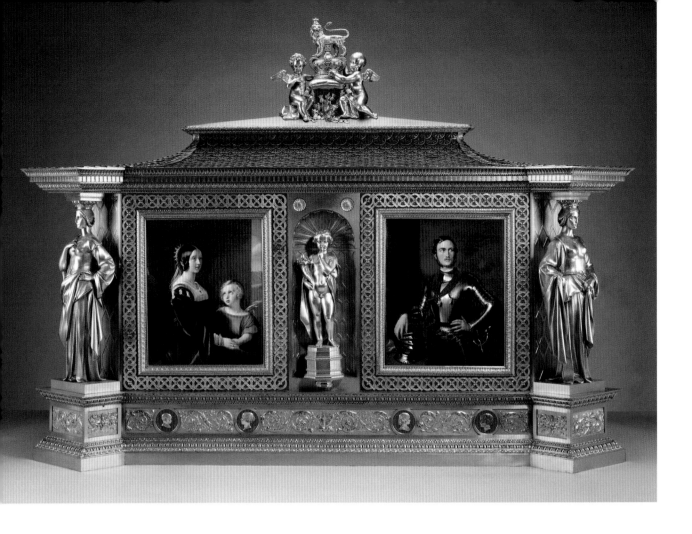

ELKINGTON, MASON & CO.; LUDWIG GRUNER (1801–1882), designer
Jewel-cabinet, 1851

Built in the form of a large reliquary, this elaborate object embodies – perhaps better than any other single work of art – the highly eclectic taste of Queen Victoria and Prince Albert. It was manufactured by the Birmingham silversmiths Elkington, Mason & Co., using their own patent electro-forming process, to the designs of the Prince's adviser on art, Ludwig Gruner of Dresden, and was first shown at the Great Exhibition of 1851.

While ostensibly functioning as a jewel-cabinet, its main purpose was undoubtedly to celebrate and commemorate the happy and successful union of the royal couple. To this end, the doors at the front incorporate Berlin porcelain panels painted with copies of Robert

Thorburn's sentimental miniatures of the Queen with the young Prince of Wales, and of Prince Albert in armour. The original of the latter (RCIN 421665), her favourite likeness of her adored husband, was a birthday present from the Prince in 1844; the original of the former (RCIN 421666) was painted a year later, and a number of copies on porcelain were made of both. The family theme is enhanced by the inclusion around the base of silvered portrait medallions by Leonard Wyon (1826–1891) of six of the royal children (excluding Leopold and Beatrice, who were born after 1851) and, on the back, Meissen porcelain panels painted with the arms of the Queen and Prince surrounded by the national

emblems. The latter, together with the porcelain side panels, were evidently created to Gruner's design, whereas the Berlin panels (see p. 17) may already have been in existence.

The Queen greatly admired Elkington's work and purchased a number of the firm's creations from the Great Exhibition: 'none struck us so much, & as likely to be useful for the taste of the country, as Elkington's beautiful specimens of electro plate', she wrote on a visit in July 1851. A month later she was admiring 'our beautiful jewel case' in the nave of the Crystal Palace: 'It is really exquisite.' No bill has been found, although a payment on 5 January 1852 to Elkington & Co. of

£242 2s. in the Prince's personal accounts could well refer to this commission. The Queen eventually placed the jewel-cabinet in the Grand Corridor at Windsor.

Oak, electro-formed and silver-plated white metal, enamelled copper, porcelain;
97.0 × 132.0 × 81.0 cm
Plaques of Queen Victoria and Prince Albert signed *DECKELMANN* (for Andreas Deckelmann, 1820–1882) and *Wustlich* (for Otto Wustlich, 1819–1896), respectively; one medallion dated *MDCCCLI*
RCIN 1562
Made for Queen Victoria

See details on pp. 1 and 17

HERBERT MINTON & CO. and
R.W. WINFIELD & CO., after designs
by SIR EDWIN LANDSEER (1802–1873)

Highlander candelabrum, 1854

Queen Victoria and Prince Albert's enduring love of all things Scottish began with their first visit to Scotland in September 1842. Six years later, the Queen bought the lease of the Balmoral estate and the freehold in 1852. Thereafter, the castle was rebuilt on a larger scale and newly furnished in the Scottish style by the fashionable London firm of Holland & Sons of Mount Street.

The Queen's great admiration for Highlanders dated from her first visit. She noted their fine dress and romantic appearance when they assembled to greet her at Dunkeld and then at Taymouth Castle. Writing in later years to her daughter, the Crown Princess of Germany, she referred to them as 'friends & not servants'. This admiration was given visible expression in her new Drawing Room, where the light was provided by six identical pairs of candelabra incorporating porcelain figures of Highlanders (see below). They were made by Mintons of Stoke-on-Trent in Parian ware, an unglazed white hard-paste first introduced by Mintons' rival Copelands, the successors to Spode, *c.*1846. The silver-plated light-fittings, in the form of trophies with deer heads and hunting horns, were provided by the Birmingham silversmith R.W. Winfield; they were originally patinated and gilded.

Sir Edwin Landseer was the first major artist to work extensively for Queen Victoria on Scottish subjects at Balmoral, and his studies of her four gillies were executed during his first visit there in September 1850. It is clear that he had responsibility for the design of the Highlander figures, if not for the overall conception of the candelabra.

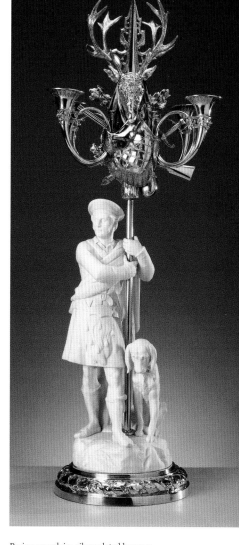

Parian porcelain, silver-plated bronze;
94.0 × 38.0 cm
RCIN 12143.1–2
Made for Queen Victoria

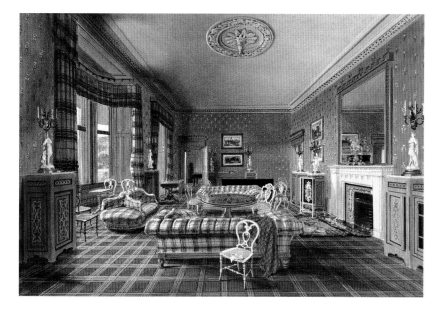

JAMES ROBERTS (*c.*1800–1867)
The Drawing Room at Balmoral Castle, 1857, showing the Highlander candelabra

Watercolour and bodycolour over pencil;
26.1 × 38.3 cm
Signed, dated and inscribed *Balmoral / Sept 1857 / Js Roberts*
RL 19477

CONTINENTAL FURNITURE

ANDRÉ-CHARLES BOULLE (1642–1732)
Wardrobe, c.1700

As furniture-maker, chaser, gilder and sculptor to Louis XIV, André-Charles Boulle enjoyed the privilege of workshops and lodgings in the Galeries du Louvre from 1672 until his death sixty years later. Monumental wardrobes (*armoires*) of this type were intended principally for display and are among the most magnificent and harmonious of Boulle's creations. The large flat surfaces provided a perfect vehicle for the display of Boulle's extraordinary skills as a designer and technician, allowing him to combine intricate marquetry of rich materials and finely modelled gilt bronze mounts (which he also designed and made) within a grand architectural framework. As on many of the finest pieces by Boulle, the bronzes of this piece are very carefully integrated with the marquetry.

Nineteen Boulle *armoires* from the late 17th century have been identified. Features common to most of them include certain mounts and patterns of inlay. Seven *armoires* (including this one) are linked by the use of bronze reliefs of Apollo and Daphne and of Apollo and Marsyas on the doors. The design for them may derive from drawings of subjects from Ovid's *Metamorphoses* that Boulle himself once owned. Of this group of seven wardrobes, two now in the Wallace Collection share many additional features with this example.

George IV had a particular fondness for Boulle furniture, but it was not until he began the refurnishing of Windsor Castle in the 1820s that he acquired this piece and another wardrobe of similar large dimensions (RCIN 21630). Nothing is known of the provenance of this wardrobe except that it was said to have come from the *Garde Meuble* (the French royal furniture store). The presence of the crowned *C poinçon* (tax stamp) on virtually all the bronzes indicates that the *armoire* was in the Paris trade in the period from 1745 to 1749. After thorough restoration by Morel & Seddon in 1828, which included the insertion of a mahogany lining and new locks, the King intended to place the *armoire* and its companion piece in his Sitting Room at Windsor. Perhaps on account of their overwhelming scale, they were actually installed at the angle of the Grand Corridor, where they have remained to this day.

Oak, ebony, tortoiseshell, brass, pewter, kingwood, rosewood, mahogany, gilt bronze; 262.6 × 167.0 × 62.8 cm
RCIN 21642
Purchased by George IV

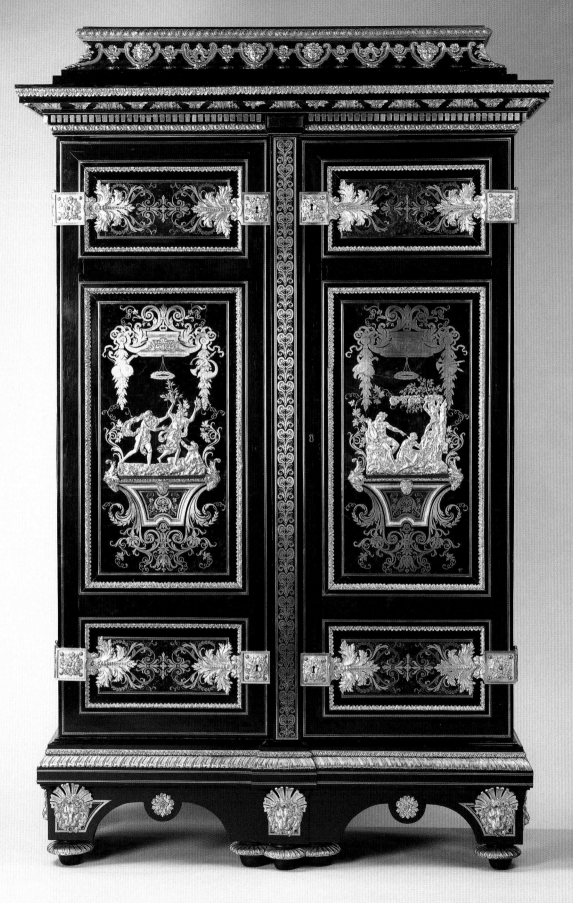

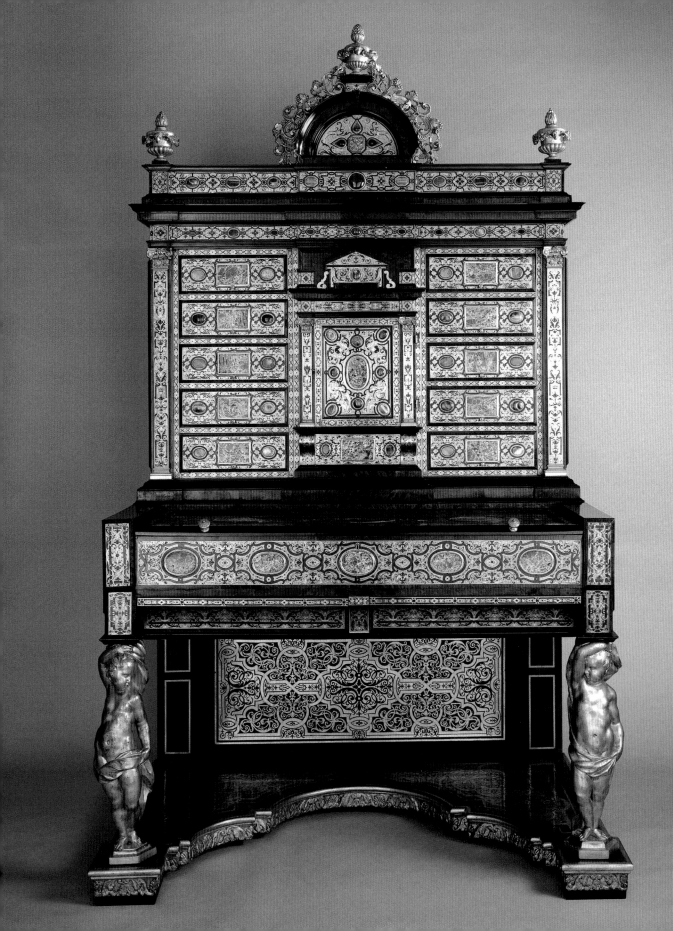

NETHERLANDISH (?ANTWERP)
Boulle secretaire-cabinet, c.1700

The imposing scale and highly elaborate decoration of this cabinet, consisting of geometric marquetry of brass, pewter, copper and tortoiseshell enriched with agate and jasper panels, place it firmly in the category of 'parade' furniture of the kind made fashionable by Louis XIV. These 'parade' characteristics stand out when comparisons are made between this piece and the furniture with which it has most in common, a group of Flemish Boulle secretaire-cabinets which are now usually attributed to the Antwerp workshop of Hendrick van Soest (*fl.*1648–1716). One of the most elaborate of these, a desk made for the Elector Max Emanuel of Bavaria (r. 1680–1726) and now in the Munich Residenz, shares with this example the same general form (raised back, enclosed writing surface supported on giltwood legs and elaborately shaped base) and a similar technique of decoration. However, it is approximately half the size and does not use hardstones.

This piece was purchased by George IV in 1828 from the well-known dealer and restorer E.H. Baldock (1777–1845). The grandeur and style of decoration (then considered to be French) no doubt appealed to the King and he originally intended it for Windsor Castle. It was sent direct to Morel & Seddon, but the following year it was returned to store in London. Its date of acquisition by the Onslows of Clandon Park – the previous owners – is not recorded, but the cabinet may well have been known at first hand by George IV, who was a frequent visitor to Clandon in the early 19th century.

Pine, oak, brass, copper, pewter, tortoiseshell, hardstones, ebony, rosewood, ivory, gilt bronze, giltwood; 270.0 × 160.0 × 105.0 cm
RCIN 1382
Purchased by George IV

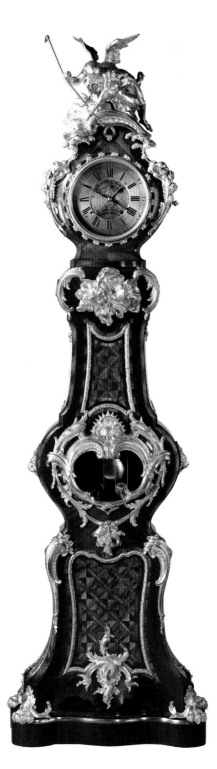

FERDINAND BERTHOUD (1727–1807), CHARLES CRESSENT (1685–1768) and BENJAMIN LEWIS VULLIAMY (1780–1854)
Longcase equation clock, c.1755

Ferdinand Berthoud, clock-maker to Louis XV and to the French navy, was accorded the unusual distinction for a foreigner of election in 1764 to a Fellowship of the Royal Society of London in recognition of his contribution to horological theory, particularly in the area of marine chronometers and equation movements (i.e. those which automatically correct the difference between solar and mean time).

Berthoud's original equation and calendar movement for this piece, of which only the centre part of the dial survives, cannot have been made before 1753, the year Berthoud became *maître-horloger*. The case, which is by the sculptor and cabinet-maker Charles Cressent, is therefore likely to be a fairly late repetition of a model he had first devised in the 1730s. The perfectly integrated gilt bronze mounts, notably the elegantly poised figure of Time, betray Cressent's training as a sculptor, a skill which he continued to practise in defiance of the strict Parisian guild rules.

The clock is first recorded in the Royal Collection in the background of the celebrated portrait of Queen Charlotte in Buckingham House with her two eldest sons, painted by Johan Zoffany c.1765 (see p. 12). George III presumably acquired the clock for the Queen in deference to her taste for French works of art; but, given his own special interest in horology, he would also have recognised it as a notable addition to the growing collection of important timepieces at Buckingham House (see pp. 85, 92).

Oak, pine, purplewood, mahogany, gilt bronze; 236.2 × 70.5 × 35.0 cm
Inscribed on the dial *Ferdinand Berthoud A Paris* and *Vulliamy LONDON A.D. 1821*; movement inscribed *783 Vulliamy LONDON*
RCIN 30035
Probably acquired by George III

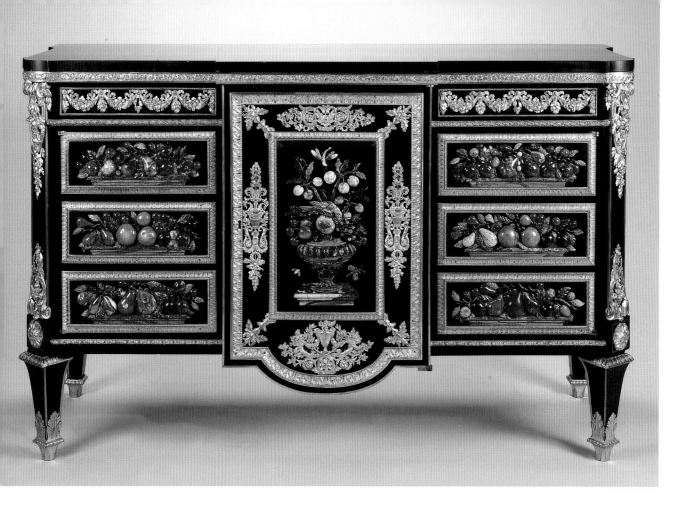

MARTIN CARLIN (c.1730–1785) and DOMINIQUE DAGUERRE (fl.1772–d. 1796)
Cabinet (commode à vantaux), c.1778

Above all else this cabinet is a vehicle for the display of the pietra dura panels that adorn its front and sides. The ostentatious massing of these panels, seven carved in relief with fruit on the front and six inlaid panels at either end, consciously evokes the luxury and splendour of the *grand siècle*, as do the unusually densely modelled gilt bronze mounts. The panels themselves almost certainly come from one of the great cabinets made for Louis XIV in the royal workshops at the Gobelins factory; during conservation, two of the relief panels were found to be signed on the back *Gachetti* [*sic*], for Gian Ambrogio Giachetti, a Florentine lapidary working at the Gobelins between 1670 and 1675.

Most of these royal cabinets were broken up in the 18th century as they went out of fashion, but the pietra dura panels were preserved as precious objects in their own right. With the revival of interest in the Louis XIV period during the 1760s and 1770s, these panels began to be recycled on neo-classical furniture. Among the *marchands-merciers* (dealer-decorators) who specialised in this field were P.-F. Julliot and Dominique Daguerre. It was almost certainly the latter who commissioned

this ambitious piece from Martin Carlin, one of a group of cabinet-makers who worked almost exclusively for Daguerre.

The first owner of this cabinet was the notorious Parisian opera singer Marie-Joséphine Laguerre (1754–1782), whose dissolute life led to an early grave. It appeared in the sale of her collection, among other furniture by Carlin and Weisweiler. Subsequently it belonged to Baron de Besenval, Colonel of the Swiss Guards and friend of Queen Marie-Antoinette, at whose sale in 1795 Daguerre's connection with it was first noted.

George IV, whose liking for pietra dura was almost as marked and long lived as his love of Sèvres porcelain, acquired the cabinet in Paris in 1828 through his confectioner François Benois. It may first have been placed in the King's temporary apartments in St James's Palace, but was intended eventually for the rebuilt Buckingham Palace.

Oak, ebony, pietra dura, gilt bronze, marble; 105.2 × 152.5 × 58.4 cm
Stamped four times *M. CARLIN JME*
RCIN 2588
Purchased by George IV

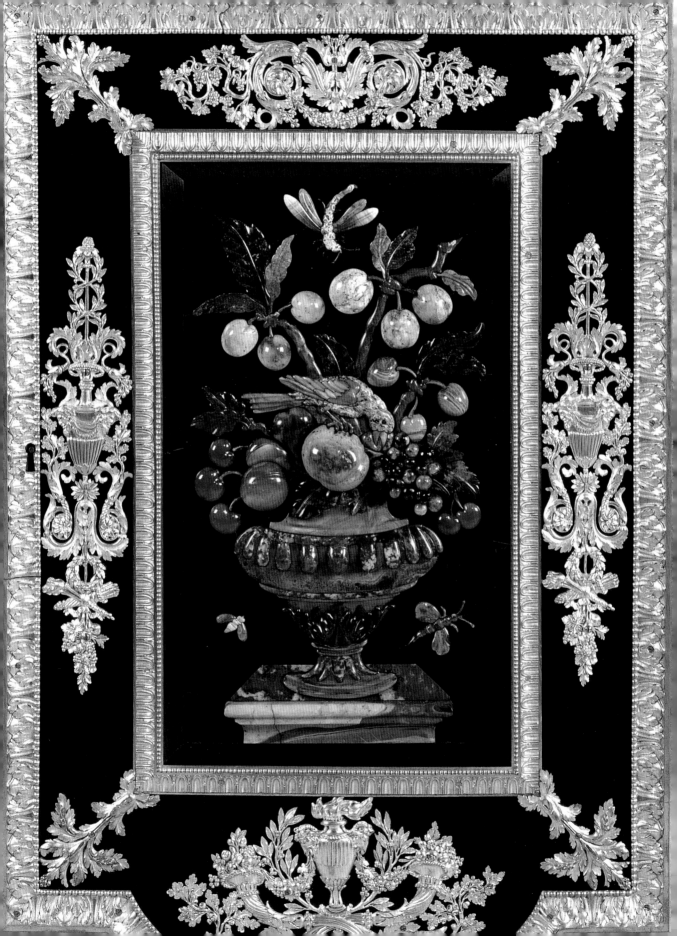

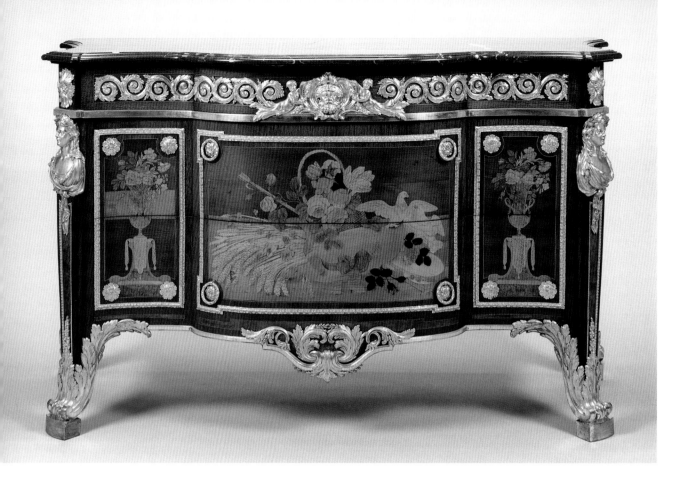

JEAN-HENRI RIESENER (1734–1806)
Chest-of-drawers (commode), 1774

The history of this imposing piece of furniture was discovered by Pierre Verlet, whose pioneering researches in the 1930s first re-established the link between the numbers painted on certain pieces of French furniture and surviving royal inventories. This chest-of-drawers was ordered for the Chambre du Roi at Versailles shortly after the death of Louis XV in May 1774. In design and price (7,800 *livres*, reduced to 7,180 *livres*), this piece compares very closely with several other commodes in a similarly restrained neo-classical idiom made by Riesener for the French royal family in the 1770s. The careful construction, including central locking for the three short drawers in the frieze and two long drawers below, is typical of Riesener's best work.

The chest-of-drawers was completed in slightly over three months and was in place before the return of the court at the beginning of September 1774. To achieve this, Riesener may have had to use some 'stock' elements, for example partly prefabricated marquetry panels (though presumably not the highly characteristic and exquisitely finished central panel representing *la poésie pastorale*), and perhaps some mounts. In any case, the new commode was itself displaced a year later

by a much more lavish example, which took Riesener 14 months to make and cost the enormous sum of 25,356 *livres*. The chest-of-drawers was then transferred to the adjoining Arrière-Cabinet du Roi before being moved in 1780 to one of the most important rooms at Versailles, the Cabinet Intérieur du Roi. At this point the original white marble top was changed to the present *griotte d'Italie* to harmonise with the existing chimneypiece in that room, and a pair of corner cupboards (RCIN 21212) were made to match. The ensemble was sold in 1794, with a writing table from the same room (now at Waddesdon Manor), for the negligible sum of 5,000 livres. George IV bought the chest-of-drawers, the corner cupboards and three other pieces by Riesener 31 years later at the sale of George Watson Taylor's celebrated collection, for use at Windsor (see p. 103). In 1855 it was recorded in the King's Bedroom, which was used during the State Visit of the Emperor Napoleon III and the Empress Eugénie to Windsor.

Oak and marquetry, gilt bronze, marble; 91.0 × 153.0 × 63.0 cm
Inscribed *Nº 2777*
RCIN 21213
Purchased by George IV

Jean-Henri Riesener (1734–1806)
Jewel-cabinet, c.1787

This *objet de luxe* – long regarded as one of the greatest masterpieces of furniture in the Louis XVI style – combines cabinet-making virtuosity of a high order with exceptional gilt bronze mounts. The well-figured, plain mahogany veneers, characteristic of Riesener's output in the later 1780s, provide a deliberate foil to the mounts, jewel-like on the doors (as befits the purpose of the cabinet) and treated as sculpture-in-the-round at the front angles and on the cresting.

Although signed, the cabinet bears no French royal inventory number (see p. 102). However, the prominent coat of arms identifies the first owner as Marie-Joséphine-Louise of Savoy, who married Louis XVI's younger brother, the Comte de Provence (the future Louis XVIII), in 1771. We know that, as *ébéniste du roi*, Riesener supplied furniture for the royal couple in the 1770s, and that he was working for them directly in the early 1780s. The jewel-cabinet was made for the Comtesse's bedchamber at Versailles and cost the enormous sum of 45,800 *livres*. The maker of the bronzes is also unknown, although the *bronzier* François Rémond, who certainly worked for Riesener, is a possible candidate.

The subsequent history of the cabinet provides a fascinating commentary on changing tastes. Confiscated with the rest of the Provence property in 1793, it was initially reserved for display in a national museum. Three years later, as the financial situation in France worsened, the cabinet was sold off. In 1809 it was offered to the imperial household for 30,000 francs by the then owner, who was said to have paid over 60,000 francs for it. Napoleon was strongly encouraged to acquire the cabinet for Saint-Cloud, but this advice was unequivocally rejected in 1811. George IV had no such inhibitions when it came up for sale in the Watson Taylor collection; he purchased it for 400 guineas with the intention of using it at Windsor Castle.

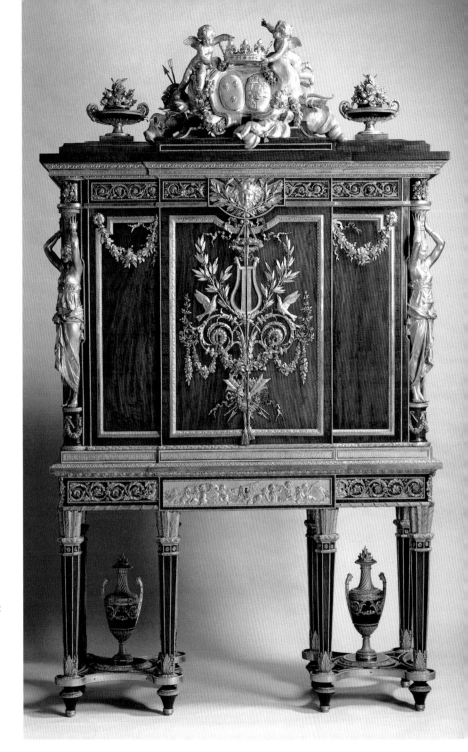

In 1853 Queen Victoria allowed the 4th Marquess of Hertford to have a copy made. Executed by John Webb from 1855 to 1857, it cost the then considerable sum of £2,500.

Oak, mahogany, gilt bronze;
246.0 × 147.0 × 54.6 cm
Stamped *J.H. RIESENER*
RCIN 31207
Purchased by George IV

See details on pp. 78–79

CERAMICS

British monarchs have never taken a direct controlling interest in a porcelain factory, although royal patronage has played an important role throughout the history of porcelain production in England. Porcelain factories began to be established in the early 18th-century, often by immigrant continental artists and craftsmen such as Nicholas Sprimont.

George III gave a helping hand to the fledgling industry when he commissioned the fabulous Mecklenburg dinner and dessert service (pp. 106–07) as a gift for his brother-in-law. His consort, Queen Charlotte, one of the first in this country to collect Sèvres porcelain, was equally active in buying English wares, ordering in 1765 an elaborate Wedgwood tea service known as 'Queen's Ware'. Much of her Wedgwood collection was dispersed in her posthumous sale in 1819 but some pieces were repurchased in the early 20th century by Queen Mary.

During the early 19th century the factories at Worcester, Wedgwood and other Staffordshire towns began to compete for royal patronage in their attempts to take advantage of the interruptions in the supply of Sèvres due to the protracted hostilities between England and France. Many pieces commissioned by George IV and his brother after their visits to the factories remain in the Royal Collection (see pp. 108, 109). The factories made the most of their royal connections and the Rockingham Works exhibited their dessert service (p. 110) for William IV in public in London before it was delivered.

In the middle of the 19th century English ceramic manufacture was dominated by the Minton factory, which produced not only royal portraits but also a number of reductions of full-size marble statues in the Royal Collection (see p. 95). Queen Victoria was a keen supporter, buying several services, as well as encaustic tiles for the Grand Corridor at Osborne.

George IV built up the world's greatest collection of 18th-century Sèvres porcelain by purchasing sophisticated display pieces (p. 115) and many 'useful' wares, such as cups and saucers, broth basins, *déjeuners* and entire services, still in use.

Although both George IV and Queen Victoria regarded French porcelain as suitable for show, their aims were very different. Whereas George IV's displays were designed to dazzle the visitor to Carlton House, Queen Victoria's loans to exhibitions were intended to instruct, by serving as models for craftsmen and inspiration for students.

Oriental works of art are present in the Royal Collection in large quantities and cover almost every branch of the decorative arts of China and Japan, including lacquer, porcelain, jade, arms and armour and enamels. It was above all Queen Mary II, consort of William III, who encouraged the taste in England for using oriental porcelain vessels decoratively. By the time of her death in 1694, aged only 32, she had acquired a major collection of oriental porcelain, to which she added Delftware flower vases and ornamental vases commissioned from the 'Greek A' manufactory of Adriaen Kocks (see p. 113). A few of her acquisitions survive in the collection.

From the 16th century, the practice of mounting oriental porcelain became a standard way of emphasising the rarity or exotic quality of porcelain vessels. With the increased familiarity of oriental porcelain in Europe the purpose of the mounts evolved. It was above all in mid-18th-century France that the fashion for mounted Chinese porcelain took hold. Vases of traditional oriental forms such as the 'ginger jar' (p. 126), as well as those based on Western prototypes such as the square bottles (p. 126), were mounted so as to harmonise with other gilt bronze objects, for instance clocks and statuettes. Occasionally the mount would adapt the use of the oriental vessel; thus the jar on p. 126 was converted into a pot-pourri vase. George IV took advantage of the break-up of the *ancien régime* collections to enrich his own with mounted Chinese porcelain (p. 129).

The oriental collections continued to grow with Queen Victoria's additions and other gifts in the 20th century.

Details: Sèvres, pot-pourri vase and cover, 1758/59 (see p. 115)

English Ceramics

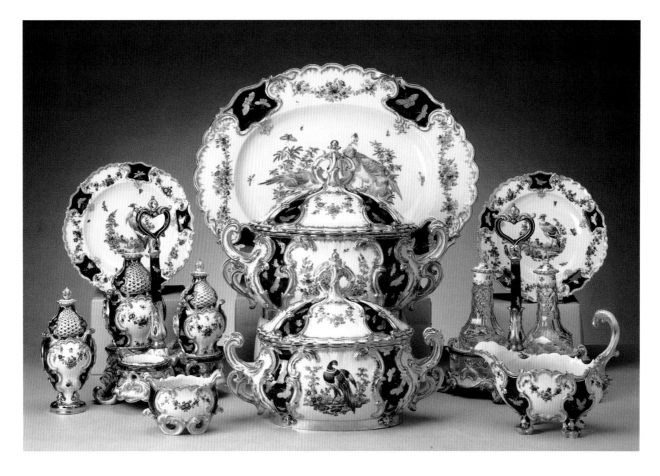

Chelsea
Pieces from a dinner and dessert service, 1763

This combined dinner and dessert service, which originally also included tea and coffee wares, was presented by George III and Queen Charlotte to the Queen's elder brother, Adolphus Frederick IV, Duke of Mecklenburg-Strelitz (1738–1794; see also p. 177). The service – known as the Mecklenburg Service – was completed by March 1763.

The plates follow an existing pattern, first used at Chelsea in around 1757 for a service decorated with fruit and flowers, of which a large number of pieces are also in the Royal Collection (for instance, RCIN 58781). However, precedents for the Mecklenburg Service are more likely to be found in silver than in porcelain.

When Nicholas Sprimont – a professional goldsmith and designer – arrived to manage the Chelsea works in 1749, the table services in the fashionable aristocratic houses were all of silver, and the difference in quality and refinement between English silver and English porcelain was vast. The silver ancestry of the Mecklenburg Service can be seen in the design of the plates – with scalloped edges and reserves within raised borders around the rim – the cruets, candelabra and the epergne or centrepiece, an object previously confined to silver (see p. 163).

For the decoration of the service Sprimont employed the deep cobalt pigment known as 'mazarine' blue.

It was applied thickly and fused to the glaze. Although it must have been intended to remain within the barrier formed by the borders of the reserves, in several instances the colour seems to have escaped. These faults were disguised by butterflies and other insects in gold, following the practice of earlier Meissen decorators. The painted centres, with pheasants and other exotic birds, also recall in their palette and style the work of the Meissen painters.

When Queen Victoria's first cousin Princess Augusta of Cambridge married the Grand Duke of Mecklenburg-Strelitz in 1843, she found the service in use below stairs by the castle servants at

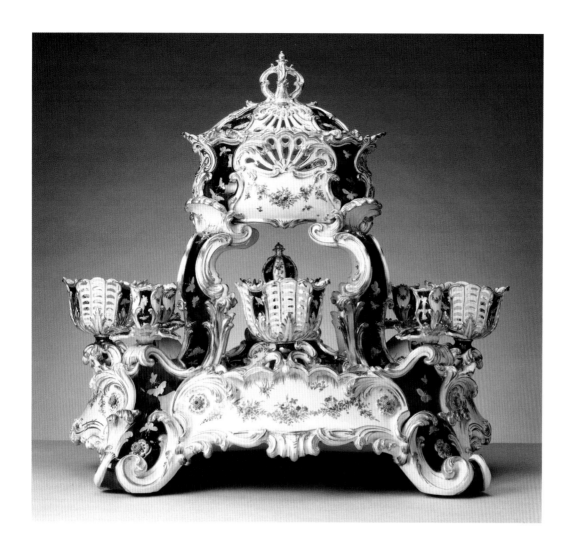

Neu Strelitz. Having redeemed it for the Duke's dining table, the Princess commissioned a number of replacement pieces in 1847 and 1849 from the Prussian royal factory at Berlin. A pair of broken candelabra was disposed of somewhat later by the castle steward.

Queen Mary saw the service at Neu Strelitz in 1904 and moved it to the dining room. However, after the end of the First World War the Mecklenburg family were forced to dispose of it. Although the service was offered to King George V by Duveen, it only entered the Royal Collection in 1947 as a gift from Mr James Oakes. There are 137 Chelsea pieces and five Berlin replacements.

Soft-paste bone-ash porcelain;
centrepiece 42.5 × 66.7 × 59.0 cm;
large tureen 24.3 × 27.2 × 21.2 cm;
small tureen 14.2 × 27.2 × 21.2 cm;
cruet set (porcelain bottles) 31.8 × 21.9 × 22.7 cm;
cruet set (glass bottles) 30.0 × 28.0 × 15.3 cm;
sauceboat 17.2 × 21.7 × 11.6 cm;
salt 8.2 × 11.6 × 8.3 cm; oval platter 41.0 × 51.0 cm;
plates diameter 23.5 cm
Inscribed in gold with anchor,
on the underside of each piece
RCIN 57012.2 (large tureen),
57012.3 (small tureen),
57013 (sauceboat),
57014 (porcelain cruet set),
57015 (plates), 57022 (oval platter),
57023 (glass cruet set),
57024 (salt), 57028 (centrepiece)
Presented to Queen Elizabeth
the Queen Mother

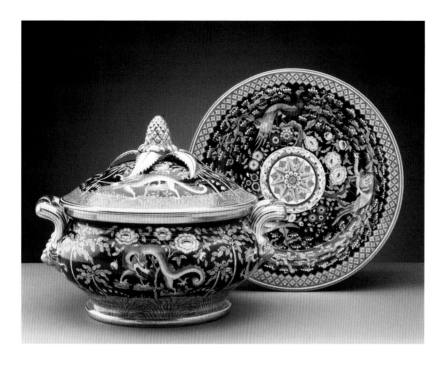

Hybrid paste porcelain ('The Regent' body); tureen 24.0 × 32.2 × 26.5 cm; tureen stand diameter 30.7 cm; soup plates diameter 23.4 cm Painted in red script under the lid of the tureen *Chamberlains / Worcester*; printed in puce script within a leafy cartouche on the underside of the tureen stand *Chamberlains / Worcester / & 155 / New Bond Street / London*; painted in red script on the underside of the plates *Chamberlains / Worcester*
RCIN 58401 (plates), 58403 (tureen and tureen stand)
Commissioned by George IV when Prince of Wales

WORCESTER (H. & R. CHAMBERLAIN)
Pieces from a dinner service and dessert service, 1807–16

During a visit to Worcester in September 1807, the future George IV toured both of the principal porcelain factories – Barr, Flight & Barr, and H. & R. Chamberlain – and granted each of them his Royal Warrant. From the Chamberlain factory he ordered dinner, dessert and breakfast services; each piece was to be decorated in a completely different pattern.

The 140-piece harlequin dessert service was the first to be delivered, in July 1811. The matching dinner service, which took five more years to complete, consisted of six large round soup tureens (as here), two tureens for vegetables and

six for sauce, 12 dozen dinner plates, eight dozen soup plates (as here), 147 dishes of varying shapes and sizes, and 16 candlesticks. The painted decoration considerably extended the repertoire of 'Old Japan' patterns developed by Chamberlain from around 1800, to encompass Chinese *famille rose* and other styles, in addition to many variations on Japanese Imari designs. Several hundred of the original watercolour designs survive in the Worcester Porcelain Museum. The total order, including the breakfast wares (delivered in October 1816), came to more than £4,000.

Several members of the Chamberlain family were associated with the early history of porcelain manufacture at Worcester. Robert Chamberlain served his apprenticeship in the factory begun by Dr John Wall in 1751, and he and his two sons Robert and Humphrey were employed as decorators by Thomas Flight before starting their own production in around 1791. After the elder Robert's death in 1798, this firm belonged to his sons and traded as H. & R. Chamberlain. Royal patronage brought their work to a wider public and after George IV's order they opened a showroom in London.

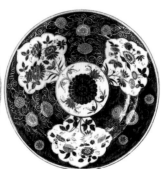

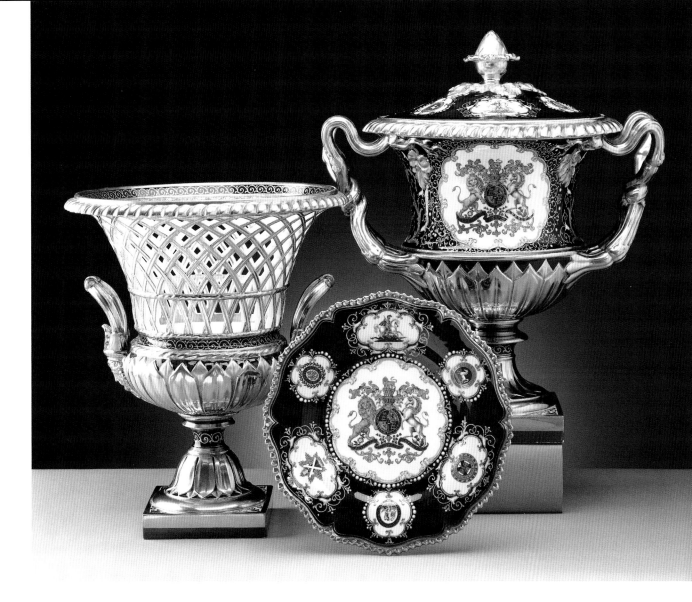

WORCESTER (FLIGHT, BARR & BARR)
Pieces from a dessert service, 1831–33

William IV was a patron of the Worcester porcelain factories for more than 40 years. In 1789 he commissioned from the Flight factory a dessert service with a ribboned border inspired by Sèvres patterns, and decorated in honour of his elevation to the dukedom of Clarence and St Andrews; a small number of pieces from that service remain in the Royal Collection (RCIN 58103). The following year he ordered from the same factory a large dinner service later known as the 'Hope' Service, which is no longer in the Royal Collection.

This grand dessert service was commissioned for William IV's coronation in 1831. It now consists of 116 pieces. They are decorated with a very rich underglaze blue ground, with six reserves painted with the insignia of the Orders of the Garter, Thistle, St Patrick, Bath, St Michael and St George, and of the Guelphic Order, surrounding the royal arms, the work of the painter John Bly. Pieces from this service are regularly used to decorate the table for the annual luncheon for the Knights and Ladies of the Garter at Windsor.

Soft-paste porcelain; ice pail 44.0 × 37.0 × 28.8 cm; dessert stand 34.1 × diameter 30.5 cm; dessert plates diameter 25.6 cm
Printed in gold on the underside of plates and lid of ice pail *ROYAL PORCELAIN WORKS / FLIGHT BARR & BARR / WORCESTER & COVENTRY ST LONDON* below a crown; stamped under the foot of the ice pail and dessert stand *FBB* below a crown (Sandon (J.) 1993, no. 37); painted in puce script under the foot of the dessert stand *Flight Barr & Barr / Royal Porcelain Works / Worcester / & / Coventry St London*; numbered in gold on the underside of the ice pail lid and liner 3
RCIN 58393 (dessert plates), 58394 (ice pail), 58396 (dessert stand)
Commissioned by William IV

Rockingham Works (Brameld)
Pieces from a dessert service, 1830–37

This service, originally consisting of 56 large pieces and twelve dozen plates, may claim to be the most ambitious ever produced by an English factory. By far the youngest of the factories from which services were ordered by William IV following his accession in 1830, the Rockingham Works, founded in 1825, soon established a reputation for producing wares of outstanding quality.

Designs for the service were in hand during the autumn of 1830, and samples were sent to the King for approval: a plate resembling the final pattern, but with an orange ground to the rim instead of the chosen 'Brunswick' blue, is one such sample (RCIN 58123). As with the Davenport and Worcester services (see p. 109), national symbols formed part of the decorative imagery: the centres of the plates (RCIN 29761) were painted with the royal arms, and the national flowers occupy those of some of the comports; while raised and gilded roses, thistles and shamrocks, as well as oak leaves and acorns, are entwined and encrusted around the painted reserves of the shaped pieces. In addition, the Rockingham service evoked Britain's maritime achievements and foreign dominions. In the 760 painted reserves there are Indian and Caribbean scenes as

'Tropical' dessert stand

well as British landscapes, castles and country houses; and the wonderfully modelled pineapples, sugar-cane stems, exotic fruits, corals and shells also evoke Britain's more distant possessions. The designs were made by John Wager Brameld. All of the artists responsible came from within the Rockingham factory's own workforce of around 600.

The service was not completed until 1837, when it was placed on show in the Bramelds' London showroom. It was still on display there when the King died in June, and remained unused until Queen Victoria's coronation the following year. Despite widespread praise for the service at the time, its protracted manufacture brought about the Bramelds' ruin.

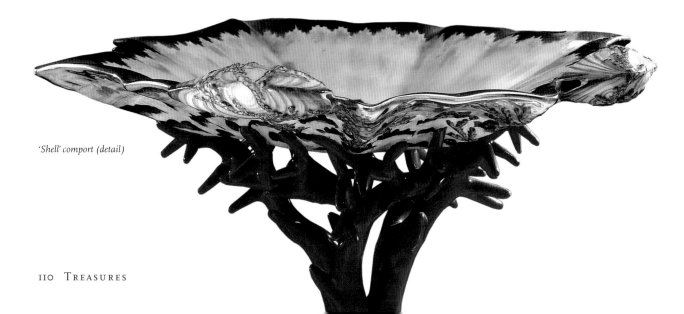

'Shell' comport (detail)

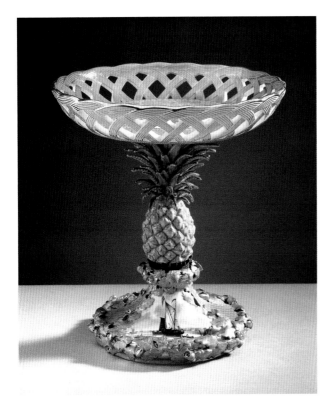

'Pineapple' comport

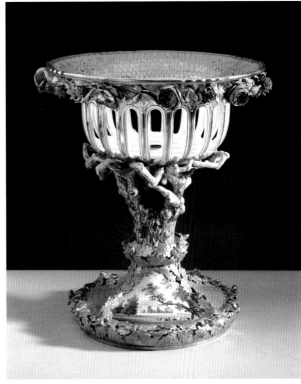

'Grand basket'

Bone china; 'Grand basket' 30.5 × diameter 27.0 cm; 'shell' comport 19.8 × 25.0 × 24.0 cm; 'tropical' dessert stand 24.5 × diameter 37.0 cm; ice pail 35.0 × 37.6 × 26.3 cm; 'pineapple' comport 26.0 × 23.9 cm

Incised in script on base of 'Grand basket' *No. 1 / Triple Assiette*; printed in puce script within a cartouche (twice) under the foot of comports *Rockingham Works / Brameld / Manufacturer to the King / Queen and Royal Family* below a griffin; inscribed under the foot of the comports with the names of fruits and the titles of the reserve scenes as above. The reserve scenes on the comports are also briefly titled in white within the reserves or with a burnishing tool on the gilt borders.

RCIN 58377 ('Grand basket'), 58381 ('shell' comport), 58382 ('tropical' dessert stand), 90208 (ice pail), 90209 ('pineapple' comport)

Commissioned by William IV

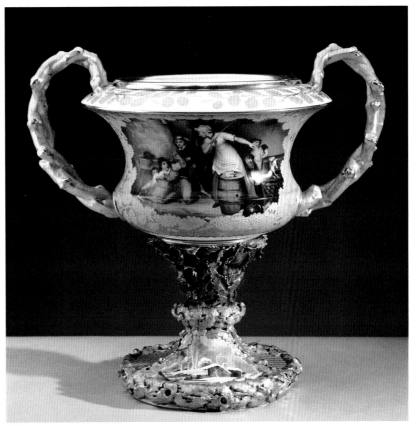

Ice pail

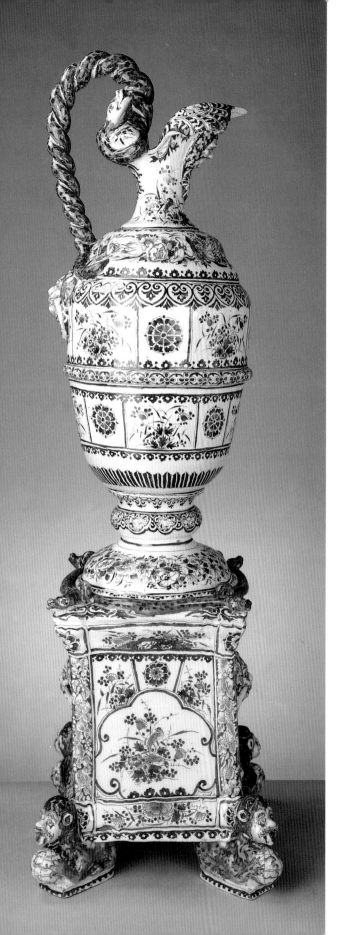

CONTINENTAL CERAMICS

DELFT ('Greek A' factory of ADRIAEN KOCKS)
*Ewer and stand, c.*1694

The production of blue and white tin-glazed earthenware at Delft in the Netherlands in the mid-17th century was stimulated in part by interruptions (caused by hostilities in China) in the supply of the oriental porcelain that had been imported in very large quantities by the Dutch East India Company since the beginning of the century. Although it is mentioned in contemporary sources as *Delffs porcelijn*, the material produced at Delft is quite different, retaining the grey colour of the clay after firing at much lower temperatures than true porcelain. This material was then whitened with a thick glaze based on lead oxide with the important addition of tin, which produced the milky opacity required to imitate porcelain. Various factories were established, often in disused breweries whose names they retained, such as *De Metalen Pot* (the Metal Pot) or, as in this instance, *De Griexe A* (the 'Greek A').

The 'Greek A' factory was founded in 1658 by Wouter van Eenhoorn, taken over by his son Samuel in 1678, and sold after the latter's death in 1686 to his brother-in-law, Adriaen Kocks (d. 1701), who was in charge when both these ewers and the tulip vases opposite were made. Queen Mary II (1662–1694; r. 1689–97) was the factory's most important customer, ordering many vessels for her Dutch palaces of Honselaarsdijk and Het Loo, as well as for Hampton Court. A clear difference can be seen between the decoration of those pieces that were ordered for the Dutch and for the English palaces. The Dutch pieces, many of which date from the Samuel van Eenhoorn period, are generally painted with *chinoiseries* in imitation of their Chinese prototypes, whereas those supplied for Hampton Court have purely Western, stylised floral decoration between bands of loosely classical ornament. There are still 10 large vessels (including the one shown here) and three smaller pieces at Hampton Court, all of which were supplied directly to Queen Mary by Adriaen Kocks's factory. They were probably designed by William and Mary's court architect, Daniel Marot (1663–1752), who may have been inspired by 17th-century French silver for some of the shapes.

Many of Queen Mary's vases must have been ordered for the 'Delft-Ware Closett' near the Water Gallery at Hampton Court, probably intended for the Queen's use during the rebuilding of the State Apartments. The vases were moved by William III to the State Apartments in 1700 on the gallery's demolition.

Tin-glazed earthenware; 117.0 cm high
Marked with conjoined *AK* in blue under the foot of each ewer
and under the base of RCIN 1083.1
RCIN 1083.1–2
Made for Queen Mary II

DELFT ('Greek A' factory of ADRIAEN KOCKS)
Tulip vase, c.1694

Many of Queen Mary II's Delft vases are described in the inventories of her palaces at Het Loo and Hampton Court as standing on the hearth. Flower vases such as this (one of a pair) were used to decorate the fireplace during the spring and summer, when fires were not lit.

Each of the nine hexagonal stages was made separately, with a sealed water reservoir and six protruding grotesque animal mouths, into which the cut stems of tulips or other flowers could be placed. There may originally have been a pointed finial or stopper in the top of each vase. The lowest stage is attached to the backs of six recumbent cows placed at the angles of the hexagonal base.

Two sides of the base are painted with a youthful bust of William III; two have a winged putto seated on an overturned ewer, holding a lead, which is attached by a collar to a standing stork; the remaining two have a peacock displaying its tail plumage and standing on a rocky fountain ornamented with shells, suggestive of a garden grotto. The forms and ornaments of this and similar vases are distinctly playful; the six tiers of a hexagonal pyramid at Williamsburg, for example, rest on the backs of snails. A pyramid vase of this general design and bearing the mark of Adriaen Kocks is at Chatsworth House; a pair of square examples painted in the base with architectural *capricci*, and another pair of the same shape with allegorical figures, are at Dyrham Park in Gloucestershire.

Delft vases which formerly belonged to William and Mary survive in other collections, the most important being an orange-tree pot at Erddig in Clwyd which bears the royal arms and cypher.

Tin-glazed earthenware; 97.5 cm high
Marked with conjoined AK in blue on the side of one cow on each base.
Each stage of both vases bears an identifying mark *A* (RCIN 1085.2)
or *B* (RCIN 1085.1) inscribed in blue, inside and underneath, and in most
cases also incised beneath the glaze on the underside.
RCIN 1085.1–2
Made for Queen Mary II

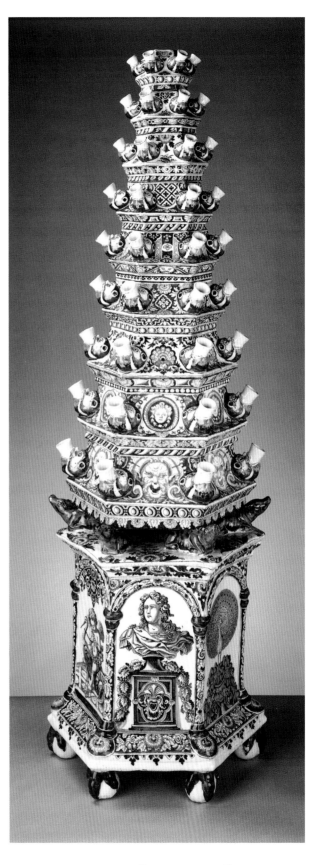

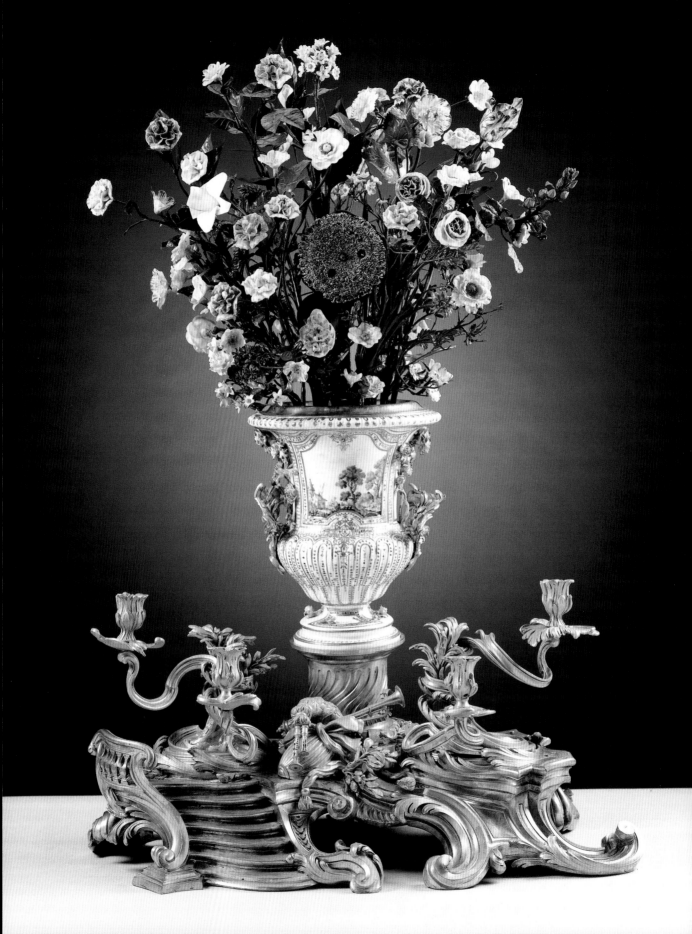

VINCENNES
'The Sunflower Clock', c.1752

The vase (*vase Le Boiteux*) is filled with a
bouquet of flowers. Concealed within the
bouquet is a clock, whose eccentrically
designed dial is formed by the seeding
centre of a sunflower. In its original state
the vase with its bouquet and clock must
have been less elaborately mounted.
It would have stood directly on the gilt
bronze terrace, flanked very probably by
Vincennes porcelain figures. By the time
of George IV's purchase of the clock in
1819 gilt bronze additions had been
made, namely foliate handles, a drum
and candelabra in the place of figures.
The white porcelain had been enriched
with later polychrome jewelling. It had
also acquired a suitably impressive
provenance – Madame de Pompadour.

Even if there are no grounds for
believing that this clock ever belonged to
Louis XV's illustrious mistress, it closely
matches the porcelain bouquet (now in
the Zwinger, Dresden) given by the
King's daughter-in-law, the Dauphine
Marie-Josèphe de Saxe, to her father
Augustus III, Elector of Saxony, in 1749.

After George IV's death the vase
became separated from its bouquet and
clock, to which it was only reunited in the
early 20th century. By then many of the
original flowers had been lost or broken.
The restoration by H.J. Hatfield & Sons,
using flowers from a Meissen vase and
new imitations, was based on the draw-
ing in George IV's Pictorial Inventory.
Despite its chequered history, the piece
retains much of its former glory. The
two painted scenes on the vase are of the
finest quality, while the gilt bronze
terrace is typical of the Louis XV style.

Soft-paste porcelain, green-lacquered brass wire
(for the stems), gilt bronze; overall 105.4 × 66.7
× 54.0 cm; vase 30.0 × 13.9 cm
Vase inscribed in blue with interlaced *LL*s
enclosing a dot; backplate engraved by the clock-
maker Benoist Gérard (d. 1758); strike spring
signed by the spring manufacturer Missier, and
dated February 1752
RCIN 30240
Purchased by George IV when Prince Regent

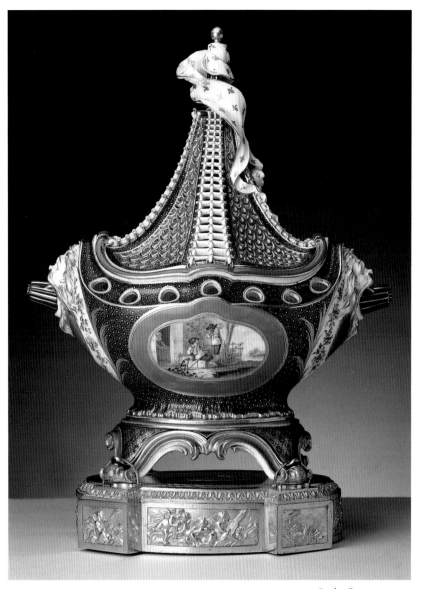

See details on pp. 104–05

SÈVRES
Pot-pourri vase and cover (vase pot-pourri à vaisseau), 1758/59

For many admirers of Sèvres porcelain
the *vase pot-pourri à vaisseau* represents
the height of sophistication, a splendid
combination of the technical mastery of
the modellers and repairers and the skill
of the painters and gilders. This piece
is an example of the most frequently
reproduced model, in the larger size,
of the three possible designs.

Madame de Pompadour bought the
piece at the end-of-year sale at Versailles
in December 1759. She is known to have
owned as many as three of these vases,
clearly regarding them as important
components of her interior decoration.
This example was first recorded in the
Royal Collection in 1826.

Soft-paste porcelain, gilt bronze stand;
overall height 51.2 cm; dimensions excluding
stand 45.2 × 37.8 × 19.3 cm
Inscribed in blue with interlaced *LL*s enclosing
the date-letter *F* for 1758/59
RCIN 2360
Acquired by George IV

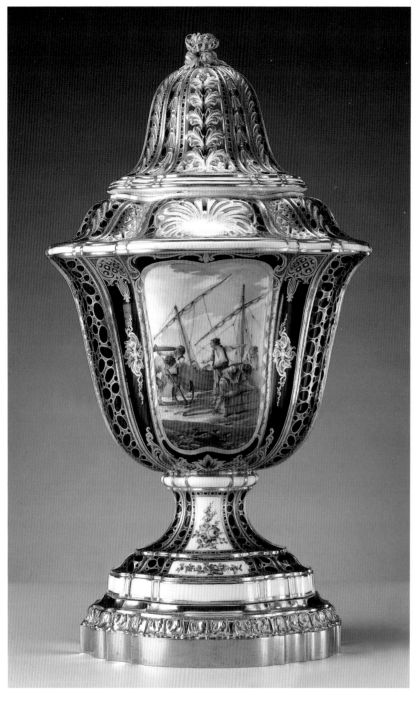

Soft-paste porcelain, gilt bronze base;
overall height 51 cm; dimensions excluding base
46.4 × 28.0 × 23.1 cm
Inscribed in blue with interlaced *LL*s. Incised 5
RCIN 2299
Acquired by George IV

Pot-pourri vase and cover (vase Boileau), c.1761

This majestic vase, with its curving shape and asymmetric decoration, is still very rococo in style. Its model and moulds date from 1758. The piercings in the shoulders and cover have transformed the original non-utilitarian ornamental vase into a vessel to contain pot-pourri. This change may be associated with the documented modification in 1761 to the original model, named after Jacques-René Boileau de Picardie, who was Director of the Sèvres manufactory from 1 July 1751 until his death in 1772.

The vase cannot be identified in the sales ledgers, in which only three *vases Boileau* are listed by name, priced at the high figures of 960, 840 and 720 *livres*, respectively. It must therefore have been sold 'anonymously' under the generic term *vase d'ornement*, probably for an equally large sum. The complexity of the shape accounts for its rarity and price. Only five versions are known, of which two are in the Royal Collection. This

example is the richer of the two; the second is RCIN 36081. The painting of the marine scene, which is possibly the work of Jean-Louis Morin, and of the loosely drawn cluster of flowers and fruit on the back, is of high quality, as is the richly tooled and burnished gilding which accords perfectly with the sinuous lines of the vase and cover.

SÈVRES
Vase and cover (vase à médaillon du roi), c.1768

Four versions of this shape are known today: three – with a dark blue ground – are in the Royal Collection, while a fourth – which has a green ground – is in the Wallace Collection. They may all once have belonged to George IV.

The model, which dates from 1767, has plausibly been attributed to Jean-Claude Duplessis because of the similarity of its crown lid with the crown that he designed for an inkstand made in 1758 for Louis XV's daughter Madame Adélaïde. This vase combines many of the qualities which George IV admired most in Sèvres porcelain: bold modelling, fine decoration characterised by subtle variations in the tooling of the flutes of the stem and a French royal association symbolised both by the profile medallion heads of Louis XV (fitted to the front and back) and by the closed crown surmounted by the lily, the emblem of the Bourbon dynasty.

Notwithstanding the royal associations, there are no grounds for believing that Louis XV (r. 1715–74) ever owned a version personally, although he evidently

regarded it as a suitable choice for a present. In November 1768 he gave a green ground version, priced at 600 *livres*, to Christian VII, King of Denmark. As noted by Rosalind Savill, the Danish gift is probably the fourth surviving version of the vase, which is now in the Wallace Collection. It is conceivable that this vase (or one of the other two versions in the Royal Collection; RCIN 30160, 36108) may also have had a near-royal pedigree. In December 1768 Madame Du Barry, who was shortly to be received at court and acknowledged as the King's mistress, bought a version for 504

livres – a delicate gesture, possibly, in anticipation of this happy turn in her fortunes. The medallion of Louis XV was designed by Edmé Bouchardon and was first cast in bronze in 1738. It was used subsequently on coinage and on commemorative medallions.

Soft-paste porcelain, medallion portraits of biscuit porcelain, gilt bronze base; overall height 39.8 cm; dimensions excluding base 37.6 × 21.7 × 16.5 cm
Incised *CD* (in script) and *Bl* (in script)
RCIN 4966
Purchased by George IV when Prince Regent

Sèvres

Vase (vase fontaine Du Barry), *c.*1772–78

The model for this vase (one of a pair), which probably dates from 1771, appears to have borne a variety of names at Sèvres: *vase Du Barry à guirlandes*; *vase fontaine Du Barry*; *vase Borrie [? Barry] à 4 mascarons*. The 'fountain' could be an oblique association of ideas connected with the bulrushes round the stem. The reference to *4 mascarons* (masks) firmly links the name with the model and adds validity to the Du Barry connection, if it is conceded that Borrie is a corruption of Barry.

The distinctive feature of this model is the four heads – two male, two female – emerging out of ruffs, over each of which is looped a floral garland suspended between their heads to studs tied in a bow with a ribbon. The refinement in the modelling of these vases and the crispness of detail recall the work of the finest gilt bronze chasers working in the Louis XVI style. It is as if the *répareur* (repairer who chased the sculptural details and provided handles, spouts, knobs etc.) at Sèvres had set up in competition with the *ciseleur* (chaser) in Paris.

Both vases lack their covers. Only one other pair of vases of this rare shape is known. Dated 1776, they are of hard-paste porcelain and form part of the collections of the Museum of Fine Arts, Boston.

Soft-paste porcelain; 40.1 × 26.2 × 25.8 cm
Inscribed in blue with interlaced *LL*s, with (below) the mark of the gilder Jean-Pierre Boulanger (*fl.*1754–85)
RCIN 298
Acquired by George IV

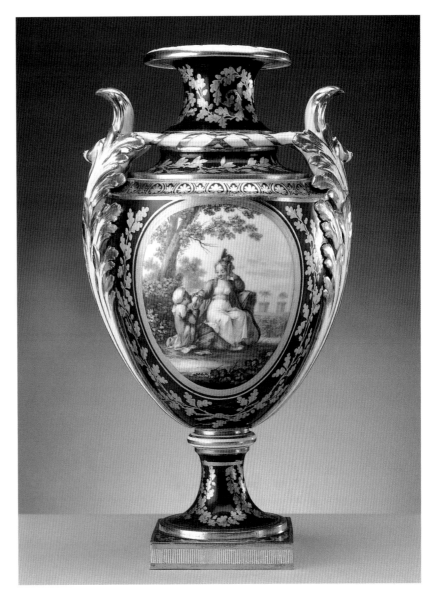

Sèvres

Vase (vase à gorges or vase à trois gorges), *c.*1773

There are two unusual design features in this vase: the three cavetto mouldings of the neck; and the manner in which the reeded moulding separating the middle from the upper cavetto moulding, seemingly bound with a gold ribbon, is looped at either end round the acanthus branch handle, where it breaks away to form a plume.

When George IV bought this vase and its pair from the London dealer Robert Fogg in 1818, they were part of a three-piece garniture (including RCIN 4967). While Fogg may have put the garniture together himself, the decoration, frames, gilding and plinths suggest that all three pieces may have been designed as one piece. It is likely that Louis XV bought this garniture in 1773.

Soft-paste porcelain; 34.6 × 18.6 × 15.4 cm
RCIN 36109.1
Purchased by George IV when Prince Regent

SÈVRES

Garniture of three vases (vases Duplessis), 1779

This garniture was purchased by Queen Marie-Antoinette for 2,400 *livres* at the end-of-year sale at Versailles in December 1779. By 1793 the central vase had already been separated from the two smaller vases. It remained unlocated until its purchase by HM The Queen in 2004. The two side vases had been in the Royal Collection since 1817, when they were acquired by the Prince Regent (later George IV).

The collective name by which the two smaller vases were known in the artists' ledger and kiln records – *vases Duplessis à monter* – clearly indicates that they were made to be fitted with mounts. The reference is to Jean-Claude-Thomas Duplessis (son of Jean-Claude), who supplied gilt-bronze mounts to the manufactory from 1774 to 1783. It is possible that he also supplied models of vases for the Sèvres manufactory.

The Sèvres records provide details of manufacture of the garniture. The three pieces were fired in the enamel kiln on 21 November 1779. The names of the painters and gilder involved were noted, with their areas of responsibility: Charles-Eloi Asselin for the *chinoiserie* scenes; Jean-Armand Fallot for the birds; Vincent Taillandier for the ground pattern (*fond pointillé*); and Henri-Martin Prévost for the gilding. For the figures and birds selective use of prints seems to have been made by both Asselin and Fallot. One of the figures was based on an engraving by Gabriel Huquier after François Boucher, while one of the birds derives from an engraving by François-Nicolas Martinet entitled *L'Honoré de Cayenne* included in the Comte de Buffon's folio and quarto editions of *Histoire Naturelle des Oiseaux* (1770–86).

Although less enthusiastic about Sèvres porcelain than Louis XVI, Marie-Antoinette nevertheless made some important and expensive purchases. As white and gold were her favourite colours in interior decoration, this garniture, with its white ground and gilt bronze mounts, suited her taste admirably and would have fitted in well in her private apartments at Versailles.

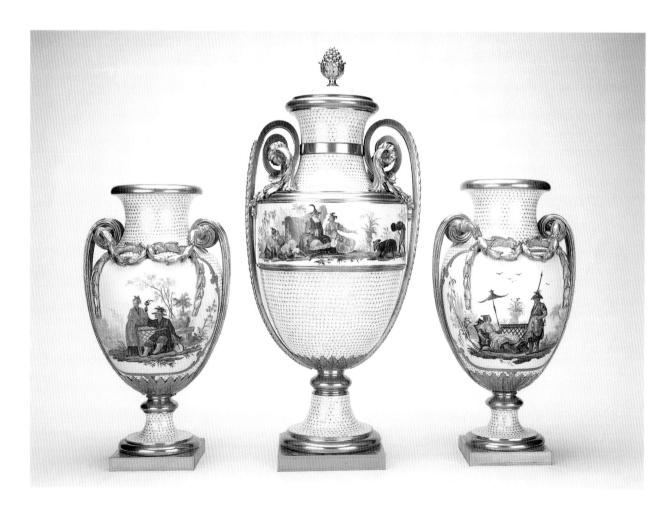

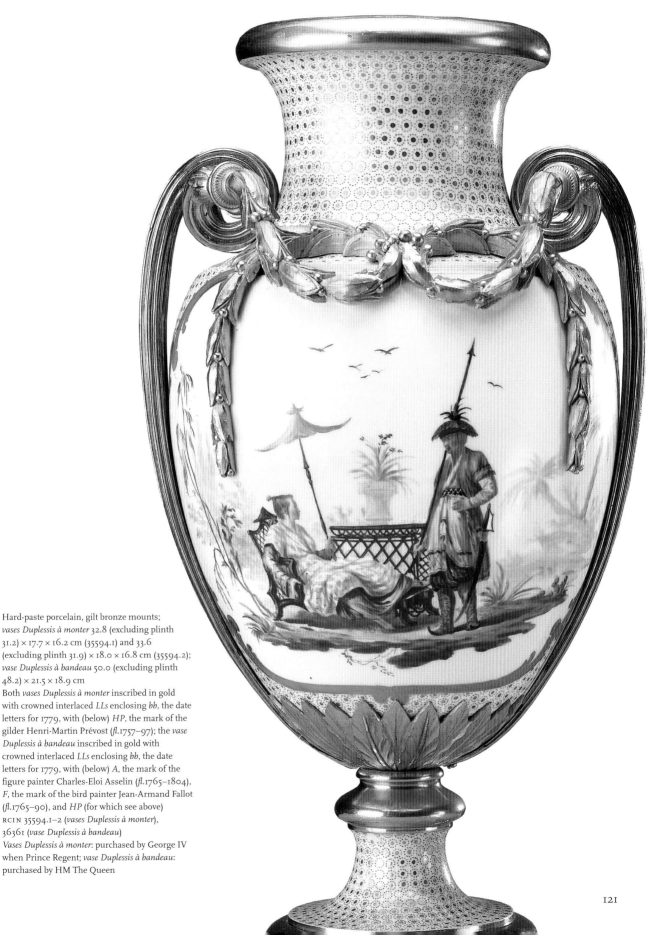

Hard-paste porcelain, gilt bronze mounts;
vases Duplessis à monter 32.8 (excluding plinth
31.2) × 17.7 × 16.2 cm (35594.1) and 33.6
(excluding plinth 31.9) × 18.0 × 16.8 cm (35594.2);
vase Duplessis à bandeau 50.0 (excluding plinth
48.2) × 21.5 × 18.9 cm
Both *vases Duplessis à monter* inscribed in gold
with crowned interlaced *LL*s enclosing *bb*, the date
letters for 1779, with (below) *HP*, the mark of the
gilder Henri-Martin Prévost (*fl.*1757–97); the *vase
Duplessis à bandeau* inscribed in gold with
crowned interlaced *LL*s enclosing *bb*, the date
letters for 1779, with (below) *A*, the mark of the
figure painter Charles-Eloi Asselin (*fl.*1765–1804),
F, the mark of the bird painter Jean-Armand Fallot
(*fl.*1765–90), and *HP* (for which see above)
RCIN 35594.1–2 (*vases Duplessis à monter*),
36361 (*vase Duplessis à bandeau*)
Vases Duplessis à monter: purchased by George IV
when Prince Regent; *vase Duplessis à bandeau*:
purchased by HM The Queen

Garniture of three vases (vases chinois), 1780

This garniture incorporates a pair of vases and a third, larger vase, recorded in the Sèvres archives. In 1780 Nicolas Schradre was paid 480 *livres* for decorating the three vases. They were fired in the kiln for painted decoration on 10 December 1780 and were bought anonymously at the end-of-year sale in Versailles for 1,920 *livres*.

The most distinctive features in the decoration of the vases are the *chinoiserie* figures and diminutive scenes in the roundels and ovals on the neck, which seem to have been inspired by Meissen designs of the 1720s. The actual sources of inspiration are, however, French: Aléxis Peyrotte for the figures (from Gabriel Huquier's *Second livre de cartouches chinois*) and Jean Pillement for the miniature scenes. Part of the attraction of these vases for the future George IV must have been their Chinese appearance.

In 1818 they were sent to Brighton Pavilion, which he was transforming into a 'vision of Cathay'. He later changed his mind. Perhaps he felt that their delicate decoration and miniature-like scenes clashed with the plain celadon vases enriched with elaborate gilt bronze mounts at Brighton. By 1826 the garniture was back at Carlton House, with the rest of George IV's Sèvres porcelain collection.

Hard-paste porcelain, gilt bronze bases; side vases 38.5 (excluding base 35.8) × 15.1 × 12.8 cm (36076.1) and 38.4 (excluding base 35.7) × 15.1 × 12.9 cm (36076.2); centre vase 50.0 (excluding base 46.5) × 22.4 × 18.5 cm
Each piece inscribed in red within the foot (and within the cover of the centre vase) with crowned interlaced *LLs* enclosing *CC*, the date letters for 1780, with (below) the mark of the painter Nicolas Schradre (*fl.*1773–85)
RCIN 36076 (side vases), 36075 (centre vase)
Purchased by George IV when Prince Regent

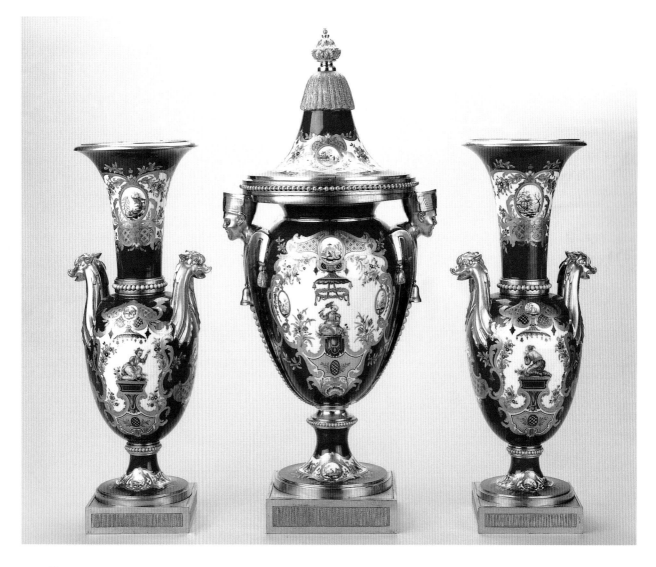

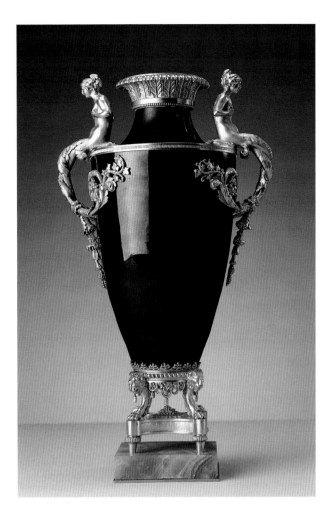

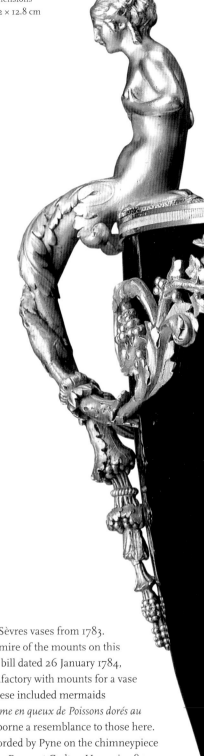

Hard-paste porcelain, gilt bronze
mounts, onyx stand;
overall height 35.0 cm; dimensions
excluding stand 32.7 × 19.2 × 12.8 cm
Not marked
RCIN 253
Purchased by George IV
when Prince Regent

Sèvres

Mounted vase (vase à monter), c.1785

The beauty of this piece lies in its simplicity of shape and
delicacy of colouring – a clouded brown-black ground in
imitation of lacquer – which sets off to full advantage the
finely chased gilt bronze mounts. These include mermaid
figures, lion's paw monopode legs and pierced and tasselled
lambrequins. The fitting of mounts to porcelain, which was
introduced at Sèvres c.1764, was no doubt inspired, in a spirit of
emulation, by the popularity of mounted oriental porcelain vases
in the first half of the 18th century. This vase and its pair (also in
the Royal Collection) were clearly designed for mounts. The hole
in the bottom through which the spindle passes was pierced
when the vase was still in its biscuit state whereas, paradoxically,
the two holes in the shoulders for the attachment of mounts
were drilled after glazing.

The shape of this piece resembles a drawing of a vase dated
4 March 1785, which, on the evidence of the annotations, was
designed by Louis-Simon Boizot and was intended to be fitted
with mounts supplied by Pierre-Philippe Thomire, the principal
maker of mounts for Sèvres vases from 1783.
An attribution to Thomire of the mounts on this
vase is tempting. In a bill dated 26 January 1784,
he supplied the manufactory with mounts for a vase
priced at 500 *livres*; these included mermaids
(*Garniture à petite femme en queux de Poissons dorés au
matte*) and may have borne a resemblance to those here.

The vases were recorded by Pyne on the chimneypiece
of the Golden Drawing Room at Carlton House in 1817.
They were still at Carlton House when the Pictorial Inventory
was made ten years later.

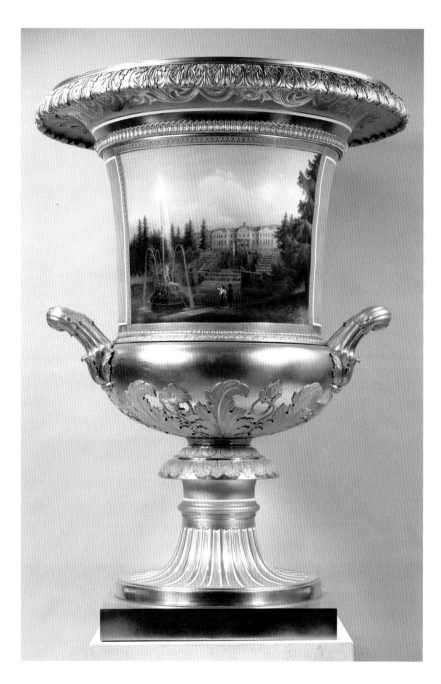

Hard-paste porcelain, gilt bronze mounts;
142.0 × 108.0 cm
Painted (in black inside the bell) with an imperial
crown above *JTC*. Signed and dated within each
reserve scene *N. Korniloff / 1844*. Inscribed (with a
burnishing tool) on the gilt borders of the painted
reserves *Peterhoff L'an 1844* and *Czarskoe Selo
L'an 1844*
RCIN 41230
Presented to Queen Victoria and Prince Albert
by Tsar Nicholas I

ST PETERSBURG
Vase, 1844

The Russian Emperor Nicholas I (1796–
1855; r. 1825–55) made a State Visit to
Britain in June 1844, staying at both
Buckingham Palace and Windsor Castle.
This was the first visit of a ruling Tsar
since that of Alexander I in 1814, at the
time of the allied celebrations after the
defeat of Napoleon. Nicholas I was
determined to make the most of his
short visit. He called on the Duke of
Wellington at Apsley House, and
attended a banquet at Chiswick given in
his honour by the Duke of Devonshire.
He twice attended Ascot races, donating
a cup worth £500 to be run for annually,
and contributed towards the completion
of Nelson's Column. Having resisted the
proposed visit for some time, the Queen
warmed to the Tsar but found him
humourless and lacking in education.
Subsequently, when a number of the
ground floor reception rooms at
Buckingham Palace were refitted in
1849, one of them was named the 1844
Room in memory of the visit, with the
double-headed eagle prominent in the
heraldic plasterwork of the ceiling.

On his return to Russia, the Tsar sent
this vase (with its marble pedestal) and
a mosaic table to the Queen and Prince
Albert. When the gifts arrived at
Windsor, the Queen pronounced the vase
'splendid and immense'. It is of 'Medici'
form and was made at the Imperial
Porcelain Manufactory in St Petersburg,
decorated with matt and burnished gold,
with large-scale views of the imperial
palaces of Peterhof and Tsarskoe Selo
on either side, painted by N. Korniloff
(d. 1852). The handles and the moulding
around the rim are of gilt bronze.

The vase was placed in the window bay
of the Green Drawing Room at Windsor
Castle. Soon after Queen Victoria's death
it was removed to Osborne. Following the
restoration of Windsor Castle after the
1992 fire, the vase and its pedestal were
returned to Windsor and placed in the
State Dining Room.

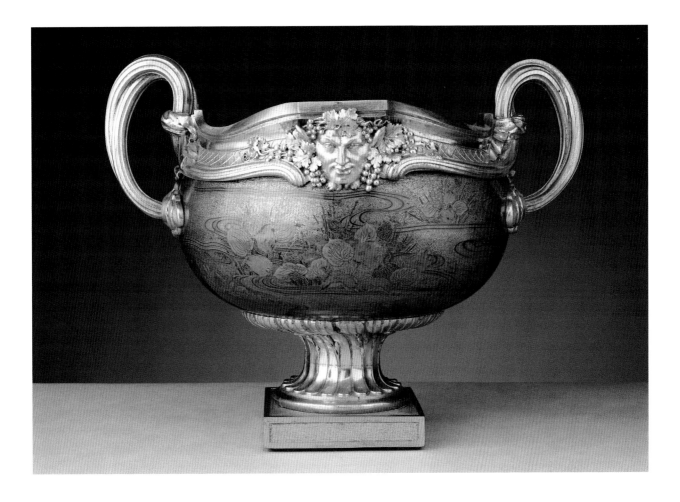

JAPANESE

Bowl, (?)late 17th century (French mounts, *c.*1760)

This bowl is one of a pair which combine Japanese lacquer and French mounts of equally high quality. The bowl was made by building up numerous very thin layers of lacquer on a thin wooden base. The lacquer is decorated with swirling eddies, herons and plants against a granular gold (*nashiji*) ground. Lacquer objects of this quality were not made for the export market and this may have reached the West by means of the private trading permitted to officers of the various East India companies. The heavily cast and finely chased gilt bronze mounts consist of nine separate castings. The deep rim is centred on a bacchic mask surrounded by grapes and vine leaves, and appears to be tied at the sides by the thick, sinuous double handles. They terminate in a mount in the form of overlapping clouds or petals of descending sizes, a rare case in which the designer of the mounts appears to have adopted a convention of oriental art. In most cases the *marchands-merciers* were content either to transform the oriental vase into a Western form, or to invent spurious *chinoiserie* motifs. This bowl is raised on a tapering foot of a standard early neo-classical design, equally likely to be found supporting a vase or urn of Sèvres porcelain or hardstone.

The bowl and its pair stood on cabinets flanking the chimney-piece in the library at Brighton Pavilion. They are listed in 1826 as '2 very fine circular gold spangled wood Japan bowls, raised leaves and flowers; finely mounted in chased scrolled rims, satyr masks with fruited Vines twisted handles, & fluted stem, on square panneled sanded bases. 1 ft. high'.

Lacquer and gilt bronze; 29.8 × 38.7 × 31.4 cm
RCIN 3154
Probably purchased by George IV

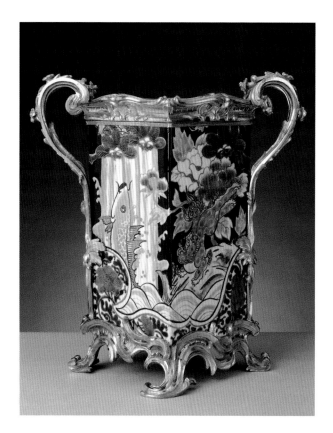

JAPANESE

Vase, c.1700–20 (French mounts, c.1750)

This vase is one of a pair. They probably originated as flasks or canisters with low shoulders and circular mouths and lids, which were cut down for the purpose of mounting. This form of container was based on European, especially Dutch, pottery or glass spirit flasks, and was made in large numbers for export from Japan from the end of the 17th century. The decoration – with carp leaping in a waterfall and a lion with peonies in underglaze blue and enamels on a black ground – is rarer on Japanese porcelain than Chinese (the so-called *famille noire* style). The French gilt bronze mounts have been designed with some care in relation to the very colourful and asymmetric decoration. Thus the short 'C'-scrolls of the foot mounts respect the curving border lines of the painted scenes, and the painted flowers seem to sprout from the gilt bronze stems which run up the handles.

The vases are probably those recorded at Brighton Pavilion in 1826 as 'A pair of square Japan China Jars, with fish, flowers, Kylins & green enamelled leaves mounted diamond shape, in rich ormolu top and bottom scroll and leaf borders and handles'.

Porcelain, gilt bronze; 29.5 × 28.0 × 20.5 cm
RCIN 12
Probably purchased by George IV

Right:

CHINESE

Pot-pourri vase, c.1725–50 (French mounts, c.1750)

This single Chinese celadon jar was probably originally of the ovoid form with a raised neck and lid known as a 'ginger jar'. It has been cut at the neck and the raised section removed from both the jar and the lid. It is decorated with deer and with pine, bamboo and prunus, the 'three friends of winter'. After importation into France the jar was mounted as a pot-pourri vase with six separate gilt bronze castings, probably made by the lost-wax process and very well chased and burnished. The eight 'eyes' in the neck mount allowed the escape of the scent contained within the jar.

In the inventory of Madame de Pompadour's possessions taken after her death in 1764, her apartments at the Hôtel d'Evreux in Paris contained (in the *première antichambre*) '*un pot-pourri d'ancienne porcelaine Celadon avec des desseins bleus, garnis de deux ances de bronze doré*' valued at 100 *livres*. A further pair of similar vases was included in the L.-J. Gaignat sale of 1769 (lot 95). The present vase was probably that listed in store in the 1826 inventory of Brighton Pavilion as 'A Pot Pourri bowl & cover sea green, blue & white trees & flowers ormolu flower top pierced rim scroll handles & base 14 In'. All the mounts appear to have been regilded.

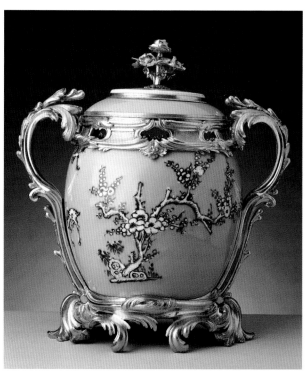

Porcelain, gilt bronze; 34.6 × 31.7 × 21.6 cm
RCIN 2306
Probably purchased by George IV

John Agar (c.1770–c.1835)
after Augustus Charles Pugin (1769–1832)
and James Stephanoff (1789–1874)

Brighton Pavilion: The Music Room, 1824

Etching with aquatint, printed in colours
and hand coloured. 26.5 × 34.8 cm
RCIN 1150260.ap

CHINESE
*Pagoda, c.*1810 (English additions and mounts, 1817–18)

This colossal Chinese tower (one of four), festooned with golden bells, fish and *kylin* dogs and topped with snake-entwined arrow-heads piercing winged dragons, might be said to represent the apogee of the taste for *chinoiserie* in England. Their already exceptional size was further increased by the addition in England of their gilt finials and Spode bases, designed to fit them to the proportions of the Music Room at Brighton Pavilion, where the ceiling rose to a height of 41 feet [12.5 m]. They stood against the window piers, while a slightly smaller pair of pagodas (RCIN 2400.1–2) was placed on either side of the chimney-piece. In the Music Room, decorated under George IV's direct supervision by Frederick Crace, pagodas could also be seen in the picturesque wall panels and in the red-japanned door panels.

In 18th-century European art and architecture the pagoda was perhaps the most universal symbol of the Orient. Ivory and porcelain models were exported from China to the West. This pagoda consists of 10 diminishing hexagonal tiers of Chinese *famille rose* porcelain with eight protruding roofs, on a hexagonal blue-and-white base bordered with 'bamboo' mouldings. Three of the round-headed doors of each stage are open, and each stage is bordered by a pierced porcelain balustrade.

Hard-paste porcelain and bone china, gilt bronze; 518.5 × 104.0 × 87.0 cm
Marked in blue on the back of the panels of the base *SPODE / STONE CHINA*
RCIN 1
Purchased by George IV when Prince Regent

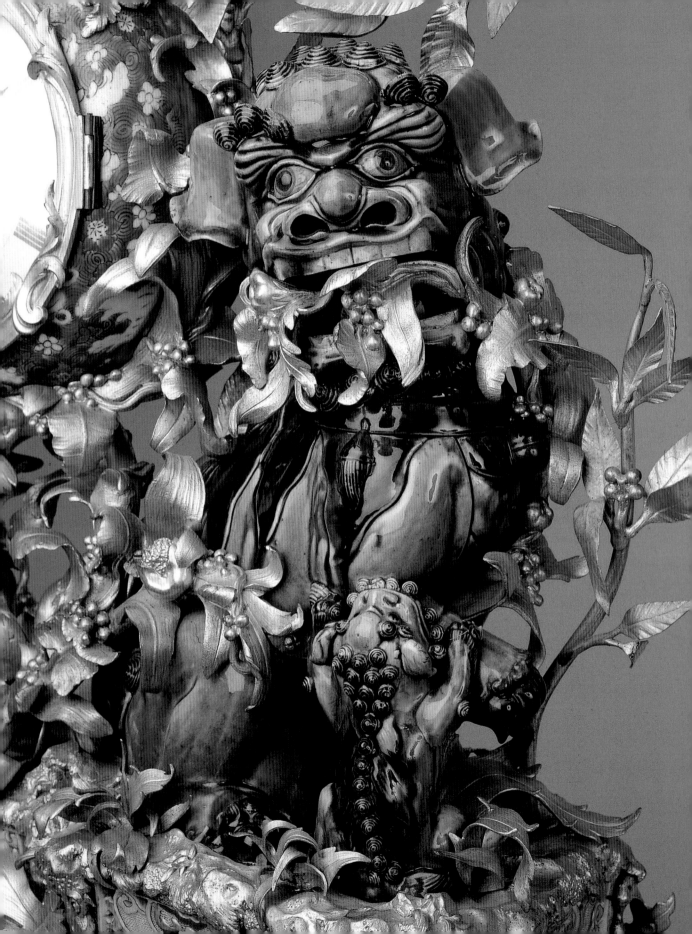

French
The 'Kylin' clock, mid-18th century (English mounts and base, 1821–23)

Entwined within an arbour of lotus, berried stems, exotic fruits and wind-blown leaves fashioned in gilt bronze, are several pieces of oriental porcelain: two large, early 18th-century Chinese turquoise lions support a mid-17th-century Chinese *famille verte* bowl, turned on its side, with its base replaced by a clock dial. The word *'kylin'* refers to a composite mythical beast, but was probably wrongly applied to the lions during the 19th century. Above the dial is a late 17th-century Japanese Arita group of a seated, grimacing *putai* between two boys. The five panels of porcelain around the base were probably cut from a Chinese (Kangxi) teapot stand of *c.*1720.

This piece was probably purchased by George IV for the fitting-out of Brighton Pavilion around 1820. The following year the royal clock-maker B.L. Vulliamy fitted a new eight-day Spring Clock movement. The *Kylin* clock was recorded in the Saloon at Brighton in 1823 but in 1847 it was taken to London.

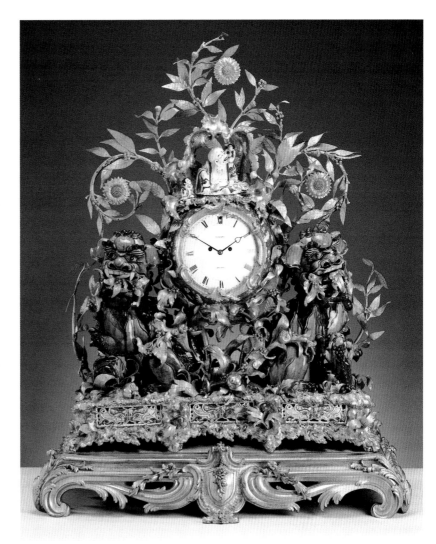

Porcelain, gilt bronze; 111.7 × 81.3 × 36.9 cm
RCIN 2867
Purchased by George IV

JAMES ROBERTS (c.1800–1867)

The Pavilion Breakfast Room at Buckingham Palace, 1850, with the 'Kylin' clock on the mantelpiece

Watercolour and bodycolour with gum arabic; 25.6 × 38.0 cm
Signed and dated *J Roberts / May 1850*
RL 19918

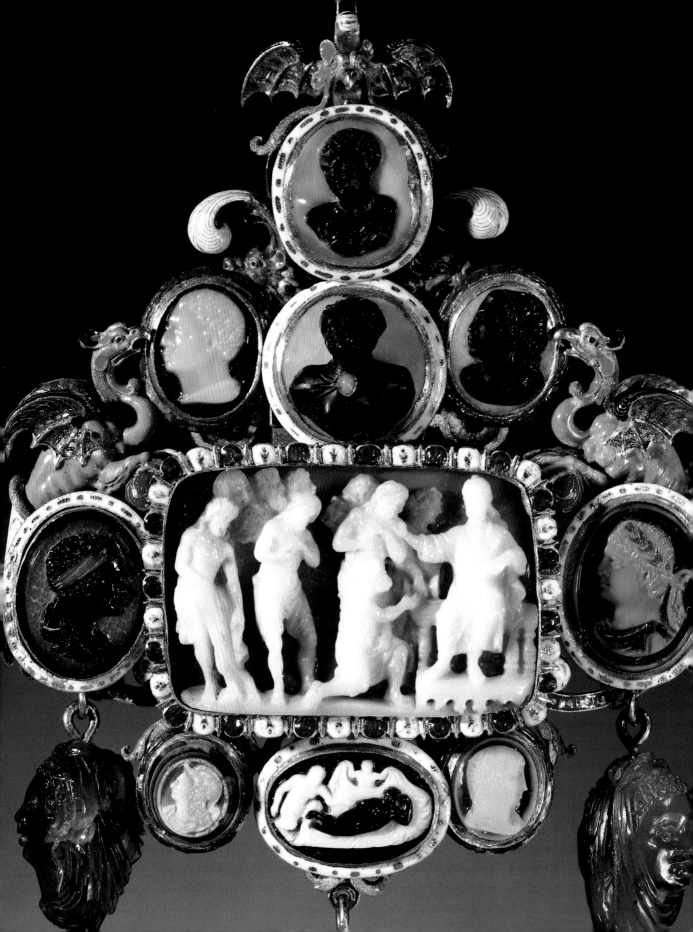

GEMS AND JEWELS

Although by no means as extensive as some of the great European royal and princely collections, the European gems (cameos and intaglios) and historic jewels – the precious objects distinct from the Crown Jewels and from the Sovereign's personal jewellery – in the Royal Collection nonetheless include several pieces and groups of international importance.

The collection of gems ranges from classical antiquity to the 19th century. The finest early piece is undoubtedly the 1st-century AD cameo portrait of the Emperor Claudius (p. 132), which is known to have been in the collection of Charles I. Most of the cameos and intaglios date from the 16th to the 18th centuries and include virtuoso carvings, superb portraits and fine work by Italian gem-cutters.

The jewels are equally varied and range from precious survivals such as the 16th-century enamelled gold hat badge traditionally associated with Henry VIII (p. 132) and the spectacular Darnley Jewel (p. 133), to the so-called Queen Elizabeth emerald with its 19th-century Holbein-style setting. Most of the cameos and intaglios are framed, some simply in plain gold mounts, others (p. 137) in elaborate enamelled settings transforming them into pieces of jewellery.

Documentary evidence about the formation of the collection is patchy. We know that Henry VIII possessed important examples, but none survives in the Royal Collection today. Charles I's collection was largely dispersed. However, his son Charles II reassembled a fine collection of gems and jewels, seen by the diarist John Evelyn in 1660. Recent research has shown that Queen Caroline (1683–1737) was also a discriminating collector of cameos (pp. 134, 137); George III added a major group of gems when he bought the collection of Consul Smith in 1762; and George IV purchased numerous cameos.

As well as adding important and historic pieces to the collection, most notably the Darnley Jewel from Horace Walpole's collection at Strawberry Hill (p. 133), Queen Victoria (under the guidance of Prince Albert) was the first sovereign to organise the collection in a historical manner. Queen Mary continued this work in the 20th century, commissioning a catalogue of additions.

From the earliest times, precious gems, especially personal jewellery, have been used to enhance the sense of magnificence associated with the monarchy. Elizabeth I was always depicted with a formidable display of jewellery. This tradition continued with Charles I through the later Stuarts and early Hanoverians to Queen Caroline, some of whose collection (p. 137) was considered equal to those of any continental court.

In addition to amassing huge quantities of personal jewellery (pp. 138, 139), George IV appropriated the best part of his mother's collection, including many stones deemed by her to belong to Hanover. This violation of Queen Charlotte's will led to the lawsuit which eventually caused George IV's niece Queen Victoria to lose some of her best jewellery to her first cousin (George IV's nephew), the King of Hanover (p. 141).

As the head of a vast and powerful empire, Queen Victoria received gifts from rulers all over the world wishing to cement their relationship with the British Crown. From India came the celebrated Koh-i-Nûr, the 'Timur Ruby' (p. 143), the Lahore Diamond (p. 141) and Sher Singh's emeralds (p. 143). For the Queen, the arrival of such marvels from India made some amends for the loss of her grandmother's jewels.

The division between the Sovereign's personal jewellery, the historic gems and jewels, and the Crown Jewels is fairly arbitrary and there are inevitably some overlaps. Thus, the history of the Cullinan Brooch (p. 141) is now inextricably tied to that of the Imperial State Crown and the Sovereign's Sceptre. Likewise, the history of the stones now forming Queen Victoria's collet diamond necklace and earrings (p. 141) goes back to the period of George II and George III, embracing important chapters in the history of Britain and Hanover on the one hand and of the Indian Empire on the other.

Details: English(?), pendant with cameos, early 18th century (see p. 137)

Antique and Renaissance Jewellery

Roman
Cameo head of the Emperor Claudius, c.43–45 AD

This idealised portrait of Claudius, who reigned from 41 to 54 AD, is the finest ancient cameo in the Royal Collection. The monumental grandeur and formality of the image, combined with the crisp and highly polished cutting of the four strata or layers of this unusually large stone, place it in the top rank of surviving portrait cameos from imperial Rome. It has been suggested that the stone may have been cut to celebrate Claudius's victory in Britain in 44 AD.

The entry of this cameo into the Royal Collection is unrecorded, but it was in Charles I's collection, and was possibly inherited from his elder brother, Henry, Prince of Wales. We know from Abraham van der Doort's inventory of Charles I's collection, completed in 1639, that the cameo was broken by the notorious Lady Somerset during her husband's tenure as Lord Chamberlain to James I (1613–15).

The damaged state of the stone may have prevented its sale during the Interregnum (1649–60) and ensured its survival in the Royal Collection. It was seen by John Evelyn at Whitehall in 1660 and may be identified with the broken antique cameo seen by Horace Walpole at Kensington Palace in 1764.

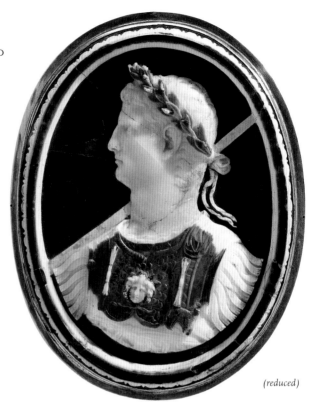

(reduced)

Onyx, gilt copper mount; 19.0 × 14.6 cm
(excluding mount)
RCIN 65238
Acquired before 1615

Gold, enamel; diameter 4.3 × 0.9 cm
RCIN 442208
Said to have belonged to Henry VIII

Flemish(?)
Hat badge, c.1520

The very fine detail and delicate high relief enamelling of this exceptional jewel, depicting an equestrian St George in armour slaying the dragon, suggest that it may have been made in the Southern Netherlands, perhaps in the region of Antwerp. In this area, the great Burgundian tradition of enamelling survived into the period of Habsburg rule, as seen on a small number of similarly decorated early 16th-century reliefs using the same enamelling technique. In this example, it may be that the unusual iconography of the saint, shown bearded and with flowing hair, is a deliberate reference to the 12th-century Emperor Frederick Barbarossa. The badge, which is supposed to have been given to Henry VIII by the Emperor Maximilian I (r. 1493–1519), would have been fixed to a hat or cap, as seen in Horenbout's portrait of Henry VIII (p. 60). The first reference to the jewel appears to be 1830; its date of acquisition is unknown, but it is the type of object that would have appealed to George IV.

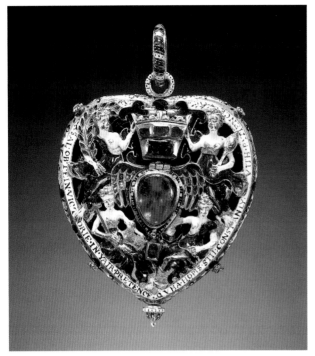

Front

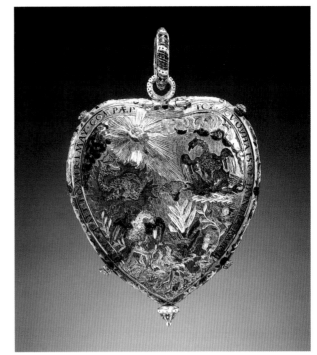

Back

Scottish(?)
The Darnley Jewel, c.1571–78

This celebrated jewel, or 'tablet' (in the language of the 16th century), which was intended to be worn at the neck or on the breast, was probably made for Lady Margaret Douglas (1515–1578) following the death in 1571 of her husband Matthew, Earl of Lennox, Regent of Scotland. Lady Margaret was the granddaughter of Henry VII, half-sister of James V of Scotland and first cousin of Elizabeth I. Through her elder son Henry Stewart, Lord Darnley, who married her niece Mary, Queen of Scots, in 1565, Lady Margaret was the grandmother of James VI of Scotland and I of England.

The iconography of the jewel is unusually complex. Twenty-eight emblems and six inscriptions in old Scots, alluding to the turbulent history of the Lennox family and perhaps to the hopes and ambitions of Matthew and Margaret Lennox for their grandson James, born in 1566, are incorporated in the design. The decoration, mainly in translucent enamel over a textured gold surface (*basse-taille*), and the construction, with interior compartments concealing further emblematic devices, are equally elaborate. The place of origin of the jewel is not known, but workmanship of this quality was certainly available in Edinburgh in the mid-16th century.

The first serious research into the history and iconography of the jewel took place only after it was acquired by Queen Victoria from Horace Walpole's famous collection at Strawberry Hill in 1842. The Queen, alerted to the sale by her Prime Minister Lord Melbourne, purchased both the Darnley Jewel and Anne Boleyn's clock (RCIN 30018). Walpole, who described the early provenance of the jewel correctly, never revealed how he had come by it. He valued it so highly ('I never let it go out of my own hands') that he refused even to allow it to be drawn for the Society of Antiquaries of Scotland. By contrast, the Queen commissioned an illustrated account from the antiquarian P. Fraser Tytler, published in 1843. Fraser Tytler suggested that the jewel might either have been made for James VI and I – unlikely in view of its feminine nature – or have passed by will from Lady Margaret to her grand-daughter, the unfortunate Lady Arabella Stewart (d. 1615), and thence perhaps to Arabella's widower, William Seymour, 2nd Duke of Somerset (d. 1660). In 1855, on a visit to the British Museum, it was suggested to Prince Albert that the jewel could have been the 'Poor Remembrance' bequeathed by Elizabeth (née Talbot), Countess of Lennox (daughter-in-law of the original owner and mother of Arabella), to Elizabeth I in 1582. This intriguing suggestion remains unsubstantiated.

Gold, enamel, rubies, emerald and a false sapphire; 6.6 × 5.2 cm
RCIN 28181
Purchased by Queen Victoria

English(?)
Cameo of Elizabeth I, c.1575–85

Sardonyx cameos showing Elizabeth I (r. 1558–1603) in profile have survived in considerable numbers: six (including this one) of this large size and superb quality are known. These cameos (and the smaller versions of them) were distributed by the Queen as diplomatic presents or as a sign of high favour to members of her court. In this respect such apparently unageing images, which are always of the same general format, would certainly have contributed to the burgeoning cult of the Virgin Queen (see p. 62). Their place of manufacture and the gem-cutter or cutters responsible are, however, still unidentified. If an English workshop was involved, as seems likely, it must have been under the direction of an experienced foreign artist or, at the very least, an English artist trained abroad. Julien de Fontenay (*fl.*1575–1600), who

is known to have been sent from France by Henry IV to portray Queen Elizabeth, is one of a number of possible candidates. The artist and musician Jerome Lanier owned a version 'cut by a famous Italian' which he showed to the diarist John Evelyn in 1653.

Together with several other cameos still in the Royal Collection (see pp. 134, 137), it appears that this piece belonged to Queen Caroline, consort of George II. It was noted by Horace Walpole in 1764 at Kensington Palace among a group of gems which are known to have formed part of the collection of this cultivated and learned Queen (who also owned cameo images of other members of the Tudor dynasty). It was probably while in her possession that it acquired the present 18th-century mount.

Sardonyx, gold mount; 6.7 × 5.5 cm
RCIN 65186
Belonged to Queen Caroline, consort of George II

North Italian
Cameo of the Adoration of the Magi, 16th century

This exceptional cameo exploits to the full the three contrasting strata – yellow, white and dark brown – of the oval agate from which it is made. Deep undercutting and careful use of the darker and lighter veins produce an extraordinary illusion – on a miniature scale – of space and perspective. The kings, their pages, a horse and a camel process from the right background to the left foreground, towards the Virgin and Child, giving a convincing sense of movement and animation to the familiar scene.

One of only a small number of cameos of religious subjects in the Royal Collection (see p. 137), this tour de force of the gem-cutter's art belonged to Queen Caroline and is first recorded in a posthumous inventory of her collection drawn up before 1755.

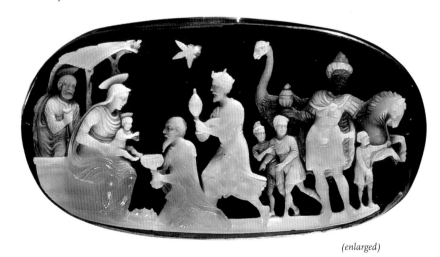

(enlarged)

Agate, silver-gilt mount; 3.5 × 6.5 cm
RCIN 65175
Belonged to Queen Caroline, consort of George II

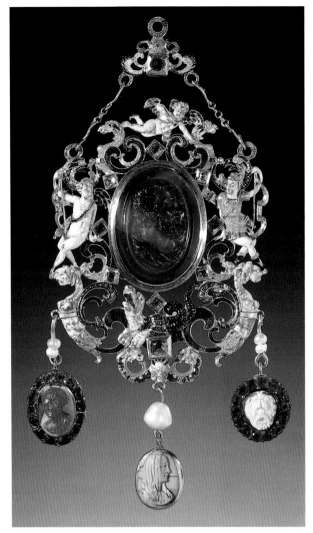

Front (enlarged)

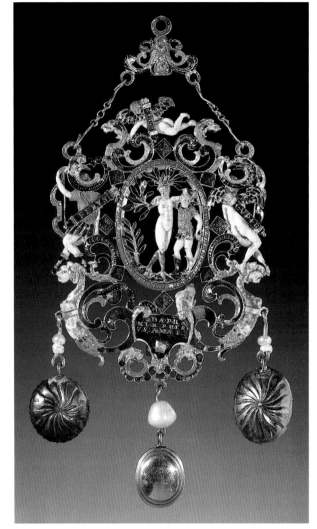

Back (enlarged)

ENGLISH(?)

Pendant jewel, 2nd half of the 16th century

In its original form, this elegant Mannerist-style jewel would almost certainly have held a locket in the centre, perhaps containing a miniature, in place of the present late 18th-century onyx cameo of a bearded male head. The iconography of the enamelled openwork frame – incorporating the figures of Apollo and Daphne in the centre of the reverse, and Cupid at the top – taken with the inscriptions, suggests the theme of unrequited love, and this theme was presumably echoed in the original contents of the locket. The place of manufacture of the pendant is uncertain; the design owes something to the court style of Etienne Delaune (*c.*1518–1583), but features such as the setting of jewels on the enamel may point to an English origin.

Although nothing is known of the early history of the jewel, the three pendant cameos, two of onyx of probable 16th-century date, and one of turquoise possibly slightly later, belonged to Consul Smith, whose collection was acquired by George III in 1762. They were probably added to the jewel in the reign of George IV.

Gold, enamel, diamonds, pearls, emeralds,
rubies, onyx, turquoise; 11.8 × 5.5 cm
The back inscribed *DAPH / NEM: PHEB / VS: AMAT;
FERVS; CVPID;* and *CPID*
RCIN 65254
Pendant cameos purchased by George III;
possibly assembled for George IV

SPANISH(?)
Devotional pendant, c.1630–40

The pelican in her piety, scoring her breast to feed her young with her own blood – to symbolise either Christ's sacrifice, or Charity – together with the phoenix, symbol of the Resurrection or of Chastity, were among the most familiar and potent of devotional images in Christian (especially Catholic) Europe from the late Middle Ages to the 17th century. Both birds were regularly used on personal jewellery. Henry VIII and Elizabeth I, for example, owned pelican or phoenix jewels. In this example, features such as the design of the scroll-work and the manner of setting the gems point to a continental, probably Spanish origin.

Gold, enamel, silver, rubies, diamonds, pearls; 6.5 × 3.7 × 1.3 cm
RCIN 65255
Belonged to Queen Victoria

Pendant with cameos, early 18th century (with antique, 16th- and 17th-century elements)

Originally a 17th-century enamelled pendant with a central scene surrounded by jewels (the fixings for which are visible beneath the present arrangement of cameos), this piece presumably became damaged and was reused as a vehicle for the display of 13 assorted cameos, probably in the early 18th century (certainly before 1737). An English (or possibly French) origin for the enamel (of which the dragons are the principal survivors) has been proposed. The cameos vary in date and quality. The large chalcedony central relief, representing Joseph and his brothers, is probably a 16th-century version of the 13th-century cameo of the same subject in the Hermitage, and may have been cut in the Veneto. The head of the Emperor Commodus (d. 193 AD), immediately to the right of centre, is antique. The remainder – portraying emperors, Africans, Minerva, goddess of Wisdom, and a nymph with satyrs – are Italian, 16th century.

Until recently it was thought likely that this pendant was a 19th-century confection, although a possible connection with a jewel listed by Horace Walpole in 1764 at Kensington Palace had been suggested. With the rediscovery of the posthumous inventory of the possessions of Queen Caroline, drawn up before 1755, the connection of the jewel in its present form with Queen Caroline is now firmly established (see also p. 134). It is not impossible that the transform-ation was carried out for her.

Gold, enamel, chalcedony, onyx; 12.5 × 8.9 cm
RCIN 65256
Belonged to Queen Caroline, consort of George II

See details on pp. 130–31

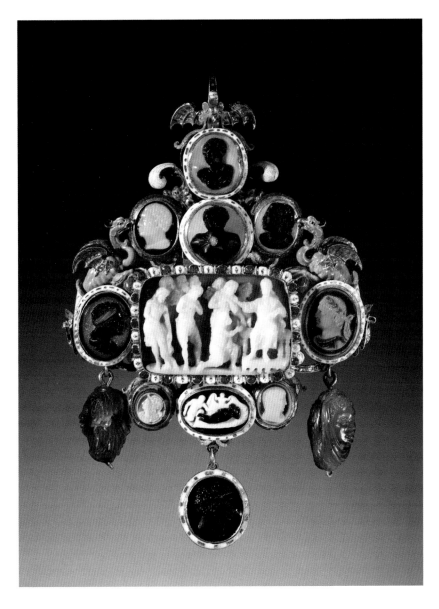

PERSONAL JEWELLERY AND INSIGNIA

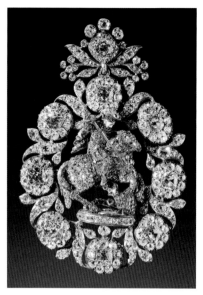

(reduced)

ENGLISH
Garter collar badge (Great George), before 1750(?); altered 1765(?) and 1858

Founded in 1348 by King Edward III, the Order of the Garter is the oldest surviving order of chivalry in the world. The 24 Knights and Lady Companions are appointed by the sovereign.

George III had a particular reverence for the Order. The King's insignia included this Garter collar badge, probably one of George II's two jewelled Georges. In 1765 two pieces of George III's insignia were altered and enriched by his Swiss-born jeweller, John Duval (fl.1748–1800). The fine 'paving' of the figure of St George with small diamonds may date from then.

After the success of the Hanoverian claim against Queen Victoria in 1857 (see p. 141), the nine large brilliant-cut diamonds around the figure of St George were removed by R. & S. Garrard & Co. The badge was then remade by Garrards with the present clusters, using lesser stones from the Queen's collection. This piece, one of several jewelled Georges in the Royal Collection, was worn by King George VI at his coronation in 1937.

Diamonds, sapphires, rubies, amethysts, gold;
11.6 × 7.8 cm
RCIN 441145
Probably made for George II

Right:
THOMAS GRAY (fl.1780–1800)
*Sash badge (Lesser George) of George IV
when Prince of Wales*, 1787–88

George IV's association with the Order of the Garter began remarkably early. He was invested at the age of 3 by his father George III on 26 December 1765 and installed at Windsor just before his ninth birthday, on 25 July 1771. That he enjoyed everything to do with the Order – when Prince of Wales, Regent or King – may be safely inferred from his possession of no fewer than 55 jewelled or enamelled Garter badges. This spectacularly lavish example was made by the fashionable London jeweller Thomas Gray. When first supplied to the Prince in 1787, the badge cost £403 15s. 6d. Gray reset it the following year, adding a further substantial number of diamonds at a cost of £420.

At this period Gray's firm stood high in the favour of the Prince of Wales; between 1786 and 1789 the Prince spent the colossal sum of £21,201 11s. 2d. with Gray, having only recently transferred his patronage from his father's jeweller, John Duval. On Gray's retirement around 1800, the Prince moved his patronage to Rundells, with whom he remained for the rest of his life.

The central cluster of the ribbon tie may have been replaced by Garrards in 1858 (see p. 141).

Diamonds, rubies, sapphires, emeralds, gold; 16.8 × 8.5 cm
RCIN 441151
Made for George IV when Prince of Wales

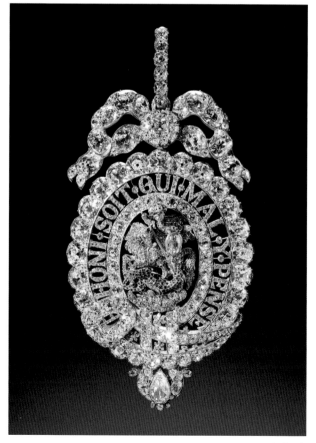

(reduced)

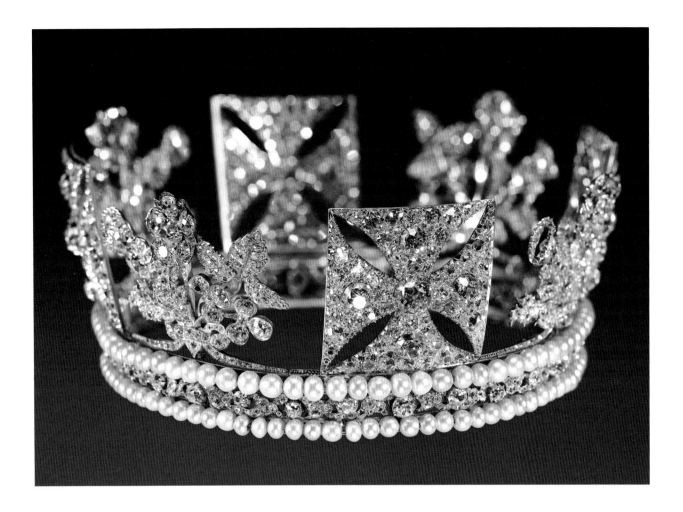

RUNDELL, BRIDGE & RUNDELL
The Diamond Diadem, 1820

From its frequent appearance on postage stamps and coins, this exceptionally beautiful head ornament, incorporating the national emblems of England, Scotland and Ireland, is probably the most familiar piece of Her Majesty The Queen's jewellery. Set with 1,333 diamonds, including a four-carat pale yellow brilliant in the centre of the front cross, the diadem has been regularly worn (and slightly modified) by queens regnant and consort from Queen Adelaide onwards. This feminine association belies its origin, since it was made for George IV's use at his famously extravagant coronation in 1821 (see p. 208).

The order for the diadem was placed with Rundells early in 1820 and work was complete by May. The design, probably by Rundells' chief designer Philip Liebart, reflects something of the discarded plan for George IV's Imperial State Crown, which was drawn up by Liebart in the same period and was to have included the national emblems in place of the traditional fleurs-de-lis.

Together with a diamond-studded loop (which was broken up to help make Queen Victoria's Garter armlet), the bill for the diadem amounted to the large sum of £8,216. This included an £800 hire charge for the diamonds – stones were regularly hired for use at coronations up to 1837 – computed on a percentage of the value of the stones. When the coronation had to be postponed for a year due to Queen Caroline's trial for adultery, a further hire charge was levied. Normally the stones would have been returned to Rundells after the coronation, but in this case there is no sign that the delicately worked diamond sprays and crosses, a masterpiece of the new transparent style of setting, have been disturbed. Equally, there is no evidence that the King purchased the stones outright, so it could be that the bill was met by a discreet barter of old stones from George IV's extensive collection.

Today the diadem is worn by Her Majesty The Queen when travelling to and from the State Opening of Parliament.

Diamonds, pearls, silver, gold; diameter 19 cm; 7.5 cm high
RCIN 31702
Made for George IV

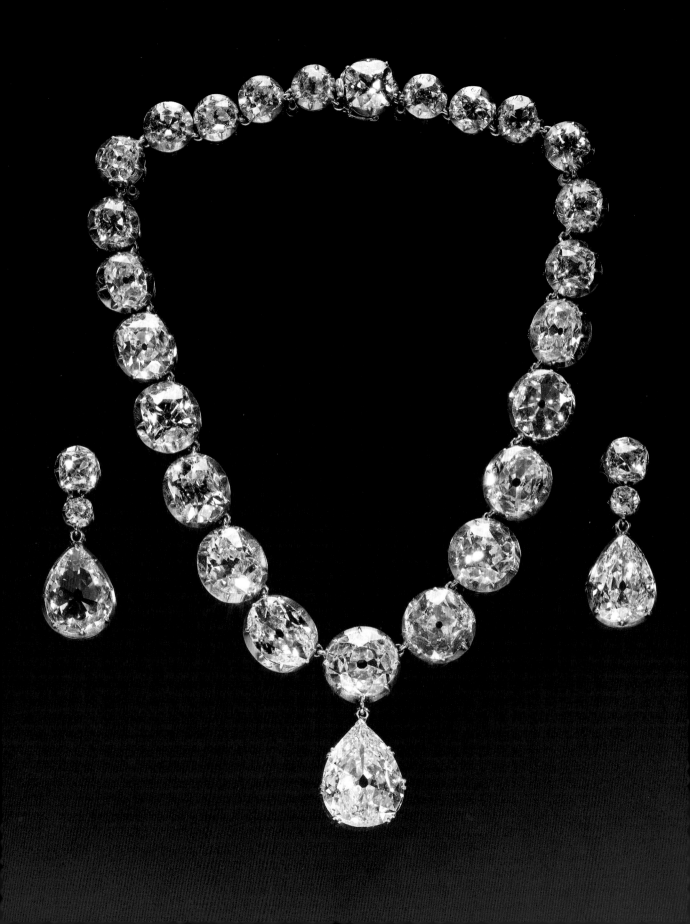

R. & S. GARRARD & CO.
*Queen Victoria's diamond necklace
and drop earrings*, 1858

This spectacular necklace is formed of 25 graduated cushion-shape brilliant-cut diamonds set in cut-down silver collets (settings) with gold spiral links, and a central drop-shaped pendant set in platinum. The nine largest stones in the necklace weigh between 11.25 and 8.25 carats and the pendant weighs 22.48 carats. The earrings comprise two larger cushion-cut stones matching those of the necklace, two smaller stones and two non-matching drop-shaped pendants, which are of approximately 12 and 7 carats.

Like almost all royal jewellery, the stones in this necklace and accompanying earrings have undergone a series of complicated transformations. The story begins in December 1857 when, as a result of a claim initiated by George III's fifth son, Ernest, Duke of Cumberland (from 1837 King of Hanover), Queen Victoria lost to Hanover a significant part of the family jewels she had regarded as her own. Greatly chagrined, she ordered Garrards to replace the lost jewels by taking stones from 'swords and useless things'. For this necklace, 28 stones were removed from two Garter badges (p. 138) and a sword hilt. At the same time, the central pendant of the 'Timur Ruby' necklace (p. 143), known as the Lahore Diamond, was made detachable for use as the pendant on this necklace; and two of the smaller pendants from the same necklace, originally the side stones in the Indian setting of the Koh-i-Nûr, were made detachable for use as earrings (with additional stones taken from an aigrette and a Garter star). The charge for making the necklace was £65 and for making up the earrings £23 10s.

In 1911, Queen Mary removed two stones from Queen Victoria's necklace to make solitaire earrings. She replaced them with three stones from another necklace of 158 collets, probably one that Queen Victoria had inherited in 1837. For the 1937 coronation, the Lahore Diamond was marginally recut, losing 0.12 of a carat, and set temporarily on the new crown made for Queen Elizabeth by Garrards. After the coronation, it was returned to the necklace. Either at this time or subsequently the necklace was reduced in length by four stones.

Both necklace and earrings were often worn by Queen Victoria, who bequeathed them to the Crown. Queen Alexandra and Queen Mary wore the necklace at their coronations (1901 and 1911). Queen Elizabeth wore both necklace and earrings in 1937, as did Her Majesty The Queen in 1953.

Diamonds, gold, silver, platinum;
necklace 38.1 cm long; earrings 4.5 cm long
RCIN 100003, 100004.1–2
Commissioned by Queen Victoria

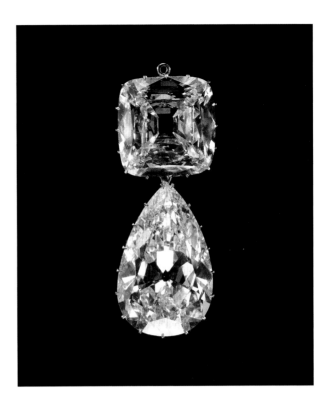

JOSEPH ASSCHER & CO.
The Cullinan Brooch, 1908–10

The brooch consists of the third and fourth largest stones cut from the largest diamond ever found, the celebrated Cullinan. This stone, which weighed 3,106 carats in its uncut state, was discovered near Pretoria in 1905 and named after the chairman of the mining company, Thomas Cullinan. In 1907, still uncut, it was given to King Edward VII for his sixty-sixth birthday by the government of the Transvaal. In 1908 Asscher of Amsterdam split the stone into nine numbered parts. Cullinan I and II, the two largest colourless and flawless cut diamonds in the world, known as the First and Second Stars of Africa, were reserved for King Edward. After Edward VII's death in 1910, Cullinan I and II were set respectively in the head of the Sovereign's Sceptre and in the Imperial State Crown, though they were detachable.

The other stones numbered III–V and VII–IX (King Edward had purchased VI), together with the 96 smaller stones and fragments, were bought from Asscher by the South African government and were given to Queen Mary in 1910. She had Cullinan III and IV set temporarily in her new crown for the coronation of 1911, but generally she wore the stones hooked together as a brooch. Her Majesty The Queen inherited the brooch (now known as the Cullinan Brooch) from Queen Mary.

Diamonds, silver; 7.0 × 2.8 cm
RCIN 100005
Presented to Queen Mary by the Government of South Africa

Indian Jewels

Indian (Mysore)
Bird of Paradise (Huma) from Tipu Sultan's throne, c.1787–93

When secret despatches to Napoleon Bonaparte from Tipu Sultan (1749–1799), ruler of Mysore, were discovered in 1798, the Governor-General of India, Marquess Wellesley, decided on immediate action to protect British interests. Overseen by Lord Clive, Governor of Madras, the formidably equipped British army led by General Harris stormed Tipu's citadel at Seringapatam on 4 May 1799. Tipu himself was killed and the city, the richest in southern India, was taken.

The Governor-General's younger brother, Colonel Arthur Wellesley (the future Duke of Wellington), was installed as Governor of Seringapatam. He was instructed by his brother to preserve Tipu's magnificent throne for present-ation to George III, but found that it had already been broken up and distributed as spoils of war. The sacred *Huma* bird, which formed the finial of the throne canopy, was acquired by Marquess Wellesley for £1,760 and, with other parts of the throne, was despatched to London. It was said that every head the *Huma* bird overshadowed would in time wear a crown.

In 1800 the Directors of the East India Company presented the *Huma* to George III, who in turn gave it to Queen Charlotte. At the Queen's death in 1818 the bird was left to four of her daughters. They gave it to their brother the Prince Regent (George IV), extracting from him a promise that 'this jewel should never be separated from the Crown of Great Britain and Ireland'.

Gold, rubies, emeralds, diamonds, pearls;
42.0 × 20.0 × 28.0 cm
RCIN 48482
Presented to George III by the
East India Company

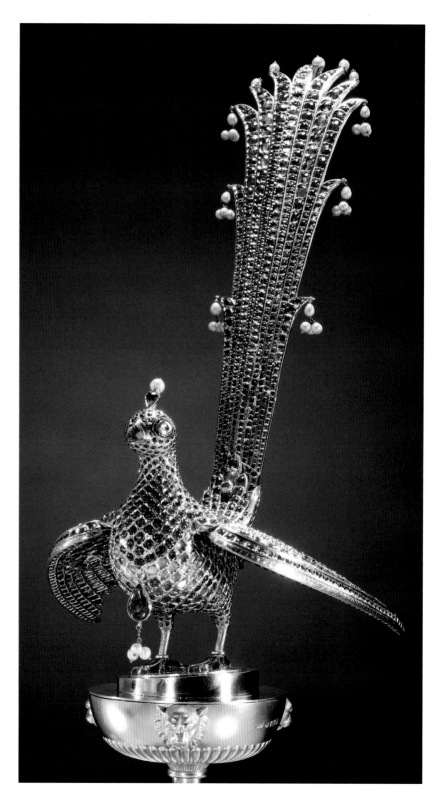

INDIAN (LAHORE)
The emerald belt of Maharaja Sher Singh, c.1840

Together with the 'Timur Ruby' and other important jewels (below), this magnificent belt was presented to Queen Victoria by the East India Company at the end of the Great Exhibition in 1851.

The belt, of the traditional form worn by Mughal grandees from the 17th century on, was made for Maharaja Sher Singh (d. 1843) at the end of independent Sikh rule of the Punjab. The stones may date from the 17th or 18th centuries.

The emeralds vary in quality and country of origin. Three of the rectangular emeralds are very fine (possibly from the Afghan/Kashmir region) and all the hexagonal stones appear to have been cut from the same stone, which may be from the Ural region. Two of the carved stones have matching designs and were probably executed by the same hand. The diamonds are either flat-cut (lasques) or more regularly faceted stones cut either in the West or in India for the Western market. The pearls are probably 18th century or earlier.

Emeralds, diamonds, pearls, gold, fabric and silver-gilt thread; 6.9 × 83.5 cm
RCIN 11291
Presented to Queen Victoria by the East India Company

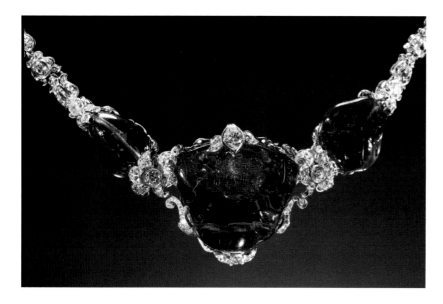

R. & S. GARRARD & CO.
The 'Timur Ruby' necklace, 1853

At the end of the Great Exhibition in 1851, the East India Company presented Queen Victoria with a selection from the Indian Section in recognition of her patronage of the exhibition. This gift included the collection of superb Indian jewellery taken from the Lahore Treasury when the British annexed the Punjab in 1849 and the wonderful 'rubies' admired by the Queen.

In April 1853 Garrards set four of these so-called 'rubies' (in fact, spinels) in a new diamond-encrusted gold and enamel necklace 'of Oriental design', with four diamond pendants also from Lahore. The huge stone of 352¼ carats noted by Queen Victoria was placed at the centre. Garrards adjusted the necklace to allow this stone to be detached for use as a brooch and to alternate with the recently recut Koh-i-Nûr. Queen Victoria wore the necklace occasionally. In 1911 Queen Mary had the necklace lengthened, but it has seldom been worn since.

Spinels, diamonds, gold, enamel; 50.0 cm long
RCIN 100017
Spinels presented to Queen Victoria by the East India Company

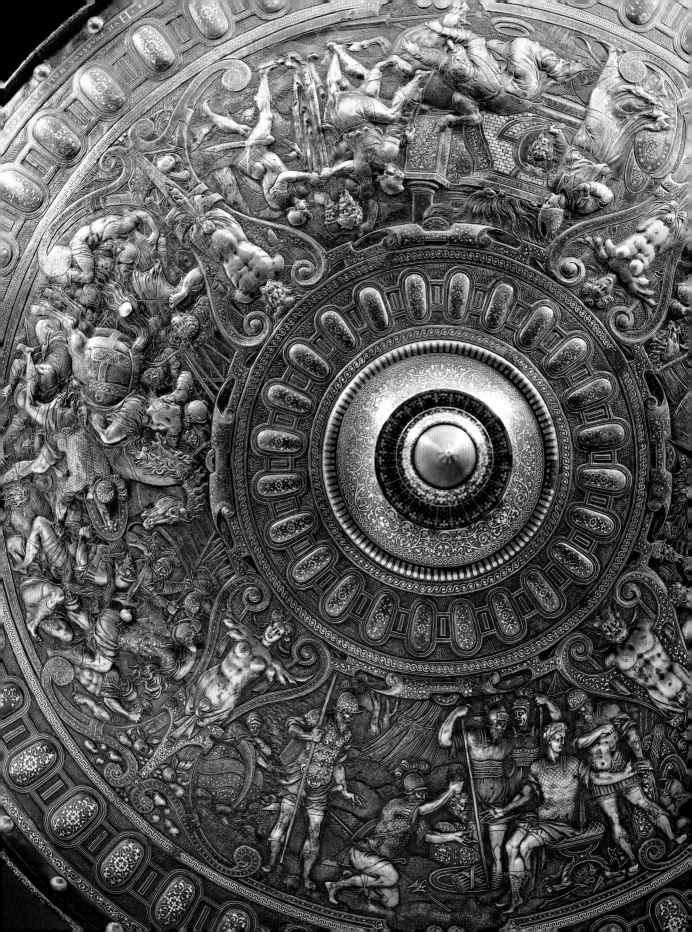

ARMS AND ARMOUR

The European arms, armour and militaria in the Royal Collection can be divided into two categories: those pieces that formed part of the useful armoury of the sovereign at the time they were made, and those which have been acquired by either gift or purchase as antique or presentation pieces. Such a distinction between the useful and ornamental should not be applied too strictly. The exceptionally beautiful armour made for Henry, Prince of Wales, at Greenwich in around 1608 (RCIN 72831) was designated for 'barriers, field, tourney and tilt', an all-purpose armour that could be adapted for chivalric exercises as well as for combat. The collection also includes many highly wrought sporting weapons, including those belonging to Frederick, Prince of Wales; George IV and his brother Frederick, Duke of York; Prince Albert; and Edward VII.

The execution of Charles I in 1649 did not have the same effect on arms and armour as it did on many of the other contents of the royal residences. The bulk of the arms and armour that were seized in the palaces by the officials of the new regime were not offered for sale but were retained for use. Thus, one set of armour made for Henry VIII around 1540 in the workshops he established at Greenwich (RCIN 72834) can still be found on display at Windsor Castle, and two other sets remain in the Royal Armouries, the main repository of historic royal arms and weapons. However, it would be erroneous to suggest that the collection has remained intact in its pre-Civil War state. Henry VIII's hunting sword (p. 146) is one of a very small number of weapons of any Tudor or Stuart monarch to survive in either the Royal Collection or the Armouries, but it had spent 350 years in other collections before being reacquired in 1966. The extraordinary 15th-century agate mace was presented to Her Majesty The Queen in 1978, entering the Royal Collection for the first time. It was said to have belonged to Charles I's sister, Elizabeth of Bohemia. The early provenance of the so-called 'Cellini Shield' (pp. 146–47)

remains unclear. It was certainly not, as was once claimed, presented to Henry VIII by Francis I of France at the Field of Cloth of Gold in 1520; having been made around 1562, it cannot have belonged to either monarch (both of whom died in 1547). In the past, two of the swords (pp. 148–49, 150) have been attributed to Benvenuto Cellini, whose detailed autobiography does not refer to the manufacture of weapons or armour of any kind. They are the finest examples of a group of very sculptural swords that were acquired by George IV. His taste, not surprisingly perhaps, also favoured swords with heavily jewelled hilts, along with the luxurious products of the Versailles workshops of Nicolas-Noël Boutet, which formed part of his collection of objects with Napoleonic associations.

The growth of George IV's collection was documented in an inventory which remained in use until some time after the collection was transferred to Windsor in the 1840s. This was supplanted by a new inventory in 1868. The first modern catalogue of arms and armour in the collection was published by Sir Guy Laking, Keeper of the King's Armoury, in 1904. A complete catalogue is now in preparation.

The majority of the Indian pieces in the Royal Collection date from the period of British supremacy in the subcontinent from the late 18th century to 1948. After the defeat in 1799 of Tipu, Sultan of Mysore, the implacable enemy of British interests in south India, 'relics' of his remarkable collections became highly sought after in Britain. The future George IV received the Sultan's quilted fighting armour (or 'war-coat', RCIN 67229) and a blunderbuss (RCIN 67240). Not all the Indian treasures that entered the collection at that time were spoils of war, however. In 1823 the Nawab of Oudh presented a jewelled sword to George IV as a gift. In the winter of 1875–76, the future Edward VII toured the sub-continent. During the tour, Indian princes made large gifts of weapons (pp. 151, 153), jewels, ivories, metalwork and animals.

EUROPEAN ARMS AND ARMOUR

DIEGO DE ÇAIAS (*fl.c.*1535–52)
Hunting sword, by-knife and scabbard, 1544

This is the only known surviving work made by the Spanish decorator of arms Diego de Çaias, while he was employed by Henry VIII between 1543 and 1547. It was probably one of the items described in the inventory of the King's possessions taken after his death in the latter year as 'iij longe woodknives ij of them of Dego his makinge'. The sword is in the form of a hunting weapon, with an auxiliary knife decorated in the same style of 'counterfeit' damascening (in which thin gold wires are pressed into lines incised on a hatched background). The wooden scabbard, covered in tooled black leather, is probably an 18th-century replacement, with the original iron mounts reapplied. The grip of the sword, which is made of wood and bound with iron wire, is also thought to be a replacement.

The decoration includes hunting scenes of a kind to be expected on a weapon of this type, but the most interesting feature is the miniature topographical scene at the top of the sword blade. It depicts with some accuracy the siege of Boulogne, which began on 19 July 1544 and was conducted under Henry VIII's direct command from 26 July; the French defenders eventually capitulated on 14 September. The city of Boulogne appears on the upper right, while, on the left, can be seen the offensive mound on which the English artillery was arranged. The Latin elegiac inscription on the other side of the blade may have been written by a court poet in celebration of the victory; the sword was presumably made soon afterwards. It is unsigned, but the style of the gold decoration is extremely close to signed examples of Diego de Çaias's work, in particular the mace made for Henry II of France, now in the Metropolitan Museum of Art, New York.

Iron and gold; sword 65.4 cm long
The sword inscribed on one side of the blade, damascened in gold *HENRICI OCTAVI / LETARE BOLONIA / DVCTV PVRPVREIS / TVRRES CONSPICIE / NDA ROSIS IAM / TRACTA IACEN* [sic] */ MALE OLENTIA / LILIA PVLSVS G / ALLVS ET INVI[C]TA / REGNAT IN ARCE / LEO SIC TIBI NEC / VIRT[V]S DEERIT / NE[C GR]ATIA FOR / MAE [CV]M LEO / TVTELA CVM / ROSA [S]IT DECORI* (Rejoice Boulogne in the rule of the eighth Henry. Thy towers are now seen to be adorned with crimson roses, now are the ill-scented lilies uprooted and prostrate, the cock is expelled, and the lion reigns in the invincible citadel. Thus, neither valour nor grace of beauty will fail thee, since the lion is thy protection and the rose thy ornament [translation by Claude Blair])
RCIN 61316
Acquired by HM The Queen

Attributed to ELISEUS LIBAERTS (*fl.*1557–72)
Parade shield ('The Cellini Shield'), c.1562–63

The superb quality of this embossed and chased iron shield gave rise to its traditional – but wrong – attribution to Benvenuto Cellini (1500–1571), who did not in fact make any armour. It is embossed with four episodes from the life of Julius Caesar: 1. The Battle of Dyrrachium: Caesar's armour-bearer cuts off the arm of his assailant; 2. The defilement of Caesar's robe by the blood of the sacrifice; 3. (?)The Battle of Pharsalus and death of one of Pompey's generals; and 4. The head and ring of Pompey brought to Caesar on his arrival in Egypt. The long inscription applied in gold around the edge attributes the fall of both Pompey and Caesar to ambition, 'than which there is no more weighty evil'.

Further episodes featuring the same protagonists were embossed on armour made for the French King Henry II (r. 1547–59), now in the Louvre, Paris, and in the Deutsches Historisches Museum, Berlin, which are thought to have been made in Antwerp by Eliseus Libaerts, a goldsmith who also made medals. There is still some doubt as to whether he was responsible for fashioning the armour or for decorating and supplying it. Some drawings suggest that this armour was designed by Étienne Delaune (1518/19–1583), medallist, draughtsman and engraver to the court of Henry II.

The first mention of the shield in England dates from 1783, when Horace Walpole noticed it in the Marine Gallery at Buckingham House – the second-floor library room in which George III kept his drawings, coins and medals, and models of ships. As the sole example of Renaissance parade armour in the Royal Collection then, the shield was probably valued as a piece of *histoire métallique*.

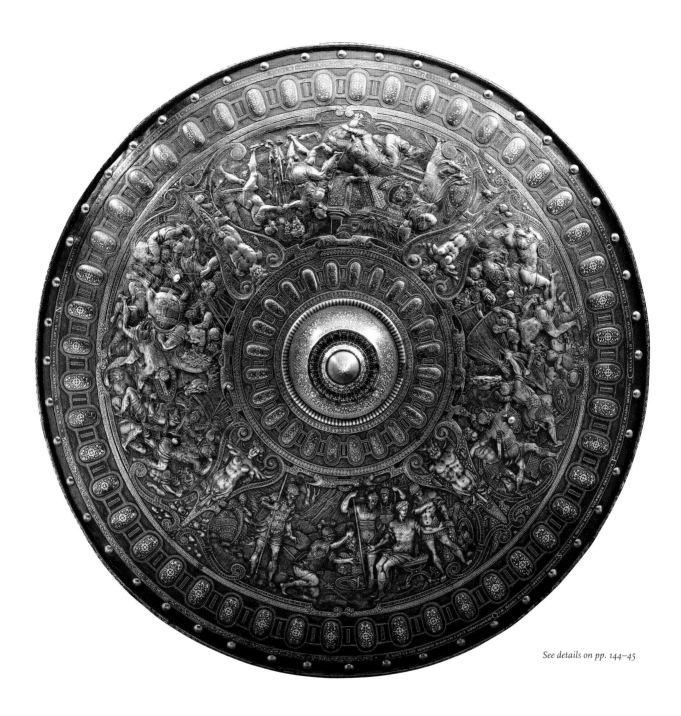

See details on pp. 144–45

Blued iron overlaid with silver and gold;
diameter 58.5 cm
Inscribed +*AMBITUS HIC MINIMVS MAGNAM
CAPIT AMBITIONEM · QVAE REGNA
EVERTIT DESTRVIT IMPERIA · SVSTVLIT E
MEDIO MAGNI VITAMQVE DECVSQVE ·
POMPEII EVEXIT CAESARIS IMPERIVM ·
CAESARIS IN COELVM MITIS CLEMENTIA
FERTVR · QVAE TAMEN HVIC TANDEM
PERNICIOSA FVIT · ANNVLVS EXCIT EI
LACHRYMAS CERVIXQVE RESECTA ·
POMPEII HINC PATVIT QVAM PROBVS ILLE*

*FORET · IN SACRIS DOCVIT VESTIS
CONSPERSA CRVORE · HVIC PRAESAGA
MALI TALIA FATA FORE · SI VIRES IGITVR
SPECTAVENS [SIC] AMBITIONIS · NON
GRAVIVS VIDEAS AMBITIONE MALVM* (This
circuit, though very small, holds great ambition,
which overturns kingdoms and destroys empires.
It took from sight the life and glory of Great
Pompey, and raised up the Empire of Caesar. The
mild clemency of Caesar is famed to the heavens,
but in the end it brought about his destruction.
The ring and severed neck of Pompey aroused his

tears: from this it became clear how virtuous he
was. The clothing sprinkled with blood at the
sacrifice taught him that such a fate would be
prophetic of evil. If therefore you consider the
power of ambition, you may see that there is no
more weighty evil [translation by Peter Howell])
RCIN 62978
Belonged to George III

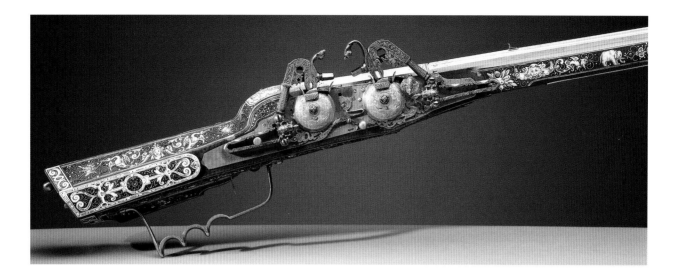

GERMAN
Superimposed charge wheel-lock rifle, 1606

George IV maintained an interest in firearms and shooting
from his childhood onwards, as his correspondence with his
brother Frederick, Duke of York, in the early 1780s shows.
Debarred from military service by his status as heir to the
throne, the Prince of Wales assembled a collection of antique
and 'curious' weapons in the Armoury at Carlton House.
This included a number of guns with technical idiosyncrasies
which he no doubt valued as much as their ornamental design.
This gun was one of a small group of antique pieces that he
purchased from one Colonel Benningson in 1807, including one
other by the same stock-maker, Hans Fleischer of Dresden.

The double wheel-lock enabled two shots to be fired from a
single loading. The first pull of the trigger fired the first charge,
and the second (rear) lock was then set by pressing the button
between the arms of the dog spring. The trigger could then be
pulled again. The sides of the butt are finely inlaid with arab-
esques, including, surprisingly, fish and winged horses, as well
as terrestrial quarry, including bears, elephants and foxes.

NORTH EUROPEAN
Rapier, c.1640

This sword, with its superbly sculptural hilt, was once
thought to be the work of the 16th-century Florentine goldsmith
and sculptor Benvenuto Cellini. As with the 'Cellini Shield'
(pp. 146–47), the tradition was refuted when historic arms and
armour came under more serious scrutiny in the last quarter
of the 19th century. Nevertheless, the work of the anonymous
sculptor of the forged and chiselled iron hilt is of very high
quality. The subjects are from the Old Testament Book of Samuel.
On one side of the pear-shaped pommel David is depicted

Above:
Walnut, staghorn, mother-of-pearl, iron, steel, gilt brass; 113.0 × 8.0 × 22.0 cm
The barrel incised *1606* and stamped twice with the maker's mark, a lion
rampant facing right (Støckel, 5511); engraved on the stock with the mark *HF*
(for Hans Fleischer)
RCIN 61101
Purchased by George IV when Prince of Wales

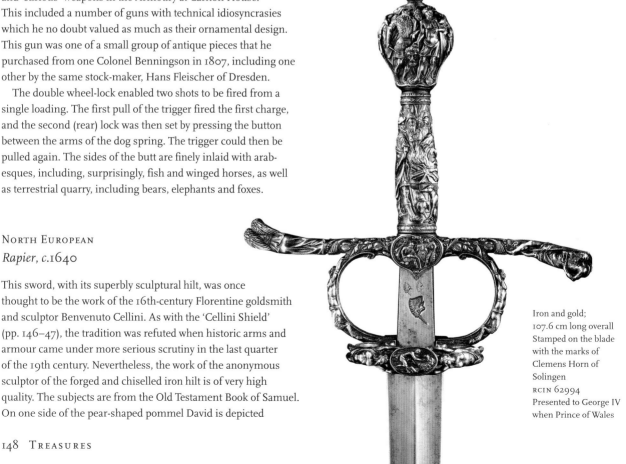

Iron and gold;
107.6 cm long overall
Stamped on the blade
with the marks of
Clemens Horn of
Solingen
RCIN 62994
Presented to George IV
when Prince of Wales

beheading Goliath, while on the other he brings his giant opponent's head to Saul. These two scenes are separated by male and female herms. The oval grip has a scene of Samuel anointing David. Next, on one side of the quillon-block (the central point of the two guards or quillons) David is shown making a libation or sacrifice with water brought from the well by the gates of Bethlehem, and, on the other, Abigail, the wife of Nabal, brings David two flasks. At the centre of the side ring is an oval cartouche with the young David slaying the lion. The quillons terminate in hunched and winged figures of Fame and Time. The details of the figurative scenes are picked out in gold, overlaid on the iron ground.

A second tradition attaching to this sword is that it belonged to John Hampden (1594–1643), one of the leaders of the parliamentary opposition to Charles I, who was mortally wounded at the Battle of Chalgrove Field. This was claimed by another former owner, the author Pryse Lockhart Gordon (?d. 1834), who had casts made from the reliefs of the hilt by the prolific Scottish cameo artist James Tassie; he gave these to friends 'as memoirs of the patriot' (i.e. Hampden). Gordon sold the sword to 'a royal purveyor of *virtu*, a man of fine taste', Walsh Porter (d. 1809), the writer, collector and connoisseur who advised George IV on the decoration of Carlton House and who presented the rapier to his patron in 1807.

NETHERLANDISH (? MAASTRICHT)
Dress sword, (?) mid-17th century (blade *c.*1700)

The elaborately carved hilt of this sword depicts the rescue of Andromeda by Perseus, who descends on his winged horse Pegasus to destroy the fierce dragon tormenting his captive. It resembles ivory carvings produced at Maastricht in Holland during the mid-17th century, when ivory was being imported in quantity by the Dutch East India Company. The hilt consists of four separate pieces: the pommel and grip (with Perseus and the chained Andromeda), the knuckle-guard (with the long neck and mouth of the dragon); the quillon-block and rear quillon (the dragon's back and tail); and the somewhat diminished shells, carved with the dragon's wings and feet. A.V.B. Norman related it in style to the work of Maastricht carvers, in particular on the stocks of a pair of pistols in the Wallace Collection.

The wavy-edged blade, which was added after the hilt entered George IV's collection in 1820, is etched on one side with the half-length figure of a woman in the fashionable dress of around 1700, and on the other side with a bust of a man, similarly dressed. The blade, which was was probably made in Germany, was waved during forging rather than by the more usual method of filing the edges of a conventional blade.

Ivory and steel; 96.5 cm long overall
RCIN 67142
Purchased by George IV

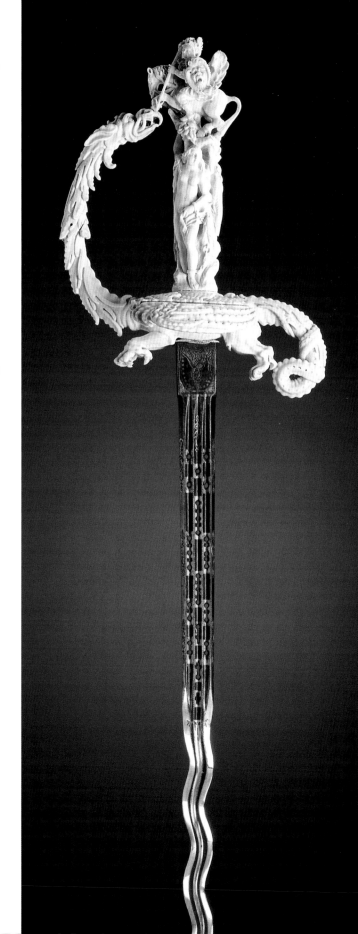

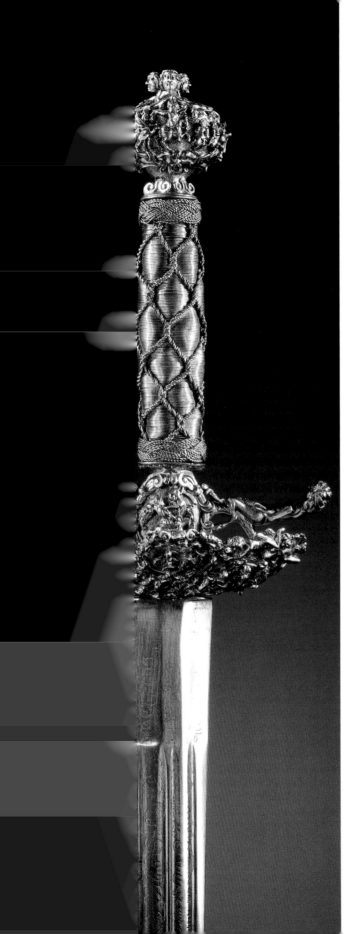

FRENCH (probably PARIS)
Small-sword, c.1655

This magnificent sword was purchased by the future George IV in 1789 to further enhance what was already a substantial collection of historic weapons. In the manuscript catalogue of his Armoury at Carlton House this sword is said to have been given by the Emperor Charles VI (1685–1740) to the 1st Duke of Marlborough (1650–1722) and its hilt – like that of the so-called Hampden sword (pp. 148–49) and the embossed parade shield (pp. 146–47) – was attributed to Benvenuto Cellini. While the second of these claims can be set aside on the simple grounds that Cellini made no swords, the supposed provenance, though uncorroborated, is not so implausible; Charles VI did indeed present a sword to the Duke of Marlborough in 1703, but that sword had a hilt set with diamonds.

The iron hilt demonstrates a range of techniques executed to the highest standard. The pommel, with its four-headed tang-button (or finial), shells and quillons, is forged, chiselled and pierced; while the grip, which is made of wood cut with spiralling grooves in two directions, is bound with steel wire and overlaid by a further network of twisted wire.

The precise subject matter of the figurative decoration has not been identified. On one side of the pommel is a scene of soldiers in Roman dress approaching a town, and on the other is a group of captives led before an officer standing in a chariot. The larger scenes on the shells are the same on both sides, one in the opposite direction to the other; they comprise a cavalry combat with a commander in a cartouche, and soldiers presenting captured colours to a commander. The quillons are in the form of satyrs, and the other secondary motifs include serpents, masks and naked, winged children. The blade is probably a near-contemporary replacement.

Iron; 101.4 cm long overall
RCIN 62995
Purchased by George IV when Prince of Wales

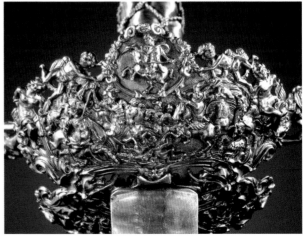

Detail of hilt

INDIAN ARMS AND ARMOUR

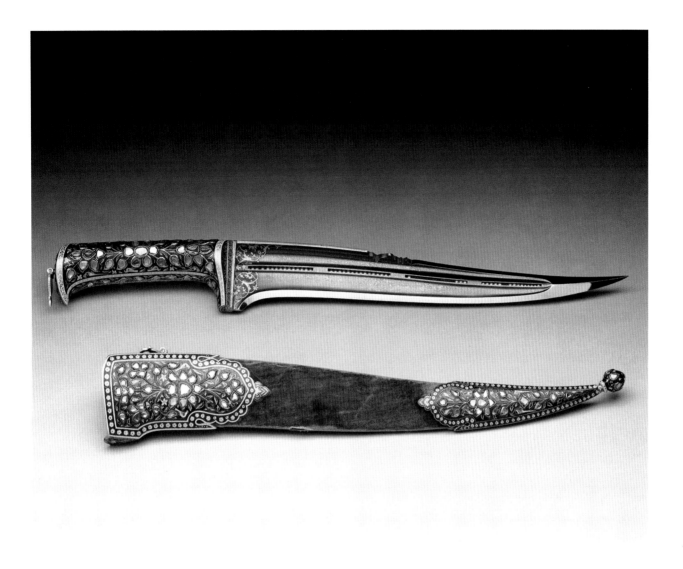

INDIAN
Dagger (peshkabz) and scabbard, 1877

In addition to the luxurious, jewelled quality, which is common to most of the gifts presented during the Prince of Wales's Indian tour of 1875–76, this dagger boasts a blade of exceptional accomplishment. It is of steel, with a single polished edge and with two etched shallow grooves flanking a drilled bore in four sections which are filled with loose seed pearls. It is all the more admirable on technical grounds for the fact that the bore follows the curve of the blade. Such a weapon would obviously have certain practical limitations and it must be seen instead as an exercise in master bladesmithing.

Gold, steel, pearls, diamonds, wood and velvet;
dagger 40.6 × 4.5 × 3.7 cm;
scabbard 32.1 × 5.6 × 3.4 cm
Inscribed (in Persian) W*ork of Ibrahim 1877*
RCIN 11289
Presented to King Edward VII when Prince of Wales by the Maharaja of Bharatpore

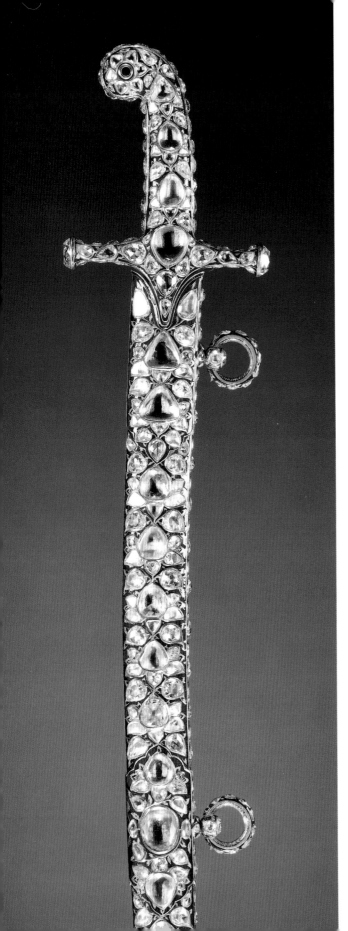

INDIAN (JAIPUR)
Sword and scabbard, c.1902

This exceptionally rich sword and scabbard were presented
to King Edward VII on the occasion of his coronation by Sawai
Sir Madho Singh Bahadur (1861–1922), Maharaja of Jaipur, one
of the small group of Indian princes and nobles invited to attend
the ceremony at Westminster Abbey in June 1902. For the
journey to England, Madho Singh chartered a ship which was
fitted with large copper vats containing sufficient Ganges water
to sustain him and his retinue of 400 followers throughout both
sea passages and while in England. At the eleventh hour, after
their arrival in London together with large numbers of other
foreign royalty and heads of state, the coronation was cancelled
because of the King's appendicitis. It did not in fact take place
until 9 August, by which time most of the royal guests had
departed for home. The Maharaja, however, duly attended the
postponed ceremony, having spent the intervening period
staying at Kedleston Hall and other country houses, closely
attended at all times by his cook and his jeweller.

The importance of the jeweller in the Maharaja's household
is clear from this coronation gift, which is set with a total of 719
diamonds (there has been one loss, from the upper suspension
ring). These include a large number of rose-cut and brilliant-cut
stones as well as the flat, 'lasque' stones more commonly used
in Indian jewellery, and it is possible that many of them were cut
in Europe. They are held in 'rub-over' gold settings and backed
with silver foil, which makes it impossible to assess their total
weight with precision. The largest appear to be the two mixed-
cut pale yellow diamonds at the end of the quillons, one of
which is estimated at 36 carats. The combined weight of all the
diamonds is possibly in the region of 2,000 carats. The scabbard
and hilt are of gold, finely enamelled in dark blue, green and red.
The steel blade is of markedly poor quality by comparison.

Jaipur was one of the largest and richest of the Rajput states,
with 2.8 million inhabitants in 1897. During his visit from 1875
to 1876, the future King Edward VII had laid the foundation
stone of the Albert Hall in Jaipur, one of a number of new public
buildings erected in the capital city at the time, including
libraries, art galleries and hospitals.

Gold, coloured enamel, diamonds, steel;
sword 88.5 cm long; scabbard 79.7 cm long
Inscribed (etched) on the blade *A TOKEN OF THE LOYALTY OF / SAWAI
MADHO SINGH / MAHARAJA OF JAIPUR / 9th AUGUST 1902*;
an illegible armoury mark is incised on the neck of the scabbard
RCIN 11288
Presented to King Edward VII by the Maharaja of Jaipur

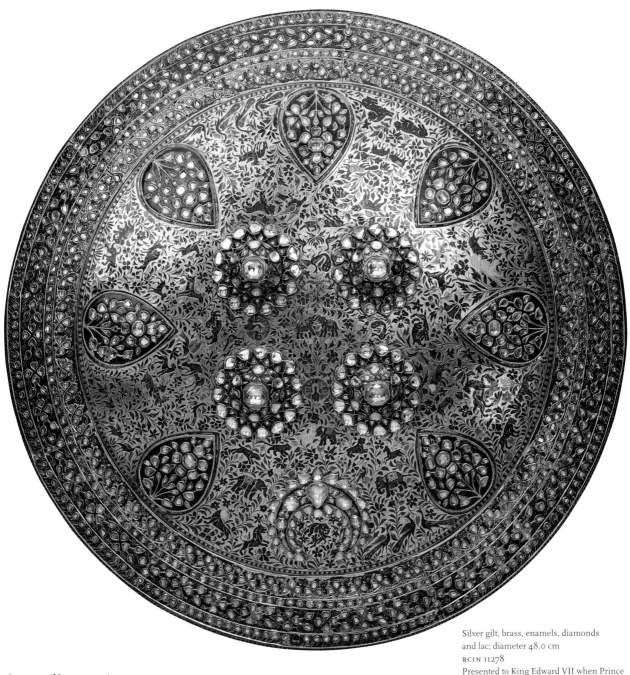

Silver gilt, brass, enamels, diamonds
and lac; diameter 48.0 cm
RCIN 11278
Presented to King Edward VII when Prince
of Wales by the Maharaja of Kashmir

INDIAN (?LUCKNOW)
Shield, early 19th century

Like the weapons and other articles presented to the Prince of
Wales in India during the winter of 1875–76, this is a particularly
elaborate and rich example of a traditional form. Shields of
this type (*Dhal*) were usually made of hide, often painted or
lacquered, with metal bosses applied at the points to which the
handles were fastened on the reverse. In this instance the front
of the shield is made of silver gilt, decorated overall with
champlevé enamels, mounted with four bosses and inset with
seven tear-shaped ornaments and a crescent motif, all of them
set with diamonds. The colours employed for the enamelling,
and the subject matter – numerous animals and birds – are
characteristic of Lucknow work of the 18th and 19th centuries.
The four jewelled borders around the edges are formed on
segmental plates about 20 cm long, whose joins are disguised
in ingenious ways. The thickness of the shield is probably filled
with lac, and the reverse is a plain lacquered brass disc.

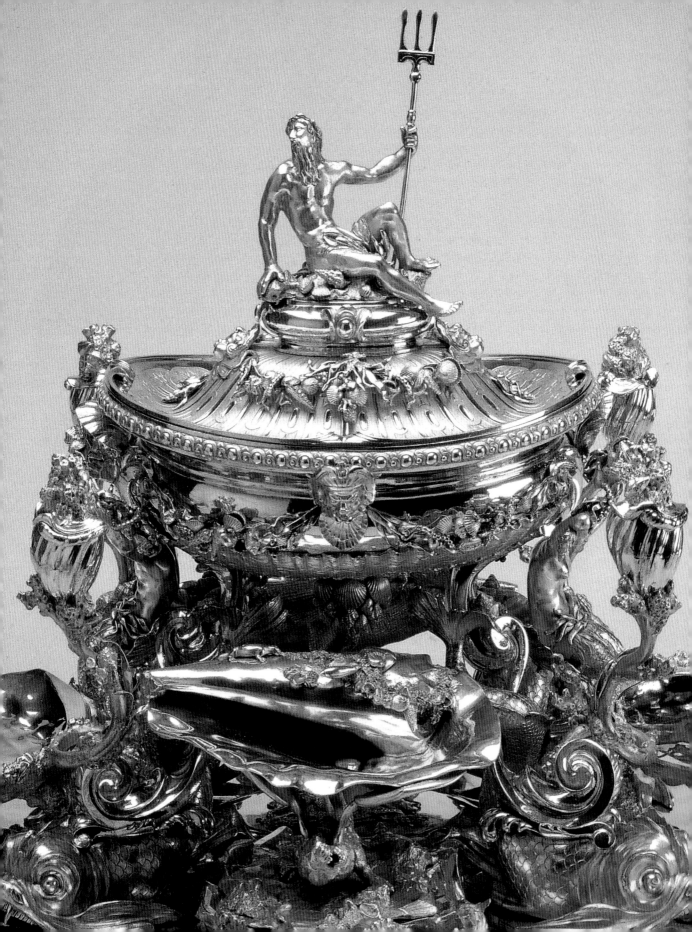

SILVER AND GOLD

The silver in the Royal Collection today was mainly assembled after the restoration of the monarchy in 1660. The remnants of the splendid treasuries of Henry VIII, Elizabeth I and James I, together with much of Charles I's silver, had been melted for coinage during the Civil War and Interregnum. As a result, Charles II had to restock the collection.

Both secular and ecclesiastical silver was required for the restored monarchy. The superb altar silver supplied for Charles II's coronation ceremony in Westminster Abbey has survived largely intact and is either displayed with the coronation regalia in the Tower of London (see p. 156) or is still used in the Chapel Royal in St James's Palace (p. 158). Little of the secular dining, buffet and domestic silver is still in the collection, though a few outstanding examples remain (p. 159).

The later Stuarts continued to acquire silver, though on a smaller scale. James II while Duke of York ordered a remarkable group of altar silver in the 1660s. The most outstanding examples of silver furniture to survive are the cast and wrought silver table and mirror refashioned from an earlier set for William III in 1699 (p. 81).

Frederick, Prince of Wales, son of George II and father of George III, was – unlike his father – an important patron of the arts and was responsible for commissioning some of the most inspired and important English rococo silver of the 18th century (p. 163). Perhaps George III's most significant contribution to the collection was his transferral of royal patronage to the goldsmiths Rundell & Bridge in 1797.

Despite the additions of the 18th century, the royal silver collection was, at the beginning of the 19th century, unremarkable. The enormous breadth and richness of the silver in the Royal Collection today is due to the concerted efforts of the royal goldsmiths and jewellers Rundell, Bridge & Rundell, and George IV. The King spent lavishly on silver, not only on the so-called Grand Service, but also on a number of objects –

such as a tureen (p. 166) – in the rococo revival style inspired by the Marine Service of Frederick, Prince of Wales. The quality of all the pieces was superb and the Royal Collection remains unsurpassed in its extensive holdings of early 19th-century silver. George IV also accumulated an impressive collection of historic sideboard pieces, including splendid continental *Kunstkammer* objects of the 17th and 18th centuries (pp. 171, 174).

Such was George IV's legacy that there has been little need for his successors to add much to the collection, though silver and gold have remained popular royal gifts (pp. 169, 175). The collection suffered a great loss in 1837, when all the Hanoverian possessions passed to George III's third son, Ernest, who became King of Hanover in that year.

Prince Albert's love of the arts extended to silver and he was responsible for commissioning and designing a number of pieces. King George V and (especially) Queen Mary took a close interest in silver, as contemporary photographs show. Major acquisitions of historic silver by Her Majesty The Queen include the Hutton Cup and the caddinet used at the coronation banquet of William and Mary in 1689 (p. 160).

The Royal Collection contains a rich group of 18th- and 19th-century gold boxes which admirably demonstrate the wide variety of materials and techniques used in the production of these highly finished and luxurious objects. The craft reached unparalleled levels of skill and virtuosity in Paris during the reign of Louis XV (see p. 178), though the most spectacular boxes ever made were those created in Potsdam for Frederick the Great of Prussia (p. 178).

The most important British royal collectors of gold boxes were King George V and Queen Mary. The latter's interest in royal history led her to acquire many boxes with royal provenances (see p. 176). During the present reign, one of the earliest boxes in the collection was acquired: Queen Mary II's striking enamelled gold and diamond patch box (p. 176).

Details: Rundell, Bridge & Rundell, The Neptune centrepiece, 1741–42 (see pp. 162–63)

ENGLISH SILVER AND GOLD

Attributed to AFFABEL PARTRIDGE (*fl.*1554–1579)
'Queen Elizabeth's Salt', 1572–73

Ceremonial standing salts, often of elaborate and intricate construction, were used on royal and aristocratic dining tables from the medieval period into the 18th century to mark the status of those dining by reference to their position at table in relation to the salt (i.e. 'above' or 'below'). This piece is normally displayed with the banqueting plate and coronation regalia in the Tower of London. Its association with Queen Elizabeth I appears to be a 19th-century invention and was probably suggested by the Tudor rose inside the cover. It is not identifiable in any royal inventories or Jewel House records until the 1680s. The Jewel House was the department of the Royal Household with responsibility for providing silver and jewels to the royal family and court. Charles II's cypher engraved under one of the feet suggests that it was acquired around 1660, probably from Sir Robert Vyner, who held the warrant to replace the royal plate and crown jewels sold or melted during the Interregnum (1649–60). With the exception of this salt and two German tankards (RCIN 31770 and 31771), all the replacements were newly made in London.

Of the salt's earlier history nothing is known. It is struck with the maker's mark attributed to Affabel Partridge (goldsmith to Queen Elizabeth from about 1558 to 1576), whose work is characterised by its exceptional quality and lavish decoration. This example is closely related to a salt belonging to the Vintners' Company, with the same maker's mark and dated 1569–70. Both incorporate panels depicting the Virtues after plaquettes by the German sculptor Peter Flötner (master 1522). The domed cover, which originally sat on the main body of the salt, is cast with panels depicting Ceres, Lucretia and Cleopatra; around 1610 an open ring frame with scrolled brackets was added, altering the cover to a canopy raised above the cellar bowl.

'Queen Elizabeth's Salt' appears to have been added to the set known as the St George's Salts following the loss of one of their number after 1688. The ceremonial use of the St George's Salts remains unclear. They were perhaps used at the lavish banquets held in Westminster Hall after coronation ceremonies in Westminster Abbey. It has also been suggested that they were originally part of a larger set of salts ordered for the banquet of the Garter Knights held before Charles II's coronation in 1661 and used at subsequent Garter banquets at Windsor Castle.

Silver-gilt; 35.0 cm high
Hallmarks for London, 1572–73 and maker's mark
attributed to Affabel Partridge
RCIN 31773
Probably acquired by Charles II

ENGLISH
'Feathered' flagon, 1660–61

This flagon, one of a pair, formed part of
the new altar plate supplied to the Chapel
Royal at Whitehall Palace after the
restoration of the monarchy in 1660.
The front of the flagon is embossed with
the 'rose slipped' with crown above, an
emblem found on other plate supplied
for Charles II around 1660.

The unusual form and feather
decoration of these two pairs of flagons
appear to be a deliberate, and perhaps
symbolic, re-creation of early 16th-century
feathered flagons: the 1521 Jewel House
inventory included 'two great gilte pottis
chased wt fethers'. The 1649 Jewel House
inventory listed 'one great fether pott'
and 'one old fethered ewer with a broken
handle'. They may have been part of the
new plate ordered by James I to replace
the 14,000 ounces of Jewel House plate
given to the Tsar of Russia in 1604.
Many of these pieces reproduced the
portcullises, roses and 'feather fashion'
of the Tudor plate they replaced.

This piece and its pair were often
described as 'potts' rather than flagons
in Jewel House inventories, a reference
to their pear-shaped form. The 1688
inventory records them under 'Chappel
plate' at Whitehall Palace. On the destruc-
tion of Whitehall Palace in 1698, they
were moved to the Chapel Royal in St
James's Palace. In the instructions for use
in the chapel in 1676, the flagons formed
part of the altar furnishings, flanking the
great altar dish (p. 158).

This flagon is struck with the maker's
mark, *JB* or *TB*, possibly James Beacham
or Beauchamp, of whom little is known.
The maker was highly skilled: this piece
and its pair are only a few pennyweights
different from each other, a remarkable
achievement, as such vessels were then
raised by hand from ingots of silver.

Silver-gilt; 52.0 cm high
London hallmarks for 1660–61 and maker's mark
JB or *TB* in script cypher
RCIN 31756
Made for Charles II

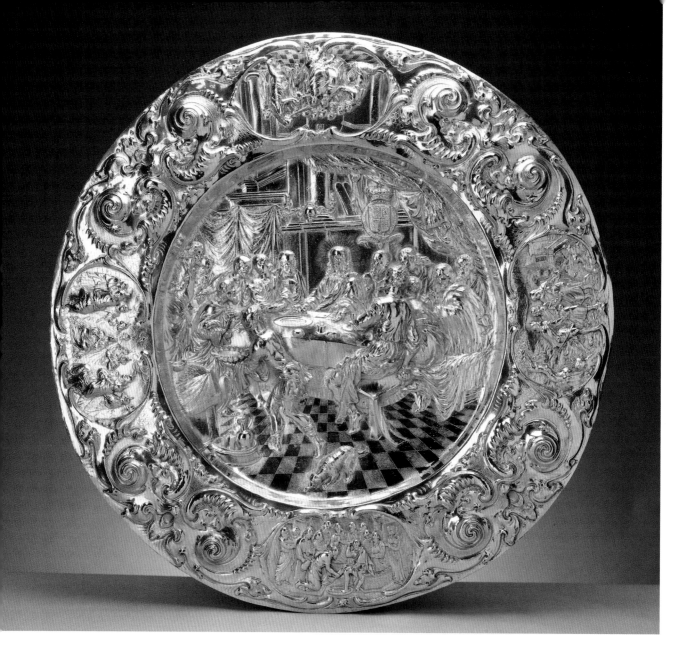

Attributed to HENRY GREENWAY (*fl.*1648–1670) and WOLFGANG HOUSER (*fl.*1652–88)
Altar dish, 1660–61

This magnificent dish, one of the largest of its type in existence, first adorned the high altar of Westminster Abbey for Charles II's coronation ceremony in 1661. Since the early 18th century it has formed part of the altar plate of the Chapel Royal, St James's Palace, where the marriages of George III, George IV, Queen Victoria and King George V took place. It is still in regular use.

The centre of the dish is deeply embossed with a representation of the Last Supper and with the royal arms and crown of Charles II prominently displayed to the right of Christ's head. Four panels in the outer rim depict *The Washing of the Apostles'*

Feet (from a woodcut of 1574 by Jan Wierix), *The Road to Emmaus* (from a woodcut by A. Wierix after Martin de Vos), *Christ's Commission to the Apostles* and *The Coming of the Holy Ghost*.

The chased decoration can be attributed with confidence to Wolfgang Houser of Zurich (free of the Zurich Goldsmiths' Guild 1652). Most of the hallmarks have been obliterated.

Silver-gilt; diameter 94.5 cm
Marked with London date-letter for 1660–61
RCIN 92012
Made for Charles II

Unknown maker (fl.1660–61) and George Garthorne (fl.1680–1700)
Basin, 1660–61 and ewer, 1690–91

The ewer was made for William III and Mary II in 1691, as a companion to the basin. It replaced an earlier ewer, presumably supplied for Charles II with the basin in 1660. The form of the ewer is unique. The domed lid resembles a closed helmet and the spout is fashioned like a visor. The embossed military trophies echo those around the outer rim of the basin. On the inner rim of the basin, four panels contain depictions of the Labours of Hercules.

The basin is struck with an indeterminate maker's mark variously described as an orb and cross, orb and star, or grenade. The use of a device mark possibly indicates a foreign goldsmith working in London. It has been suggested that the similarities between this dish and the altar dish in the Chapel Royal (p. 158) make it possible to attribute the embossed decoration to Wolfgang Houser. The ewer is struck with the mark associated with George Garthorne, apprenticed in 1669 and 'turned over' to his probable elder brother Francis. Numerous other pieces of royal plate bear the same mark, including two covered ewers.

After the basin's appearance at the coronation of Queen Anne in 1702, the ewer and basin seem to have been little used and by 1808 were among the royal silver sold to Rundells. Remarkably, they have been twice separated and twice reunited between leaving the Royal Collection in 1808, when the basin was sold to the great collector William Beckford, and entering the collection of Queen Elizabeth The Queen Mother in the mid-20th century. In 1823, the basin was sold with most of Beckford's celebrated collection. It was acquired by George IV's brother, the Duke of Sussex, whose important collection of old plate was sold on his death in 1843. The Queen Mother bought the ewer in 1940 and the basin in 1958.

Silver-gilt; basin 3.2 × diameter 52.7 cm; ewer 26.7 cm high
Basin hallmarked for London, 1660–61 and maker's mark an orb and cross; ewer hallmarked for London 1690–91 and maker's mark of George Garthorne
RCIN 100006 (ewer), 100007 (basin)
Purchased by Queen Elizabeth The Queen Mother

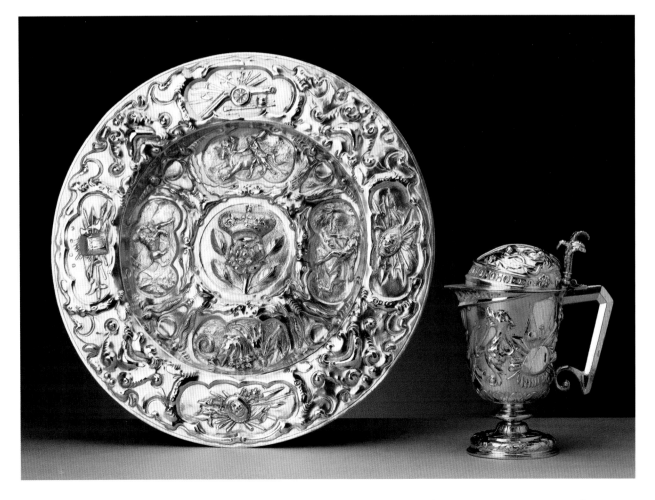

Robert Smythier (*fl.*1660–*c.*1686)
Sconce, 1686

Silver sconces were an essential part of the fashionable baroque interior; the Jewel House inventory of 1721 lists 191 of them in the royal palaces. This sconce is from a set of six embossed with the Judgement of Solomon. They are almost certainly the 'six silver chaced sconces' weighing 881 ounces troy 15 penny-weights delivered to the 'deputy keeper of his MajS Councell Chamber' at Whitehall Palace on 26 November 1686. Warrants dated 13 September and 16 October 1686 show that the set was ordered in two stages. The Jewel House Accounts and Receipts Book reveals that the total cost came to £396 11s. 3d. The new Council Chamber formed part of Sir Christopher Wren's substantial rebuilding of Whitehall Palace for James II. There the King would have met the Ministers of his Privy Council; the Judgement of Solomon, symbolic of wisdom, embossed on the back of the sconces was therefore a particularly appropriate subject.

The cyphers of William and Mary were added later. It was usual for the cyphers and arms of the previous monarch to be replaced on royal plate at the beginning of a new reign.

The Solomon sconces are listed in the Council Chamber at Whitehall Palace in the 1688 inventory and were probably the six sconces weighing 880 ounces used to furnish the room where Queen Mary II lay in State. In 1742 the sconces were noted in the State Bedchamber at Hampton Court. The set was shown to George IV in 1812; they were subsequently restored and gilded by Rundells for use at Carlton House. New nozzles costing £25 5s. 3d. were added in 1816.

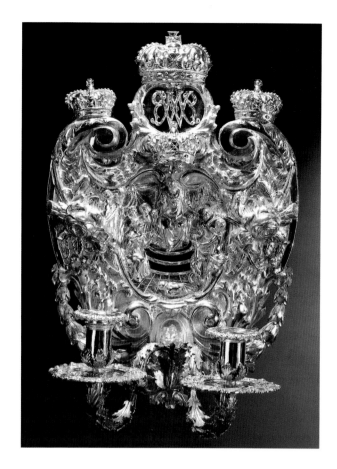

Silver-gilt; 51.5 × 26.0 × 24.5 cm
Maker's mark attributed to Robert Smythier (free 1660); nozzles struck with London hallmarks for 1816–17 and maker's mark of Paul Storr
RCIN 51539
Made for James II

Anthony Nelme (*fl.*1680–1720)
Caddinet, 1688–89

Caddinets first appeared in the 16th century in France, where their use was restricted to the tables of the aristocracy. Salt and cutlery were kept in the compartments and, prior to dining, a napkin was laid on the tray and set with bread. The name is derived from *cadenas* (padlock) and suggests that the salt compartments on early examples were originally locked to guard against poisoning. Caddinets were first used in Britain at the coronation banquet of Charles II in 1661 and their use remained strictly a royal prerogative. This piece is one of only three surviving English caddinets. It is normally displayed (with the second surviving example) in the Tower of London.

This caddinet was supplied for the coronation banquet of William and Mary held on 11 April 1689. It is probably the 'Gilt Caddanett' weighing 104 ounces troy, 15 dwt (pennyweights),

received by the Jewel House on 9 April, charged at £64 11s. 11d. The magnificent engraved arms of William and Mary prior to their recognition as sovereigns by Scotland are almost certainly the work of the Frenchman Blaise Gentot. The English Parliament formally offered the Crown to William and Mary on 13 February 1689. The Scottish Parliament did not meet until 4 March and their decision was not known until the day of the coronation ceremony. The Scottish arms have therefore been tactfully omitted and the arms of Ireland inserted twice.

This piece was probably one of three caddinets sold to Rundells in 1808, along with unwanted silver. It was bought by the 1st Earl of Lonsdale at the time. Her Majesty The Queen acquired it from the 7th Earl of Lonsdale in 1975.

Silver-gilt; 13.3 × 39.4 × 31.1 cm
London hallmarks for 1688–89 and maker's mark of Anthony Nelme;
engraved with the arms and cypher of William and Mary (as used
13 February–11 April 1689)
RCIN 31736
Purchased by HM The Queen

BENJAMIN PYNE (d. 1732)
Pricket candlestick, 1717–18

This altar candlestick is one of a pair listed at Whitehall Chapel in the Jewel House inventory of 1721. Although made in the reign of George I (whose cypher is on the base), this shape of candlestick with its triangular base and baluster stem is of a type which emerged during the previous century. This piece and its pair have been described as the 'last really important Baroque candlesticks' of the early 18th century. They remain the only major examples of plate commissioned for the Chapel Royal in the reigns of George I and George II.

The old Chapel Royal was destroyed in the Whitehall fire of 1698. Thereafter a new Chapel Royal, designed by Christopher Wren, was established in Inigo Jones's Banqueting House, the only important element of Whitehall Palace to survive the fire. Although Queen Anne moved the choral headquarters of the Chapel Royal to the King's Chapel at St James's Palace in 1702, private services for the royal family continued at Whitehall into the reign of George I. The Royal Maundy service was celebrated there for much of the 18th and 19th centuries. This candlestick appears to have been used on the high altar of the chapel with the large altar dish and feathered flagons supplied to Charles II in the 1660s (see pp. 157, 158). After the closure of Whitehall Chapel in 1890, the candlesticks were used in the chapel at Marlborough House before being moved to Buckingham Palace. Today they form part of the magnificent altar plate used in the Chapel Royal and the Queen's Chapel at St James's Palace.

Benjamin Pyne (free 1676) was one of the few native English goldsmiths who was able to compete with the Huguenots. In 1714 he was appointed Subordinate Goldsmith to George I.

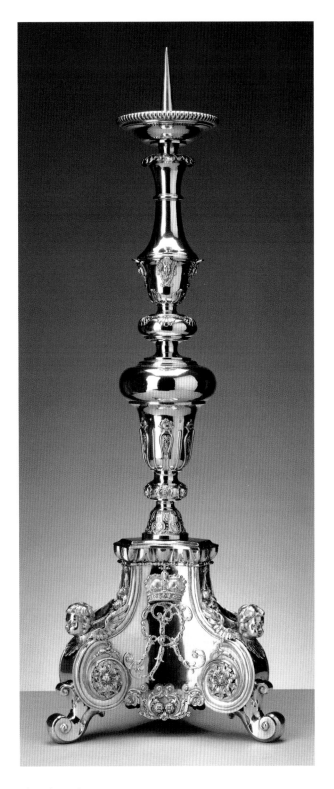

Silver-gilt; 103.6 × 32.0 × 32.0 cm
London hallmarks for 1717–18 and maker's mark of Benjamin Pyne,
with the applied cypher of George I
RCIN 92008
Made for George I

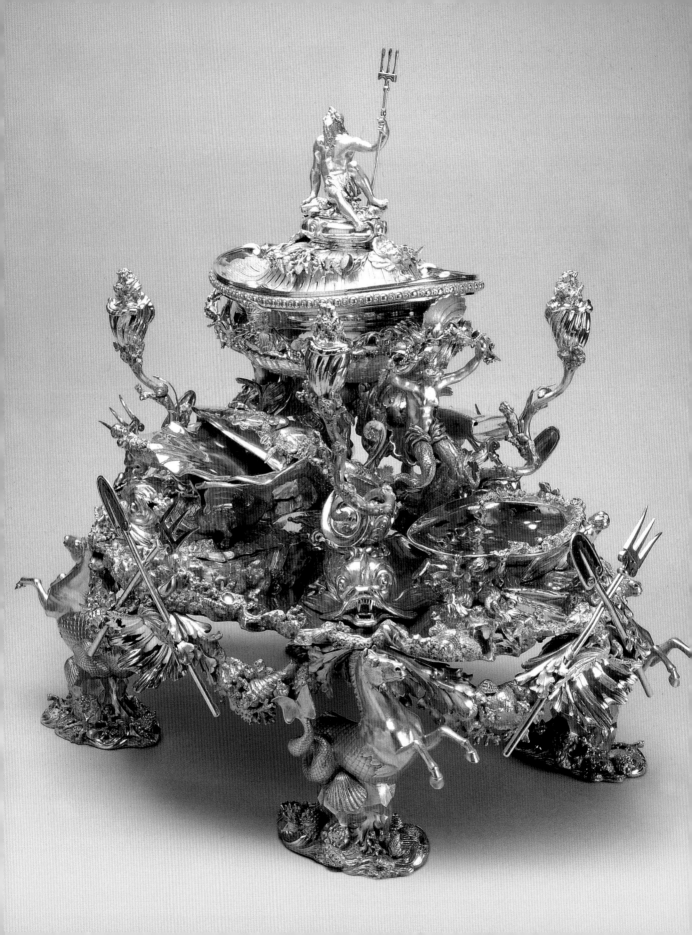

PAUL CRESPIN (1694–1770) and NICHOLAS SPRIMONT (1716–1771);
JOHN BRIDGE (1755–1834), for RUNDELL, BRIDGE & RUNDELL
The Neptune centrepiece, 1741–42 (and 1826–27)

This unique centrepiece, described as 'the purest rococo creation in English silver', forms part of the superb Marine Service of rococo plate which was almost certainly supplied for Frederick, Prince of Wales in the early 1740s (see also the two pairs of salts below). This association is based on the listing of all the pieces in the 1832 Inventory of Plate under the heading of 'Frederick Prince of Wales'. The highly fashionable design of the Neptune centrepiece shows a strong continental influence and reflects the sophisticated tastes and inspired patronage of the Prince, who played a significant role in introducing the rococo style into England. Although it bears the mark of Paul Crespin, the involvement of the Liègeois Nicholas Sprimont is suggested by stylistic similarities with his work (see below). It is possible that the centrepiece was made by Sprimont shortly after his arrival in London but marked by Crespin, a fellow Huguenot and neighbour in Compton Street, Soho; Sprimont's own mark was not registered until 1743.

During recent detailed examination of the centrepiece it was discovered that the two pairs of entrée dishes with dragon and mer-figure supports, located on the base, previously thought to be separate 'salts', formed an integral part of the design. It was also found that at least two pre-existing elements – the shallow shell and the tureen, cover and S-scroll legs – had been incorporated, perhaps because of the need to finish the object quickly.

In 1780 James Young and Robert Henley copied the centrepiece, sauceboats and salts for Charles, 4th Duke of Rutland – a clear instance of the enduring appeal of Sprimont's creations. The Marine Service was used by George IV at Carlton House and in 1827 Rundells added the sea-horse stand with supports and marine decoration for the King.

Silver-gilt; 68.0 × 66.0 × 47.0 cm
London hallmarks for 1741–42 and maker's mark of Paul Crespin;
the shell mount below the tureen with Turin townmark and maker's
mark of Andrea Boucheron; the later hippocamp (sea-horse) base with
hallmarks for London, 1826–27 and maker's mark of John Bridge
RCIN 50282
Made for Frederick, Prince of Wales

See details on pp. 154–55

NICHOLAS SPRIMONT (1716–1771)
Two pairs of salts, 1742–43

The salts are struck with the maker's mark of Nicholas Sprimont, a Liègeois Huguenot who appears to have moved to London early in 1742, where he became a leading practitioner of the rococo style. Sprimont's silver is exceptionally rare and these pairs of salts are among the best-known examples of his work. It has been suggested that their striking naturalism was achieved by casting actual seashells, crabs and crayfish from life. They were almost certainly supplied for the Marine Service of Frederick, Prince of Wales, in the early 1740s (see above). Sprimont appears to have worked only with silver for six or seven years. From *c.*1745 he was involved with the establishment of the Chelsea porcelain factory (see pp. 106–07). The crayfish salt served as a model for porcelain versions subsequently reproduced by the factory.

The accompanying spoons are modelled as branches of coral with cockleshell bowls; they are illustrated here resting inside the bowls of the salts. The spoons, which are unmarked, appear on an undated sheet of designs attributed to Sprimont for a salt cellar with alternate spoons discovered in a collection of 78 sheets of drawings in the Victoria and Albert Museum.

Silver-gilt; crab salts 8.9 × 17.8 × 11.7 cm;
crayfish salts 8.7 × 14.0 × 14.1; spoons 11.0 cm long
London hallmarks for 1742–43 and maker's mark
of Nicholas Sprimont; spoons unmarked
RCIN 51368 (spoons), 51392.1–2 (crab salts), 51393
(crayfish salts)
Made for Frederick, Prince of Wales

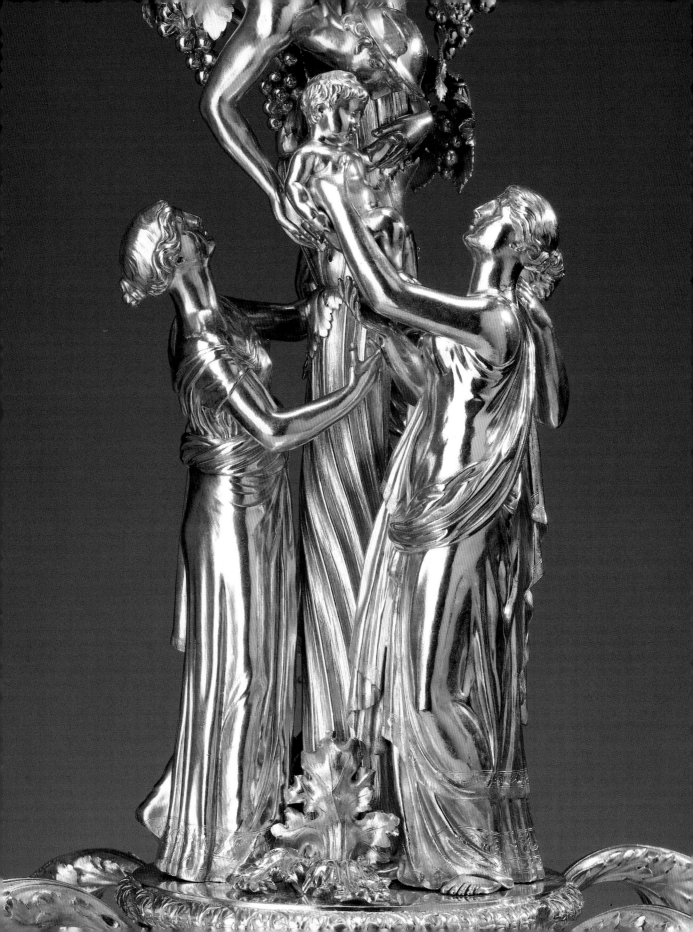

PAUL STORR (1771–1844) for RUNDELL, BRIDGE & RUNDELL;
JOHN FLAXMAN (1755–1826), designer
The Mercury and Bacchus candelabrum,
1809–10 and 1816–17

This monumental candelabrum and its pair, *The Apples of the
Hesperides candelabrum* (1810–11 and 1816–17; RCIN 51976),
were the largest and most magnificent candelabra in George IV's
splendid Grand Service of banqueting plate. The sculptural
group around the stem of this candelaburm depicts Mercury
presenting the infant Bacchus to the nymphs of Nysa after he
was born from the thigh of his father Jupiter; Mercury had sewn
him into Jupiter's thigh after his mother Semele had been
consumed by a thunderbolt during her pregnancy.

The stems and the upper branches of both candelabra were
added by Rundells in 1816–17 to a pair of smaller centrepieces
also made by Paul Storr (for Rundells) about seven years earlier.
The base and lower candle branches of this candelabrum,
described as 'a very large and superb Ornament for Centre of
the Table', were supplied by Rundells to George IV and invoiced
in June 1811 for the huge sum of £2,017 16s. The figures of
piping fauns and panthers were almost certainly modelled by
the sculptor William Theed (1764–1817) and show a surprising
naturalism which anticipates silver of the Victorian period.
The centre was originally occupied with '3 dancing Nymphs, and
a Basket for flowers'.

The enrichment of both candelabra in 1816–17, involving the
stems and everything above the level of the lower candle branches,
was made at a total cost of £1,365. The invoice describes '2 elegant
richly chased Candelabra to fit occasionally the gilt Tripod Stands
with the piping Fauns, composed from Designs made by
FLAXMAN on the subject of Mercury presenting Bacchus to the
Nymphs, the other the Serpent guarding the Tree of Hesperides
with elegant falling Branches and Ornamental devices'.

John Flaxman began designing plate for Rundells around
1805 and continued until his death over 20 years later. Designs
for the Mercury and Bacchus stem survive in the British
Museum and the Victoria and Albert Museum. Because Flaxman
was rarely concerned with functional components, the candle
branches are omitted from the design; his figure groups would
have been worked up by Rundells later. The figures are likely
to have been modelled by either William Theed or Edward
Hodges Baily (1788–1867), a former pupil of Flaxman who
joined Rundells in 1815. Rundells' artists made use of both
Renaissance and ancient sources. The form of both candelabra
recalls the richly sculptural bronze tripod candelabra made in
Venice during the 16th century. Likewise, the piping fauns at the
angles resemble bronze statuettes such as the *Pan listening to
Echo*, traditionally attributed to Riccio, in the Ashmolean
Museum, Oxford.

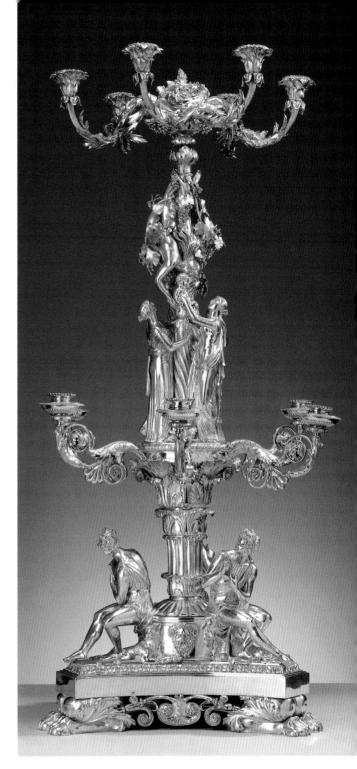

Silver-gilt; 125.0 × 66.0 × 66.0 cm
Base struck with London hallmarks for 1809–10 and maker's mark of Paul
Storr, engraved *RUNDELL BRIDGE ET RUNDELL AURIFICES REGIS ET
PRINCIPIS WALLIÆ LONDINI FECERUNT* and with the Prince of Wales's
feathers and motto within crowned Garter; stem and upper branches struck
with London hallmarks for 1816–17 and maker's mark of Paul Storr
RCIN 51977
Made for George IV when Prince of Wales and when Prince Regent

PAUL STORR (1771–1844) for RUNDELL, BRIDGE & RUNDELL
Phoenix lamp, 1813; *base*, 1817

The Carlton House Inventory of Plate (*c*.1825) lists this lamp (right) and its pair as '2 elegant Ornaments to ... receive Plates or Basons, for the Sideboard or Centre of Table, with device of Phoenix rising from the flames'. Dishes of hot food supported on the head and outstretched wings of the phoenix would have been kept warm by the naphtha oil lamp underneath. Such heating devices were essential at a time when diners still served themselves from tureens and dishes of food placed on the table, a practice known as *service à la française*.

The arrival of the two lamps at Carlton House on 5 July 1813 is recorded in the continuous inventory of plate. E. Alfred Jones states that Rundells charged £505 1s. 9d. for both lamps, but this bill remains untraced. In the following year '2 fluted Pedestals for Phoenixes' were added. However, by 1817 they had been adapted to take two Warwick vases. The present bases were added by Rundells in 1817 at a total cost of £202. They are listed in the continuous inventory on 5 January 1818 as '2 chased Silver gilt stands to receive two phoenix Lamps in form of Rocks & Sea Weeds &c'.

Silver-gilt; 24.3 × 29.1 × 28.5 cm
London hallmarks for 1813–14 and maker's mark of Paul Storr; the bases with London hallmarks for 1817–18 and maker's mark of Paul Storr; engraved *RUNDELL BRIDGE ET RUNDELL AURIFICES REGIS ET PRINCIPIS WALLIÆ REGENTIS BRITANNIAS*; and with Prince of Wales's feathers and motto within crowned Garter motto
RCIN 50278
Made for George IV when Prince Regent

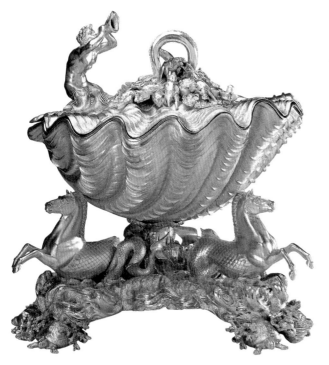

Silver-gilt; 42.0 × 41.0 × 38.0 cm
London hallmarks for 1826–27 and maker's mark of John Bridge; the crowned Garter and motto engraved inside
RCIN 50279
Made for George IV

PHILIP RUNDELL (1743–1827) for RUNDELL, BRIDGE & RUNDELL; JOHN FLAXMAN (1755–1826), designer
Tureen, 1826–27

This impressive tureen was one of four supplied by Rundells for George IV's Grand Service from 1826 to 1827. They were designed to match the superb Marine Service of rococo silver made for Frederick, Prince of Wales, in the 1740s; the extreme naturalism of their design parallels Nicholas Sprimont's crayfish and crab salts made in 1743 (p. 163). However, the massive scale and weight of the tureens is quite unlike mid-18th-century silver and reflects the increasingly opulent tastes of George IV.

Rundells pioneered organic naturalism and the rococo revival style in silver in the early 19th century, largely by means of the plate that they supplied for George IV. They also drew inspiration from 16th- and 17th-century plate: the hippocamps or seahorses which support the bowl of the tureen are derived from an early 17th-century nautilus cup, considered by Flaxman to be by Cellini, sold to George IV by Rundells in 1823 (p. 171). These revivalist styles of the 1820s were revolutionary departures after decades of classicism.

Further versions of the tureen are known. The attribution of the design for the model to Flaxman is supported by two sheets of designs by that artist, in the Victoria and Albert Museum and in the British Museum, which echo the marine themes of the tureens.

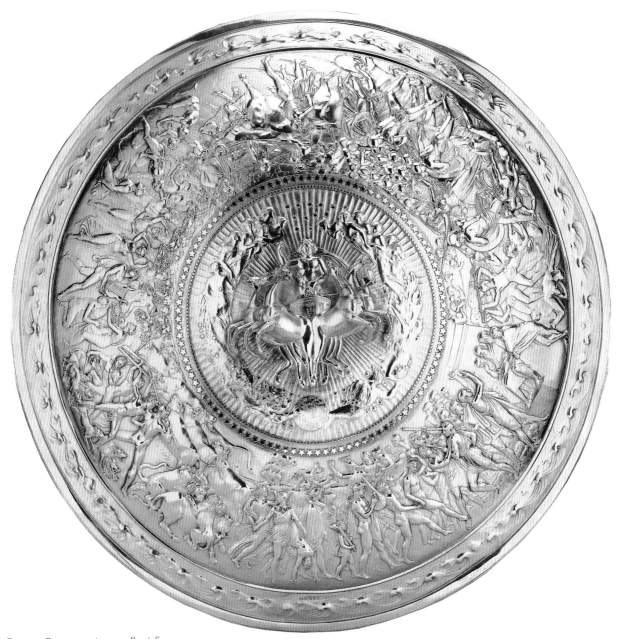

Philip Rundell (1743–1827) for
Rundell, Bridge & Rundell; John Flaxman (1755–1826), designer
The Shield of Achilles, 1821

In the 18th book of the *Iliad*, Homer vividly described a legendary shield, a mirror of the world of gods and men, made for Achilles by the lame god Hephaestus. In 1810 John Flaxman was paid by Rundells to 'reconstruct' this mythological shield from Homer's description. His chief source for the design was probably the narrative in Pope's translation of Homer (1715–20). The final design was not completed until 1817. This shield, the first in a series of silver-gilt and bronze casts, was only completed in 1821, when it was displayed at George IV's coronation banquet. Flaxman was said to have been 'justly proud' of his design, described by Rundells as a 'masterpiece of modern art'.

Silver-gilt; diameter 90.7 cm
London hallmarks for 1821–22 and maker's mark of Philip Rundell; engraved on back *DESIGNED & MODELLED BY JOHN FLAXMAN R.A. EXECUTED & PUBLISHED BY RUNDELL BRIDGE & RUNDELL, GOLDSMITHS & JEWELLERS TO HIS MAJESTY, LONDON MDCCCXXI*, and with cypher of George IV within crowned Garter motto
RCIN 51266
Made for George IV's coronation banquet

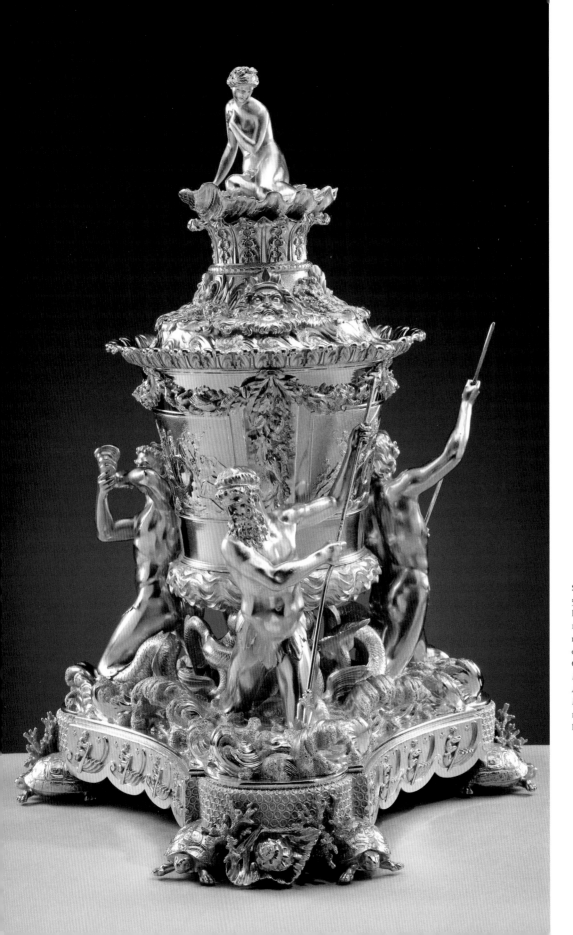

Silver-gilt;
57.8 × 40.0 × 40.0 cm
London hallmarks for
1827–28 and maker's
mark of John Bridge;
engraved with the
Garter and *RUNDELL
BRIDGE ET RUNDELL
AURIFICES REGIS
LONDINI*
RCIN 50843
Made for George IV

JOHN BRIDGE (1755–1834) for RUNDELL, BRIDGE & RUNDELL
Bottle cooler, 1827–28

The design for this magnificent bottle cooler has been attributed to John Flaxman (1755–1826), chief modeller at Rundells from 1809 until his death. Flaxman is perhaps better known for his severely classical designs after the Antique. However, this cooler, like the other marine plate supplied by Rundells for George IV's Grand Service in the 1820s, reflects an interest in Renaissance and rococo plate which foreshadowed the eclecticism of the Victorian period. This interest was almost certainly influenced by the examples of early plate in the collection of George IV. The design of this bottle cooler, with three tritons supporting a vase surmounted by Venus rising from the waves, is clearly inspired by continental 16th-century plate (see pp. 170–71). A similar figure of a triton blowing a conch is found on four tureens supplied for the Grand Service from 1826 to 1827 (p. 166).

This piece is one of four bottle coolers supplied to George IV in 1828 and 1829 for £2,814 16s. 8d. and described in Rundells' invoice as '4 large superbly chased Ice pails with fine figure of Venus on Covers with fine chased antique devices'. Similar coolers were supplied to George IV's brother Ernest Augustus, Duke of Cumberland, and to Thomas Coutts in 1821.

The surmounting figure of Venus appears to have been the conception of Edward Hodges Baily, who carved a full-scale marble version of it in 1855 (Bristol, City Museum and Art Gallery). Baily joined Rundells in 1815 and was responsible for interpreting, modelling and adapting Flaxman's designs. He succeeded Flaxman as chief modeller in 1826.

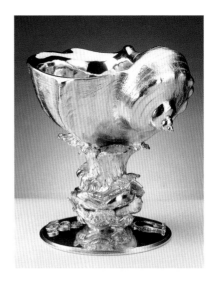

LESLIE DURBIN (1913–2005)
Salt, 1959

This salt (from a set of four) was presented to Queen Elizabeth The Queen Mother when she officially opened the Kariba Dam in the former colony of Rhodesia and Nyasaland in May 1960. Each salt is formed as a trochus shell supported on a group of fish, a suitably watery theme to commemorate the creation of the world's largest man-made lake. The design also echoes the great standing cups of the 16th and 17th centuries, which incorporate real nautilus and trochus shells within elaborate silver-gilt mounts (see pp. 170–71).

Leslie Durbin was one of the finest British goldsmiths of the post-war period. His work is notable for its innovative design and a mastery of traditional techniques. These salts demonstrate his skills as a modeller and chaser. Durbin received many important public and private commissions throughout his long career and has several works in the collection of The Queen Mother and in the Royal Collection.

Silver-gilt; 16.0 × 14.0 cm
Hallmarks for London, 1959, and maker's marks of Leslie Durbin; engraved on bases *Kariba 1960*
RCIN 100008
Presented to Queen Elizabeth The Queen Mother

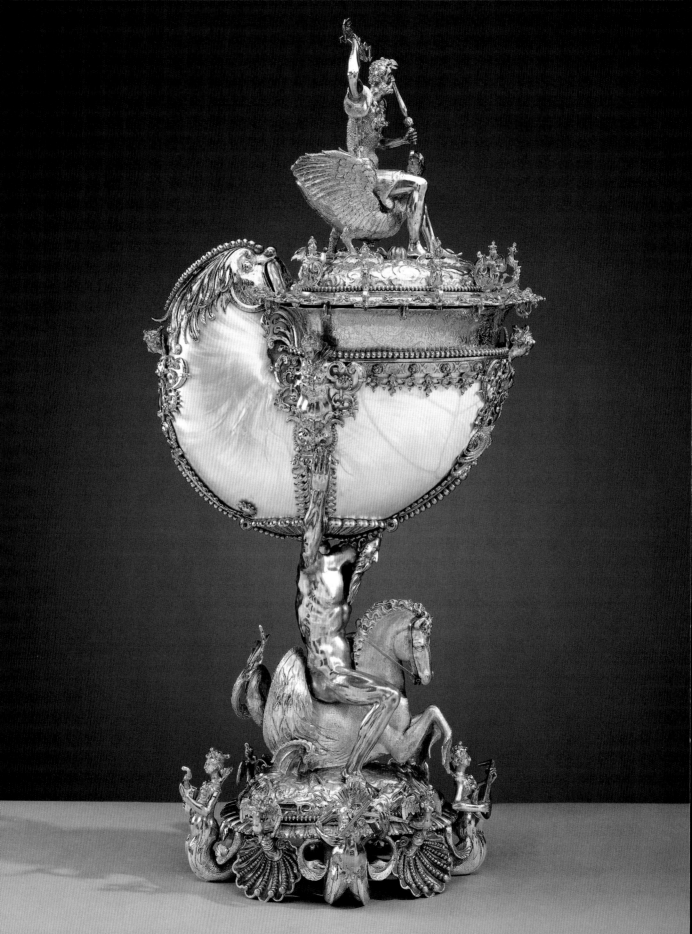

CONTINENTAL SILVER AND GOLD

Opposite:

NIKOLAUS SCHMIDT (*c.*1550/55–1609)
*Nautilus cup, c.*1600

This spectacular *Kunstkammer* object is one of the finest examples of antiquarian plate acquired by George IV. Although once considered to be the work of Benvenuto Cellini, it bears the mark of Nikolaus Schmidt (master 1582), a Nuremberg gold-smith, and is one of Schmidt's most celebrated pieces. His work is notable for its superb quality, fine sculptural elements and frequent incorporation of natural rarities. From the 16th century, nautilus shells from the western Pacific were highly prized by collectors. The outer layer of this shell has been stripped away to reveal the nacreous surface below and the heel has been elaborately carved. The marine origins of the nautilus are echoed in the supporting figures of Neptune, mermaids and hippocamps (sea-horses). The cup may have belonged to the wealthy Peller family from Nuremberg in the 17th century. Nothing more is known of the cup until it appeared in the sale at Wanstead House, Essex, in 1822. Wanstead's heiress Catherine Tylney Long (d. 1825) had married the Duke of Wellington's disreputable nephew William Pole Wellesley (1788–1857) in 1812. Within ten years he had reduced the estate to ruin; Wanstead's treasures were sold and the house demolished.

INDIAN (GUJARAT); mounts attributed to
ELIAS BALDTAUFF (*fl.*1600)
*Casket, c.*1600

Queen Elizabeth The Queen Mother was presented with this casket when she launched the liner *Queen Elizabeth* at Clydebank in 1938. For over 300 years before that it had been kept in the Grünes Gewölbe (Green Vaults) in Dresden, the celebrated treasury assembled by the electors of Saxony.

The casket was made in Gujarat, western India, specifically for export to Europe, via Portuguese traders. Mother-of-pearl was one of the most highly prized natural rarities in Renaissance Europe; the value placed upon this casket is reflected in the elaborate silver-gilt mounts, added around 1600 by the German goldsmith Elias Baldtauff of Torgau, Saxony. It appears to have been purchased for the Green Vaults from the dealer Veit Böttiger at the Leipzig Easter Fair in 1602. Other mother-of-pearl objects, including two further caskets (which survive in the Green Vaults), were also acquired from Böttiger at a total cost of 8,500 *thaler.*

After the First World War the kingdom of Saxony became a republic and the royal house of Wettin was deposed. As compensation, they were given a number of treasures from the Green Vaults, including this casket, which was sold shortly after.

Opposite:
Nautilus shell with
parcel-gilt silver mounts;
52.5 × 24.5 × 16.0 cm
Nuremberg townmark
and maker's mark of
Nikolaus Schmidt
RCIN 50603
Purchased by George IV

Right:
Mother-of-pearl, teak,
silver-gilt, rock crystal
feet, velvet;
19.2 × 28.6 × 18.1 cm
Torgau townmark and
maker's mark attributed
to Elias Baldtauff
RCIN 100009
Presented to
Queen Elizabeth
The Queen Mother

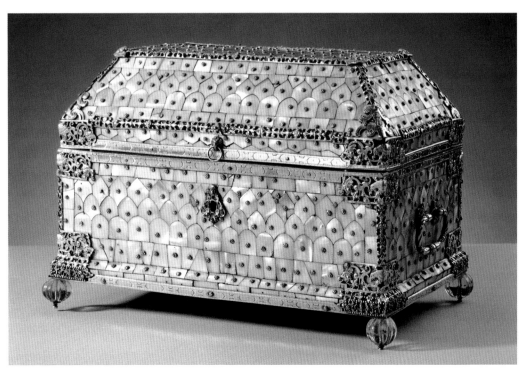

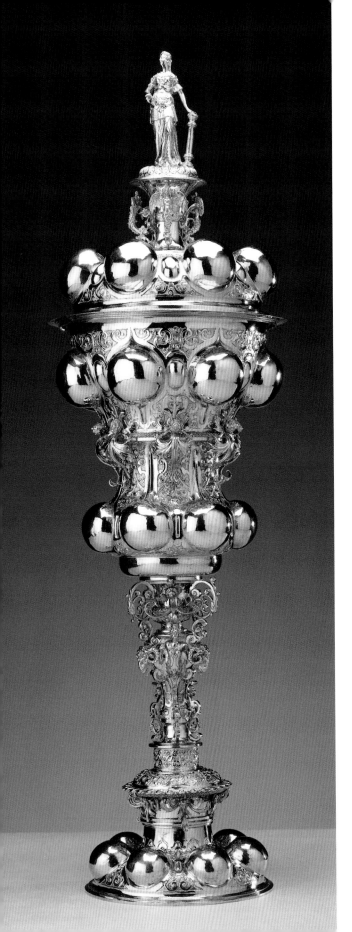

MICHEL HAUSSNER (1573–c.1638)
Standing cup and cover, c.1610–20

This elaborately chased cup and cover is first recorded in the Carlton House Inventory of Plate (c.1825). It was said to have been 'presented by His Majesty Charles the First to one of the Principals of the University at Oxford, whilst holding the Parliament in that City'.

In 1843 the cup was illustrated and described (in its original partly gilt state) in Henry Shaw's influential publication *Dresses and Decorations of the Middle Ages*, where an alternative account of its early history is given. Shaw, apparently with the help of John Bridge (of Rundell, Bridge & Rundell), records that the cup had formerly belonged to Charles II and that he had presented it to a Master of Queen's College, Oxford, for services to his father during the Civil War. The cup is said to have remained in the same family until the 1820s, when it was bought by Rundells and sold by them to George IV.

Given John Bridge's involvement, Henry Shaw's account is probably more reliable than that in the Carlton House Inventory. It is unlikely that Charles I would have given away such an object at a time when the Jewel House was heavily depleted and the King had requested plate from many individuals and institutions, including the Oxford colleges, to help finance the royalist army.

This cup and cover is a particularly large and elaborate example of the type of presentation vessel popular in Nuremberg in the late 16th and early 17th centuries. With its tall, slender and organic form, embossed bulb decoration and filigree foliage, it is typical of the neo-Gothic style adopted by Nuremberg goldsmiths at this date.

Finial figures representing the Virtues were popular; on this cup Fortitude is symbolised by the column. In 1606, Michel Haussner (master 1601; about whom little else is known) supplied a similar *Knorretes Trinkgeschirr* ('burred' drinking cup) to the Nuremberg City Council, surmounted by the figure of Patience.

Silver-gilt; 58.3 × diameter 16.9 cm
Nuremberg townmark and maker's mark of Michel Haussner
RCIN 51466
Purchased by George IV

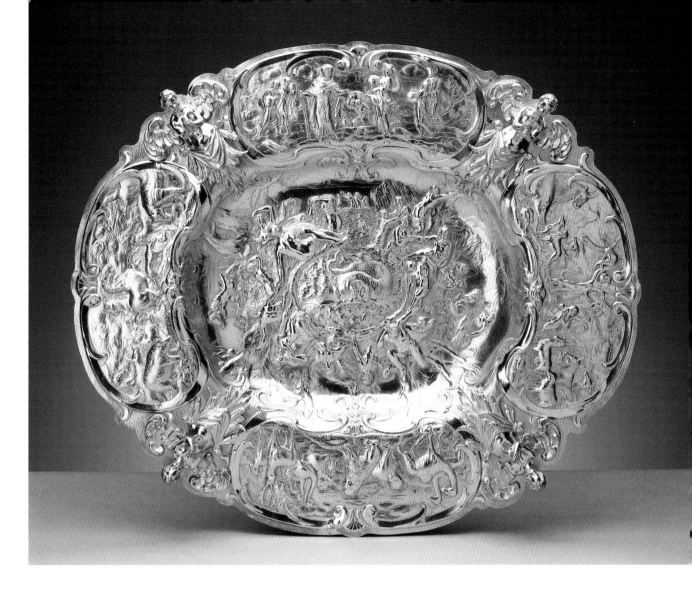

ANDREAS WICKERT I (1600–1661)
Rosewater basin, c.1650

This exuberant example of Baroque silver admirably demonstrates George IV's pioneering taste for early silver. It was one of the first examples to be acquired by him and was purchased, together with a ewer (now unlocated), in 1817. The majority of such pieces were bought in the 1820s and, like this basin, came from Rundells. It is not clear whether the basin and ewer described in the account originally belonged together. They appear to have been separated shortly after their acquisition: the Carlton House Inventory of Plate (*c.*1825) records the basin only.

The surface of the basin is richly embossed with scenes from the story of the Deluge. Writhing bodies, struggling in the rising floodwaters, surround a dolphin in the centre of the basin. In the border, Noah and his family are shown about to enter the Ark. The groups of exotic animals and birds within the remaining cartouches may represent the continents of Europe, Asia and Africa. The theme of water appropriately reflects the original function of the basin: it was used for the ceremonial rinsing of the hands in rosewater before dining.

Andreas Wickert I (master 1629) was a citizen of Augsburg. It is probable that this basin was originally partly gilt, a characteristic feature of High Baroque silver from Augsburg, and that the four cartouches were left ungilded. George IV came to prefer gilt to plain silver. The majority of his plate (possibly including this piece) was gilded by *c.*1820.

Silver-gilt; 8.2 × 64.6 × 54.5 cm
Hallmark for Augsburg and maker's mark
of Andreas Wickert I
RCIN 51497
Purchased by George IV when Prince Regent

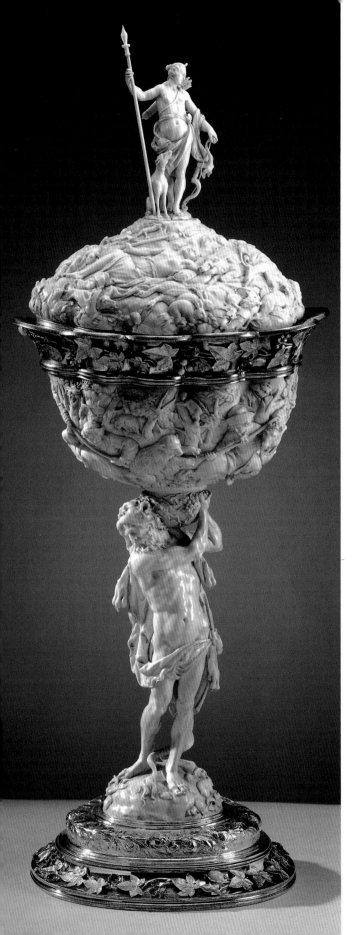

SOUTHERN GERMAN, and JOHN BRIDGE (1755–1834)
for RUNDELL, BRIDGE & RUNDELL
Cup and cover, c.1700, jewelled mounts, 1824–25

The arrival in England of this superb example of virtuoso ivory carving was announced in the *Morning Post and Daily Advertiser* on 20 May 1788: 'RECENTLY brought from Vienna, and added to the Museum [the *Holophusicon*], an inconceivably beautiful effort of art ... consisting of a cup or vessel carved in ivory; the figure of Hercules dressed in the skin of the Nemean Lion forms the handle or stem.' A few weeks later one 'PROFESSOR THORKELIN of Copenhagen' attributed it to the Danish court sculptor Magnus Berg (1666–1739). A tentative attribution has since been made to the southern German ivory carver Johann Gottfried Frisch (*fl.*1689–1716).

The *Holophusicon*, Sir Ashton Lever's noted collection of natural history and ethnography, opened in Leicester House, London, in 1775. The collection was acquired (via a winning lottery ticket) by James Parkinson in 1786. Parkinson brought this cup and cover from Vienna two years later. The *Holophusicon* was dispersed by auction in 1806 (in perhaps 8,000 lots). The cup and cover were subsequently acquired by the collector William Beckford of Fonthill Abbey. The cup was illustrated in John Rutter's *Delineations of Fonthill and its Abbey* (1823), prominently displayed in King Edward's Gallery on the Borghese Table (now at Charlecote Park, Warwick), flanked by two ivory vases (now in the British Museum). Most of Beckford's dazzling collection was sold by auction in 1823, when George IV purchased the cup for 90 guineas. The King shared Beckford's taste for virtuoso pieces in exotic materials and the cup joined a growing collection of mounted ivories at Carlton House. The original chased silver-gilt mounts were evidently too plain for George IV's increasingly flamboyant tastes and in 1824 Rundells added 'a new silver chased rim ... set with coloured stones to raise the cover' for £148 10s.

Ivory, silver-gilt, gemstones;
52.8 × 20.5 × 16.5 cm
Illegible (town?) mark and maker's mark *DC* (unidentified) on silver-gilt inner rim; London marks for 1824–25 and maker's mark of John Bridge on jewelled mounts
RCIN 50554
Purchased by George IV

Back

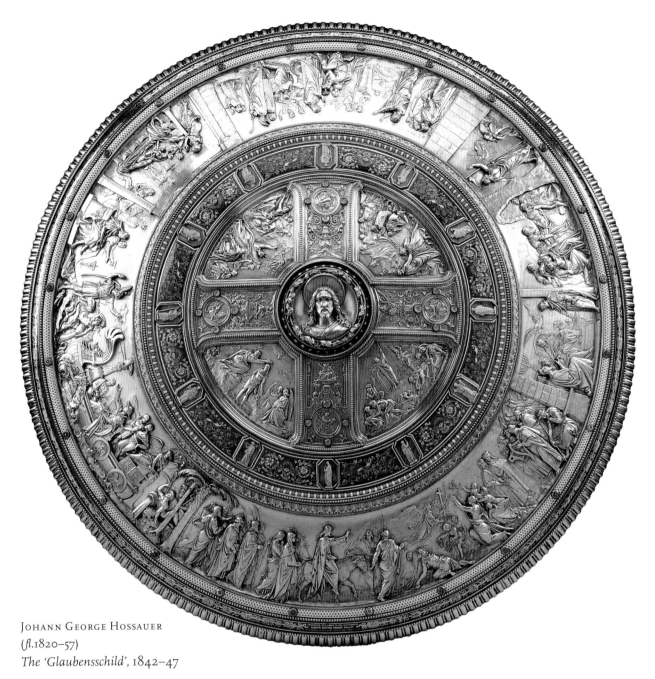

JOHANN GEORGE HOSSAUER
(*fl.*1820–57)
The 'Glaubensschild', 1842–47

The *Glaubensschild* was given to the infant Prince of Wales (later King Edward VII) by his godfather, King Frederick William IV of Prussia. The name means 'Shield of Faith', a reference to the Prince's future title 'Defender of the Faith'. The King had attended the Prince's baptism in St George's Chapel, Windsor, on 25 January 1842 and afterwards declared his intention to present the Prince with a shield to commemorate this event.

Many artists and craftsmen were involved in the design and execution of this exemplary piece. Such was the complexity of the work that it was over five years before the completed shield was finally presented to the Prince, in April 1847.

The very Christian iconography reflects Cornelius's membership of the Nazarene Brotherhood, who believed all art should have a religious or moral purpose. The idealised scenes include one showing Prince Albert, the Duke of Wellington and St George receiving the King of Prussia on his arrival in England.

Silver, gold, enamel, onyx, chrysoprase; diameter 89.0 cm
Inscribed *FRIDERICUS GUILELMUS IV REX BORUSSORUM ALBERTO EDUARDO PRINCIPI WALLIÆ IN MEMORIAM DIEI BAPT.XXV.M.IAN. A.MDCCCXLII*
RCIN 31605
Christening present from King Frederick William IV of Prussia to the future King Edward VII

GOLD BOXES

ENGLISH (?)
Queen Mary's patch box, c.1694

The maker of this remarkable enamelled gold box, which bears the crowned monogram of Queen Mary II (1662–1694), is not recorded. However, the markedly sophisticated use of enamels, engine-turning and engraving indicates continental craftsmanship, probably the work of a foreign jeweller in London. Queen Mary's accounts indicate that she had a weakness for jewellery and bijouterie of all kinds. The maker of this box was almost certainly the same as that of an agate and gold box discovered in Holland in the 1960s. That gold box may be identifiable with the 'Gold pach [sic] box with an Agatt Stone Cover' purchased by the Queen on 10 May 1694 for £10 from the jeweller James Schuelt, whose name suggests a Germanic origin.

Patch boxes were used to contain face patches, worn from the early 17th century to disguise blemishes, particularly smallpox scars. By the time of the Restoration, patches had become highly fashionable accessories; as many as seven or eight were worn at a time and elaborately decorated boxes such as this one, with sprung and mirror-lined lids, were much in vogue. The fashion attracted criticism from moralists of the day,

who considered face patches a sign of grotesque vanity. Despite the Bishop of Gloucester boasting that Queen Mary 'did not entertain such childish vanities as spotted faces', her accounts show that during the last year of her life she was regularly buying from her milliner 'paper for patches' costing 1s. a sheet. Ironically the Queen died of smallpox, at the tragically young age of 32 in December 1694. It is possible that this patch box was then presented to Anthony, 11th Earl of Kent, one of six pall-bearers at her funeral. Alternatively it may have been given to Hans Willem Bentinck, 1st Earl of Portland, a close confidant of William III; Portland's daughter, Elizabeth Ariana, was the grandmother of John, 7th Earl of Bridgewater, in whose family the box remained until purchased by The Queen in 1963.

Gold, enamel, diamonds; 2.3 × 5.2 × 4.5 cm
RCIN 19133
Made for presentation by Queen Mary II.
Purchased by HM The Queen

ENGLISH
Gold box, c.1749

This exceptional box was given to Francis, Lord North (1704–1790), in 1749, when he was appointed governor to the 11-year-old Prince George of Wales (later George III).

The thumb piece is chased with the North crest below a coronet; an enamel portrait (shown below) of Prince George's father Frederick, Prince of Wales, c.1743, by Christian Frederick Zincke (1683/84–1767), is set inside the lid and the Prince of Wales's initials, feathers and motto are chased on the arched top.

Pastoral allegories on the lid and base depict scenes of sowing and the harvest – perhaps a symbolic tribute to the governor's role in ploughing the ground in preparation for a rich harvest. The symbolism continues with the peacock and pelican on the lid, the piety of the pelican contrasting with the vanity of the peacock.

Lord North's position as governor or Preceptor to Prince Frederick's sons was a lucrative appointment. His duties were 'to go about with Prince George and appear with him in public', for which he received £1,000 a year, in addition to the £500 salary he already received as a Lord of the Bedchamber to the Prince of Wales. The importance and responsibility of North's task is reflected in the superb quality of the box.

This piece belongs to a small group of finely chased English gold boxes supplied to Frederick, Prince of Wales, in the 1740s, probably the work of an immigrant German goldsmith. Zincke was appointed Cabinet Painter to Prince Frederick in 1732.

Inside

Top

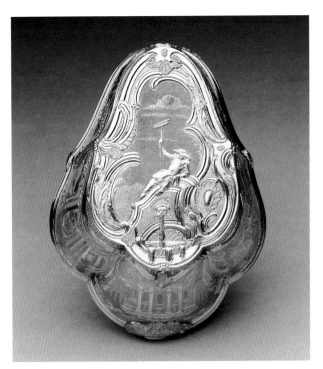

Base

Gold, enamel; 3.8 × 6.8 × 9.0 cm
RCIN 3926
Purchased by Queen Mary as a gift for
King George V

Below:

FRENCH

Snuff box, c.1765

Most gold boxes were ostensibly made to contain snuff – a mixture of finely ground tobacco leaves and aromatics – for which there was a great vogue in Europe during the 18th century. Yet many boxes were not used for this purpose at all, but were simply admired for their virtuosity and beauty.

Although unmarked, the superb quality of this box indicates a leading Parisian workshop. It is elaborately chased in vari-coloured gold with allegories of putti and cherubs, emblematic of the arts and sciences, against an unusual dark tinted background. The underside of the lid is set with a painted miniature of Adolphus Frederick IV, Duke of Mecklenburg-Strelitz (1738–94; see also p. 106). The Duke, elder brother of Queen Charlotte, was installed as a Knight of the Garter in 1764 and is portrayed here wearing the Garter collar and star.

This snuff box was given to Hugh Seton of Touch in April 1769 by Duke Adolphus Frederick in thanks for his gift of a post chaise (a four-wheeled carriage) sent from England. During an audience with the Duke the previous September, Seton, a keen agricultural improver, had been entrusted with the task of delivering a number of letters to Queen Charlotte, who was confined in England for the birth of Princess Augusta. Having fulfilled the task, Seton wrote to the Duke confirming the safe delivery of the letters; he added that he was sending the Duke a post chaise as a mark of his attachment to him. The delighted Duke wrote to thank Seton for his generous gift, in which he drove out daily, and begged him to accept the *petit paquet* he was sending as a mark of his friendship.

Vari-coloured gold; lid inset with glazed miniature painted on ivory;
4.2 × 8.2 × 6.1 cm
RCIN 100014
Purchased by Queen Mary as a gift for King George V

HENRY BODSON (fl.1763–90)
Snuff box, 1768–69

This box is notable for both the quality of its *en plein* enamel work (enamel applied directly onto the body of the box) and its finely chased gold borders. Blue and gold flecked painted panels give the impression that the body of the box is made from the finest lapis lazuli. Oval enamel panels, on the top, bottom and sides of the box, depict marble statues with amatory themes. One panel shows Edmé Bouchardon's sculpture *Cupid Making a Bow from Hercules' Club* (Louvre), exhibited at the Paris Salon in 1746. The compositions of two other panels are derived from non-sculptural sources: *Cupid Sacrificing at the Altar of Love and Marriage,* on the base of the box, is taken from the engraving *Autel de l'Amitié* by Gilles Demarteau, after a design by Boucher; *Cupid Aiming his Bow* is taken from *L'Amour menaçant* by Carle Van Loo, engraved in 1765 by Charles de Méchel. The gold borders display a variety of goldsmith's techniques. They are predominantly of red gold but incorporate green gold chased in low relief over *sablé* or sanded gold backgrounds. This snuff box is struck with the mark of Henry Bodson, who trained in the Louvre studio of François-Thomas Germain, goldsmith to Louis XV. Bodson was received master in 1763 and established his own studio on the pont Notre-Dame, Paris. Boxes bearing his mark survive in the Louvre and the Musée Cognacq-Jay in Paris, and the Wallace Collection in London.

Two-colour gold, *en plein* enamel; 3.8 × 7.9 × 6.0 cm
Charge and discharge marks for the *fermier-général*
Julien Alaterre, Paris, 23 December 1768–31 August 1775;
warden's mark for Paris, 13 July 1768–11 July 1769;
enamel plaque on the base inscribed
HOTEL DE / CHIMEN ET DE / L'AMOUR [sic]
RCIN 19136
Presented to King George V and Queen Mary
on the King's Silver Jubilee

GERMAN
Table snuff box, c.1770–75

This spectacular bloodstone box is encrusted with nearly 3,000 diamonds backed with delicately coloured foils in shades of pink and yellow. It is one of the finest of the series of boxes made in the Fabrique Royale in Berlin and associated with Frederick II ('the Great') of Prussia (1712–1786). Frederick was a passionate snuff-taker and is said to have had a collection of over 300 boxes. Jewellers flocked to Berlin to supply the King and the Prussian court with elaborate boxes of hardstone, gold and enamel. Many other boxes were made as diplomatic gifts. The brothers André and Jean-Louis Jordan and Daniel Baudesson were among the most frequent suppliers, but an absence of hallmarks on surviving examples makes it difficult to attribute individual boxes to particular makers. Many of the box designs are attributed to Jean Guillaume George Krüger, who arrived in Berlin from Paris in 1753. Frederick himself is said to have contributed to the design of many boxes.

This table snuff box is unique among the surviving Frederick the Great boxes for both its elaborately chased vari-coloured gold mounts and its particularly lavish use of diamonds. Although its early provenance remains unclear, it was an important royal commission and was possibly made for Frederick's personal use. It was latterly in the Russian imperial collection, which may suggest that it was a gift from Frederick the Great to Catherine the Great. However, as the box is not listed in early Russian inventories, it is more likely to have belonged to Tsarina Alexandra Feodorovna (1798–1860), consort of Tsar Nicholas I. She was the daughter of Frederick William III of Prussia, who succeeded to the throne in 1797 and is known to have presented his son Albrecht with one of Frederick the Great's boxes.

Bloodstone, vari-coloured gold, foiled diamonds; 5.1 × 10.7 × 8.5 cm
RCIN 9044
Purchased by Queen Mary

English
Watchcase with chatelaine, c.1781

The crowned cypher of George III in diamonds decorates the back of the watchcase. It was reputedly given (together with a matching locket and chatelaine, RCIN 43798–9) by George III to his godson James George, 3rd Earl of Courtown (1765–1835), Treasurer of the Royal Household in 1793, and from 1806 to 1812. The King had presented a watch and chatelaine of the same model to his close friend Simon, 1st Earl Harcourt, before Harcourt's death in 1777. However, this piece was probably made in or soon after 1781, as the matching locket contains a miniature of George III, after the portrait by Thomas Gainsborough exhibited at the Royal Academy in that year. The watch may have been given to the Earl on his marriage in 1791; the corresponding chatelaine and locket, a particularly feminine object, was perhaps a gift to his bride, Mary (1769–1823).

Lord Courtown's parents lived in Windsor Castle and had especially close links with the court. James, the 2nd Earl (1731–1810), had been Lord of the Bedchamber to the King, when Prince of Wales, and was made Treasurer of the Royal Household in 1784. His wife Mary (d. 1810) was the Queen's 'Lady in Waiting in the Country'. In view of these connections, it is possible that the reputed provenance of this piece is incorrect and that the watch and locket were in fact given to the 2nd Earl and his wife, perhaps in the early 1780s.

Although the watch movement is now missing, it was almost certainly supplied by the Swiss-born watch- and clock-maker François-Justin Vulliamy (1712–1797). Vulliamy received a number of important commissions from George III, including the watch given to Lord Harcourt and a second almost identical watch, also in the Royal Collection, which belonged to the King (RCIN 65350). His son Benjamin and his grandson Benjamin Lewis later worked extensively for George IV.

Gold, enamel, diamonds (watch movement missing);
chatelaine 14 cm long; watch 7.0 × 5.5 × 1.5 cm
RCIN 43796 (watchcase), 43797 (chatelaine)
Made for George III. Purchased by King George V and Queen Mary

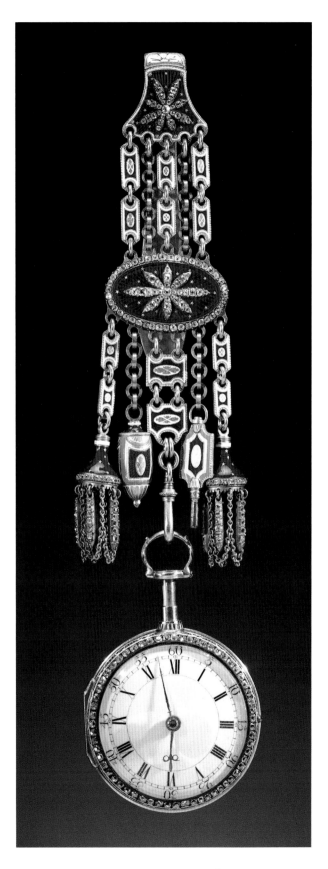

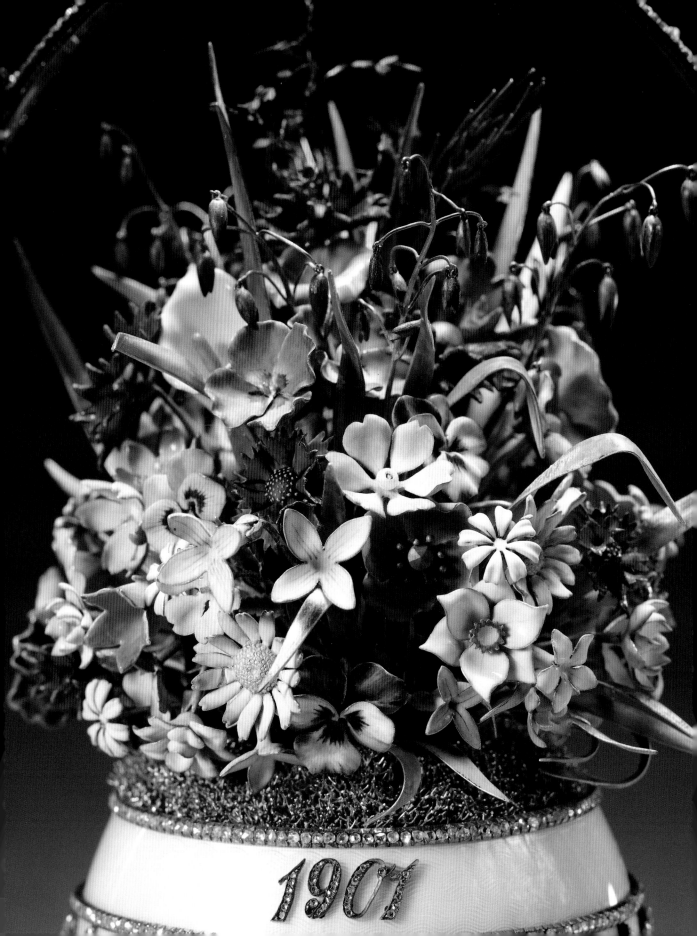

FABERGÉ

One of the most famous jewellers and goldsmiths of the late 19th and early 20th centuries, Peter Carl Fabergé (1846–1920) has a reputation that has long outlived the short period between 1882 and 1917 that his workshop was principally in production. The reasons for his fame are well documented: outstanding technical skill, an instinct for innovation, highly organised workshops, talented craftsmen, exacting standards and an ability to elevate the most mundane object into a work of art. The unique character of Fabergé's work comes from the combination of a wide variety of sources, from antiquities and oriental art to the Louis XV and Art Nouveau styles. Most of the objects were unique, made by hand to a design that was not repeated.

In 1885 Fabergé was made Supplier to the Court of His Imperial Majesty Tsar Alexander III. Under his leadership, the family business in St Petersburg went from strength to strength, employing some 500 staff, with branches in Moscow (1887), Odessa (1900), London (1903) and Kiev (1905).

The close family links between the Russian, Danish and English royal houses were crucial to Fabergé's success. Queen Alexandra, wife of King Edward VII, frequently exchanged presents by Fabergé (the less expensive animals and flowers or frames) with her family. Most of the elaborately jewelled pieces acquired by the royal couple were gifts rather than purchases.

The most important event in the formation of the royal Fabergé collection was King Edward VII's decision in 1907 to commission for Queen Alexandra's birthday miniature sculptures of over 100 domestic and farmyard animals at Sandringham.

King George V inherited his parents' interest in Fabergé's work, but his consort, Queen Mary, became the greatest royal collector of Fabergé after King Edward VII and Queen Alexandra, acquiring numerous pieces, including three of the 50 costly imperial Easter eggs produced by Fabergé for the Russian imperial family between 1885 and 1916.

The Fabergé flowers in the Royal Collection represent one of the largest Fabergé collections ever formed (27 out of a total 80 flowers that he made). The principal collectors were Queen Alexandra, her daughter Princess Victoria and her daughter-in-law Queen Mary.

Fabergé's frames ranged from the most elaborate gold and jewel-encrusted ornaments, given as official gifts, to simple wooden examples mounted with silver and normally containing photographs. The majority in the Royal Collection were collected by King Edward VII and Queen Alexandra.

The imperial family ordered hundreds of presentation boxes (of which four by Fabergé are in the Royal Collection), as official gifts or for special occasions (p. 183). They ranged from lavish bejewelled snuff boxes set with miniature portraits to more mundane enamelled examples.

Fabergé produced a number of unusual miniature items, in the main charming decorative objects made with minute attention to detail. They range from musical instruments to furniture (p. 184) in a variety of styles, notably interpretations of Louis XV or Louis XVI designs.

Fabergé's everyday business was based on the supply of practical objects, including (mainly) silverware and desk items, which Fabergé turned into an art form. The enormous range – well represented in the Royal Collection – covers seals (p. 185), paper-knives, glue-pots, stamp boxes and bell-pushes.

The royal fascination with Fabergé continued with Queen Elizabeth The Queen Mother, who formed her own collection of flowers, bibelots, boxes and photograph frames. In the present reign, selections from the Fabergé collection have been exhibited all over the world.

Notes: All objects shown were made in St Petersburg; the purity of gold and silver is measured in *zolotniks*: 56 and 72 *zolotniks* indicate 14 and 18 carat gold; 84, 88 and 91 *zolotniks* indicate 21, 22 and 22¾ carat silver.

Details: Peter Carl Fabergé, Basket of Flowers Egg, 1901 (see p. 186)

FRAMES

Frame holding a painted miniature of Tsarina Marie Feodorovna, c.1895

This frame contains a painted miniature of Marie Feodorovna (1847–1928), Princess Dagmar of Denmark, who married the future Tsar Alexander III in 1866. Unlike her husband, she enjoyed the extravagance of court life in St Petersburg, and greatly admired Fabergé. After her husband's death in 1894, their son continued the tradition of presenting her with a Fabergé Easter egg.

The frame combines two of Fabergé's famous skills – guilloché enamel and coloured gold decoration, both revivals of French 18th-century techniques.

Gold, enamel, ivory; 9.0 × 7.8 × 7.3 cm
Frame: mark of Michael Perchin; gold mark of 56 *zolotniks* (before 1896); *FABERGÉ* in Cyrillic characters; miniature: signed *Zehngraf*
RCIN 40107
Acquired by King Edward VII and Queen Alexandra

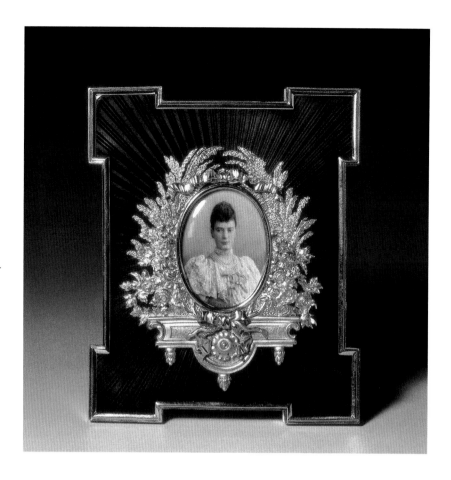

Strut frame holding a photograph of Persimmon, c.1908

Enamelled in King Edward VII's racing colours, this frame has a photograph of one of the King's most successful race-horses, Persimmon, winner of the Derby and the St Leger in 1896 and of the Ascot Gold Cup and Eclipse Stakes in 1897.

Persimmon was retired to stud at Sandringham, where he had been bred. In 1908 he slipped in his box and fractured his pelvis; despite every effort to save him he had to be put down.

Persimmon was among the animals modelled from life for Fabergé during the Sandringham commission in 1907.

Gold, enamel, silver-gilt, moonstones; 12.0 × 15.8 × 10.1 cm
Mark of Henrik Wigström; gold mark of 56 *zolotniks* and silver mark of 91 *zolotniks* (1908–17); *FABERGÉ* in Cyrillic characters
RCIN 15168
Purchased by Queen Alexandra

Boxes

Below:

Imperial presentation box, 1896–1908

During the reign of Tsar Nicholas II (r. 1894–1917), a total of 300 snuff boxes with the diamond-set cypher of the sovereign were commissioned. These boxes were intended for presentation to ambassadors, aides-de-camp and other prominent officials in the service of foreign heads of state. This box is an example of one of the grandest types of presentation box produced by Fabergé. A number of these, similarly mounted with the Tsar's cypher in diamonds, were made at the time of Nicholas II's coronation in 1896. These boxes are usually in the colours of the imperial mantle (yellow and black).

This box is a very fine example of guilloché enamelling with a combined concentric circle and sunburst design. Fabergé's enamellers did not mark their work, but the importance of their contribution to Fabergé's success cannot be overestimated. The separate workshop entirely devoted to enamelling was run by Alexander Petrov and his son Nicholas.

Gold, enamel, diamonds; 3.1 × 8.3 × 8.3 cm
Mark of August Höllming; gold mark of 56 *zolotniks* (1896–1908);
FABERGÉ in Cyrillic characters
RCIN 100012
Purchased by Queen Elizabeth The Queen Mother

Above:

Cigarette case, 1908

Practical objects such as cigarette cases and boxes formed a large part of the output of Fabergé's workshop. The Art Nouveau style of this case, one of Fabergé's most successful designs, is something of a departure from the restrained 'Louis XVI' classicism of most of his output. Fabergé was criticised at the 1900 Exposition Universelle in Paris for his neo-classical designs, which the French felt compared unfavourably with the popular style of Art Nouveau from the early 1890s. As a response, Fabergé produced pieces in the new style, notably three imperial Easter eggs and some smaller pieces. In spite of the criticisms of his designs, there was praise for his workmanship. In this case the skilfully recessed hinge allows the edges to be simplified and the design of the snake to be integrated on both sides.

The cigarette case demonstrates Fabergé's brilliant handling of guilloché enamelling, the geometric moiré wave pattern being one of his favoured designs. The remarkably vivid colour of the enamel is one example of the rainbow of colours Fabergé used.

The cigarette case was given to King Edward VII by Mrs Keppel, also an avid collector of Fabergé. She became the King's mistress in the late 1890s and remained close to him until his death in 1910. At that time Queen Alexandra returned the case to Mrs Keppel. She in turn gave it to Queen Mary in 1936.

Gold, enamel, diamonds; 1.7 × 9.6 × 7.0 cm
Moscow gold mark of 56 *zolotniks* (1896–1908)
RCIN 40113
Presented to Queen Mary

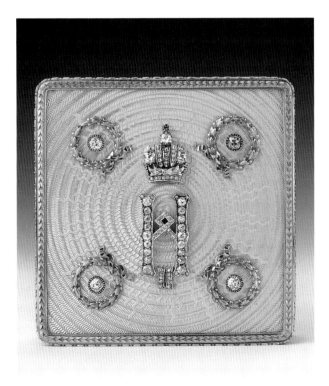

Miniature Items

Miniature table, 1896–1903

This Louis XVI-style table is one of four pieces of miniature furniture in the Royal Collection. In its clever use of materials, this piece is a good example of Fabergé's versatility. The red guilloché enamel imitates the wood veneer, the two-coloured gold mounts imitate gilt bronze, and the blue and white enamel mounts imitate Wedgwood porcelain. The eight plaques above the legs have been described as incorporating the cypher of Tsarina Marie Feodorovna, but this is not obvious on close examination. The mother-of-pearl top, in imitation of marble, is engraved with Romanov eagles and the central shelf joining the legs is also lined with mother-of-pearl.

Gold, mother-of-pearl, enamel; 8.9 × 8.4 × 6.1 cm
Mark of Michael Perchin; gold mark of
56 *zolotniks* (1896–1908); *FABERGÉ* in
Cyrillic characters
RCIN 9142
Purchased by Queen Mary

Terrestrial globe, before 1886

This globe was produced in the workshop of Erik Kollin, Fabergé's first chief workmaster, who specialised in the production of gold objects. It is an early example of Fabergé's characteristic use of different coloured golds in combination with silver-gilt. At least two other rock crystal globes by Fabergé are known.

Rock crystal, gold, silver-gilt;
10.5 × diameter 6.0 cm
Mark of Erik Kollin; gold and silver marks of
56 and 88 *zolotniks* respectively (before 1896);
FABERGÉ in Cyrillic characters
RCIN 40484
Purchased by Queen Mary

Miniature desk, 1896–1908

The drop front of this Louis XV-style roll-top desk with rococo mounts opens by means of a miniature gold key to reveal an interior lined with engraved mother-of-pearl and divided into compartments. Although the workmaster's mark is now illegible, the neo-rococo design is reminiscent of the objects produced in Perchin's workshop. The attention to detail, particularly in the fine mauve and opalescent white enamel on such a minute scale, exemplifies Fabergé's exacting standards of workmanship.

Gold, enamel, mother-of-pearl; 11.0 × 8.7 × 6.5 cm
Illegible workmaster's mark; gold mark of
56 *zolotniks* (1896–1908); *FABERGÉ* in
Cyrillic characters
RCIN 100013
Acquired by Queen Elizabeth The Queen Mother

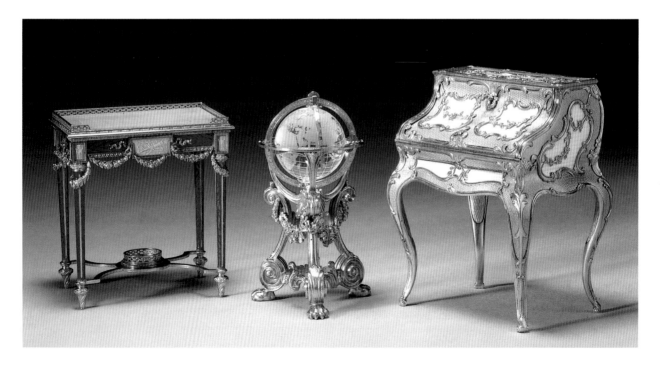

DESK ITEMS

Clock, 1896–1901

Fabergé's clocks, however extravagantly decorated, were designed to be functional and easy to use. The four lobes engraved with trophies are of rock crystal, a naturally occurring stone. The panels are divided by red gold arrows set with diamonds and rubies. The reverse of the movement has two fixed keys with folding handles and is engraved in Russian, indicating an eight-day movement. The design of this clock is unusual in Fabergé's repertoire; the model most frequently produced was an enamelled strut clock. One of only two pieces of Fabergé known to have belonged to Queen Victoria, this clock was later used by King George V on his desk.

Rock crystal, gold, silver-gilt, enamel, diamonds, rubies; 11.6 × 12.5 × 9.9 cm
Mark of Michael Perchin; silver mark of 88 *zolotniks* (1896–1908)
RCIN 40100
Presented to Queen Victoria by Tsarina Alexandra Feodorovna

Far left:
Seal, c.1900

This nephrite hand seal is engraved with the crowned cypher of King George V. The egg-shaped handle supported on a dolphin is elaborately decorated with three-coloured gold floral swags and a band of diamonds and rubies.

Nephrite, gold, diamonds, rubies; 6.4 × 2.8 cm
Mark of Michael Perchin; *FABERGÉ* in Cyrillic characters
RCIN 9258
Probably acquired by King George V

Left:
Seal, 1896–1903

The agate seal stone is engraved with two birds perched on the rim of a classical bird-bath.

Nephrite, enamel, gold, agate; 4.8 × diameter 2.3 cm
Mark of Michael Perchin; gold mark of 56 *zolotniks* (1896–1908)
RCIN 40161
Probably acquired by Queen Mary

Eggs

Below:

Easter egg, 1899

In addition to the 50 Easter eggs made for the imperial family, Fabergé was commissioned to produce eggs for members of Russian society wealthy enough to place orders, thanks to the huge growth in industry in St Petersburg and Moscow in the early 20th century.

In 1898 Alexander Kelch, a business-man with mining enterprises in Siberia who is thought to have supplied Fabergé with gold and other raw materials, commissioned the first of a series of Easter eggs from Fabergé. This egg, the second in the series, bears the initials of Kelch's wife Barbara. It is divided into 12 translucent pink and blue enamel panels by chased gold borders overlaid with enamelled roses, a feature Fabergé had used on two earlier imperial Easter eggs.

The 'surprise' this egg once contained was already missing when it entered the Royal Collection in 1933. The egg is presumed to have been brought out of Russia after the Kelchs separated in 1905.

Gold, enamel, diamonds; 9.5 × diameter 7.0 cm
Mark of Michael Perchin
RCIN 9032
Purchased by King George V as a gift
for Queen Mary

See details on pp. 180–81

Basket of Flowers Egg, 1901

For many years the imperial provenance of the Basket of Flowers Egg was doubted. However, the recent discovery of Fabergé's invoice for 6,850 roubles, dated 16 April 1901, has confirmed that the egg was commissioned by Tsar Nicholas II for Tsarina Alexandra Feodorovna, the granddaughter of Queen Victoria.

The Basket of Flowers Egg is also clearly visible in photographs of the vitrines at the Von Dervis exhibition in 1902, which indicate that the egg-shaped vase was originally of oyster-coloured enamel throughout. The base of the vase was replaced and enamelled in blue – because of damage sustained after the Revolution – some time between Queen Mary's acquisition of the egg in 1933 and the photograph of it published in H.C. Bainbridge's book on Fabergé in 1949. No trace of payment for the repair has been found, nor are the circumstances of Queen Mary's acquisition known precisely. The identity of the purchaser of the egg from the Antikvariat is not given on the official receipt, but it is likely to have been the American industrialist Armand Hammer.

The profusion of wild flowers enamelled on gold in the Basket of Flowers Egg demonstrates Fabergé's interest in nature. Each flower, leaf and husk is painstakingly modelled and enamelled to look as realistic as possible. Such eggs took about one year to make.

Silver, parcel gilt, gold, enamel, diamonds;
23.0 × diameter 10.0 cm
RCIN 40098
Acquired by Queen Mary

Mosaic Egg, 1914

The 'petit-point' flower motif repeated on the five oval medallions of this imperial Easter egg was designed by Alma Theresia Pihl, who came from a distinguished family of jewellers employed by Fabergé. She was the granddaughter of August Holmström, Fabergé's principal jeweller until his death in 1903. Her father Knut Oscar Pihl was head of the jewellery workshop in Moscow from 1887 to 1897. Her uncle Albert Holmström took over August's workshop and was responsible for the production of this particular egg.

Alma Pihl's watercolour design, from which the Mosaic Egg derives, appears in Albert Holmström's stock book, in the form of a circular brooch dated 24 July 1913. It is not known whether the circular brooch was ever made but an octagonal brooch with a similar floral mosaic motif was executed and is now in the Woolf family collection.

Each of the tiny precious stones had to be precisely cut and calibrated to fit into the curving platinum cagework which holds them in place. The skill required to do this well illustrates the exacting levels of craftsmanship of Fabergé's workshops. At one end, the initials of Alexandra Feodorovna are set beneath a moonstone.

Concealed in the egg is an enamelled medallion surmounted by the Imperial Crown. This is the 'surprise' (contained in most of the eggs) held in place by two gold clips. It is decorated on one side *en camaieu* with the profile heads of the five imperial children and on the reverse in sepia with their names and the date 1914 surrounding a basket of flowers.

The curious mark on the pedestal of the surprise is thought to represent Carl Fabergé's tribute to his father, Gustav, as 1914 marked the hundredth anniversary of his birth.

Gold, platinum, enamel, diamonds, rubies, emeralds, topaz, quartz, sapphires, garnets, moonstone; egg 9.5 × diameter 7.0 cm; surprise 7.9 × 5.5 × 2.9 cm
Engraved on the egg *C. FABERGÉ*; engraved on the pedestal of the surprise *G. FABERGÉ*
RCIN 9022
Purchased by King George V as a gift for Queen Mary

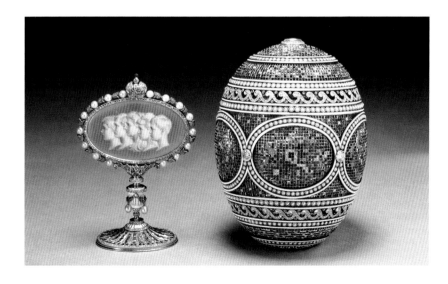

BIRDS AND ANIMALS

Cockatoo on a hanging perch, c.1900

Although the inspiration for this carving cannot be confirmed, Queen Alexandra kept a cockatoo in her own apartments at Marlborough House. There are two other carvings of cockatoos by Fabergé in the Royal Collection (RCIN 40478, 40480), one on a perch and one in a cage. In addition there are carvings of a parrot and a pair of budgerigars, both on perches.

Agate, gold, enamel, silver-gilt, olivines;
13.5 × 6.3 × 6.2 cm
Mark of Michael Perchin; silver mark of 88 *zolotniks* (1896–1908); *FABERGÉ* in Cyrillic characters
RCIN 40483
Probably acquired by Queen Alexandra

Caesar, c.1908

King Edward VII's initial idea for the 1907 commission from Fabergé was for the favourite royal dogs and racehorses to be immortalised. Fabergé and his workmasters had the ability to express the personality of their models, such as Caesar, the King's beloved Norfolk terrier, who would certainly have been one of the most important subjects to be modelled.

Of the many dogs that the King owned, Caesar was the favourite. Such was their mutual devotion that Caesar wandered the corridors of Buckingham Palace in search of his master for several days after the King's death in 1910. His final duty was to walk behind the King's coffin in the funeral procession.

Chalcedony, gold, enamel, rubies;
5.1 × 6.5 × 2.2 cm
Inscribed on the collar *I BELONG TO THE KING*
RCIN 40339
Commissioned by King Edward VII

Opposite:
Sandringham Lucy, c.1908

A charming and remarkably realistic portrait model of King George V's Clumber spaniel Sandringham Lucy.

Chalcedony, rubies; 4.4 × 10.5 × 3.6 cm
RCIN 40442
Purchased by King George V when Prince of Wales

Turkey, c.1908

Obsidian, lapis lazuli, purpurine, gold, diamonds;
9.7 × 8.5 × 7.3 cm
Mark of Henrik Wigström; gold mark of 72 *zolotniks* (1908–17)
RCIN 40446
Purchased by King George V when Prince of Wales

Seated pig, c.1908

The careful observation from nature of the Sandringham animals has resulted in many of them being 'caught' in characteristic poses. This is part of their charm and must have appealed to those who purchased them. There are several Fabergé carvings of pigs in the Royal Collection. With the other animals acquired by King Edward VII and Queen Alexandra, they were displayed in two large glass cabinets at Sandringham.

Agate, diamonds; 3.5 × 4.1 × 2.1 cm
RCIN 40015
Commissioned by King Edward VII

Pig lying down, c.1908

Agate, diamonds; 3.0 × 7.4 × 4.7 cm
RCIN 40421
Probably commissioned by King Edward VII

Four piglets, 1896–1903

Many of the animal carvings in the Royal Collection were made during Henrik Wigström's period in charge of the Fabergé workshops in the early 20th century, but this group is one of an apparently small number made earlier in the workshop of Michael Perchin, head workmaster between 1886 and 1903. Only the most skilled workmasters were elevated to this position.

Chalcedony, gold; 0.9 × 5.2 × 3.8 cm
Mark of Michael Perchin; gold mark of 56 *zolotniks* (1896–1908)
RCIN 40038
Probably acquired by Queen Alexandra

Right:

Dormouse, c.1910

Chalcedony, platinum, gold, sapphires;
6.2 × 5.2 × 5.8 cm
RCIN 40261
Purchased by Queen Alexandra

Snail, c.1910

Occasionally different stones were
combined by the carvers to give the most
realistic effect possible, a technique
described as 'mosaic sculpture'. Here the
carving and polishing of the combined
hardstones evoke the shiny hard surface
of the shell and the soft flesh of the body.

Chalcedony, jasper; 4.5 × 10.0 × 3.7 cm
RCIN 40254
Probably commissioned by King Edward VII

Wild boar, c.1908

Chalcedony, rubies; 6.7 × 8.6 × 5.0 cm
RCIN 40260
Purchased by King George V when Prince of Wales

Chimpanzee, c.1910

One of several carvings of apes in the collection, this one has a pose that is particularly expressive. The stone carver has made best use of the natural striations in the single piece of agate to suggest variations in the texture of fur and the animal's colouring.

Agate, olivines; 7.5 × 6.2 × 7.6 cm
RCIN 40377
Probably acquired by King Edward VII

Elephant, c.1910

It was necessary for Fabergé's sculptors to keep the carving dense to ensure that the fragile stone did not fracture. As Fabergé's designer Franz Birbaum mentions in his memoirs when describing animal carvings: 'it should be said that the pose was always as compact as possible, as dictated by the technique of the material.' The stylised carving also clearly demonstrates Fabergé's interest in Japanese netsuke carving. Departures from naturalistic-looking animal carvings were not uncommon with Fabergé. They add a humorous quality, such as this red elephant; blue rabbits and green dogs also exist in the collection.

Unlike the majority of Fabergé's animals, his elephant models were sometimes repeated as they were so popular.

Fabergé also produced elephant automata in silver. An elephant which walks and wags its head and trunk was given to King George V at Christmas 1929 by his family (RCIN 40486).

Purpurine, diamonds; 3.7 × 3.9 × 4.5 cm
RCIN 40270
Purchased by Queen Alexandra

Aardvark, c.1910

Agate, diamonds; 4.3 × 6.8 × 2.8 cm
RCIN 40471
Purchased by King George V

Snake, c.1910

Agate, diamonds; 0.6 × 5.7 × 2.6 cm
RCIN 40253
Acquired by Queen Mary

PLANTS AND FLOWERS

Rowan tree, c.1900

On rare occasions Fabergé repeated a plant or flower study. Duplicates are known for both the raspberry (right) and the rowan (below).

For his many botanical studies, which demonstrate the combined skills of lapidary, goldsmith and jeweller, Fabergé drew inspiration from his love of nature, oriental art and the 18th-century jewelled bouquets made for use at court. The skill and time required to make such pieces was reflected in the cost of manufacture and the sale prices, which were considerable. While their realism is remarkable, it is clear that Fabergé considered decorative quality more important than botanical accuracy.

Rock crystal, gold, nephrite, purpurine;
22.5 × 20.5 × 7.5 cm
RCIN 40508
Acquired by Queen Alexandra

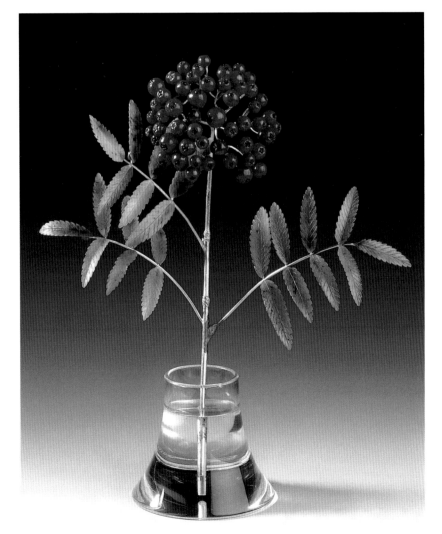

Raspberry, c.1900

One of two Fabergé raspberries (with RCIN 40176) in the Royal Collection. A third raspberry plant, given to Queen Victoria by Lord Carrington in 1894, was a different size; it cannot be traced today.

Rock crystal, gold, nephrite, rhodonite;
15.9 × 7.8 × 6.7 cm
RCIN 40251
Probably acquired by Queen Alexandra

Cornflowers and buttercups, c.1900

Fabergé produced flower studies of both cornflowers and ranunculus individually. In this example they are combined and, unusually, a jewelled enamel bee is added to the group. These incredibly delicate objects are held together with great precision by stalks and stamens of finely engraved and chased dull gold. Great skill went into the selection of the right stone to represent a leaf and into the carving and polishing of the rock crystal pots, which appear to be glasses filled with water. The flower studies are usually unmarked, as the gold was felt to be too fragile to punch. This has made their identification difficult.

Rock crystal, gold, enamel, diamonds, rubies; 22.3 × 14.0 × 8.0 cm
RCIN 100011
Purchased by Queen Elizabeth The Queen Mother

Cornflowers and oats, c.1900

In 1944 Queen Mary contributed to the purchase of this 'pretty Fabergé cornflower' for Queen Elizabeth to cheer up her shelter room at Buckingham Palace during the Second World War. Queen Elizabeth was delighted with the present and described it as 'a charming thing, and so beautifully unwarlike'. The oats are particularly well modelled and the husks are attached in such a way as to allow movement, so adding to their realistic quality.

A variant of this study exists in the Hermitage collection, indicating the way in which Fabergé satisfied the demand for certain models from his customers.

Rock crystal, gold, enamel, diamonds; 18.5 × 12.3 × 8.5 cm
RCIN 100010
Purchased by Queen Mary and others as a gift for Queen Elizabeth The Queen Mother

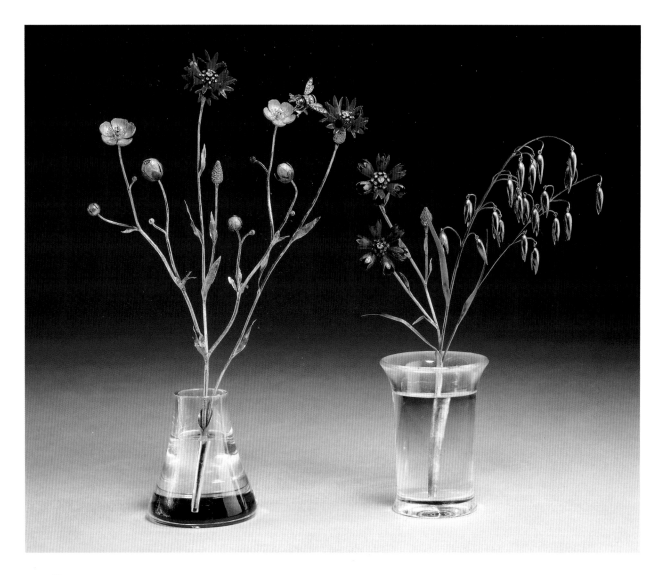

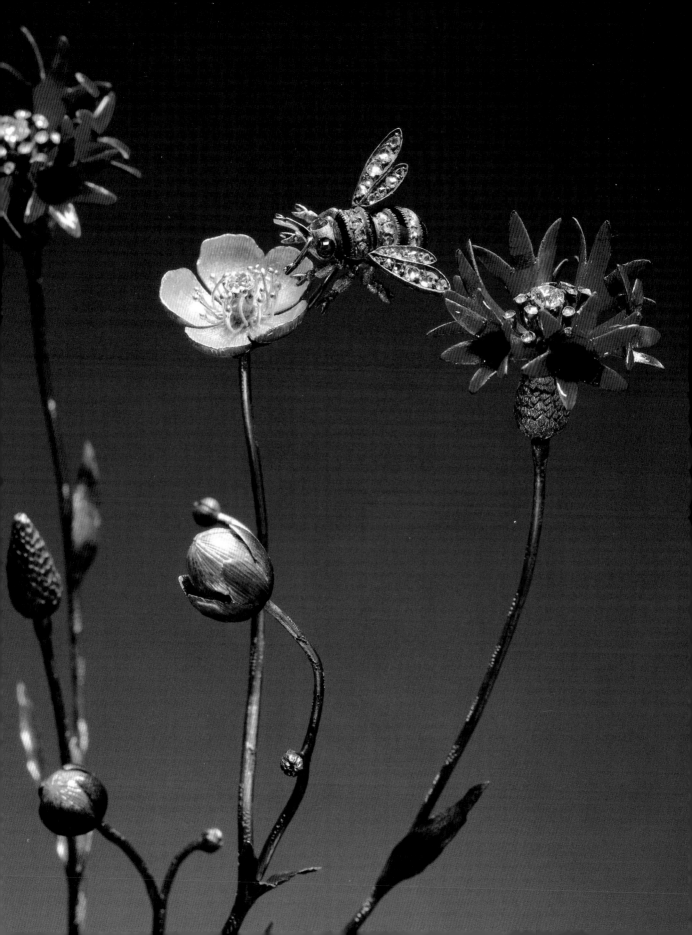

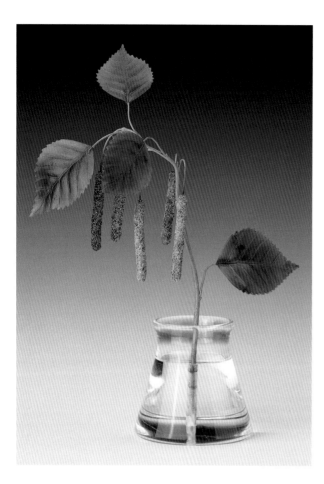

Left:
Catkins, c.1900

This piece was made in the workshop of Fedor Afanassiev, who specialised in producing small *objets d'art* such as miniature Easter eggs and picture frames. It is an interesting example of the use of different coloured golds, the matt red gold of the stems contrasting with the powdery yellow spun gold of the flowers.

Rock crystal, gold, nephrite; 13.2 × 11.7 × 5.0 cm
Mark of Fedor Afanassiev; gold mark of 56 *zolotniks*
RCIN 40507
Acquired by Queen Alexandra

Right:
Pansy, 1903–08

One of three studies of pansies by Fabergé in the Royal Collection, this flower bears the mark of Henrik Wigström. The books of Wigström's workshop contain the design for a similar pansy flower head, apparently executed in April 1912. Michael Perchin had earlier produced the Art Nouveau style imperial Pansy Egg of 1899 and in 1903 he designed a miniature frame in the form of a pansy flower. This has a mechanism which, when released, opens the petals to reveal miniature portraits of the five children of Tsar Nicholas II and Tsarina Alexandra Feodorovna (Moscow, Kremlin Armoury Museum).

All three of the pansy flower groups in the Royal Collection combine the same purple and yellow colours of enamel. The similar treatment of the petals with the variations in tone and combination of matt and polished enamel suggest that they may all have originated in Wigström's workshop.

Rock crystal, nephrite, gold, enamel, diamond; 10.1 × 5.3 × 5.0 cm
Mark of Henrik Wigström; gold mark of 72 *zolotniks* (1896–1908);
Fabergé in Cyrillic characters
RCIN 40180
Probably acquired by Queen Alexandra

Above right:
Pansy, c.1900

Rock crystal, gold, enamel, nephrite, diamond; 15.2 × 10.2 × 4.6 cm
RCIN 40505
Probably acquired by Queen Alexandra

Chrysanthemum, c.1908

This piece was purchased in 1908 at
Fabergé's London branch by Stanislas
Poklewski-Koziell, a councillor at the
Russian Embassy in London. It cost £117
and was the most expensive flower study
purchased at the London branch. The
production of flowers was not restricted
to a specific workmaster and several are
known to have produced these objects.
However, of the seven in the Royal
Collection which are marked, six are by
Henrik Wigström, including this one.

Rock crystal, gold, nephrite, enamel;
24.6 × 11.3 × 7.0 cm
Mark of Henrik Wigström; gold mark of
72 *zolotniks* (1908–17); *FABERGÉ* in
Cyrillic characters
RCIN 40506
Presented to Queen Alexandra

mis le tuas vii dieis
dóne moy rcspit lieu
de mó crateur aouir
car ie ne veil plus demouirr.

CHAPTER 9

BOOKS AND MANUSCRIPTS

The majority of the 125,000 printed books and manuscripts in the Royal Collection are housed at Windsor Castle. The present library was established by William IV in the early 1830s. It is, in effect, the third Royal Library. The first, begun by Edward IV in the 1470s, was housed in various royal residences in and near London. In 1757 it was given by George II to the newly founded British Museum. The second, 'one of the finest libraries ever created by one man', was built up over sixty years by George III. By the time of his death in 1820, the library, housed in Buckingham House (later Palace), held over 65,000 books.

George IV was not such a keen bibliophile as his father. In 1823, in order to make space for his conversion of Buckingham House into a palace, George IV gave most of George III's collection, known as the King's Library, to the British Museum. It is still a distinct unit in the British Library. George IV had himself formed a small library at Carlton House, London, which contained many fine items: the Sobieski Book of Hours, a magnificent illuminated manuscript from the early 1420s (p. 198); the beautiful 17th-century *Florilegium* (flower album) of Alexander Marshal; and outstanding Islamic manuscripts, including the *Divan-i-Khaqan* by Fath 'Ali Shah, ruler of Persia (p. 204).

In the early 1830s William IV decided to establish the present Royal Library in Windsor Castle. There were five main sources of books for the new library: 30 of George III's finest books from Buckingham House library, including incunabula from the collector Jacob Bryant; the Mainz Psalter (p. 205); the only existing perfect copy of Aesop's *Fables*, printed by William Caxton in 1484; Charles I's Second Folio of Shakespeare (1632), with annotations made by the King; and the finest Islamic manuscript in the Royal Collection, the 17th-century *Padshahnama* (p. 202). Also smaller groups of George III's books kept at residences other than Buckingham House; the

books, maps and papers of William Augustus, Duke of Cumberland, bequeathed to his nephew, George III; George IV's former library at Carlton House; and books from George III's nephew, the 2nd Duke of Gloucester. Although no bibliophile himself, William IV also made some important acquisitions, including 30 incunabula in 1835.

With the help of the Librarian Bernard Woodward, Prince Albert undertook a fundamental reorganisation of the library from the early 1860s. Queen Victoria also sanctioned large expenditure on books, buying such valuable items as the Wriothesley Garter Book (p. 201) and fine bindings, a passion of Richard Holmes, the next Librarian. Many books with ownership marks of sovereigns before George III had been reacquired by 1900.

King George V and Queen Mary took a great interest in the library, adding the superbly bound Bible which had belonged to Charles II (p. 206) and the Duke of Sussex's Bible and Prayer Book (p. 208). Their love of books and collecting was encouraged by the Librarian at Windsor, Owen Morshead, who had a particular interest in Private Press books (see pp. 206, 210).

Although the majority of the volumes are printed books of the 18th and 19th centuries (see p. 208), the Royal Library's greatest treasures include the small collection of Western manuscripts. Its finest illuminated manuscripts are the Sobieski Book of Hours and Cardinal York's Book of Hours (pp. 198, 199). Other major strengths are the manuscripts relating to the Order of the Garter (p. 201) and books in fine and unusual bindings (p. 210).

Of the 40 Islamic manuscripts in the Royal Library, the largest group is Persian. Notable highlights of the collection include miniature paintings and calligraphy of the Mughal period in India (1526–1858), such as the *Padshahnama* (see p. 202), and the Safavid period in Persia (1501–1736), such as the *Shahnama* (RCIN 1005014).

Western Manuscripts

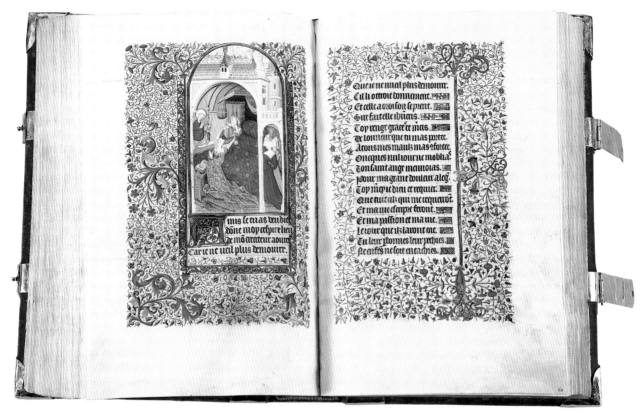

See details on pp. 196–97

The Master of the Bedford Hours (*fl.*1415–1430)
*The Sobieski Book of Hours, c.*1420–25
Open at ff. 162v–163r: part of a prayer to St Margaret of Antioch, with a miniature of the patroness praying to St Margaret

This manuscript and its companion, the Bedford Hours in the British Library, were produced in the same Parisian workshop in the early 15th century. The Bedford Hours is named after John, Duke of Bedford (1389–1435), whose portrait appears on its pages. The Duke was the third son of Henry IV, the brother of Henry V, and the uncle of the infant Henry VI, for whom he acted as Regent in France, from 1422 to 1435. His first wife was Anne, sister of Philip the Good, Duke of Burgundy. It appears that the Sobieski Book of Hours may have been produced for Anne's sister, Margaret, and that Margaret of Burgundy is the patroness shown here, praying to the patron saint of expectant mothers. Margaret's marriage in 1423 (to Arthur of Richmond) was childless. In this opening the patroness is shown in front of a bed hung with green draperies, the traditional colour for French royal birth chambers. The miniature is accompanied by *La Vie de Sainte Marguerite*, a popular poem in the 15th century.

At this time Paris was the major centre for the production of Books of Hours, richly illuminated devotional books for lay people. The anonymous Master of the Bedford Hours (possibly Jean Haincelin of Haguenau) was responsible for the pages in this manuscript introducing the life of the Virgin Mary and for the miniature shown here. Two other major illuminators continued work on the manuscript in the 1440s: the Fastolf Master and the Master of the Munich Golden Legend. The manuscript is named after John Sobieski, King of Poland (1624–1696), from whom it passed to his granddaughter, the Old Pretender's wife, and then to Cardinal York, who left it to the future George IV in 1807.

Manuscript on vellum; miniature, decorated initial and borders in bodycolour and gold leaf; 234 ff.; 28.9 × 20.0 × 6.5 cm
RCIN 1142248
Bequeathed by Henry Benedict Stuart, Cardinal York, to George IV when Prince of Wales

Unidentified French Illuminator

*Cardinal York's Book of Hours, c.*1500

Open at ff. 66v–67r: showing the anointing of David by Samuel

This Book of Hours is a later production of the Paris workshops than the Sobieski Hours (p. 198) and has been attributed to Jean Pichore (*fl.*1489–1517). Its miniatures are framed in the fictive architectural borders that were popular at the turn of the 15th century. The coat of arms seen on f. 66v (and on ff. 23v and 77v) is likely to have belonged to the patron. The arms on the sinister, or lady's side (our right), with the sheaves of wheat, are those of the French family Francon, from the Dauphiné in the south of France; the arms on the dexter, or man's side, have not yet been identified. The earliest identified owner is Alexander de Ostrog. The opening shows the beginning of the seven Penitential Psalms, with an image of David being anointed King of Israel by the Prophet Samuel, in the presence of his father Jesse and brothers (1 Samuel 16). While decorative themes used in other parts of the Book of Hours had become standardised, the Psalms allowed for choice, though usually a scene from the life of their author, King David, was considered appropriate.

Manuscript on vellum; in bodycolour and gold leaf; 132 ff., numbered in pencil; bound in pink velvet, with the arms of Cardinal York as Henry IX embroidered on both boards, in silk, gold thread, gilt sequins and knobs, end 18th century; 25.8 × 17.4 × 4.4 cm
RCIN 1005087
Presented to George IV when Prince of Wales

Sir Thomas Wriothesley (c.1460–1534)

The Wriothesley Garter Book, early 16th century

Open at f. 1 of quire P: Henry VIII in Parliament, 1523

Sir Thomas Wriothesley, who from 1505 to 1534 occupied the post of Garter King of Arms (doyen of the College of Arms), is known to have compiled many books and rolls of arms, pedigree and precedence. This manuscript is concerned particularly with the Order of the Garter.

The manuscript is open at what may be the first contemporary view of the opening of Parliament, at Blackfriars on 15 April 1523. To the far left of the enthroned King are Garter King of Arms (Wriothesley himself, in the distinctive tabard of a herald) and officers of the Royal Household. To the King's right are three bishops: Thomas Wolsey, Archbishop of York, with the red Cardinal's hat, and William Warham, Archbishop of Canterbury (see p. 222) seated; behind Wolsey stands Cuthbert Tunstall, Bishop of London. Other senior clerical figures are clearly visible in the lower part of this image of a pre-Reformation Parliament. The back of the Speaker (Thomas More) is shown bottom centre.

Manuscript on vellum; in bodycolour, with gold leaf and brush and pen linear work; 127 ff.; 30.8 × 22.2 × 5.2 cm
RCIN 1047414
Purchased by Queen Victoria

Sir Gilbert Dethick (1499/1500–1584)

The Dethick Garter Book, 1551–88

Open at ff. 30v–31r: arms of Garter Knights created 1555–59

Sir Gilbert Dethick was of German origin, and first entered the College of Arms in 1536. He held the office of Norroy King of Arms (Norroy indicating the area north of the river Trent) under Henry VIII and Edward VI, and was appointed Garter King of Arms in 1550. He was a scholar and antiquary, and several collections of his heraldic papers survive. He began this manuscript early in the reign of Edward VI and continued it through the reign of Mary into that of Elizabeth I. This was a period of great unrest, with major changes in the state religion, from Edward VI's and Elizabeth's Protestantism to Mary's fervent Catholicism; this is reflected in the appointments to the Order. The arms shown here belong to Sir Edward Hastings; Sir Anthony Browne; Thomas Radcliffe, 3rd Earl of Sussex; William, 13th Baron Grey of Wilton; and (right page) Thomas Howard, 4th Duke of Norfolk; Henry Manners, 2nd Earl of Rutland; and Robert Dudley (later Earl of Leicester).

Manuscript on vellum; in bodycolour, with brush-and-pen linear work; 67 ff.; 28.6 × 21.2 × 3.2 cm
RCIN 1047416
Purchased by King George VI

ISLAMIC MANUSCRIPTS

Illustrations from the Padshahnama, c.1630–40
Left folio: Attributed to RAMDAS (*fl.*1640s)
Right folio: BICHITR (*fl.c.*1615–1640)

Double-page spread showing Shah-Jahan receiving his three eldest sons and
Asaf Khan during his accession ceremonies in 1628 (right) and musicians and others
involved in the celebrations (left).

The *Padshahnama* (or Chronicle of the King of the World) is the unique official description of part of the reign of the Mughal Emperor, Shah-Jahan (r. 1628–58). Its 44 illustrations include some of the finest Mughal paintings ever produced. They were executed by 14 of Shah-Jahan's court painters between 1630 and 1657 and include identifiable portrait likenesses of all the key figures at the imperial court.

The illustration shown on the right folio (below right) is the most famous painting in the *Padshahnama*. It depicts one of the major ceremonies celebrating Shah-Jahan's accession to the throne. The scene in the Agra fort shows his entire court. Forty-two of those depicted can be identified. Particularly important are Shah-Jahan's three eldest sons, Dara-Shikoh, kneeling over his father's lap, and behind him, Shah-Shuja and Awrangzeb. Behind them is the Prime Minister, Asaf Khan, who was Shah-Jahan's father-in-law; many of the courtiers were Asaf Khan's relations or friends.

Bodycolour and gold; 81.5 × 101.5 cm
RCIN 1005025.k–l
Presented to George III

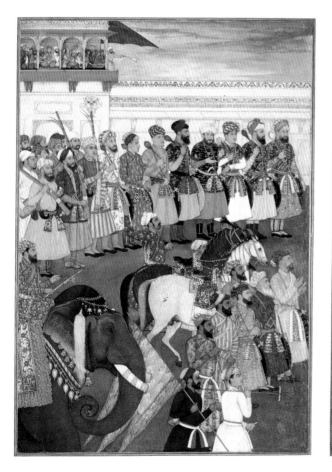

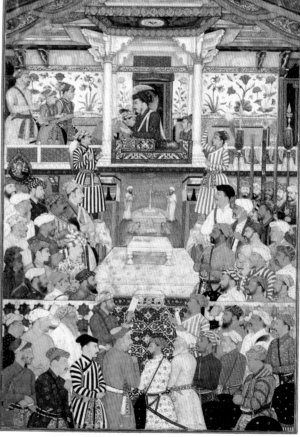

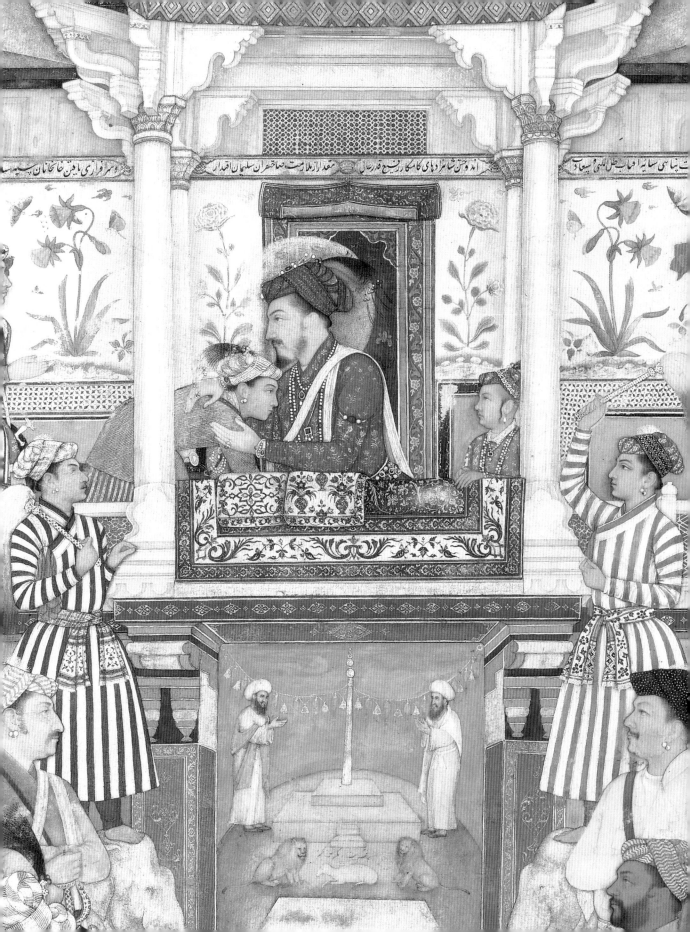

FATH 'ALI SHAH QAJAR, SHAH OF PERSIA (1772–1834);
MUHAMMAD MIHDI OF TEHERAN (*fl.*1800), scribe;
MIRZA BABA (*fl.*1789–1810), miniaturist
Divan-i-Khaqan, 1802

Early in his reign, Fath 'Ali Shah established a court noted for its artists and poets, to foster a sumptuous image of the Qajar dynasty, which ruled Persia (Iran) from 1794 to 1925. He wrote poetry himself, under the pen-name of Khaqan. He had several copies of his *Divan* (collected poems) written to present as diplomatic gifts. This copy was completed in February 1802, and portraits of Fath 'Ali Shah and of his predecessor, Aga Muhammad Khan, were added by the then Painter Laureate, Mirza Baba. It was not, however, until 1812 that the volume was given to Sir Gore Ouseley, British Ambassador Extraordinary to the Court of Persia, to convey to the Prince Regent, later George IV. Ouseley had spent several months in Teheran, negotiating the terms of a treaty between Britain and Persia.

This is a late example of Islamic lacquer binding, a technique introduced from Herat in the 15th century and perfected in the 16th century. The skills of miniature painters were often deployed on these bindings, as here; the central panel is signed by Mirza Baba. The flowers and birds are painted with lacquer coloured by pigments, and the background lacquer contains powdered gold. Several layers of lacquer give depth to each figure, the edges of which are defined by impressions of a fine comb, and the top surface is raised by deliberately created *craquelure*. The pages of the manuscript are colourful, with the text on a gold background, illuminated (i.e. decorated with gold) panels of red and blue, and wide blue borders adorned with lively animals, birds and flowers painted in gold.

Manuscript in *nasta'liq* script; text-area gilded; illuminated panels; blue borders with gold animals, birds and flowers; 180 ff.; bound with lacquer boards and plain leather spine; 29.5 × 43.5 × 6.0 cm
RCIN 1005020
Presented by the author to George IV when Prince Regent

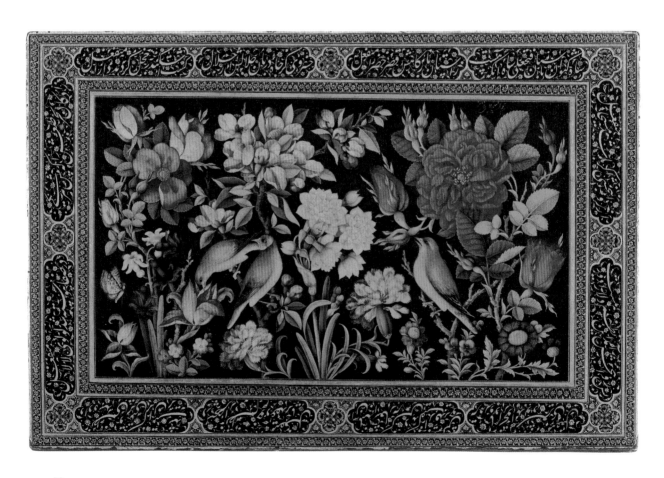

Printed Books

The Mainz Psalter, 1457
Open at ff. 97v–98r: including the opening of Psalm 98 (*Cantate Domino*)

This is one of only 10 known copies of the second book to be printed by the system of movable metal type, the first being the Gutenberg Bible, printed in Mainz from 1453 to 1455. The Windsor copy is one of the six surviving 'short issues'; the Psalter was printed in two lengths, the longer ones (of 175 leaves, of which four copies survive) specifically for the diocese of Mainz, the shorter ones for more general use. It is also the first book known to have been printed in red and black. This was done with a single pull of the press, the type to be printed in red having been inked separately from the black and reinserted into the same forme (the locked frame holding the prepared type). This process meant that the two colours would be in perfect register, without any unsightly overlaps. The large two-colour initials (e.g. the large initial C) were printed from woodblocks by a similar method, the block for the letter being separable from the block for the surrounding pattern. By contrast, the large

blue, red and black capitals (such as the blue E in *Ecce iam noctis*, f. 97v, or the red N in *Nocte surgentes*, f. 98r) were inscribed, as were some of the rubrics (words in red, usually instructions to the celebrant, or catchwords to help him find his way about the page). The music, and the words to accompany the music, were also added in manuscript. The scribe responsible wrote a beautifully even hand, which has been suggested as the model for the type, as they correspond so closely.

Mainz: Johann Fust and Peter Schoeffer
Printed on vellum in black and red, with woodblock two-colour initials, manuscript music and large coloured capitals in blue and red; folio, bound in 10s, 138 ff. (of 143; lacks ff. 137–41), numbered in pencil, 2 ff. of MS additions at end; 43.8 × 32.3 × 7.5 cm
RCIN 1071478
Purchased by George III

PRIMA TABELLA.

gne, Cum folaceuoli & iucundiffimi acti & blandiméti, Feftigianti circi-
tori quatro pretiofiffimi & diuinitriumphi,
unque fimili uiduti da gli mortali rifguar
di cum fincero & delectabiliffi
mo applaufo.

POLIPHILO IN QVESTO PRAESCRIPTO LOCO VI-
DE LE QVATRO TRIVMPHANTE SEIVGE TVTTE DI
VARIE PETRE ET DI PRETIOSISSIMI GIOIELLI. DAL-
LA MVLTITVDINE PROMISCVA DI BEATI GIOVENI
IN LAVDE DEL SVMMO IOVE MOLTO VENERA-
BONDI.

AGIONEVOLMENTE VNQVANTVLO
difficile ad gli fuperni Dei fare exiftimo, anci factibile fa-
cilmente fi praefta qualunque effecto al fuo uolere, & in
ciafcuno loco, & fopra omni cofa creata. Il perche debita-
mente chiamati fono omnipotenti. Forfa chi alcuna fa-
ta le miraueglifa e & ftupede immo opere udira
narrare, fupremamente mirauegliarfa e potrebbe. Imperoche imitare, le co-
fe naturale, l'arte aemula, quanto uale fiorcia. Ma le diuine fencia dubitare
per qualunque creato ingegno & intellecto fencia fua ope, & fpiramine
non fi pole aptamente fimular ne fingere. Dunque per fi facta ragione,
niuo da dubio alcuo douerebbe laffarfa e occupare, Ma getaméte aiaduer
tedo pona nellanimo, ad gli fuperi poffibile, ciafcuna ad nui ifueta factu
ra, Quale io cufi uidi. DESCRIPTIO PRIMI TRIVMPHI.
El primo degli mirandi & diuini triumphi haue le quatro ra-
pide rote di finiffima petra di uerdiffimo fmaragdo fcythico, di atomi di
colore rameo fcintilliato. El refiduo pofcia del carro mirai attonito facto
tutto di tabelle, nó di Arabico ne Cyprico, ma di ferrineo fcintillare in-
dico adamante infultate al duro fmerilio & del chalybe, uictrice del lacti
uo foco contempore & contumace, ma al caldo cruore Hircino quieto
& domabile, Grato alle magice arte. Lequale affule diuinamente operate
di cataglyphia explicatura infcalpte & in mundiffimo oro mirabilmen-
te infepte & inclauftrate,
Nella dextera tabella mirai expreffo una nobile & regia Nympha cú
multe coaetanee in uno prato incoronante gli uictoriofi Tauri di multi-
plici ftrophii di flori. Et uno adhaerente ad effa multo peculiareméte do-
mefticatofe.

prima

Quella Nympha cófifa la finiftra tabula cótineua, che afcenfo haue a
fopra il manfueto & candido Tauro. Et quello qlla pel tumido mare ti
mida, trâffretaua. **SECVNDA SINISTRA.**

Nel fronte anteriore, Cupidine uidi cú inumera Caterua di promi
fcua géte uulnerata, mirabódi che egli tiraffe larco fuo uerfo l'alto olym
po. In nel fronte pofteriore, Marte mirai dinanti al throno del magno
Ioue, Lamentatife che el filiolo la ípenetrabile thoraca fua egli la hauef-
fe lacerata. Et el benigno fignore el fuo uulnerato pecto gli monftraua.
Et nell'altra mano extenfo el brachio teniua fcripto, NEMO.

k iiii

Francesco Colonna (1432/33–c.1527)
Hypnerotomachia Poliphili, 1499
Open at ff. k3v–k4r: including a scene of Europa
being borne off by the bull

The *Hypnerotomachia* (Strife of love in a dream) is a prose
romance in two books, describing the symbolic dream of
Poliphilo and his love for Polia. It is widely regarded as one of
the most beautiful illustrated books ever published. The wood-
cut illustrations by an unknown artist perfectly complement the
text, and this harmonic whole, combined with the artistry of the
typographic layout and design, have led to its high reputation.

The text was written in a deliberately obscure mixture of
Latinate words with Italian syntax and endings, and Greek. Even
contemporary readers found it difficult to understand. Despite
its visual appeal, the book did not sell because of war and plague
in Italy.

Venice: Aldus Manutius
Woodcut illustrations; folio bound in 8s, 234 ff., unnumbered;
29.9 × 21.2 × 4.7 cm
RCIN 1057947
Acquired by William IV

The Holy Bible, 1659–60

This splendid Bible, and its companion Prayer Book (RCIN
1142253), were probably bound for Charles II's Chapel or Royal
Closet at Whitehall, where he had two sets, Bible and Prayer
Book uniformly bound, replaced every few years. As the Prayer
Book of this set is a 1660 edition, this must have been one of
the earliest sets; the newly revised standard edition would have
been used after 1662. This edition of the Bible, despite the
textual inaccuracies of John Field, Printer to the University of
Cambridge, was one of John Ogilby's more splendid publica-
tions, with plates by the artist Wenceslaus Hollar (1607–1677).

The Bible and Prayer Book were found in a tin bath at St
Michael's College, Tenbury, Worcestershire, in 1919, by the Revd
E.H. Fellowes. He mentioned this surprising find to Queen
Mary, who helped purchase the volumes for the Royal Library.

Cambridge: John Field for John Ogilby
1,722 pp., 7 pls, 2 vols in 1; bound in blue velvet, embroidered with coloured
silks, silver and silver-gilt wire; fore-edge painting of royal arms;
47.5 × 33.0 × 13.0 cm
RCIN 1142247
Bound for Charles II; purchased by King George V and Queen Mary

The Holy Bible, 1776 and *The Book of Common Prayer, and Administration of the Sacraments … with the Psalter or Psalms of David*, 1815

This set of Bible and Prayer Book is bound in an unusual material, tortoiseshell with gold inlay and gilt spine-hinges and clasps. The simpler decoration on the Prayer Book, and variations in the shape of the coronets, suggest that the bindings were not executed by the same binder at the same time.

The initials AF stand for Augustus Frederick, Duke of Sussex, sixth son of George III and Queen Charlotte. The most intellectual of their sons, he went abroad as a young man for his health, first to Göttingen University in Hanover, and then to Rome. There, in addition to contracting the first of his two morganatic marriages, he fostered his academic interests, predominantly theology. After returning to England in 1804, the Duke established a library in his apartments in Kensington Palace. By 1830, with judicious buying by the Duke and his librarian, T. J. Pettigrew, this magnificent collection contained over 50,000 volumes, including about 1,000 editions of the Bible. Pettigrew arranged the library in six subject categories, and published a catalogue of the Bibles. As with George III's library at Buckingham House, scholars were granted access.

The fact that the 1776 Bible is not included in Pettigrew's catalogue suggests that it was for more personal use. The set was acquired by Queen Mary. The reacquisition of belongings of members of the Hanoverian dynasty was one of her interests.

JOHN WHITTAKER (d. 1831)
Ceremonial of the Coronation of His Most Sacred Majesty King George the Fourth, 1823
Open at f. 7: the Banners of Scotland and Ireland, borne by the Earl of Lauderdale and Lord Beresford

This sumptuous volume was produced in the context of an equally splendid public event, George IV's coronation on 19 July 1821, for which the Diamand Diadem (see p. 139) was made. Parliament voted the astonishing sum of £240,000 towards the cost of the ceremony (George III's coronation had cost only £70,000). The extravagant costumes were designed to an Elizabethan and Jacobean theme, to recall England's past.

Whittaker's publication was printed in gold throughout, by a technique developed in secret. The hand-coloured illustrations give a flavour of the procession, but do not follow its order. The Banner of Scotland (the red lion on a yellow background) is borne by the Earl of Lauderdale, Lord High Keeper of the Great Seal of Scotland, wearing the collar of the Order of the Thistle. The Banner of Ireland (the gold harp on a blue background) is borne by Viscount Beresford, military hero from the Peninsular War, with the collar of the Order of the Bath. Behind the pages walk Viscount Exmouth with the collar of the Bath, and Viscount Sidmouth. Six copies of this book were printed for the crowned heads of Europe, but the expense bankrupted Whittaker.

Far left: Bible
London: J. W. Pasham
1,176 pp., 2 vols in 1; bound in tortoiseshell with gold inlay, gilt clasps and spine-hinges; all edges gilt and gauffered; 11.5 × 7.5 × 3.5 cm
RCIN 1081306

Left: Prayer Book
London: J. Reeves
572 pp., 2 vols in 1; bound as *Bible*;
11.5 × 7.5 × 2.5 cm
RCIN 1081307
Both bound for Augustus, Duke of Sussex; acquired by Queen Mary

Opposite:
London: John Whittaker
Printed on japan vellum; gold letterpress, stipple engraving with etching and aquatint, and hand-colouring; 43 ff., interleaved with blanks; bound in brown morocco, gold-tooled, with the royal arms on both boards, rebacked; 69.1 × 60.5 × 7.0 cm
RCIN 1005090
Probably George IV's presentation copy

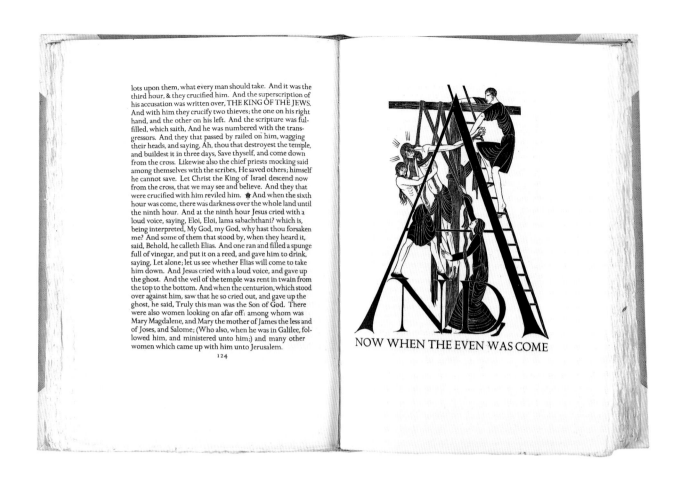

NOW WHEN THE EVEN WAS COME

Eric Gill (1882–1940)
The Four Gospels, 1931

Open at pp. 124–25: including initial with the Deposition from the Cross

This is a particularly striking example of the work of the Private Press Movement, which William Morris brought to prominence at the Kelmscott Press in the 1890s. He aimed to raise the standard of printing and book production to the high levels achieved during the incunabula period (1450–1500). The Golden Cockerel Press was set up in 1920 by Harold Midgeley Taylor, and aspiring authors were initially encouraged to set the type of, and to print, their own books. After Taylor's death in 1925, the press was taken over by Robert and Moira Gibbings, whose period of control over the press was the high point in its history. It was during their management of the press that Eric Gill became involved in its artistic life.

Gill had had a conventional artist's training at Chichester Technical and Art School, working afterwards in the ecclesiastical architectural office of William Caröe, and developing his lifelong interest in lettering and its design under the calligrapher Edward Johnston. For the *Four Gospels* Gill designed both the typeface and the wood-engraved initials, and worked closely with Gibbings to decide the precise layout of the pages and the emphasis of the illustrations. It was intended that the text (using the Authorized King James version) should predominate, despite Gill's striking designs; the letterpress was therefore set up and printed before the woodblocks were cut, so that Gill could use the proofs to size his blocks. They were cut from hardwood, enabling great precision of line and finesse of detail; at the same time Gill was able to interweave the letters and illustrations to a remarkable degree. The initial A here shows an example of this; the side of the letter becomes part of a ladder, and the letter N is used to support a man taking the weight of the body of Christ.

Waltham St Lawrence: Golden Cockerel Press
(no. 60 of a limited edition of 500 copies)
Printed on Batchelor hand-made paper; with wood-engraved illustrations;
269 pp.; 34.2 × 24.8 × 3.4 cm
RCIN 1052088
Purchased by King George V

SANGORSKI & SUTCLIFFE, binder; LYNTON LAMB (1907–1977), designer
The Holy Bible, 1953

For The Queen's Coronation in 1953, Oxford University Press was commissioned to print the Bible that would be used during the ceremony. A limited edition of 25 copies on fine paper was produced, of which two were specially bound. The first was used when the Archbishop of Canterbury administered the oath. The Queen, kneeling on the altar steps, laid her right hand on the Bible saying: 'The things which I have here before promised, I will perform and keep. So help me God.' After kissing the Bible, she signed the oath. The Bible was then formally presented to her, in a ceremony dating from the coronation of William and Mary in 1689. In 1953 for the first time it was presented jointly by the Archbishop of Canterbury and the Moderator of the General Assembly of the Church of Scotland. The Bible was subsequently placed by The Queen in the library of Westminster Abbey.

The second copy of the Bible, shown here, was identically bound and was presented to The Queen by the publisher. The firm of Sangorski & Sutcliffe executed both bindings, to designs by Lynton Lamb, graphic designer with Oxford University Press from 1930; he had studied bookbinding under Douglas Cockerell at the Central School of Arts and Crafts in London. The design 'grows' out of the spine structure, the raised bands of the spine leading to gold-tooled music staves. They are complemented by staves in black, and a restrained pattern of ER cyphers and crowns, around the central lozenge of The Queen's arms, perhaps a visual representation of the solemn music and ritual around The Queen as the central figure of the ceremony.

Oxford: University Press; no. 2 of 25 copies
Printed on Oxford India Paper, 1,428 pp.,
2 vols in 1; bound in red levant goatskin with cream
inlay, tooled in gold and black; all edges gilt;
34.0 × 26.5 × 6.5 cm
RCIN 1080362
Presented by Oxford University Press
to HM The Queen

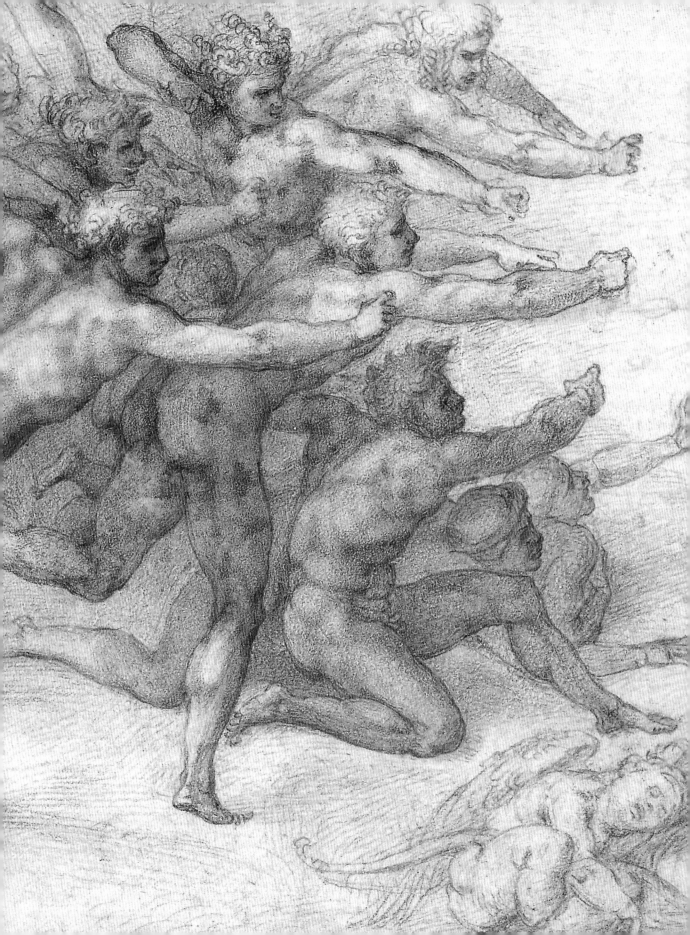

DRAWINGS, WATERCOLOURS AND PASTELS

The Royal Collection contains around 40,000 drawings and watercolours and over 150,000 prints, mostly housed in the Print Room of the Royal Library at Windsor Castle. This collection has been assembled over the last 460 years, mainly during the reigns of Charles II, George III and Queen Victoria.

The first drawings in royal ownership were the 85 portrait studies by Hans Holbein the Younger that form one of the treasures of the Royal Library (pp. 222, 225). Charles I exchanged the Holbeins in the late 1620s for a single tiny painting, Raphael's *St George and the Dragon* (now in the National Gallery of Art, Washington, DC). Though one of the great royal collectors in other areas, Charles I seems to have had little interest in drawings. Nevertheless, he did purchase the Raphael cartoons of the *Acts of the Apostles* in 1623. (Since 1865 these have been loaned to the South Kensington – now Victoria and Albert – Museum, London.)

The first monarch to have had a genuine passion for drawings was Charles II. Though there is little documentation to show how his collection was formed, it appears that the King bought the great volume containing 600 drawings by Leonardo da Vinci (see pp. 214–19) and had, by 1675, reacquired the album of Holbeins, as well as many Italian drawings.

By the mid-18 century the collection of Old Master drawings had assumed the proportions that it has today. One of the most significant purchases of drawings made by Frederick, Prince of Wales, was an album of studies by Poussin. Frederick's son, George III, was able to indulge his tastes on a grand scale. In 1762 the young King purchased the collections of Consul Joseph Smith in Venice and Cardinal Alessandro Albani in Rome. At a stroke he thus acquired large groups of drawings by Canaletto (p. 248), Sebastiano (p. 244) and Marco Ricci, Piazzetta (p. 242), Domenichino, Castiglione (p. 235), the Carracci (p. 228), Maratti, Poussin (p. 233), Sacchi and Della Bella; the bulk of the Cassiano dal Pozzo collection

(p. 232); smaller but still significant numbers by artists such as Michelangelo (pp. 220, 221), Raphael (p. 222) and Bernini (p. 231); and numerous studies by other Italian Old Masters. The King's Librarian Richard Dalton purchased many other drawings for George III, including those by Guercino (p. 230) and Sassoferrato.

Towards the end of George III's reign the first comprehensive inventory of the Royal Collection of drawings was made, known as Inventory A. It reveals that most of the collection had been rearranged and rebound in his reign, thus destroying much physical evidence of earlier provenance. The donation of George III's library to the nation after the accession of his son, George IV, involved the transfer to the British Museum of a number of albums of prints, though George III's Military Collection and the Old Master drawings (seen as distinct from the collection of books) were retained.

Queen Victoria and Prince Albert took great interest in the organisation of the prints and drawings and passed many evenings in the Print Room at Windsor. Albert initiated the Raphael Collection, an attempt to survey in some 5,500 photographs and prints, every work by, or deriving from, Raphael. Meanwhile, the couple either commissioned or received as gifts many contemporary watercolours to record visits at home and overseas (p. 250). Around 6,000 drawings and watercolours date from the reign of Queen Victoria, and at the same period the process of removing Old Master drawings from albums and mounting them individually commenced.

Works of historic interest continue to be acquired – or reacquired – for the Collection (see pp. 232–33, 251). New works are also commissioned (p. 251), but the main emphasis in the present reign is conservation, study and presentation. Access to this part of the collection is predominantly through exhibitions at The Queen's Galleries in London and Edinburgh, and the Drawings Gallery at Windsor, and through loans to external exhibitions.

Details: Michelangelo, Archers shooting at a herm, c.1530 (see p. 221)

Drawings, Watercolours and Pastels

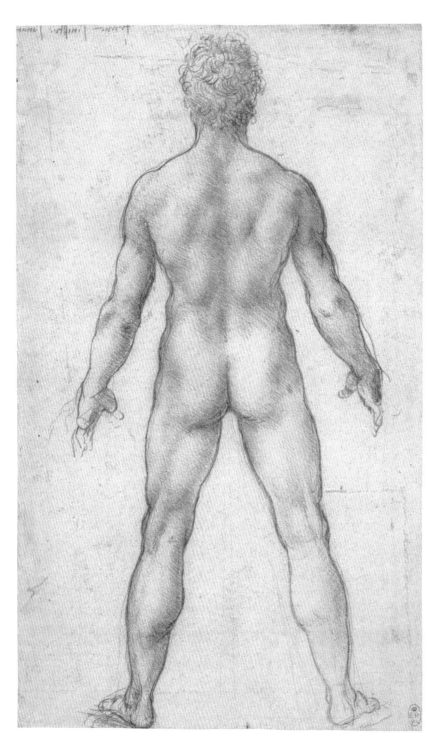

Leonardo da Vinci (1452–1519)
A standing male nude from behind,
*c.*1503–06

In 1503 Leonardo began preparations for
the huge mural of the *Battle of Anghiari*,
to be painted in the council chamber of
the Palazzo della Signoria in Florence.
His preparatory drawings for the compo-
sition of men and horses in violent action
led Leonardo back to a prolonged study
of anatomy and proportion, a subject that
had first occupied him around 1490 in
Milan. Leonardo made a number of
drawings of male nudes standing in this
tensed pose, seen directly from in front
or behind, and of legs from all angles
with the muscles strongly emphasised.
In some cases the divisions between the
muscles are so sharp that Leonardo must
have intended to represent an *ecorché*,
or flayed body. Although there is no firm
evidence that he performed human
dissection until around 1507–08, he
may have worked on corpses in the
monastery hospitals at an earlier date.

There was no attempt here, as there
was in the earlier anatomical drawings,
to impose a system of proportion on the
figure, or to derive such a system from
measurements taken from the model.
Instead, Leonardo concentrated on
capturing the subtleties of surface
modelling, drawn rapidly with lightly
hatched chalk, and of contour – the fore-
shortening of the hands, in particular, is
masterful. The outlines were drawn
repeatedly with light passes of the chalk,
giving a vibrancy that transforms the
image from a static illustration into a
study of a living, breathing individual.

Red chalk; 27.0 × 16.0 cm
Inscribed by the artist, upper left,
in reverse, *franc sinisstre sonat*[...]
RL 12596
Probably acquired by Charles II;
Royal Collection by 1690

Sprigs of oak (Quercus robur) and dyer's greenweed (Genista tinctoria), c.1505

Over the last two decades of his life Leonardo worked intermittently on two versions of a composition representing the seduction of Leda by Jupiter in the form of a swan, from which union were born Castor and Pollux, Clytemnestra, and Helen of Troy. The first version proceeded no further than the preparatory drawings, but Leonardo completed a painting of the second version, destroyed around 1700 and known through numerous copies.

A common feature throughout was a foreground teeming with plants and flowers, to augment the theme of fecundity inherent in the subject matter, and in this connection Leonardo made a number of botanical studies around 1505. The famous *Star of Bethlehem* (RL 12424) is as stylised in the twisting motion of its leaves as are the sketches of Leda herself, but some of the other plant studies rank among the most objective of Leonardo's drawings. They are mostly drawn with a finely pointed red chalk on paper coated with a delicate orange-brown preparation, itself probably composed of ground red chalk. This red-on-red technique emphasises line at the expense of volume, and the strong outlines necessary to give structure to the oak study have occasionally been misinterpreted as later reinforcement by a different hand.

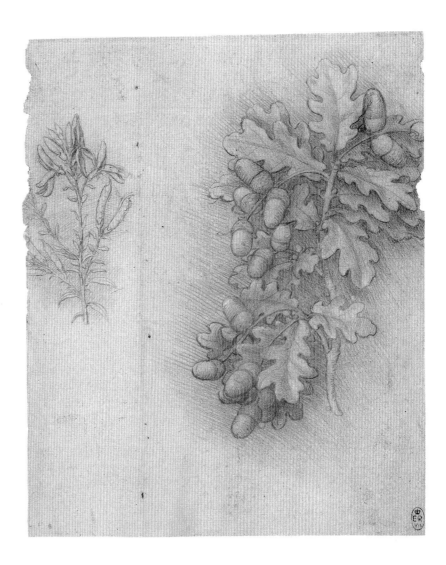

Red chalk with touches of white chalk on
pale red-brown prepared paper; 18.8 × 15.3 cm
RL 12422
Probably acquired by Charles II;
Royal Collection by 1690

Leonardo da Vinci (1452–1519)
A storm in an Alpine valley, c.1508–10

A number of landscapes by Leonardo in red chalk can be dated to his second period of residence in Milan, intermittently between 1506 and 1513, in the service of the French occupiers of the city. Some are highly objective, most remarkably a view of the Alps from the roof of Milan Cathedral (RL 12410); some are documentary, such as a distant view of the fires set by Swiss troops outside Milan in mid-December 1511 (RL 12416); others are more stylised, of which this is the finest example. But the drawing is not merely, or even primarily, a work of the imagination, and it is abundantly clear from Leonardo's notebooks that he was both familiar with the Alps north of Milan and fascinated by meteorological phenomena. He made detailed descriptions (partly first-hand) and measurements (wholly so) of the valleys; he recorded fossil shells found in the mountains, from which he deduced that the Earth was much older than indicated by the Bible; he described freak clouds and storms; and in a remarkable passage in the Codex Leicester (f. 4r), of about the same date as the present drawing, Leonardo noted how the sky darkened at high altitudes:

This may be seen, as I saw it, by going up Monte Rosa, a peak of the Alps which divide France from Italy ... No mountain has its base at so great a height as this, which lifts itself above almost all the clouds; and snow seldom falls there, but only hail in the summer ... and this hail lies unmelted there ... and in the middle of July I found it very considerable. And I saw the sky above me quite dark, and the sun as it fell on the mountain was far brighter than in the plains below.

The pursuit of mountaineering began in earnest only in the mid-19th century, and documented earlier ascents of the higher peaks, such as Petrarch's climb of Mont Ventoux, are remarkably rare. But it is plain from this passage that Leonardo,

then aged over 50, ascended Monte Rosa to some considerable altitude, perhaps 3,000 metres or more. He presumably made other ascents of the Lombard Alps, and there is no reason why the precipitous view in the drawing, looking down on a localised storm in a valley, should not have been based on experience.

Red chalk; 19.8 × 15.0 cm
Inscribed .137., probably by Francesco Melzi
RL 12409
Probably acquired by Charles II;
Royal Collection by 1690

Leonardo da Vinci (1452–1519)
Studies of flowing water, c.1509–11

Water obsessed Leonardo throughout his life. His earliest dated drawing, of 1473, is a landscape showing a river cascading over rocks and streaming away down a valley; his final sheets, 45 years later, are haunted by visions of deluges destroying the Earth. He surveyed the Arno for the Florentine government and planned a canal to render Florence navigable from the sea; and in the years from about 1508 to 1511 he studied hydraulics in great detail with the unrealised intention of compiling a treatise on the subject. Leonardo made hundreds of observations on the movement of water at this time and, although certain themes recur – in particular his astute analyses of complex motions in terms of linear and circular components – the superabundance of particular cases prevented him from ever realising a set of generally applicable laws.

This most elaborate of Leonardo's sheets of water studies investigates two basic themes. The first, in the upper two drawings, is the flow of water past a planar obstruction. Leonardo was struck by the fact that those patterns were stable and repeatable, evidence that the flow was not chaotic but subject to physical laws, and in notes on the other side of the sheet he attempted to frame such principles in terms of incidence, percussion and reflection. Below, Leonardo shows the fall of a stream of water from a sluice into a pool, a lucid and highly sophisticated study in which the multiple layered vortices are seen extending far below the surface, each welling current giving rise to concentric circles of bubbles that expand across each other without interference (a phenomenon he had studied elsewhere in his investigations of wave propagation). Leonardo was never a dispassionate observer and he wrote elsewhere of the 'beautiful spectacles of rippling water' and the 'beautiful movements which result from one element [air] penetrating another [water].'

Pen and ink, the central drawing over black chalk;
29.7 × 20.8 cm
Extensively annotated by the artist
RL 12660v
Probably acquired by Charles II;
Royal Collection by 1690

Leonardo da Vinci (1452–1519)
The babe in the womb, c.1511

Leonardo's anatomical researches can be divided between a first phase around 1490, when he seems to have had no access to human material other than skeletal; and a second, much more significant phase between about 1507 and 1515, during which time he claimed to have dissected around 30 corpses. This figure is not contradicted by the quantity of Leonardo's surviving anatomical drawings, on some 200 sheets held almost entirely at Windsor.

His most fruitful period of anatomical study was around 1510, when he investigated the mechanics of human muscles and bones, possibly in collaboration with Marcantonio della Torre, a young professor of anatomy at the University of Pavia. After Marcantonio's death in 1511, Leonardo concentrated on cardiology and embryology, working mainly with animal material. His dissections of the ox's heart are astonishing in their precision and understanding of function, but his embryological studies were less successful. Although he may have dissected a woman who died in childbirth, and a miscarried embryo of four to six weeks, Leonardo had no knowledge of the discoidal structure of the human placenta and believed it to be cotyledonous (formed of a number of small 'rosettes'), like that of a gravid cow that he had dissected a couple of years earlier.

The notes and smaller sketches here are concerned with the nature of the membranes enfolding the foetus, and the interdigitation of the supposed cotyledons; they may be considered as glosses to the main drawing in which Leonardo synthesised his understanding

of the human uterus. Despite the errors of detail, the tightly balled form of the foetus surrounded by swirling pen-work and the striking use of red chalk for the underdrawing make the sheet one of the most powerful of Leonardo's late period.

Pen and ink, the main drawing with wash over red chalk and traces of black chalk; 30.5 × 22.0 cm
Extensively annotated by the artist
RL 191021
Probably acquired by Charles II;
Royal Collection by 1690

MICHELANGELO (1475–1564)
A male nude with proportions indicated, c.1515–20

Michelangelo was primarily responsible for establishing the tradition in post-classical art that conceives of the body (and especially the male nude) as the physical manifestation of emotional and spiritual states. Intense feeling thus requires powerful form and his figures can on occasion be oppressively heavy, though they are always based on the most attentive study from the life. The main drawing here is finished with great care and ranks as one of Michelangelo's most majestic nudes; yet it seems to have had a didactic function, for it is statically posed and the proportions of various parts of the body are indicated.

The unit used is inscribed as a *testa* (head), defined in the sketch at top right as the distance from chin to hairline, or the length of a hand. Overall the model stands 11½ units tall, and while this would normally pertain to a gracefully elongated figure, this ratio is here due to an unnaturally small head which further emphasises the breadth of the shoulders. The musculature is anatomically accurate (though almost grotesquely massive in the torso) and reflects the artist's lifelong investigation of the subject, beginning with his reputed human dissections as a 17-year-old.

Michelangelo had few pupils, most of whom were inept, but he was sporadically conscientious in providing instructional drawings for his protégés. The style of this drawing suggests a date around 1515–20, a period of close association with Sebastiano del Piombo (*c.*1485–1547), the most accomplished of Michelangelo's immediate followers, and it is possible that it was drawn for Sebastiano. The proportional indications are obscure – it is difficult in most cases to discern the anatomical features to which Michelangelo was referring, and the intervals thus defined seem trivial. Another drawing of a standing nude on the verso of the sheet is not didactic, and Michelangelo may have added the measurements on the recto for himself. Though this is one of few surviving drawings to be so explicit, it is not surprising that the sculptor, painter and architect was interested in proportion.

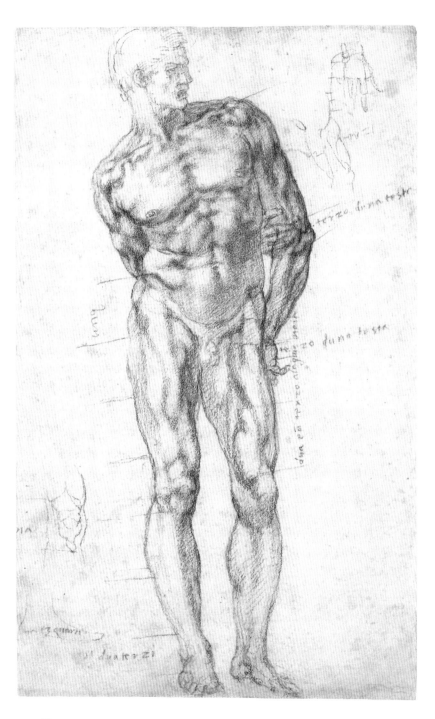

Red chalk (two shades); 28.9 × 18.0 cm
Annotated by the artist with
proportional measurements
RL 12765
Royal Collection by *c.*1810

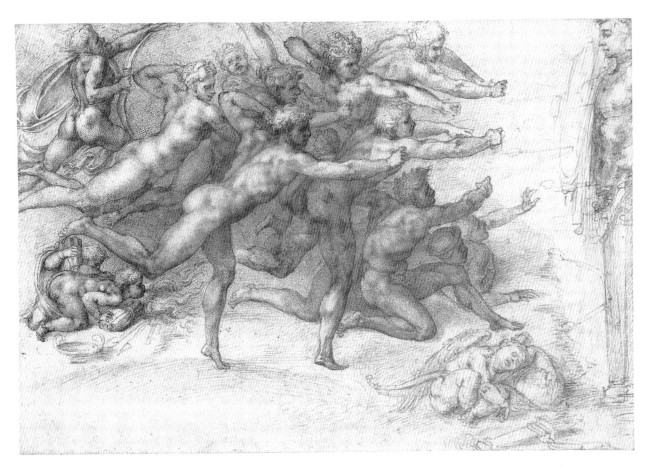

See details on pp. 212–13

MICHELANGELO (1475–1564)
Archers shooting at a herm, c.1530

The handful of 'presentation drawings' that Michelangelo produced during the latter half of his life, and especially around 1530, stand at the very pinnacle of European draughtsmanship. Made as gifts for his closest friends, they were painstakingly worked and often imbued with personal meaning, the nature and full extent of which are not always clear to us. Despite their intimate nature, most were soon famous through reproduction in engravings, copy drawings, paintings, relief sculpture and carved crystals. The Royal Collection holds five of these magnificent sheets: *Tityus*, the *Fall of Phaeton*, the *Bacchanal of Children*, *Three Labours of Hercules* and the present drawing. All may have passed through the Farnese collection in Rome, but the circumstances of their acquisition, probably for George III, are not known.

No literary source has been identified for the subject of the *Archers*, but its neoplatonic meaning is so clear that it has no need of a specific source. A group of nude youths, both male and female, some hovering in the air, fire arrows (from non-existent bows) towards a target fixed to a herm. These arrows strike the

herm and its base, and the edges of the target, but not its centre. Below, a winged cupid sleeps, his bow resting in his lap; to the left two putti kindle a fire. Thus mere striving – the frenetic actions of the archers, impelled by the burning flames of passion below – cannot achieve its aim. Only that which is guided by love will succeed; the winged cupid sleeps, and so the arrows miss their mark. The most curious element of the composition, the omission of most of the bows, may simply have been intended to simplify the composition and maintain the horizontal surge of the figures.

Red chalk (two shades); 21.9 × 32.3 cm
RL 12778
Royal Collection by *c.*1810

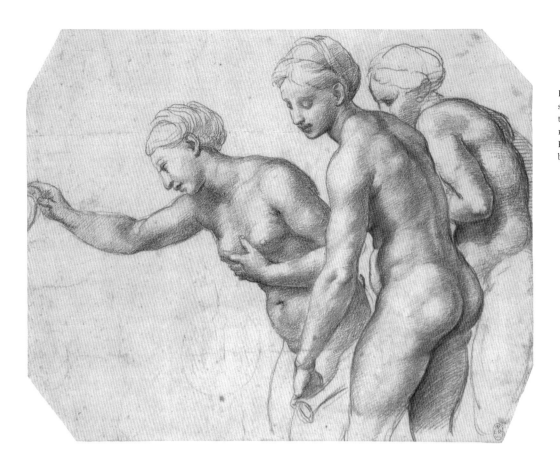

Red chalk over some
stylus; 20.3 × 25.8 cm,
the corners cut
RL 12754
Royal Collection
by c.1810

Raphael (1483–1520)
The Three Graces, c.1517

Raphael was born in Urbino, worked in Umbria and Florence,
and moved to Rome in 1508 to work for Pope Julius II. His
supreme talents and great productivity were soon recognised
and by the time of his early death he dominated the artistic scene
in Rome. Inundated with commissions, Raphael was forced to
delegate the execution of most of his projects to assistants. He
and his two most trusted colleagues, Gianfrancesco Penni and
Giulio Romano, controlled these projects through their drawings
– compositional draft, figure study and full-scale cartoon.
Despite the pressures he was under, Raphael himself prepared
some of the compositions at the most routine manual level.

 This drawing of a single model in three consecutive poses is
a study for the group in the *Wedding feast of Cupid and Psyche*,
one of two fictive 'tapestries' frescoed by Raphael's workshop in
the garden loggia of Agostino Chigi's villa by the Tiber in Rome,
now known as the Villa Farnesina. It is the work of an artist with
a seemingly effortless understanding of bodily form, fully in
control of his medium, taking the drawing as far as necessary,
and defining highlights simply by leaving areas of paper blank.
Life drawings of the female nude were rare in the Renaissance,
though they appear quite frequently in Raphael's oeuvre.

Hans Holbein the Younger (1497/98–1543)
William Warham, Archbishop of Canterbury, 1527

Holbein was the most important painter working in England
during the Reformation, though he was born in Augsburg,
trained in Basel and spent a total of only 13 years in England,
from 1526 to 1528 and from 1532 to 1543. Of the 80 portrait
drawings by Holbein now at Windsor, 30 can be linked with
surviving paintings, and nearly all the remainder were no
doubt studies for lost works. In most cases the identity of the
sitter is known only from the inscriptions on the drawings,
apparently copied in the 18th century from identifications made
by Sir John Cheke, tutor to Edward VI, in whose collection the
drawings were first recorded.

 William Warham (c.1455–1532) was appointed Archbishop of
Canterbury by Henry VII in 1503; from 1504 to 1515 he was also
Lord Chancellor. The accession of Henry VIII in 1509 and his
preferment of Thomas Wolsey brought Warham and Wolsey
into frequent conflict over matters of ecclesiastical authority.

 In 1524 Erasmus sent his friend and patron Warham his
portrait by Holbein as a gift. On Holbein's arrival in England,
Warham returned the compliment, and the present drawing
is Holbein's full-scale study for the painting sent to Erasmus.

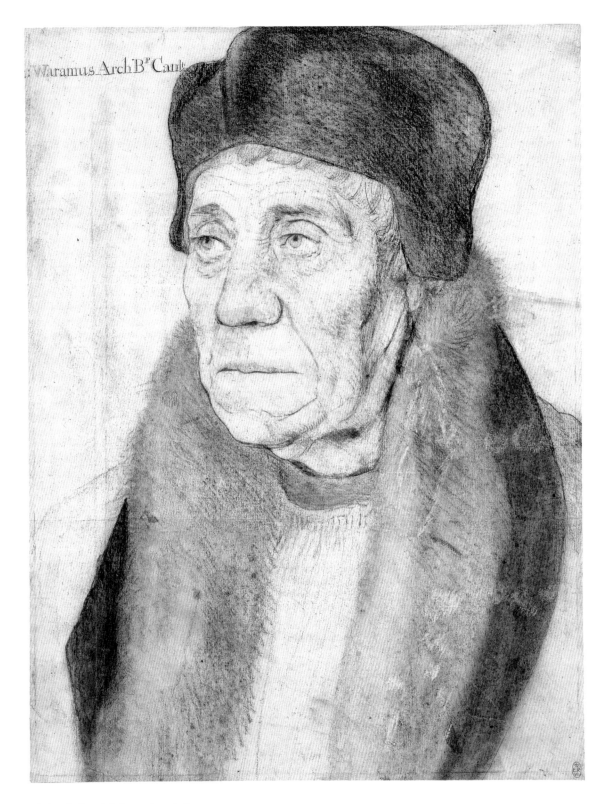

Black and coloured chalks, partly washed over; 40.7 × 30.9 cm
Inscribed [...]: *Waramus Arch Bp Cant:*
RL 12272
Acquired by Charles II

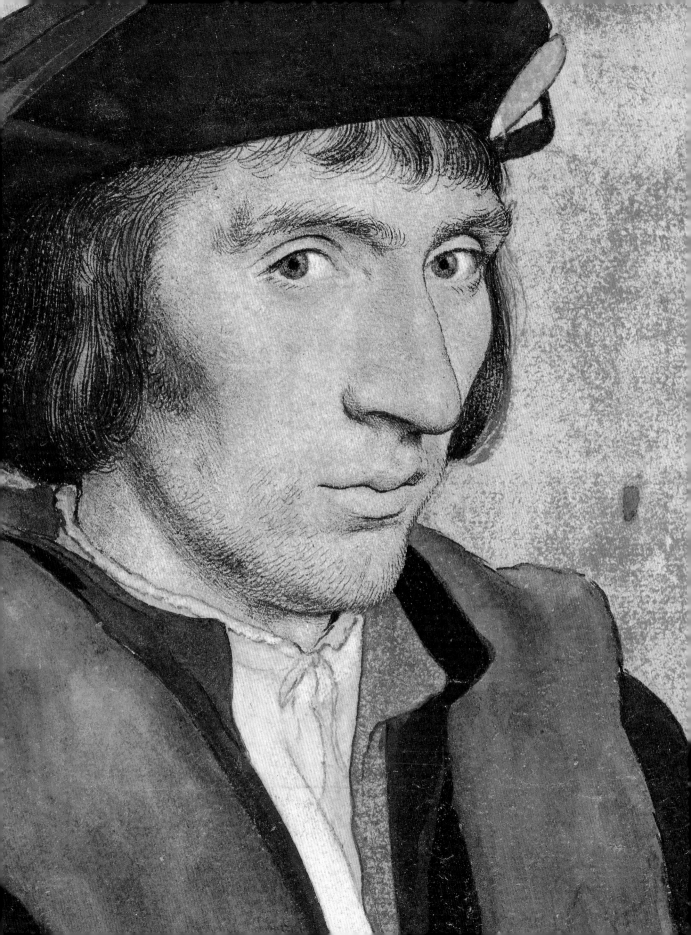

Hans Holbein the Younger
(1497/98–1543)
Sir John Godsalve, c.1532–34

John Godsalve (c.1510–1556) was first portrayed by Holbein in 1528 alongside Sir Thomas Godsalve, his well-connected father (Dresden, Gemäldegalerie). From the apparent age of the sitter, this portrait can be dated to the early years of the artist's second English sojourn. Godsalve's acquaintance with Holbein would easily have been renewed at this time, for he had been appointed to the Office of the Common Meter of Precious Tissues in 1532, bringing him into frequent contact with the Hanseatic merchants who were Holbein's main patrons following his return to England in the same year. It was perhaps this appointment that prompted Godsalve to commission a portrait of himself alone.

The status of the present drawing is, however, problematic. It is the only one of Holbein's drawings at Windsor to be fully worked up in colours, and the subtle *trompe-l'oeil* of the right arm resting on a ledge further suggests that it was drawn as a finished work of art. It is conceivable that the drawing was intended to be pasted to a panel, thus serving the same function as a painting (some Holbein portraits of this type do survive), but the presence of the drawing at Windsor implies that it was still in Holbein's studio at his death and had not been delivered to the sitter.

In the Philadelphia Museum of Art there is another half-length painting of Godsalve, at about the same age, wearing similar clothes and the same cap and also holding a folded letter, but the painting does not depend compositionally on the present drawing in any detail; nor is it by Holbein, and its relationship to the present drawing remains uncertain.

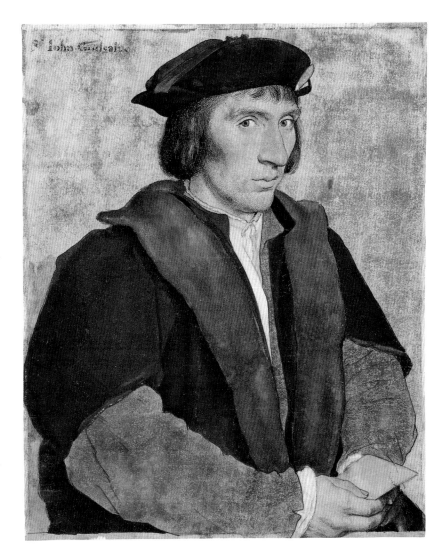

Black and red chalks, pen and ink, brush and ink, bodycolour, white heightening, on salmon-pink prepared paper; 36.2 × 29.2 cm
Inscribed *Sr Iohn Godsalue*, twice
RL 12265
Acquired by Charles II

Pen and ink, wash,
white heightening,
the outlines incised;
53.2 × 33.2 cm, arched
Signed by the artist,
lower centre
THEODORUS. /
BER. [*AMSTELODA*
and *BERNARDUS*
superscribed and
effaced] / *MUF : F.*
RL 7786
Royal Collection
by *c.*1810

Dirck Barendsz. (1534–1592)
The Fall of the Rebel Angels, c.1562–66

After training as a painter under his father in Amsterdam, Dirck Barendsz. travelled to Rome and Venice, apparently working in Titian's studio for a few years. The present drawing is probably a study for an altarpiece executed shortly after his return to Amsterdam around 1562 and destroyed in the iconoclastic riots in the city in 1566. The painting was described by the early biographer Karel van Mander as commissioned by an Amsterdam shooting company, most likely the Kloveniers or arquebusiers, for their guild altar in the Oude Kerk.

The casting from heaven of Satan and the rebel angels by St Michael is described in the Book of Revelation (12: 7–9), though the form of God the Father here, seated astride a globe and brandishing a thunderbolt, owes something to the classical analogue of the subject, the destruction of the rebellious giants by Jupiter. In a rather equivocal reference to the patrons of the painting, a figure to the lower right of centre aims a gun at St Michael and his allies. The tumultuous composition was probably inspired by Frans Floris's altarpiece of the same subject painted a decade earlier.

The high finish of the drawing suggests that it was made either for the patrons' approval before work on the altarpiece began, or (more probably) as a subsequent record of the composition. In the course of his career Barendsz. sent a number of designs to be engraved; the outlines of the figures are sharply incised for transfer, though no print is known.

Right:
Black, white and coloured chalks on blue paper; 29.9 × 23.0 cm, the corners made up
RL 5231
Royal Collection by c.1810

Federico Barocci (c.1535–1612)
The head of the Madonna, c.1582

Federico Barocci was the most innovative painter of altarpieces working in Italy in the later 16th century. He combined the strong local colour and elaborate compositions of high Mannerism with intense observation from the life to produce a body of work unequalled among his contemporaries in its richness and variety. As he was based in the small city of Urbino, much of his work was not known to artists in the major centres.

A chronic illness restricted Barocci's artistic activity to short periods in the morning and evening, but despite (or maybe because of) this he prepared his compositions meticulously. For his head studies he exploited coloured chalks, both natural and fabricated, more extensively than any artist before the 18th century; this medium allowed him to determine both lighting and colour in the preparatory sheet, and thus he could use his precious painting time as efficiently as possible.

The drawing is a study for the Virgin in the Vatican *Annunciation*.

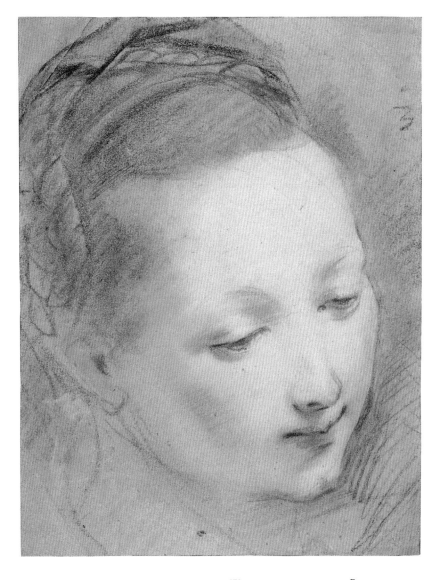

Sir Peter Paul Rubens (1577–1640)
Silenus and Aegle, with other studies, c.1612–15

Most of the sketches here depict a scene from the sixth of Virgil's *Eclogues*. Silenus, found in a drunken sleep, was bound with his own wreaths while the naiad Aegle painted his face with mulberries, and was released only when he sang a long-promised song of the creation of the world. In the most finished of the studies, at lower left, the action of Aegle and the putto binding Silenus's right arm are clear. No painting of the subject by Rubens is known, though the figures find echoes in several of his works around 1612–14. The other sketches mostly develop the poses of the main study, though the group at upper right may be a first idea for the artist's *Four Continents* (Kunsthistorisches Museum, Vienna) of c.1615.

When the sheet was lifted from its old mount prior to exhibition in 1977, several unrelated studies were found on the verso – an *Ecce Homo*, an execution, three sketches of the Dead Christ, two figures on horseback and other single figures. These studies can mostly be related to paintings by Rubens of the period 1614–18, and suggest that, unusually, he added to the sheet over a number of years. It may have been used in Rubens's studio for sketching and as a source of inspiration for motifs.

Pen and ink (two shades), wash; 28.1 × 50.8 cm
Inscribed by the artist, upper centre *Vitula gaud[ium]*,
and by another hand, lower centre, inverted, *N:jjj tekeningen*
RL 6417
Royal Collection by *c.*1810

Ludovico Carracci (1555–1619)
The Martyrdom of St Ursula, c.1615

Ludovico Carracci and his younger cousins, the brothers Annibale and Agostino (see p. 33), transformed the art world in Bologna, and ultimately throughout Italy, in the years after 1580. They established an academy that promoted study from the life as the foundation of artistic practice, consciously rejecting Mannerist artificiality and training many of the artists who formed the first wave of the full Baroque.

Ludovico painted *The Martyrdom of St Ursula* three times. It has been suggested that the present drawing was preparatory for the church of Sant'Orsola, Mantua, which was commissioned by Margherita Gonzaga and disappeared after the suppression of the convent in 1782. Though no record has survived of the painting's appearance, this is plausible from the late style of the drawing. The figures in Ludovico's works of the 1610s became increasingly stylised, even caricatural, and the bold perspectives with which he had experimented during the 1590s and 1600s gave way to a shallow space with the protagonists lined up in front of a backdrop, as here. Yet, on its own terms, this is a powerful composition and has the combination of elegance and drama that was so important to Ludovico's Bolognese followers.

Black chalk, pen and ink, grey and brown wash,
white heightening, on buff paper; 48.9 × 38.6 cm, arched
RL 2326
Purchased by George III

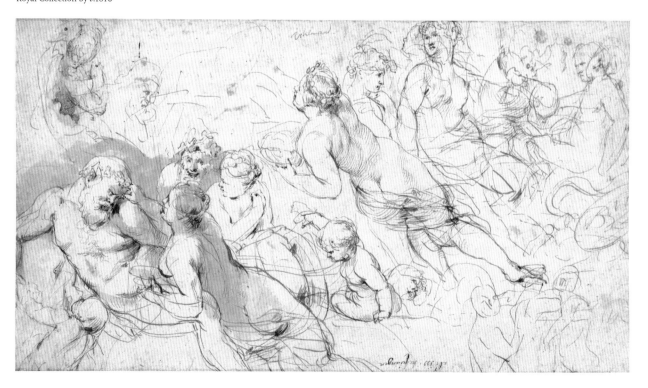

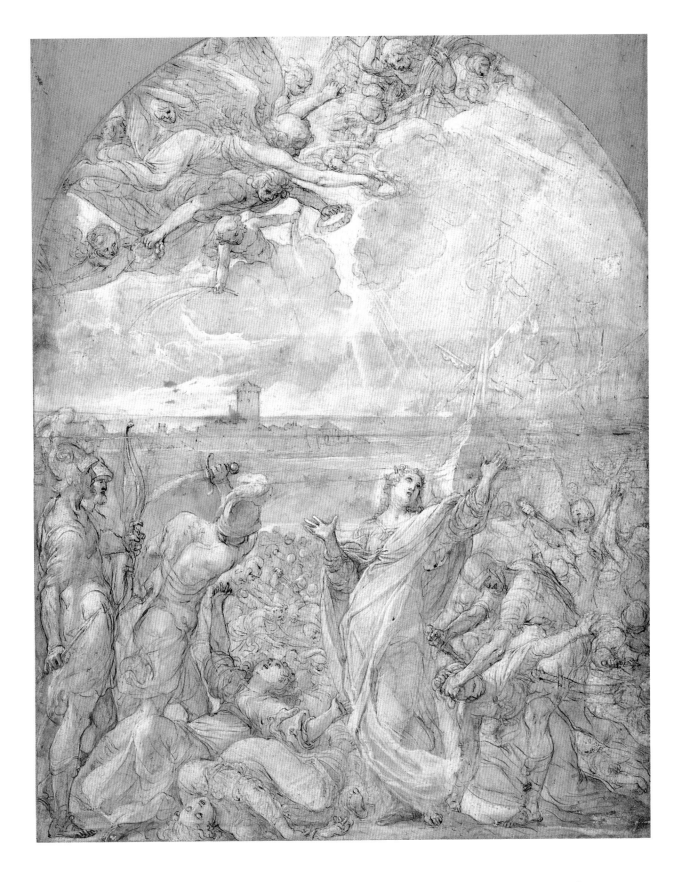

GIOVANNI FRANCESCO BARBIERI, called GUERCINO (1591–1666)
A recumbent male nude, c.1618

Guercino was raised in the small town of Cento, 15 miles north of Bologna, and began his apprenticeship at the late age of 16. The dominant influences of his first years were the works and methods of the Carracci in Bologna, especially Ludovico's *Holy Family with St Francis and Donors*, installed in 1591 in the church of the Cappuccini in Cento (now Museo Civico); its composition and rich colouring inform all of Guercino's early paintings.

Throughout his career Guercino was a prolific draughtsman, and in 1616 he opened an academy of life drawing in Cento, emulating the Carracci academy in Bologna. The youth drawn here modelled often for Guercino around 1618 and appears in several paintings and life drawings, most notably in *Erminia discovering the wounded Tancred* of 1618–19 (Rome, Galleria Doria Pamphili) and in *St Sebastian succoured* of 1619 (Bologna, Pinacoteca). In those two paintings the reclining poses are very similar to that in the present drawing without corresponding

exactly, and must depend on drawings of just this type. The technique of oiled charcoal on toned paper was a favourite of the Carracci's contemporary and rival, Pietro Faccini, whose drawings Guercino is reported to have admired. The breadth and stickiness of this medium led unavoidably to largeness of form and smoky shadows, perfectly attuned to Guercino's early figural style.

Guercino was careful to preserve his drawings and they survive in great numbers. The largest group is at Windsor, purchased from the artist's heirs a century after his death and comprising around 400 sheets by the master himself, 200 by his assistants and another 200 offsets of his chalk drawings.

Oiled charcoal, some white chalk, on buff paper;
38.5 × 58.0 cm, the corners made up
RL 01227
Purchased by George III

Red and white chalks on buff paper;
55.6 × 42.0 cm
Inscribed in pencil in an 18th-century hand
Cav Bernini; and on the verso, in pen,
Academia del Sig.r Cavaliere Bernini /
Comprata da Cesare Madona Adi 7 Aprile 1682
Scudi Sei – 6: / da me Michele Maglia
RL 5537
Royal Collection by *c.*1810

GIANLORENZO BERNINI (1598–1680)
*A seated male nude (Polyphemus?), c.*1630

Bernini was the outstanding figure of the Italian Baroque –
a sculptor, architect, painter, draughtsman and playwright,
whose boundless energy, imagination and religious conviction
profoundly transformed the city of Rome during the course of
his 70-year career. Most of his known drawings are related to his
grand projects, but a number of independent drawn portraits
and figure studies also survive. This is one of four life drawings
of the same model, all in red and white chalks on a full unfolded
royal-size sheet of paper, trimmed somewhat by later collectors.

To the posed model Bernini imaginatively added branches and
foliage, giving the figure some context; it is even possible that he
conceived of the figure as the cyclops Polyphemus, as he spies
his beloved but heedless Galatea in the arms of Acis. The
drawing cannot, however, be regarded as a preparatory study.
Bernini preferred to explore the complex poses of his sculptures
in clay or wax, and few of his surviving figure drawings – as
distinct from small sketches or studies of detail – can be related
to known projects. In the absence of external evidence it is
impossible to date these life drawings with any certainty, but it
has been suggested that they were produced around 1630,
during the period of his closest association with the art academy
in Rome, the Accademia di San Luca.

VINCENZO LEONARDI (*fl.*1621–*c.*1646)
European or Great White Pelican (Pelecanus onocrotalus), 1635

Ornithology was probably the subject that most deeply engaged Cassiano dal Pozzo (1588–1657), one of the great collectors of 17th-century Rome. He kept live exotic birds in his house, and, on his induction into the Accademia dei Lincei in 1622, he presented to the society an ornithological treatise, the *Uccelliera* of Giovanni Pietro Olina. It is probable that Cassiano was himself responsible for part of the text. The published work was illustrated with etchings after drawings in Cassiano's collection by Vincenzo Leonardi, who continued to provide Cassiano with natural-history drawings for the next two decades.

A number of Leonardi's bird drawings were made as illustrations to small treatises or *discorsi* that Cassiano wrote on individual species. Three of these survive in manuscript – on the bearded vulture, the ruby-throated hummingbird and the pelican. The last of these (now in the Bibliothèque de l'École de Médecine in Montpellier) is the only *discorso* for which we also have some of the accompanying drawings.

The white pelican illustrated here had been shot in the marshes near Ostia in June 1635 and brought to Cassiano; two months earlier he had been presented with a Dalmatian pelican,

wounded but still alive, that was the subject of another drawing by Leonardi (RL 31865). The white pelican was dissected by Cassiano's friend Giovanni Trullio, professor of medicine at the University of Rome, and Cassiano wrote in great detail about the pelican's anatomy and colouring with reference to Leonardi's drawings, which included life-size details of its head (RL 19437), feet, wings, feathers and tongue.

Watercolour and bodycolour over black chalk,
with gum arabic; 36.4 × 45.2 cm
RL 28746
Purchased by George III. Repurchased by HM The Queen

Nicolas Poussin (1594–1665)
*Bacchus discovering Ariadne, c.*1634–36

Though Nicolas Poussin was French by birth, he settled in Rome in 1624 and remained there for the rest of his life, with the exception of a short and disaffected return to Paris from 1640 to 1641. His paintings were mostly executed for private collectors and are full of scholarly references; they represent the purest form of the classical style in Rome and, avidly sought after by his countrymen, were instrumental in the development of classicism in France. But Poussin was not a natural draughts-

man, and his compositions were developed in small-scale studies that mainly impress by their rigour rather than seduce with their effects. The collection of drawings by Poussin at Windsor is second only to that in the Louvre.

The subject of the drawing is *Bacchus discovering Ariadne*. Having helped Theseus escape the Minotaur's labyrinth, Ariadne (seated to the right of centre) was abandoned by her lover on the isle of Naxos. She was found by Bacchus (standing on the left) and his train; the god is here shown proffering a bowl of wine, while a female figure seated beside Ariadne intercedes on his behalf. A pair of Bacchus's followers play pipes and cymbals, while Cupid looks on, leaning on his bow. Ariadne was received into Bacchus's chariot, and they married shortly after. No corresponding painting is known.

Poussin's drawings of the mid-1630s were the freest and, to modern eyes, the most attractive of his career. Here he used no underdrawing before attacking the paper with pen and ink, untroubled by anatomical considerations – the arm of the urn-bearer on the far left is little more than a scribble. Broad strokes of pale wash impart an overall rhythm, and a sequence of dabs of a darker wash defines the stances and gestures of the figures. For a copy of the drawing by John Piper, see p. 251.

Pen and ink, wash, on pink-tinged paper; 15.4 × 24.7 cm
RL 11911
Purchased by George III

PIETRO TESTA (1612–1650)
Midas, c.1640–50

A native of Lucca in western Tuscany, Pietro Testa was one of
the many artists who, during the 17th century, flocked to Rome,
then the most bountiful centre of artistic patronage in Europe.
Like Nicolas Poussin (p. 233), he entered the circle of the
antiquarian Cassiano dal Pozzo (see p. 232); unlike Poussin, he
was more a natural draughtsman (and etcher) than a painter, but
it was to the status of a great public painter that he aspired, and
a succession of frustrated projects and strained relationships
led to his presumed suicide by drowning in the Tiber.

This page is a fine illustration of Testa's difficult dealings
with his patrons, for it includes part of an undated draft letter
to Niccolò Simonelli, a collector whom he had known since at
least 1636 (the remainder of the letter is on a separate sheet at
Windsor). The tone of the letter is rather mercurial. Testa seems
to accuse Simonelli of trying to buy off their relationship,
whereas Testa had thought that through the few 'bagatelles'
already executed for Simonelli he could build a 'wall of
benevolence' and 'enjoy the sweetness of a most precious and,
by me, always-desired friendship'. He goes on to explain that in
the drawing he had converted an ancient fable to modern usage:
Midas was the King of Phrygia who was granted a wish that all
he touched would turn to gold, but he soon began to starve when
his food too was transformed. Testa takes this to symbolise the
tyranny of those for whom that which should nourish
(friendship) is turned not to virtue but to gold (or seen in terms
of money). But the draft ends in jovial mood: 'Who knows if I,
too, will not one day with my pencil go to Parnassus? You see
what *coglionerie* I write to you.'

Pen and ink over traces of black chalk; 20.8 × 27.2 cm
Inscribed by the artist, lower left *quel'Mida che / tanto ne tiranegga*;
at upper left [...] *che coglionerie vi scrivo*
RL 5932
Royal Collection by *c.*1810

Giovanni Benedetto Castiglione (1609–1664)
Moses receiving the Tablets of the Law, c.1660

Giovanni Benedetto Castiglione was born and trained in Genoa and may have adopted the technique of drawing in oil paint on paper in emulation of Anthony Van Dyck, who was in the city intermittently between 1621 and 1627. The rich, flowing strokes of the brush allowed by this technique were ideally suited to Castiglione's verve as a draughtsman; he produced many such drawings throughout his itinerant career, mostly as independent works of art rather than as studies for paintings. The Royal Collection holds over 200 of these striking sheets.

Castiglione was something of a stylistic magpie and was particularly responsive to Rembrandt, Rubens, Ribera and the Bassani. The recurrence of certain favourite subjects – the journeys of herdsmen or the Patriarchs, other Old Testament scenes and Nativities – makes the dating of his drawings problematic, for it is difficult to associate drawings and paintings with confidence. Here the large size of the figures relative to the picture field seems to place the drawing quite late in Castiglione's career, when he was based in Genoa but also active in Mantua, Parma and Venice. Castiglione brought the celestial vision close to Earth, with the figures of Moses and God the Father very similar in both scale and appearance. The hand of God is supported by one of the angels as he inscribes the Law with his finger on the Tablets (Exodus 31: 18); other angels blow their trumpets as the heavenly host swoops down from the left. In the remaining corner of the sheet, Castiglione quickly sketched in the distant Israelites, placing Moses on a rock and thus giving space and context to the episode.

Red-brown oil paint on paper; 40.8 × 56.3 cm
RL 4037
Purchased by George III from Joseph Smith

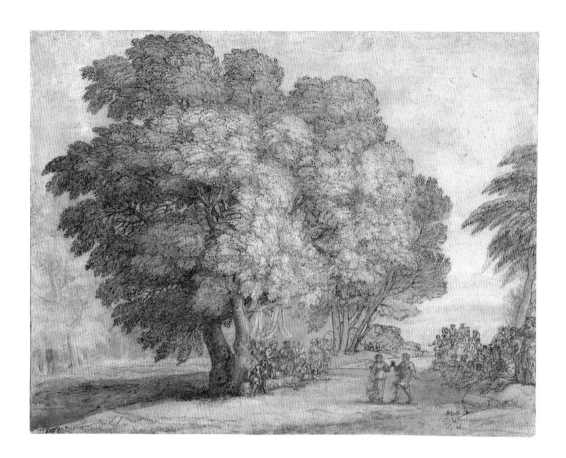

CLAUDE GELLÉE, called LE LORRAIN (1604/05–1682)
A landscape with a dance (The marriage of Isaac and Rebecca?), 1663

The ideal landscape had been developed by Annibale Carracci and Domenichino alongside their primarily figurative works, but Claude – who was several decades younger – devoted his whole career to the genre. Born in the Duchy of Lorraine, now in eastern France, Claude moved to Rome as a youth and worked there for most of his life. In his paintings he created an arcadia of shepherds and flocks, rustic dances, and episodes from myth, legend or the Old Testament – played out before ruined temples, peaceful towns and castles, perfect trees and brooks, all bathed in a nostalgic golden light (see p. 47).

Claude's many drawings fall into four distinct categories: sketches around Rome and in the countryside; compositional and (many fewer) figure studies for his paintings; records of these paintings, in his *Liber veritatis*; and independent, highly finished sheets, of which this is one of the most beautiful examples. It was worked up with great care in a variety of media to capture the fall of light on the soft mass of foliage, and signed and dated by the artist.

The drawing has been called the *Marriage of Isaac and Rebecca*, as depicted by Claude 15 years earlier in a compositionally unrelated painting now in the National Gallery, London. The seated patriarchal figure in profile to the right could be Abraham, but there are no specific details and in the absence of any closely associated work the subject must remain uncertain. Such iconographic questions, however, seem of little import beside the magnificence of the drawing, one of Claude's finest expressions of the autonomy of the natural world and the transience of human activity.

Pen and ink, grey and brown washes, white heightening, over black chalk, on paper washed buff; 34.3 × 44.4 cm
Signed and dated lower left *CLAV– / 1663* / [? *Roma* cut]; signed on the verso *CLAVDIO I.V. fecit*, and inscribed in a different hand *Claudio Lorenese Vero* RL 13076
Royal Collection by *c.*1810

Black and white chalks on blue paper;
55.0 × 40.5 cm (max.)
Inscribed lower centre *Benedetto Luti*
RL 5956
Royal Collection by *c*.1810

Benedetto Luti (1666–1724)
*A male nude, c.*1700–20

Benedetto Luti was born in Florence but moved to Rome in 1690, where he was elected to the Accademia di San Luca in 1694 and quickly rose to prominence as one of the leading painters of the early 18th century. His style was a rich combination of Florentine Baroque light and colour with Roman compositional modes, but his activities as an academician, dealer and collector left him relatively little time for painting.

He was, however, a prolific draughtsman, celebrated for his heads in coloured chalks, and in his role as an academician he frequently taught in the life classes. This is probably the origin of the present sheet, an independent drawing rather than a study for a painting, perhaps drawn by Luti as an exemplar for his students, who would have been making their own drawings from the posed model on either side of the master.

He did, however, subsequently adapt the figure for a composition of *Hercules with the Lion*, recorded in an etching of 1793 by the Comte de Saint-Morys after an untraced drawing by Luti.

Luti's collection of drawings was renowned in its day, and reputed to contain around 15,000 sheets. A part of his collection was bought from his heirs in 1759 by a dealer named Kent (not to be confused with the artist and architect William Kent, who had studied under Luti in Rome some 40 years earlier and died in 1748). The drawings were brought to London by Kent and sold at two auctions in December 1760 and December 1762. A sketchbook in the Albertina, compiled by Luti's pupil Bartolomeo Altomonte, contains a number of free copies of drawings in Luti's collection, and the originals of many of these copies can be identified today at Windsor. However, the lots were not described in detail in the 1760 and 1762 sale catalogues, and it is not possible to confirm that these drawings were bought for George III at one of Kent's auctions.

GIUSEPPE PASSERI (1654–1714)
Christ driving the money-changers from the Temple, c.1710

This is the modello, corresponding in almost all details, for a painting by Passeri in the Walters Art Museum, Baltimore. Two earlier compositional studies, rougher in handling and differing somewhat in the architecture but relatively little in the figures, are in Düsseldorf (inv. KA(FP)2307) and the Louvre (inv. 14724).

Passeri was reputed to be the favourite pupil of Carlo Maratti. The style of his chalk studies of figures and drapery (hundreds of which survive in Düsseldorf) is strongly indebted to his master, and through Maratti to the classical tradition of Sacchi, Domenichino, Annibale Carracci and, ultimately, Raphael and Michelangelo. Several of the figures in the Baltimore canvas have been identified as quotations from paintings by Maratti, and Passeri made no attempt to disguise this; indeed, academic teaching encouraged the adaptation of figures from exemplary sources, and Passeri's borrowings would have been seen as a homage to his master rather than as uninspired copying.

Passeri's compositional drawings, especially the final modellos, are, however, much more extravagant than those by Maratti. They are often executed in a highly colouristic technique of pen, wash and white gouache over an orange-red ground or extensive red chalk underdrawing, as here. The Baltimore painting is bright and clear in its colouring and a fine early example of what was to be the dominant mode in 18th-century Italian painting, the figures moving freely in space rather than locked together in a sophisticated Baroque jigsaw of forms and shadows. Although the circumstances of the painting's commission are not known, it must date from towards the end of Passeri's career.

Red chalk partly washed over, pen and ink, brown and grey wash, white heightening; 27.3 × 38.2 cm
RL 4502
Royal Collection by *c.*1810

Maria Sibylla Merian (1647–1717)

A branch of the banana tree (Musa paradisiaca) with a caterpillar and moth (Automeris liberia), c.1705

Maria Sibylla Merian was born in Frankfurt, the daughter of the successful engraver and publisher Matthäus Merian. Soon after the death of Matthäus in 1650, Maria's mother married the flower painter Jacob Marell, who became Maria's teacher. By the 1690s Merian had settled in Amsterdam and was established as a specialist flower painter. Inspired by the specimens brought back to the Netherlands from the New World, she sailed in 1699 with her daughter to the Dutch colony of Surinam, on the northern coast of South America. The Merians stayed in Surinam for two years, returning to Amsterdam with notes and drawings, dried flowers and preserved animals.

Over the next five years Merian produced her greatest work, the *Metamorphosis Insectorum Surinamensium* (1705), comprising 60 plates etched by Merian, with accompanying texts. The specimens were arranged in a tableau of birth, procreation and death, often illustrating the mutual dependence of the animals (mostly insects) and the plants. The watercolours by Merian at Windsor are painted over first states of the 60 etchings, printed on vellum, in outline only, and coloured by Merian herself, together with 35 other images drawn entirely by hand without etched outlines.

Watercolour and bodycolour over etched outlines, on vellum; 39.5 × 31.0 cm
RL 21166
Purchased by George III, when Prince of Wales

Opposite:

Mark Catesby (1682–1749)

A blue grosbeak (Passerina caerulea) and sweet bay (Magnolia virginiana), c.1728–29

Mark Catesby was an English naturalist who made two extended visits to the British colonies in North America and the Caribbean, from 1712 to 1719 and from 1722 to 1726. From the material assembled on these expeditions Catesby published the first fully illustrated natural history of North America, his *Natural History of Carolina, Florida and the Bahama Islands*, in two volumes issued in parts between 1729 and 1747. The first volume was dedicated to Queen Caroline, consort of George II, and the second to Princess Augusta, wife of Frederick, Prince of Wales. In 1768 George III, the grandson of Caroline and son of Augusta, purchased 263 of Catesby's studies, including nearly all the preparatory drawings for the 220 etchings in the *Natural History*.

This drawing is the model for folio 39 of the first volume, issued as part of the second fascicule, probably in January 1730. The sweet bay was one of a number of species of magnolia illustrated by Catesby. The magnolia had recently been introduced to England from the New World.

Coccothraustes cærulea.

Tulipifera virginiana, laurinis folijs aversâ / parte rore cæruleo tinctis, Coni baccifera —
Pluk phytogr. Tab. 68 fig 4

Watercolour and bodycolour over erased graphite,
with gum arabic; 37.5 × 26.4 cm
Inscribed by the artist, *Coccothraustes cærulea / Tulipfera*
virginiana, laurinis folijs aversa / parte rore cæruleo tinctis,
Coni baccifera – / Pluk phytogr. Tab. 68 fig 4
RL 24853
Purchased by George III

GIOVANNI BATTISTA PIAZZETTA (1682–1754)
Two girls with a bird-cage and a youth with a gun, c.1720(?)

Piazzetta's paintings and drawings, sombre in tone and of an insistent largeness of form, stand in stark contrast to the high-keyed and airy work of Sebastiano Ricci (p. 244) and Giambattista Tiepolo in early 18th-century Venice. Piazzetta was renowned for his drawings of heads in black and white chalks on a dull blue paper that has in almost every case faded to buff, for they were finished works intended to be framed and hung by their owners. Few of these heads are true portraits; they are character heads, of priests, philosophers, Moors, children and Venetian youths, and belong to a tradition that had periods of popularity throughout European art, particularly in 17th-century Holland. The 36 head studies by Piazzetta in the Royal Collection are the largest group in existence. Although their early history is not documented, they very probably came from Consul Smith's collection.

The present drawing seems to be a pendant to another of the same size and format at Windsor (RL 01251), showing an old woman attempting to procure a girl for a bravo standing behind with a bag of money. The narrative content of that drawing is overt; the meaning here is less explicit, but clearly related. The caged bird was a common symbol of a girl's virginity, for once the cage is opened the bird is gone for ever. Hunting was also a standard metaphor for amorous pursuit, and the youth with a gun raises his gaze to the skies: he is hunting for birds.

It is difficult to date the drawing, as there are few reference points to help with dating Piazzetta's heads, and the differences in approach from sheet to sheet mask any evolution of style.

Black and white chalks on buff paper; 41.2 × 55.7 cm
RL 01252
Probably purchased by George III from Joseph Smith

Antonio Gionima (1697–1732)
The triumph of David, c.1720–30

Antonio Gionima was perhaps the most exciting painter in Bologna in the decade before his death of tuberculosis at the age of 35. Gionima adopted strongly expressive compositions and dramatic chiaroscuro and colour in his paintings, and an often elaborate mixing of wash and white in his drawings. Most of his commissions seem to have been from private collectors rather than for public sites; he was thus somewhat neglected by subsequent writers, and little is known about the progress of his career. He seems to have participated in the revival of interest in Mannerism among some artists in early 18th-century Bologna, seen here in the compositional device of placing the principal action beyond a group of large gesticulating figures in the left foreground.

Gionima's drawings were esteemed in his day and this is his most beautiful surviving sheet. It seems to be a final design for a domestic painting; scenes of biblical heroism or legendary moral rectitude, including the patron's likeness, were a popular subject for such pictures, and the suggestion that the head of David here was destined to be a portrait may well be correct. However, no painting has been traced and nothing else is known about the project beyond a preparatory sketch for the composition, formerly in the Methuen collection and recently on the art market.

Pen and ink, wash, white heightening, on paper washed buff;
40.5 × 57.3 cm
RL 3742
Royal Collection by c.1810

Black, white and
coloured chalks on blue
paper; 29.1 × 41.9 cm
RL 7200
Purchased by George III
from Joseph Smith

SEBASTIANO RICCI (1659–1734)
*Two heads, c.*1726

The woman's head corresponds generally with that of the Madonna in Sebastiano Ricci's painting of the *Adoration of the Magi* (also in the Royal Collection and from Joseph Smith's collection; RCIN 405743), though there are differences in the headdress, the tilt of the head, and most significantly in the direction of the lighting. The boy's head may be identified with that of the page in the foreground of the painting, though in a different attitude, and the same model probably served for the study here and for that figure. While the head of the Madonna may be regarded as a study for the *Adoration*, and is accordingly drawn in a tight, carefully modelled manner, the much more atmospheric head of the boy seems not to have been drawn directly for the painting. Drawings in coloured chalks are uncommon in Ricci's oeuvre, but the contemporary success of Rosalba Carriera (opposite) inspired other artists to experiment with the medium.

The *Adoration* is dated 1726 and was in Smith's collection in Venice by 1742, together with six other canvases by Ricci of episodes from Christ's ministry, each around 3 metres square. The scale of the series would be most unusual for a private collector, but there is no record of the circumstances of the commission nor of any owner earlier than Smith.

ROSALBA CARRIERA (1675–1757)
*Self-portrait in old age, c.*1745

A contemporary engraving by Giuseppe Wagner after this portrait records that the pastel was a gift from Carriera to Joseph Smith, *Magnæ Britanniæ Cos.* (Consul of Great Britain). This has been taken as evidence that the portrait was made at the time of Smith's appointment as British consul in 1744; while the inscription certainly does not prove this, Carriera's apparent age (which is well documented through a succession of self-portraits) would date the pastel to around this time, and thus establish this as one of her last works before she went blind in 1746.

The theory that the pastel was made as a gift is supported by the lack of affectation in the portrait, which would imply a friendship between artist and recipient. Smith was one of Carriera's major patrons, owning 38 of her works, of which five remain in the Royal Collection (this one and RCIN 400647, 400648, 400649, 400650). He may also have acted as an intermediary between Carriera and the English travellers who, along with the French and German nobility, formed the bulk of her patronage in her native city of Venice. A respect for the sophisticated taste of the recipient is also suggested by the subdued palette and the subtle variations in texture, from the smoothly blended fur to the dry crust of the lace, instead of a more overt showiness.

Pastel on paper; 57.2 × 47.0 cm
RCIN 452375
Purchased by George III from Joseph Smith

Left:

JEAN-ETIENNE LIOTARD (1702–1789)
George, Prince of Wales (later George III), 1754

Jean-Etienne Liotard was one of the most celebrated and widely travelled pastellists of the 18th century. He trained in Geneva and Paris and worked all over Europe and the Near East, where he acquired a strong taste for orientalising subjects.

From 1754 to 1755 Liotard was in London, where he executed a series of pastel portraits of Augusta, Princess of Wales, her husband Frederick, who had died in 1751, and their nine children. These have great immediacy and charm.

Augusta's eldest son George had become heir to the throne and inherited the title of Prince of Wales on the death of his father; he succeeded his grandfather George II as King in 1760. The portrait of the 16-year-old is accordingly one of the most formal of the series, his body almost in profile and his head turned to address the viewer with a direct, though sympathetic gaze. A version in miniature by Liotard in the collection of Princess Juliana of the Netherlands is dated 1754; this date may presumably also be applied to the pastel. Liotard's series of pastels has hung in the royal apartments in London or Windsor for the last 250 years.

Pastel on vellum; 40.6 × 29.8 cm
RCIN 400897
Commissioned by Augusta, Princess of Wales

Right:

JEAN-ETIENNE LIOTARD (1702–1789)
Princess Louisa, c.1754–55

Princess Louisa was born in 1749, the third daughter and seventh child of Frederick, Prince of Wales, and his wife Augusta. She was a delicate child and died of consumption in 1768, aged 19.

This is one of the series of eleven pastels executed for Princess Augusta from 1754 to 1755 (see above). Liotard engagingly portrayed the 5- or 6-year-old seated in an armchair too big for her, so that the arm is almost level with her shoulder and her head barely clears the chairback. Like the portrait of her brother George (above), the pastel has suffered from fading, in a way that has exposed a variation in Liotard's pigments. The portion of the chair in the Princess's shadow, to the right, was modelled in the same fugitive lake as the Prince of Wales's coat (above) over a layer of a stable earth colour, and the complete fading of the lake has exposed this flat underlayer.

Pastel on vellum; 40.0 × 30.5 cm
RCIN 400900
Commissioned by Augusta, Princess of Wales

Paul Sandby (1730/31–1809)
The south-east corner of Windsor Castle, c.1765

Paul Sandby was trained by his elder brother Thomas in Nottingham, after which both worked as military draughtsmen to the Board of Ordnance at the Tower of London. In 1747 Paul was assigned to the Military Survey in Scotland, mapping the Highlands in the aftermath of the Jacobite Rebellion. He retained an interest in military subjects all his life, but landscape watercolours and gouaches (and some oils) soon became his principal activity. In 1746 Thomas's patron William Augustus, Duke of Cumberland (George III's uncle), was appointed Ranger of Windsor Great Park and in 1764 Thomas became Deputy Ranger of the Park. Thereafter both Thomas and Paul spent much time at Windsor, producing many views of the castle and its surroundings over a period of 50 years.

The present gouache is of the south and east fronts of the castle on a summer's afternoon. In the foreground is the public footpath which until 1823 crossed the Little (now Home) Park from the King's Gate at the south side of the castle to Datchet

bridge. By the trees are fallow deer, a common sight by the castle until 1785, when George III transferred all the deer to the Great Park, so that the Little Park could be put to better agricultural use.

The Royal Collection now holds approaching 500 works by the Sandby brothers, of which over 150 are views of Windsor or projects for work in the Windsor parks. Strangely, none of them seems to have been acquired by George III. The foundations of the collection were instead laid by the future George IV, who bought many works by the Sandbys through the dealers Colnaghi after the posthumous sales of the brothers' possessions, Thomas's in July 1799 and Paul's in May 1811. Sporadic acquisitions were made throughout the 19th and 20th centuries, most notably at the sale of Sir Joseph Banks's collection in 1876. This is one of 50 Sandbys acquired during the present reign.

Bodycolour on panel; 38.4 × 55.8 cm
RL 18986
Purchased by HM The Queen

See detail on endpapers

Giovanni Antonio Canal, called Canaletto (1697–1768)
A capriccio with a terrace and loggia, c.1760

Canaletto's drawings range from closely observed and atmospheric studies made in front of the motif to highly artificial compositions constructed in the studio. In the latter he often playfully recombined elements of real topography, usually Venetian, in what had been known since the 17th century as a *capriccio*, a word derived from the jumping of a goat (*capro*). Here the broad staircase is reminiscent of that in the courtyard of the Palazzo Ducale, the vaulting of the loggia resembles that of the Procuratie Nuove, while in the right background is a reworking of the view across the Bacino to the Dogana and Santa Maria della Salute.

Although the drawing seems to be an exercise in perspective, the pencil and stylus underdrawing is not so extensive as might be expected and much of the detailing has been elaborated around a broadly constructed framework. There is no secure relationship between the principal staircase and that immediately beyond the foreground couple, both of which

lead down to some indeterminable level. An unlikely tree encroaching from the right throws the foreground into shadow. It provides a foil for the strongly lit marble staircase and loggia and the atmospheric lagoon. Canaletto added the figures in his customary shorthand of thick curling strokes; their function is no different from that of the large urns, to articulate the composition and break the hard lines of the architecture.

Suspended from the angle of the loggia is a shield bearing a chevron, the device of the Canal family and here used as a signature. The drawing was plainly an end in itself and was presumably made for Consul Smith, Canaletto's friend and greatest patron. The style is late and the sheet must have been one of the last to be drawn for Smith before the sale of his collection to George III in 1762.

Pen and ink, wash, over pencil and stylus; 36.5 × 52.7 cm
RL 7564
Purchased by George III from Joseph Smith

WILLIAM HOGARTH (1697–1764)
The Bathos, 1764

This is a vigorous study for Hogarth's last engraving, published on 3 March 1764, less than eight months before his death. Hogarth knew his health was failing and advertisements for the print announcing its publication stated that it was intended to 'serve as a Tail-Piece to all the Author's Engraved Works'.

The feelings expressed, and Hogarth's manner of expressing them, are complex. The image is a comprehensive *vanitas*: the exhausted figure of winged Time breathes his last, leaning on ruins, a sundial and a tombstone, with broken pipe and scythe, clutching a Last Will and Testament, at his feet a cracked bell, a broken palette, and a derelict inn-sign (inscribed *The World's End* in the print), gallows and a blasted tree beyond. The full title of the engraving is *The Bathos, or Manner of Sinking, in Sublime Paintings, inscribed to the Dealers in Dark Paintings*, with a footnote *See the manner of disgracing ye most Serious Subjects, in many celebrated Old Pictures; by introducing Low, absurd, obscene & often prophane Circumstances into them.*

This is a genuinely pessimistic, even bitter sentiment. Hogarth, characteristically, saw degradation in the supposedly trivial incidental details of Old Master paintings. The sarcastic references to 'celebrated Old Pictures' and 'Dealers in Dark Paintings' are an attack on the unbroken vogue for imported Old Masters; to this he added a side-swipe at the growing taste for the Sublime in art (recently codified by Edmund Burke in his *Philosophical Enquiry* of 1756), equating the dark treatments of sublime paintings with the darkened varnish of the Old Masters. Hogarth's gloom was no doubt compounded by his own physical decline, and the deep weariness of the image reflects a recognition that his life's ambition, the establishment of a noble and independent English school of painting, had been (by his own standards) in vain.

Although there are significant differences of detail between the drawing and the print, those portions of the composition that agree are on the same scale. The sheet was rubbed with red chalk on the reverse and many of the outlines were incised to transfer the design to the copper plate; the final changes in detail must have been effected by Hogarth on the plate itself.

Pen and ink over red chalk and pencil, indented for transfer; 25.5 × 33.1 cm
RL 13466
Royal Collection by 1877

JAMES GILES (1801–1870)
Lochnagar: the loch in the corrie of the mountain, 1849

In 1848 Prince Albert took a 27-year lease on the Balmoral Estate, having been shown watercolour views of the property by the Aberdeen artist James Giles. Queen Victoria and Prince Albert first stayed at the estate that September and were probably introduced to Giles at that time. A year later they returned, and the royal party visited Lochnagar (the name of both the mountain and the loch below the summit) for the first time on 22 September 1849. The Queen described it three days later, in a letter to her uncle Leopold, King of the Belgians, as 'one of the wildest, grandest things imaginable; the Expedition took us 7 hours; the Lake is about 1000 feet below the highest point. – & Albert thinks it very like the Crater of Mount Vesuvius'.

On 28 September Queen Victoria commissioned Giles to paint three specific views of lochs on the estate: Lochnagar, Dubh Loch and Loch Muick. Giles arrived at Balmoral on 1 October and went up to the lochs on the following days. It was bitterly cold, with snow and sleet, and ice on the pools; further, Victoria

had chosen steep vantage points and Giles was unable to sketch properly, even losing one of his notebooks. He left Balmoral in a black humour and did not begin to work up his studies into finished watercolours until a month later. During this time Giles managed to suppress the memory of his discomforts, and he depicted the lochs in gentle sunlight. The faint mist before the distant shadowed cliffs was captured by gently abrading the surface of the paper; the sparse foreground vegetation is less successfully drawn, and betrays the separation of the studio-bound artist from the motif.

Watercolour and bodycolour over pencil; 30.1 × 45.0 cm
Signed lower left *J. Giles*
RL 19623
Commissioned by Queen Victoria

JOHN PIPER (1903–1992)
Bacchus and Ariadne
(after Nicolas Poussin), c.1941–42

In 1941 Kenneth Clark, Director of the
National Gallery and Surveyor of the
King's Pictures, who had helped to set up
the War Artists Advisory Commission,
secured for Piper a commission from
Queen Elizabeth to paint views of
Windsor Castle, a potential target for
bombing. Piper's drawings were intended
to be records of the castle as well as of
works of art. While undertaking this
commission, Piper must have had time
to study the Old Master drawings in the
Royal Library, for this is a copy of Nicolas
Poussin's *Bacchus and Ariadne* (p. 233).
Perhaps it was the delight in finding such
a loose, vibrant sketch by the master of
classicism that led Piper to make his own
version, more colourful but scarcely
more dynamic.

Brush and ink with bodycolour, over pencil
and grey wash with stopping-out; 21.7 × 30.7 cm
Signed lower left *John Piper*
RL 32568
Purchased by HM The Queen

HUMPHREY OCEAN (b. 1951)
Graham Greene, 1989

Graham Greene (1904–1991) was one of the most popular
'serious' British novelists of the 20th century. He converted to
the Catholic Church at the age of 22, and a concern with moral
and religious ambivalence pervades his works. Greene was
widely travelled, publishing accounts of journeys in Mexico,
Liberia and elsewhere in Africa, and his novels often set the
protagonist in a conspicuously foreign environment that
compels self-examination. He was appointed to the Order of
Merit in 1986 and this drawing was commissioned soon
afterwards, for the series of portraits of members of the Order,
revived in 1987.

Humphrey Ocean has exhibited widely and a number of
his works have been acquired by the National Portrait Gallery,
London. Greene knew and admired Ocean's painting of the poet
Philip Larkin (National Portrait Gallery, London), and expressed
a wish that Ocean should execute his own portrait for the Order
of Merit series. The drawing was completed in three sittings at
the start of July 1989, at Greene's home in Antibes on the south
coast of France.

Pencil; 40.7 × 31.3 cm
Signed lower right *Humphrey Ocean / Antibes 1989*
RL 29210
Commissioned by HM The Queen for the Order of Merit portrait series

Index

✑ ACKNOWLEDGEMENTS ✑

Royal Collection Enterprises are grateful for permission to reproduce works on the following pages: pp. 59, 171, 177 (below right), 183 (below), 192–3 and 251 (above) © Reserved / Royal Collection; p. 20 © Lucian Freud; p. 210 © Golden Cockerel Press.

Contributors

BW	Bridget Wright (Bibliographer)
CdeG	Caroline de Guitaut (Assistant to the Director and Loans Officer, Works of Art)
CL	Christopher Lloyd (Former Surveyor of The Queen's Pictures)
DST	Desmond Shawe-Taylor (Surveyor of The Queen's Pictures)
ES	Emma Stuart (Assistant Bibliographer)
GdeB	Geoffrey de Bellaigue (Surveyor Emeritus of The Queen's Works of Art)
HR	Hugh Roberts (Director of the Royal Collection and Surveyor of The Queen's Works of Art)
JM	Jonathan Marsden (Deputy Surveyor of The Queen's Works of Art)
KB	Kathryn Barron (Former Curator, Paintings, and Loans Officer)
LW	Lucy Whitaker (Assistant Surveyor of The Queen's Pictures)
MC	Martin Clayton (Deputy Curator, Print Room)
MW	Matthew Winterbottom (Former Research Assistant, Works of Art)
OE	Oliver Everett (Librarian Emeritus)

Paintings: CL (essay); DST (p. 51); LW (pp. 27–30, 33, 38–9, 45–9, 52–3, 56–8); KB (pp. 32, 34–7, 40–4, 50, 54–5, 59)

Miniatures: CL

Sculpture: JM

Furniture: HR; MW (p. 81); JM (p. 88)

Ceramics: JM; GdeB (contrib. essay, pp. 115–24)

Gems and Jewels: HR; JM (pp. 142–3)

Arms and Armour: JM

Silver and Gold: MW

Fabergé: CdeG

Books and Manuscripts: BW (pp. 204, 206 right, 208 left, 211); ES (pp. 198–201, 205, 206 left, 208 right, 210); OE (essay, p. 202)

Drawings, Watercolours and Pastels: MC